Going Through the Storm

O9-AID-105

GOING THROUGH THE STORM

The Influence of African American Art in History

STERLING STUCKEY

New York Oxford
OXFORD UNIVERSITY PRESS
1994

Oxford University Press

Oxford New York Toronto
Delhi Bombay Calcutta Madras Karachi
Kuala Lumpur Singapore Hong Kong Tokyo
Nairobi Dar es Salaam Cape Town
Melbourne Auckland Madrid

and associated companies in
Berlin Ibadan

Copyright © 1994 by Sterling Stuckey

Published by Oxford University Press, Inc.
200 Madison Avenue, New York, New York 10016

Oxford is a registered trademark of Oxford University Press

All rights reserved. No part of this publication may be reproduced,
stored in a retrieval system, or transmitted, in any form or by any means,
electronic, mechanical, photocopying, recording, or otherwise,
without the prior permission of Oxford University Press.

Library of Congress Cataloging-in-Publication Data
Stuckey, Sterling.
Going through the storm : the influence of African American art in history /
Sterling Stuckey.
p. cm. Includes bibliographical references and index.
ISBN 0-19-507677-X. — ISBN 0-19-508604-X (pbk.)
1. Afro-American arts. 2. Afro-Americans—History. I. Title.
NX512.3.A35S78 1994 700'.89'96073—dc20 93-3238

"Through the Prism of Folklore: The Black Ethos in Slavery." Reprinted with permission from the author and the *Massachussetts Review*, Vol. IX, No. 3, Summer 1968.
"Remembering Denmark Vesey." Reprinted with permission from *Negro Digest*, February 1966.
"'Ironic Tenacity': Frederick Douglass's Seizure of the Dialectic," an essay in *Frederick Douglass: New Literary and Historical Essays*. 1990. Reprinted by permission of Cambridge University Press.
"Classical Black Nationalist Thought," an Introduction to *The Ideological Origins of Black Nationalism*. Copyright © 1972 by Sterling Stuckey. Reprinted by permission of Beacon Press.
"A Last Stern Struggle: Henry Highland Garnet and Liberation Theory." 1988. Reprinted with permission from the University of Illinois Press.
"Black Americans and African Consciousness: Du Bois, Woodson, and the Spell of Africa." Reprinted by permission from *Negro Digest*, February 1967.
"The Poetry of Sterling A. Brown" appeared originally as the Introduction to *Southern Road*. 1974. By permission of John Dennis. (Brown's son)
"The Death of Benito Cereno: A Reading of Herman Melville on Slavery." Reprinted with permission of the *Journal of Negro History*, Winter 1982.
"'Follow Your Leader': The Theme of Cannibalism in Melville's *Benito Cereno*." 1992. Reprinted with permission from Macmillan.
"'I Want to Be African': Paul Robeson and the Ends of Nationalist Theory and Practice, 1914–1915." Reprinted with permission of the *Massachussetts Review*, Spring 1976.
"Paul Robeson's *Here I Stand*." Originally the Introduction to the 1988 edition of *Here I Stand*. Permission to reprint granted by Beacon Press.
"Toward a History of Blacks in North America." Copyright © 1975 by the author.
"Going Through the Storm: The Great Singing Movements of the Sixties." Reprinted with permission of the Smithsonian Institution. The song "Father's Grave" is reprinted with permission of Len Chandler.

9 8 7 6 5 4 3 2 1

Printed in the United States of America
on acid-free paper

For Harriette
and

To the memory of my mother and father,
Elma and Ples Stuckey

and sister,
Delois Jean

Preface

My interest in art and history began, almost imperceptibly, on hearing R. Nathaniel Dett's "Listen to the Lambs" being sung one evening around the piano in the front room of my grandparents' house in Memphis. I have not heard the song since, but it echoes in my ear to this day as one of great and tender and courageous beauty. It was so much a part of the young men and women who sang it, so much a joy to all who heard it, that, as young as I was, I was dimly conscious of a shared richness in our lives. Not long thereafter, while listening to poetry that was anchored in deep currents of reality, I came to realize that the conjunction of art and history was as natural as that between the lives we lived and the flow of historical time.

In those years, and later in Chicago, dance was no less vital than music, and music was ever being heard. In fact, art seemed as much a part of life as the sky, and its musical tones were not infrequently overcast spiritually. Yet the blues, the Negro spiritual, and jazz transmuted that pain into beauty, reminding us of the reach of human possibility. Not surprisingly, music and dance are recurring themes in these pages, but almost all of the essays are as concerned with the arts, which form the continuum along which identity is established and group life is enhanced.

The best of black art, as we see in essays on Paul Robeson, is a commentary on the human condition of such genuineness that its appeal has reached out and touched most of humanity. In addition, the grounding of the arts in history and of history in the arts was not the least of the features of African life that struck Herman Melville as extraordinarily significant, and he captures the connection in *Benito Cereno*, the subject of two essays in this volume.

That black artists have for so long been deeply interested in the question of oppression makes their art of particular use to the historian, whose task is to understand the sources of their ethos and the forms of its expression. The methodology employed is premised on the assumption that relevant disciplines can enhance our understanding of problems common to them, that one can better reveal something of the process and texture of life, spiritual and otherwise, when disciplinary barriers are lowered.

The essay that closes this volume, a consideration of the uses of music as history, from which part of the title of the volume is taken,

appears here for the first time in print, as does the one on slave dance in New York, which was largely written in the spring of 1992 at the Humanities Research Institute, the University of California, Irvine. In addition, a number of the essays have been largely inaccessible to historians, having appeared in literary journals and books, and these range from treatments of poetry and music to dance and the novel. On the other hand, some essays devoted to the arts that appeared originally in historical sources are now available to students of the arts. Consequently, the essential unity of the essays is presented here for the first time.

To some I owe debts accumulated over a number of years. Harriette made it possible for me to work at these essays with undistracted attention and, drawing on her knowledge of music and dance, illuminated obscure points and helped me keep the larger picture in focus. The poetry of my mother, which treats the inner life and the ironies of history in slavery and since, has been an inspiration and a continuing illustration of the intersection of art and history; Ossie Davis has taught me much of the largeness of the human spirit; and Sarah Vaughan's voice, which helped me to survive seemingly endless Chicago winters, made gloriously concrete the influence of art in history.

Finally, thanks to Sheldon Meyer, the consummate editor at enabling one to pursue one's work.

Riverside, Calif. S. S.
April 1993

Contents

PART IV THE ARTS, CULTURAL THEORY, AND HISTORY

PART I
SLAVERY, THE ARTS, AND RESISTANCE

These essays were written over the span of twenty-five years. Those on slavery aim at not compartmentalizing slave experience, thereby enabling slaves to come alive, on their terms, on the printed page. The study of dance in New York is a notable example of that process with dance and music propelling each other, the one the context in which the other finds expression.

Through the Prism of Folklore:
The Black Ethos in Slavery

It is not excessive to argue that some historians, because they have been so preoccupied with demonstrating the absence of significant slave revolts, conspiracies, and "day to day" resistance among slaves, have presented information on slave behavior and thought which is incomplete indeed. They have, in short, devoted very little attention to trying to get "inside" slaves to discover what bondsmen thought about their condition. Small wonder we have been saddled with so many stereotypical treatments of slave thought and behavior.[1]

Though we do not know enough about the institution of slavery or the slave experience to state with great precision how slaves felt about their condition, it is reasonably clear that slavery, however draconic and well supervised, was not the hermetically sealed monolith—destructive to the majority of slave personalities—that some historians would have us believe. The works of Herbert Aptheker, Kenneth Stampp, Richard Wade, and the Bauers, allowing for differences in approach and purpose, indicate that slavery, despite its brutality, was not so "closed" that it robbed most of the slaves of their humanity.[2]

It should, nevertheless, be asserted at the outset that blacks could not have survived the grim experience of slavery unscathed. Those historians who, for example, point to the dependency complex which slavery engendered in many African Americans offer us an important insight into one of the most harmful effects of that institution upon its victims. That slavery caused not a few bondsmen to question their worth as human beings—this much, I believe, we can posit with certitude. We can also safely assume that such self-doubt would rend one's sense of humanity,

[1]Historians who have provided stereotypical treatments of slave thought and personality are Ulrich B. Phillips, *American Negro Slavery* (New York, 1918); Samuel Eliot Morrison, and Henry Steele Commager, *The Growth of the American Republic* (New York, 1950); and Stanley Elkins, *Slavery: A Problem in American Institutional and Intellectual Life* (Chicago, 1959).

[2]See Herbert Aptheker, *American Negro Slave Revolts*; Kenneth M. Stampp, *The Peculiar Institution* (New York, 1956); Richard Wade, *Slavery in the Cities* (New York, 1964); and Alice and Raymond Bauer, "Day to Day Resistance to Slavery," *Journal of Negro History*, XXVII, No. 4 (October 1942).

establishing an uneasy balance between affirming and negating aspects of one's being. What is at issue is not whether American slavery was harmful to slaves but whether, in their struggle to control self-lacerating tendencies, the scales were tipped toward a despair so consuming that most slaves, in time, became reduced to the level of "Sambos."[3]

My thesis, which rests on an examination of folk songs and tales, is that slaves were able to fashion a life style and set of values—an ethos—which prevented them from being imprisoned altogether by the definitions which the larger society sought to impose. This ethos was an amalgam of Africanisms and New World elements which helped slaves, in Guy Johnson's words, "feel their way along the course of American slavery, enabling them to endure. . . ."[4] As Sterling Brown, that wise student of African American culture, has remarked, the values expressed in folklore acted as a "wellspring to which slaves" trapped in the wasteland of American slavery "could return in times of doubt to be refreshed."[5] In short, I shall contend that the process of dehumanization was not nearly as pervasive as Stanley Elkins would have us believe; that a very large number of slaves, guided by this ethos, were able to maintain their essential humanity. I make this contention because folklore, in its natural setting, is of, by, and for those who create and respond to it, depending for its survival upon the accuracy with which it speaks to needs and reflects sentiments. I therefore consider it safe to assume that the attitudes of a very large number of slaves are represented by the themes of folklore.[6]

[3]I am here concerned with the Stanley Elkins version of "Sambo," that is, the inference that the overwhelming majority of slaves, as a result of their struggle to survive under the brutal system of American slavery, became so callous and indifferent to their status that they gave survival primacy over all other considerations. See Chapters III–VI of *Slavery* for a discussion of the process by which blacks allegedly were reduced to the "good humor of everlasting childhood" (p. 132).

[4]I am indebted to Guy Johnson of the University of North Carolina for suggesting the use of the term "ethos" in this piece and for helpful commentary on the original paper which was read before the Association for the Study of Negro Life and History at Greensboro, North Carolina, on October 13, 1967.

[5]Professor Brown made this remark in a paper delivered before the Amistad Society in Chicago, Spring 1964. Distinguished poet, literary critic, folklorist, and teacher, Brown has long contended that an awareness of Negro folklore is essential to an understanding of slave personality and thought.

[6]I subscribe to Alan Lomax's observation that folk songs "can be taken as the signposts of persistent patterns of community feeling and can throw light into many dark corners of our past and our present." His view that African American music, despite its regional peculiarities, "expresses the same feelings and speaks the same basic language everywhere" is also accepted as a working principle in this essay. For an extended treatment of these points of view, see Alan Lomax, *Folk Songs of North America* (New York, 1960), Introduction, p. xx.

I

Frederick Douglass, commenting on slave songs, remarked his utter astonishment, on coming to the North, "to find persons who could speak of the singing among slaves as evidence of their contentment and happiness."[7] The young Du Bois, among the first knowledgeable critics of the spirituals, found white Americans as late as 1903 still telling African Americans that "life was joyous to the black slave, careless and happy." "I can easily believe this of some," he wrote, "of many. But not all the past South, though it rose from the dead, can gainsay the heart-touching witness of these songs."

> They are the music of an unhappy people, of the children of disappointment; they tell of death and suffering and unvoiced longing toward a truer world, of misty wanderings and hidden ways.[8]

Though few historians have been interested in such wanderings and ways, Frederick Douglass, probably referring to the spirituals, said the songs of slaves represented the sorrows of the slave's heart, serving to relieve the slave "only as an aching heart is relieved by its tears." "I have often sung," he continued, "to drown my sorrow, but seldom to express my happiness. Crying for joy, and singing for joy, were alike uncommon to me while in the jaws of slavery."[9]

Sterling Brown, who has much to tell us about the poetry and meaning of these songs, has observed: "As the best expression of the slave's deepest thoughts and yearnings, they (the spirituals) speak with convincing finality against the legend of contented slavery."[10] Rejecting the formulation that the spirituals are mainly otherworldly, Brown states that though the creators of the spirituals looked toward heaven and "found their triumphs there, they did not blink their eyes to trouble here." The spirituals, in his view, "never tell of joy in the 'good old days.' . . . The only joy in the spirituals is in dreams of escape."[11]

Rather than being essentially otherworldly, these songs, in Brown's opinion, "tell of this life, of 'rollin' through an unfriendly world!" To substantiate this view, he points to numerous lines from spirituals: "Oh, bye and bye, bye and bye, I'm going to lay down this heavy load"; "My

[7]Frederick Douglass, *Narrative of the Life of Frederick Douglass* (Cambridge, Massachusetts, 1960), p. 38. Originally published in 1845.

[8]John Hope Franklin, ed., *Souls of Black Folk* in *Three Negro Classics* (New York, 1965), p. 380. Originally published in 1903.

[9]Douglass, *Narrative*, p. 38. Douglass's view adumbrated John and Alan Lomax's theory that the songs of the folk singer are deeply rooted "in his life and have functioned there as enzymes to assist in the digestion of hardship, solitude, violence (and) hunger." John A. and Alan Lomax, *Our Singing Country* (New York, 1941), Preface, p. xiii.

[10]Sterling Brown, "Negro Folk Expression," *Phylon* (October 1953), p. 47.

[11]Brown, "Folk Expression," p. 48.

way is cloudy"; "Oh, stand the storm, it won't be long, we'll anchor by and by"; "Lord help me from sinking down"; and "Don't know what my mother wants to stay here fuh, Dis ole world ain't been no friend to huh."[12] To those scholars who "would have us believe that when the Negro sang of freedom, he meant only what the whites meant, namely freedom from sin," Brown rejoins:

> Free individualistic whites on the make in a prospering civilization, nursing the American dream, could well have felt their only bondage to be that of sin, and freedom to be religious salvation. But with the drudgery, the hardships, the auction block, the slave-mart, the shackles, and the lash so literally present in the Negro's experience, it is hard to imagine why for the Negro they would remain figurative. The scholars certainly did not make this clear, but rather take refuge in such dicta as: "the slave never contemplated his low condition."[13]

"Are we to believe," asks Brown, "that the slave singing 'I been rebuked, I been scorned, done had a hard time sho's you bawn,' referred to his being outside the true religion?" A reading of additional spirituals indicates that they contained distinctions in meaning which placed them outside the confines of the "true religion." Sometimes, in these songs, we hear slaves relating to divinities on terms more West African than American. The easy intimacy and argumentation, which come out of a West African frame of reference, can be heard in "Hold the Wind."[14]

> When I get to heaven, gwine be at ease,
> Me and my God *gonna do as we please.*
>
> Gonna chatter with the Father, argue with the Son,
> *Tell um 'bout the world I just come from* (italics added).[15]

If there is a tie with heaven in those lines from "Hold the Wind," there is also a clear indication of dislike for the restrictions imposed by slavery. And at least one high heavenly authority might have a few questions to answer. *Tell um 'bout the world I just come from* makes it abundantly clear that some slaves — even when released from the burdens of the world — would keep alive painful memories of their oppression.

If slaves could argue with the son of God, then surely, when on their knees in prayer, they would not hesitate to speak to God of the treatment being received at the hands of their oppressors.

[12]*Ibid.*, p. 407.

[13]*Ibid.*, p. 48.

[14]Addressing himself to the slave's posture toward God, and the attitudes toward the gods which the slave's African ancestors had, Lomax has written: "The West African lives with his gods on terms of intimacy. He appeals to them, reviles them, tricks them, laughs at their follies. In this spirit the Negro slave humanized the stern religion of his masters by adopting the figures of the Bible as his intimates." Lomax, *Folk Songs of North America*, p. 463.

[15]Quoted from *Ibid.*, p. 475.

> Talk about me much as you please, (2)
> Chillun, talk about me much as you please,
> Gonna talk about you when I get on my knees.[16]

That slaves could spend time complaining about treatment received from other slaves is conceivable, but that this was their only complaint, or even the principal one, is hardly conceivable. To be sure, there is a certain ambiguity in the use of the word "chillun" in this context. The reference appears to apply to slaveholders.

The spiritual *Samson*, as Vincent Harding has pointed out, probably contained much more (for some slaves) than mere biblical implications. Some who sang these lines from *Samson*, Harding suggests, might well have meant tearing down the edifice of slavery. If so, it was the antebellum equivalent of today's "burn baby burn."

> He said, "An' if I had-'n my way,"
> He said, "An' if I had-'n my way,"
> He said, "An' if I had-'n my way,
> I'd tear the build-in' down!"
>
> He said, "And now I got my way, (3)
> And I'll tear this buildin' down."[17]

Both Harriet Tubman and Frederick Douglass have reported that some of the spirituals carried double meanings. Whether most of the slaves who sang those spirituals could decode them is another matter. Harold Courlander has made a persuasive case against widespread understanding of any given "loaded" song,[18] but it seems to me that he fails to recognize sufficiently a further aspect of the subject: slaves, as their folktales make eminently clear, used irony repeatedly, especially with animal stories. Their symbolic world was rich. Indeed, the various masks which many put on were not unrelated to this symbolic process. It seems logical to infer that it would occur to more than a few to seize upon some songs, even though created originally for religious purposes, assign another meaning to certain words, and use these songs for a variety of purposes and situations.

At times slave bards created great poetry as well as great music. One genius among the slaves couched his (and their) desire for freedom in a

[16]Quoted from Sterling A. Brown, Arthur P. Davis, and Ulysses Lee, *The Negro Caravan* (New York, 1941), p. 436.

[17]Vincent Harding, *"Black Radicalism in America."* An unpublished work which Dr. Harding recently completed.

[18]See Harold Courlander, *Negro Folk Music, U.S.A.* (New York, 1963), pp. 42, 43. If a great many slaves did not consider Harriet Tubman the "Moses" of her people, it is unlikely that most failed to grasp the relationship between themselves and the Israelites, Egypt and the South, and Pharaoh and slavemasters in such lines as: "Didn't my Lord deliver Daniel / And why not every man"; "Oh Mary don't you weep, don't you moan / Pharaoh's army got drowned / Oh Mary don't you weep"; and "Go down Moses / Way down in Egypt-land / Tell old Pharaoh / To let my people go."

magnificent line of verse. After God's powerful voice had "Rung through Heaven and down in Hell," he sang, "My dungeon shook and my chains, they fell."[19]

In some spirituals, Alan Lomax has written, African Americans turned sharp irony and "healing laughter" toward heaven, again like their West African ancestors, relating on terms of intimacy with God. In one, the slaves have God engaged in a dialogue with Adam:

> "Stole my apples, I believe."
> "No, marse Lord, I spec it was Eve."
> Of this tale there is no mo'
> Eve et the apple and Adam de co'.[20]

Douglass informs us that slaves also sang ironic seculars about the institution of slavery. He reports having heard them sing: "We raise de wheat, dey gib us de corn; We sift de meal, dey gib us de huss; We peel de meat, dey gib us de skin; An dat's de way dey take us in."[21] Slaves would often stand back and see the tragicomic aspects of their situation, sometimes admiring the swiftness of blacks:

> Run, nigger, run, de patrollers will ketch you,
> Run, nigger run, its almost day.
> Dat nigger run, dat nigger flew;
> Dat nigger tore his shirt in two.[22]

And there is:

> My ole mistiss promise me
> W'en she died, she'd set me free,
> She lived so long dat 'er head got bal'
> An' she give out'n de notion a-dyin' at all.[23]

In the antebellum days, work songs were of crucial import to slaves. As they cleared and cultivated land, piled levees along rivers, piled loads on steamboats, screwed cotton bales into the holds of ships, and cut roads and railroads through forest, mountain, and flat, slaves sang while the white man, armed and standing in the shade, shouted his orders.[24] Through the sense of timing and coordination which characterized work songs well sung, especially by the leaders, slaves sometimes quite literally created works of art. These songs not only militated against injuries but enabled the bondsmen to get difficult jobs done more easily by not having to concentrate on the dead level of their work. "In a very real sense the chants of Negro labor," writes Alan Lomax, "may be considered the

[19]Quoted from Lomax, *Folk Songs of North America*, p. 471.

[20]*Ibid.*, p. 476.

[21]Frederick Douglass, *The Life and Times of Frederick Douglass* (New York, 1962), p. 146.

[22]Brown, "Folk Expression," p. 51.

[23]Brown, *Caravan*, p. 447.

[24]Lomax, *Folk Songs of North America*, p. 514.

most profoundly American of all our folk songs, for they were created
by our people as they tore at American rock and earth and reshaped it
with their bare hands, while rivers of sweat ran down and darkened the
dust."

> Long summer day makes a white man lazy,
>> Long summer day.
> Long summer day makes a nigger run away, sir,
>> Long summer day.[25]

Other slaves sang lines indicating their distaste for slave labor:

> Ol' massa an' ol' missis,
> Sittin' in the parlour,
> Jus' fig'in' an' a-plannin'
> How to work a nigger harder.[26]

And there are these bitter lines, the meaning of which is clear:

> Missus in the big house,
> Mammy in the yard,
> Missus holdin' her white hands,
> Mammy workin' hard (3)
> Missus holdin' her white hands,
> Mammy workin' hard.

> Old Marse ridin' all time,
> Niggers workin' round,
> Marse sleepin' day time,
> Niggers diggin' in the ground, (3)
> Marse sleepin' day time,
> Niggers diggin' in the ground.[27]

Courlander tells us that the substance of the work songs "ranges
from the humorous to the sad, from the gentle to the biting, and from
the tolerant to the unforgiving." The statement in a given song can be
metaphoric, tangent, or direct, the meaning personal or impersonal.
"As throughout Negro singing generally, there is an incidence of social
criticism, ridicule, gossip, and protest."[28] Pride in their strength rang
with the downward thrust of axe —

> When I was young and in my prime, (hah!)
> Sunk my axe deep every time, (hah!)

Blacks later found their greatest symbol of manhood in John Henry,
descendant of Trickster John of slave folktales:

[25]*Ibid.*, p. 515.
[26]*Ibid.*, p. 527.
[27]Courlander, *Negro Folk Music*, p. 117.
[28]*Ibid.*, p. 89.

> A man ain't nothing but a man,
> But before I'll let that steam driver beat me down
> I'll die with my hammer in my hand.[29]

Though Frances Kemble, an appreciative and sensitive listener to work songs, felt that "one or two barbaric chants would make the fortune of an opera," she was on one occasion "displeased not a little" by a self-deprecating song, one which "embodied the opinion that 'twenty-six black girls not make mulatto yellow girl,' and as I told them I did not like it, they have since omitted it."[30] What is pivotal here is not the presence of self-laceration in folklore but its extent and meaning. While folklore contained some self-hatred, on balance it gives no indication whatever that blacks, as a group, liked or were indifferent to slavery, which is the issue.[31]

To be sure, only the most fugitive of songs sung by slaves contained direct attacks upon the system. Two of these were associated with slave rebellions. The first, possibly written by ex-slave Denmark Vesey himself, was sung by slaves on at least one island off the coast of Charleston, S.C., and at meetings convened by Vesey in Charleston. Though obviously not a folk song, it was sung by the folk.

> Hail! all hail! ye Afric clan,
> Hail! ye oppressed, ye Afric band,
> Who toil and sweat in slavery bound

[29]Brown, "Folk Expression," p. 54. Steel-driving John Henry is obviously in the tradition of the axe-wielding blacks of the antebellum period. The ballad of John Henry helped spawn John Henry work songs:

> Dis ole hammer—hunh
> Ring like silver—hunh (3)
> Shine like gold, baby—hunh
> Shine like gold—hunh
>
> Dis old hammer—hunh
> Killt John Henry—hunh (3)
> Twont kill me baby, hunh
> Twon't kill me. (Quoted from
> Brown, "Folk Expression," p. 57.)

[30]Frances Anne Kemble, *Journal of a Residence on a Georgia Plantation, 1838–1839* (New York, 1864), pp. 260–61. Miss Kemble heard slaves use the epithet "nigger": "And I assure you no contemptuous intonation ever equalled the prepotenza (arrogance) of the despotic insolence of this address of these poor wretches to each other." Kemble, *Journal*, p. 281. Here she is on solid ground, but the slaves also used the word with glowing affection, as seen in the "Run, Nigger, Run" secular. At other times they leaned toward self-laceration but refused to go the whole route: "My name's Ran, I wuks in de sand, I'd rather be a nigger dan a po' white man." Brown, "Folk Expression," p. 51. Some blacks also sang, "It takes a long, lean, black-skinned gal, to make a preacher lay his Bible down." Newman I. White, *American Negro Folk Songs* (Cambridge, 1928), p. 411.

[31]Elkins, who believes southern white lore on slavery should be taken seriously, does not subject it to serious scrutiny. For a penetrating—and devastating—analysis of "the richest layers of Southern lore" which, according to Elkins, resulted from "an exquisitely rounded collective creativity," see Sterling A. Brown, "A Century of Negro Portraiture in American Literature," *Massachusetts Review* (Winter 1966).

> And when your health and strength are gone
> Are left to hunger and to mourn,
> Let independence be your aim,
> Ever mindful what 'tis worth.
> Pledge your bodies for the prize,
> Pile them even to the skies![32]

The second, a popular song derived from a concrete reality, bears the marks of a conscious authority:

> You mought be rich as cream
> And drive you coach and four-horse team,
> But you can't keep de world from moverin' round
> Nor Nat Turner from gainin' ground.
>
> And your name it mought be Caesar sure,
> And got you cannon can shoot a mile or more,
> But you can't keep de world from moverin' round
> Nor Nat Turner from gainin' ground.[33]

The introduction of Denmark Vesey, class leader in the A.M.E. Church, and Nat Turner, slave preacher, serves to remind us that some slaves and ex-slaves were violent as well as humble, impatient as well as patient.

It is also well to recall that the religious David Walker, who had lived close to slavery in North Carolina, and Henry Highland Garnet, ex-slave and Presbyterian minister, produced two of the most inflammatory, vitriolic and doom-bespeaking polemics America has yet seen.[34] There was theological tension here, loudly proclaimed, a tension which emanated from and was perpetuated by American slavery and race prejudice. This dimension of ambiguity must be kept in mind, if for no other reason than to place in bolder relief the possibility that a great many slaves and free African Americans could have interpreted Christianity in a way quite different from white Christians.

Even those songs which seemed most otherworldly, those which expressed profound weariness of spirit and even faith in death, through their unmistakable sadness, were accusatory, and God was not their object. If one accepts as a given that some of these appear to be almost wholly escapist, the indictment is no less real. Thomas Wentworth Higginson came across one—". . . a flower of poetry in that dark soil," he called it.[35]

[32]Quoted from Archie Epps, "A Negro Separatist Movement," *Harvard Review*, IV, No. 1 (Summer–Fall 1956), p. 75.

[33]Quoted in William Styron, "This Quiet Dust," *Harpers* (April 1965), p. 135.

[34]For excerpts from David Walker's *Appeal* and Henry H. Garnet's *Call to Rebellion*, see Herbert Aptheker, ed., *A Documentary History of the Negro People in the United States*, 2 vols. (New York, 1965). Originally published in 1951.

[35]Thomas Wentworth Higginson, *Army Life in a Black Regiment* (New York, 1962), p. 199.

> I'll walk in de graveyard, I'll walk through de graveyard,
> To lay dis body down.
> I'll lie in de grave and stretch out my arms,
> Lay dis body down.

Reflecting on "I'll lie in de grave and stretch out my arms," Higginson said that "Never, it seems to me, since man first lived and suffered, was his infinite longing for peace uttered more plaintively than in that line."[36]

There seems to be small doubt that Christianity contributed in large measure to a spirit of patience which militated against open rebellion among the bondsmen. Yet to overemphasize this point leads one to obscure a no less important reality: Christianity, after being reinterpreted and recast by slave bards, also contributed to that spirit of endurance which powered generations of bondsmen, bringing them to that decisive moment when for the first time a real choice was available to scores of thousands of them.

When that moment came, some slaves who were in a position to decide for themselves did so. W. E. B. Du Bois re-created their mood and the atmosphere in which they lived.

> There came the slow looming of emancipation. Crowds and armies of the unknown, inscrutable, unfathomable Yankees; cruelty behind and before; rumors of a new slave trade, but slowly, continuously, the wild truth, the bitter truth, the magic truth, came surging through. There was to be a new freedom! And a black nation went tramping after the armies no matter what it suffered; no matter how it was treated, no matter how it died.[37]

The gifted bards, by creating songs with an unmistakable freedom ring, songs which would have been met with swift, brutal repression in the antebellum days, probably voiced the sentiments of all but the most degraded and dehumanized. Perhaps not even the incredulous slavemaster could deny the intent of the new lyrics. "In the wake of the Union Army and in the contraband camps," remarked Sterling Brown, "spirituals of freedom sprang up suddenly. . . . Some celebrated the days of Jubilo: 'O Freedom; O Freedom!' and 'Before I'll be a slave, I'll be buried in my grave!,' and 'Go home to my lord and be free.'" And there was: "'No more driver's lash for me. . . . Many thousand go.'"[38]

Du Bois brought together the insights of the poet and historian to get inside the slaves:

> There was joy in the South. It rose like perfume—like a prayer. Men stood quivering. Slim dark girls, wild and beautiful with wrinkled hair, wept silently; young women, black, tawny, white and golden, lifted shivering

[36]*Ibid.*

[37]W. E. B. Du Bois, *Black Reconstruction* (Philadelphia, 1935), p. 122. Originally published in 1935.

[38]Brown, "Folk Expression," p. 49.

hands, and old and broken mothers, black and gray, raised great voices and shouted to God across the fields, and up to the rocks and the mountains.[39]

Some sang:

> Slavery chain done broke at last, broke at last, broke at last,
> Slavery chain done broke at last,
> Going to praise God till I die.
>
> I did tell him how I suffer,
> In de dungeon and de chain,
> *And de days I went with head bowed down,*
> And my broken flesh and pain,
> Slavery chain done broke at last, broke at last, broke at last.[40]

Whatever the nature of the shocks generated by the war, among those vibrations felt were some that had come from African American singing ever since the first Africans were forcibly brought to these shores. Du Bois was correct when he said that the new freedom song had not come from Africa, but that "the dark throb and beat of that Ancient of Days was in and through it."[41] Thus, the psyches of those who gave rise to and provided widespread support for folk songs had not been reduced to *tabula rasas* on which a slave-holding society could at pleasure sketch out its wish-fulfillment fantasies.

We have already seen the acute degree to which some slaves realized they were being exploited. Their sense of the injustice of slavery made it so much easier for them to act out their aggression against whites (by engaging in various forms of "day to day" resistance) without being overcome by a sense of guilt, or a feeling of being ill-mannered. To call this nihilistic thrashing about would be as erroneous as to refer to their use of folklore as esthetic thrashing about.[42] For if they did not regard themselves as the equals of whites in many ways, their folklore indicates

[39]Du Bois, *Reconstruction*, p. 124.

[40]Quoted in Brown, *Caravan*, pp. 440–41. One of the most tragic scenes of the Civil War period occurred when a group of Sea Island freedmen, told by a brigadier general that they would not receive land from the government, sang, "Nobody knows the trouble I've seen." Du Bois, *Souls*, p. 381.

[41]Du Bois, *Reconstruction*, p. 124.

[42]If some slavemasters encouraged slaves to steal or simply winked at thefts, then slaves who obliged them were most assuredly *not acting against their own interests*, whatever the motivation of the masters. Had more fruitful options been available to them, then and only then could we say that slaves were playing into the hands of their masters. Whatever the masters thought of slaves who stole from them—and there is little reason to doubt that most slaves considered it almost obligatory to steal from white people—the slaves, it is reasonable to assume, were aware of the unparalleled looting in which masters themselves were engaged. To speak therefore of slaves undermining their sense of self-respect as a result of stealing from whites—and this argument has been advanced by Eugene Genovese—is wide of the mark. Indeed, it appears more likely that those who engaged in stealing were, in the context of an oppressor–oppressed situation, on the way to realizing a larger measure of self-respect. Moreover, Genovese, in charging that certain forms of "day to-

that the generality of slaves must have at least felt superior to whites morally. And that, in the context of oppression, could make the difference between a viable human spirit and one crippled by the belief that the interests of the master are those of the slave.

When it is borne in mind that slaves created a large number of extraordinary songs and greatly improved a considerable proportion of the songs of others, it is not at all difficult to believe that they were conscious of the fact that they were leaders in the vital area of art — giving protagonists rather than receiving pawns. And there is some evidence that slaves were aware of the special talent which they brought to music. Higginson has described how reluctantly they sang from hymnals — "even on Sunday" — and how "gladly" they yielded "to the more potent excitement of their own 'spirituals'"[43] It is highly unlikely that the slaves' preference for their own music went unremarked among them, or that this preference did not affect their estimate of themselves. "They soon found," commented Alan Lomax, "that when they sang, the whites recognized their superiority as singers, and listened with respect."[44] He might have added that those antebellum whites who listened probably seldom understood.

What is of pivotal import, however, is that the esthetic realm was an area in which slaves knew they were not inferior to whites. Small wonder that they borrowed many songs from the larger community, then quickly invested them with their own economy of statement and power of imagery rather than yield to the temptation of merely repeating what they had heard. Since they were essentially group rather than solo performances, the values inherent in and given affirmation by the music served to strengthen bondsmen in a way that solo music could not have done.[45] In a word, slave singing often provided a form of group therapy, a way

day" resistance, in the absence of general conditions of rebellion, "amounted to individual and essentially nihilistic thrashing about," fails to recognize that that which was possible, that which conditions permitted, was pursued by slaves in preference to the path which led to passivity or annihilation. Those engaging in "day to day" resistance were moving along meaningful rather than nihilistic lines, for their activities were designed to frustrate the demands of the authority-system. For a very suggestive discussion of the dependency complex engendered by slavery and highly provocative views on the significance of "day to day" resistance among slaves, see Eugene Genovese, "The Legacy of Slavery and the Roots of Black Nationalism," *Studies on the Left*, VI, No. 6 (Nov.–Dec. 1966), especially p. 8.

[43]Higginson, *Black Regiment*, p. 212. Alan Lomax reminds us that the slaves sang "in leader–chorus style, with a more relaxed throat than the whites, and in deeper-pitched, mellower voices, which blended richly." "A strong, surging beat underlay most of their American creations . . . words and tunes were intimately and playfully united, and 'sense' was often subordinated to the demands of rhythm and melody." Lomax, *Folk Songs of North America*, Introduction, p. xx.

[44]Lomax, *Folk Songs*, p. 460.

[45]Commenting on the group nature of much of slave singing, Alan Lomax points out that the majority of the bondsmen "came from West Africa, where music-making was largely a group activity, the creation of a many-voiced, dancing throng. . . . Community songs of labour and worship (in America) and dance songs far outnumbered narrative pieces, and the emotion of the songs was, on the whole, joyfully erotic, deeply tragic,

in which a slave, in concert with others, could fend off some of the debilitating effects of slavery.

The field of inquiry would hardly be complete without some mention of slave tales. Rich in quantity and often subtle in conception, these tales further illumine the inner world of the bondsmen, disclosing moods and interests almost as various as those found in folk songs. That folktales, like the songs, indicate an African presence, should not astonish; for the telling of tales, closely related to the African griot's vocation of providing oral histories of families and dynasties, was deeply rooted in West African tradition. Hughes and Bontemps have written that the slaves brought to America the "habit of story-telling as pastime, together with a rich bestiary." Moreover, they point out that the folktales of slaves "were actually projections of personal experiences and hopes and defeats, in terms of symbols," and that this important dimension of the tales "appears to have gone unnoticed."[46]

Possessing a repertoire which ranged over a great many areas, perhaps the most memorable tales are those of Brer Rabbit and John.[47] Brer Rabbit, now trickster, ladies' man, and braggart, now wit, joker, and glutton, possessed the resourcefulness, despite his size and lack of strength, to outsmart stronger, larger animals. "To the slave in his condition," according to Hughes and Bontemps, "the theme of weakness overcoming strength through cunning proved endlessly fascinating."[48] John, characterized by a spiritual resilience born of an ironic sense of life, was a secular high priest of mischief and guile who delighted in matching wits with Ole Marster, the "patterollers," Ole Missy, and the devil himself. He was clever enough to sense the absurdity of his predicament and that of white people, smart enough to know the limits of his powers and the boundaries of those of the master class. While not always victorious, even on the spacious plane of the imagination, he could hardly be de-

allusive, playful, or ironic rather than nostalgic, withdrawn, factual, or aggressively comic—as among white folk singers." Lomax, *Folk Songs*, pp. xix, xx. For treatments of the more technical aspects of African American music, see Courlander, *Negro Folk Music*, especially Chapter II; and Richard A. Waterman, "African Influences on the Music of the Americas," in *Acculturation in the Americas*, edited by Sol Tax.

[46]Arna Bontemps and Langston Hughes, eds., *The Book of Negro Folklore* (New York, 1965), Introduction, p. viii. Of course, if one regards each humorous thrust of the bondsmen as so much comic nonsense, then there is no basis for understanding, to use Sterling Brown's phrase, the slave's "laughter out of hell." Without understanding what humor meant to slaves themselves, one is not likely to rise above the superficiality of a Stephen Foster or a Joel Chandler Harris. But once an effort has been made to see the world from the slave's point of view, then perhaps one can understand Ralph Ellison's reference to African Americans, in their folklore, "backing away from the chaos of experience and from ourselves," in order to "depict the humor as well as the horror of our living." Ralph Ellison, "A Very Stern Discipline," *Harpers* (March 1967), p. 80.

[47]For additional discussions of folktales, see Zora Neale Hurston, *Mules and Men* (Philadelphia, 1935); Richard Dorson, *American Negro Folktales* (Greenwich, Connecticut, 1967); and B. A. Botkin, *Lay My Burden Down* (Chicago, 1945).

[48]Bontemps and Hughes, *Negro Folklore*, Introduction, p. ix.

scribed as a slave with an inferiority complex. And in this regard it is important to note that his varieties of triumphs, though they sometimes included winning freedom, often realistically cluster about ways of coping with everyday negatives of the system.[49]

Slaves were adept in the art of storytelling, as at home in this area as they were in the field of music. But further discussion of the scope of folklore would be uneconomical, for we have already seen a depth and variety of thought among bondsmen which embarrasses stereotypical theories of slave personality. Moreover, it should be clear by now that there are no secure grounds on which to erect the old, painfully constricted "Sambo" structure.[50] For the personalities which lay beneath the plastic exteriors which slaves turned on and off for white people were too manifold to be contained by cheerful, childlike images. When it is argued, then, that "too much of the Negro's own lore" has gone into the making of the Sambo picture "to entitle one in good conscience to condemn it as 'conspiracy,'"[51] one must rejoin: Only if you strip the masks from black faces while refusing to read the irony and ambiguity and cunning which called the masks into existence. Slave folklore, on balance, decisively repudiates the thesis that Negroes *as a group* had internalized "Sambo" traits, committing them, as it were, to psychological marriage.

II

It is one of the curiosities of American historiography that a people who were as productive esthetically as American slaves could be studied as if they had moved in a cultural cyclotron, continually bombarded by devastating, atomizing forces which denuded them of meaningful Africanisms while destroying any and all impulses toward creativity. One

[49]The fact that slaveowners sometimes took pleasure in being outwitted by slaves in no way diminishes the importance of the trickster tales, for what is essential here is how these tales affected the slave's attitude toward himself, not whether his thinking or behavior would impress a society which considered black people little better than animals. Du Bois's words in this regard should never be forgotten: "Everything Negroes did was wrong. If they fought for freedom, they were beasts; if they did not fight, they were born slaves. If they cowered on the plantation, they loved slavery; if they ran away, they were lazy loafers. If they sang, they were silly; if they scowled, they were impudent. . . . And they were funny, funny—ridiculous baboons, aping men." Du Bois, *Reconstruction*, p. 125.

[50]Ralph Ellison offers illuminating insight into the group experience of the slave: "Any people who could endure all of that brutalization and keep together, who could undergo such dismemberment and resuscitate itself, and endure until it could take the initiative in achieving its own freedom is obviously more than the sum of its brutalization. Seen in this perspective, theirs has been one of the great human experiences and one of the great triumphs of the human spirit in modern times, in fact, in the history of the world." Ellison, "A Very Stern Discipline," p. 84.

[51]Elkins sets forth this argument in *Slavery*, p. 84.

historian, for example, has been tempted to wonder how it was ever possible that "*all* this (West African) native resourcefulness and vitality have been brought to such a point of *utter* stultification in America" (italics added).[52] This sadly misguided view is, of course, not grounded in any recognition or understanding of the African American dimension of American culture. In any event, there is a great need for students of American slavery to attempt what Gilberto Freyre tried to do for Brazilian civilization—an effort at discovering the contributions of slaves toward the shaping of the Brazilian national character.[53] When such a study has been made of the American slave, we shall probably discover that, though he did not rival his Brazilian brother in staging bloody revolutions, the quality and place of art in his life compared favorably. Now this suggests that the humanity of people can be asserted through means other than open and widespread rebellion, a consideration that has not been appreciated in violence-prone America. We would do well to recall the words of F. S. C. Northrop who has observed:

> During the pre–Civil War period shipowners and southern landowners brought to the United States a considerable body of people with a color of skin and cultural values different from those of its other inhabitants. . . . Their values are more emotive, esthetic and intuitive. . . . [These] characteristics can become an asset for our culture. For these are values with respect to which Anglo-American culture is weak.[54]

These values were expressed on the highest level in the folklore of slaves. Through their folklore, black slaves affirmed their humanity and left a lasting imprint on American culture. No study of the institutional aspects of American slavery can be complete, nor can the larger dimensions of slave personality and style be adequately explored, as long as historians continue to avoid that realm in which, as Du Bois has said, "the soul of the black slave spoke to man."[55]

In its nearly two and one half centuries of existence, the grim system of American slavery doubtless broke the spirits of uncounted numbers of slaves. Nevertheless, if we look through the prism of folklore, we can see others transcending their plight, appreciating the tragic irony of their condition, then seizing upon and putting to use those aspects of their experience which sustain in the present and renew in the future. We can see them opposing their own angle of vision to that of their oppressor, fashioning their own techniques of defense and aggression in accordance

[52]*Ibid.*, p. 93.

[53]Gilberto Freyre, *The Masters and the Slaves* (New York, 1956). Originally published by Jose Olympio, Rio de Janeiro, Brazil.

[54]F. S. C. Northrop, *The Meeting of East and West* (New York, 1952), pp. 159–60.

[55]Du Bois, *Souls*, p. 378. Kenneth M. Stampp in his *The Peculiar Institution* (New York, 1956) employs to a limited extent some of the materials of slave folklore. Willie Lee Rose, in *Rehearsal for Reconstruction* (New York, 1964), makes brief but highly informed use of folk material.

with their own reading of reality, and doing those things well enough to avoid having their sense of humanity destroyed.

Slave folklore, then, affirms the existence of a large number of vital, tough-minded human beings who, though severely limited and abused by slavery, had found a way both to endure and preserve their humanity in the face of insuperable odds. What they learned about handling misfortune was not only a major factor in their survival as a people, but many of the lessons learned and esthetic standards established would be used by future generations of African Americans in coping with a hostile world. What a splendid affirmation of the hopes and dreams of their slave ancestors that some of the songs being sung in antebellum days are the ones African Americans sang in the freedom movement: "Michael, row the boat ashore"; "Just like a tree planted by the water, I shall not be moved."

Remembering Denmark Vesey

In 1800, a slave named Denmark Vesey won a lottery and purchased his freedom from his master. Twenty-two years later, in Charleston, South Carolina, he was arrested, interrogated, and sent to the gallows for having led a conspiracy against slavery involving thousands of slaves.[1]

Inspired by the Vesey example, black abolitionists used it on a number of occasions to exhort the slaves to sunder their bonds. Henry Highland Garnet, in an address in 1843 at Buffalo, New York, called for a rebellion on the part of slaves, reminding them that Denmark Vesey had shaken "the whole empire of slavery."[2] Later, during the Civil War, Frederick Douglass urged the slaves to take up arms, to "remember Denmark Vesey of Charleston."[3] Moreover, civil rights partisans invoked the spirit of Vesey on numerous occasions in the latter part of the nineteenth century to strengthen the will of their followers in the face of fierce, overwhelming odds.

Since the death of Vesey, chroniclers of the slave era have referred to his conspiracy as one of the most extensive and ingeniously planned of all slave plots, and its validity has been attested by contemporaries and historians alike. Indeed, there was general agreement on the existence of a full-scale plot by Vesey, until Richard C. Wade of the University of Chicago raised serious questions regarding the entire incident and called for reconsideration.[4] Professor Wade has advanced the view that "there is persuasive evidence that no conspiracy in fact existed, that, at the most, it was a vague and unformulated plan in the minds or on the tongues of a few colored townsmen."[5] Wade, in *Slavery in the Cities*, again challenged the veracity of the usual historical accounts of the conspiracy, asserting that "the 'plot' was probably never more than loose talk by aggrieved and embittered men."[6]

Some of the details concerning the events which threw the city of

[1] Carter G. Woodson, *The Negro in Our History* (Washington, D.C., 1922), p. 179.

[2] Herbert Aptheker, *A Documentary History of the Negro People in the United States* (New York, 1962), p. 231.

[3] *Ibid.*, p. 479.

[4] Richard C. Wade, "The Vesey Plot: A Reconsideration," *Journal of Southern History* (May 1964), pp. 143–61.

[5] *Ibid.*, p. 150.

[6] Richard C. Wade, *Slavery in the Cities* (New York, 1964), pp. 240–41.

Charleston into a state of great unrest during the summer of 1822 are likely to remain forever clothed in obscurity. Nevertheless, a reconstruction of the broad outline of developments which caused the defenders of slavery to seek certain retribution against scores of slaves is possible. By recounting those developments, as viewed for more than a century by those who have studied the Vesey incident, a historical screen against which Wade's charges can be projected for purposes of more meaningful scrutiny will be provided.

On May 25, 1822, Devany, the slave of John C. Prioleau, was standing alongside the Fitzsimmons fish wharf in Charleston, gazing out to sea. He was accosted by William Paul, the slave of Messrs. J. and D. Paul. The Pauls' slave drew Devany into conversation, asking him if he knew that something serious was about to happen. Devany, answering that he did not, was told that the slaves were determined to do something about their condition, to rise up against slavery in great numbers in order to right themselves.[7] Frightened by this startling disclosure, Devany carried the intelligence to his master, which precipitated the arrest of Paul. Other slaves—Peter Poyas and Mingo Harth—were later implicated by Paul, who had begun to fear for his life. But Poyas and Harth displayed such coolness when questioned that they were released.

William Paul, however, was placed in solitary confinement. Within a week, he divulged more names, stated that the plot was one of extensive proportions, and revealed that its object was the massacre of whites. But at least one of the men named, Ned Bennett, immediately came forth of his own volition and asked to be questioned if he was suspected, a move which served to perplex the authorities more than ever, especially since Bennett was the governor's slave.[8]

Vesey was not idle while these proceedings were taking place. "Upon the arrest of Peter Poyas," John Lofton has written, "Vesey—fearing that the plan would be frustrated if its execution were delayed until July 14 as originally scheduled—had advanced the date to June 16."[9] Meanwhile, a white resident of Charleston, Major John Wilson, having heard about the plot, enlisted the aid of one of his mother's slaves, a blacksmith prominent in Negro church affairs, George Wilson. On Friday June 14, 1822, startling information was revealed to the blacksmith by a member of his church class. He was told that not a moment should be lost informing the authorities, since the outbreak was scheduled to begin at midnight on Sunday, June 16.[10] George Wilson dutifully reported this information to the major.

Notified of this new development, the authorities moved with dispatch. Governor Thomas Bennett began to shore up the military re-

[7]Thomas Wentworth Higginson, *Travelers and Outlaws* (Boston, 1889), p. 1.
[8]*Ibid.*, p. 2.
[9]John Lofton, *Insurrection in South Carolina: The Turbulent World of Denmark Vesey* (Yellow Springs, Ohio, 1964), p. 149.
[10]*Ibid.*

sources of the city by ordering the quartermaster general of militia to place in the city's arsenal twenty thousand ball cartridges and to prepare three hundred muskets for delivery. John Hope Franklin, referring to the state of panic toward which Charleston was moving at this time, has observed:

> All kinds of military groups were called into service. A person unfamiliar with the problem doubtless would have thought that such extensive mobilization was for the purpose of meeting some foreign foe. The Neck Rangers, the Charleston Riflemen, the Light Infantry, and the Corps of Hussars were some of the established military groups called up. A special city guard of one hundred and fifty troops was provided for Charleston.[11]

Only the authorities and those involved in the plot knew that a rebellion was scheduled to take place within two days. "The whole was concealed," said the governor, "until the time came; but secret preparations were made. Saturday night and Sunday morning passed without demonstrations; doubts were excited, and counter orders were issued for diminishing the guard."[12]

Due to the unusual activity among the militia, it was borne in upon Vesey and his co-conspirators that the defenders of slavery had been forewarned, that they—Vesey and his followers—could no longer expect to avail themselves of the element of surprise. Though twenty or thirty of his country followers reached the city on Sunday morning, June 16, Vesey, still clinging to the hope that he could lead them in an uprising, ordered them to disperse and wait for further orders. As if to reinforce his leader's hope, Bacchus, the slave of Benjamin Hamet, brought to Vesey's house—on Sunday night—a sword as well as a pistol which he had stolen from his master.[13]

Rumors of the projected uprising had, by this time, already reached the citizenry.

> There was great excitement among the whites that evening. The streets were filled until a late hour with persons who were uncertain whether it was safe to retire. Even children were allowed to remain up. At the appointed hour of 10 P.M. the extra military units took up their stations, although their size had been ordered reduced somewhat as a result of the noticeable lack of activity among the slaves. A night of sleepless anxiety in the white community followed.[14]

The 16th of June passed. On the 18th, ten suspicious slaves were arrested, a development which sounded the plot's death knell, for the investigation soon revealed a free Negro named Denmark Vesey as the leader of the enterprise—"among his chief coadjutors being that innocent

[11]John Hope Franklin, *The Militant South* (Boston, 1964), p. 77.
[12]Quoted in Higginson, *Travelers*, p. 3.
[13]Lofton, *Insurrection*, p. 151.
[14]*Ibid.*, p. 153.

Peter and that unsuspecting Mingo who had been examined and discharged nearly three weeks before."[15]

As tension mounted, Vesey, who had managed to elude his pursuers for three days, was arrested and brought to trial on June 22, the day following his arrest.[16] Less than two weeks later, he and five other Negroes were taken to the edge of the city, the trap door was sprung, and the bodies of the six were left suspended from the gallows.[17]

> The uprising now seemed quashed. But, as word of it spread in the city, public shock turned into hysteria. No master could be sure his bondsmen were not involved; whites who owned no slaves had little more assurance. Every Negro became a possible enemy, indeed assassin; every action by a black could be construed as a prelude to violence. Since slaves lived in the same yard with their masters, it was not even possible to lock out the intruder.[18]

Considering the details of the original plot, as disclosed by witnesses as the trials proceeded, it is small wonder that passions were roused to the point of hysteria. Lofton, basing his account of the conspirators' original plans on the evidence as recorded and believed by the court, has described the stratagems of Vesey and his men. Some nine thousand slaves, drawn from the countryside as well as the city, were simultaneously to march at midnight—armed with pikes, daggers, swords, bayonets, scythes, and a few pistols—upon the U.S. Arsenal, the governor's mansion, the main guardhouse, and a number of other points in the city.[19] They were then to fire the city and liquidate "not only whites but those blacks who did not join." No one—not children or women or ministers of the gospel—would be spared.[20]

From late June until the 26th of July, over 130 cases were heard by the court. "The number arrested," H. M. Henry has recorded, "was 131, 67 of whom were convicted; the number executed was 35, all slaves except Vesey; number deported, 32."[21] Among the leaders brought to trial, only one—Gullah Jack—admitted involvement in a conspiracy against slavery. The other principals maintained that they were innocent.

Throughout July, slaves were being executed. On one occasion, twenty-two were hanged at once, left dangling from the long gallows in full view of the populace. The vengeance of whites, with this singular act, had all but spent itself, though a few more hangings followed in its

[15]Higginson, *Travelers*, p. 4.

[16]Among the arrested slaves, in addition to Vesey, Poyas, and Harth, were Batteau, Rolla, and Ned Bennett, all slaves of the governor.

[17]Lofton, *Insurrection*, p. 169.

[18]Wade, "The Vesey Plot," *Journal of Southern History* (May 1964), p. 144.

[19]Lofton, *Insurrection*, pp. 140–41.

[20]*Ibid.*, p. 141.

[21]H. M. Henry, *The Police Control of the Slave in South Carolina* (Emory, Virginia, 1914), p. 152.

wake. In late summer, the cry went up for the banishment of all free Negroes from the state. The deed had been done.[22] It remained for posterity to interpret it.

This account of the Vesey plot is representative of the views of the great majority of scholars who have described the insurrection. Indeed, until recently, the scope and existence of the plot have gone unquestioned. Even Ulrich B. Phillips, who was quick to seize upon the alleged submissive nature of the slave and turn such an attribute against the Negro's claim to full manhood rights, never questioned the existence of the plot. Asserting that the Vesey plot was "elaborate," Phillips further remarks, in a chapter entitled "Slave Crimes," that the conspiracy "is one of the most notable of such episodes on record." Herbert Aptheker characterizes the incident as "one of the most serious, widespread, and carefully planned conspiracies." In addition, he describes Vesey as a "master of several languages" who couched his appeals to the rights of man "in both theological and secular terms." Louis Filler observes that the Vesey insurrection "horrified Southerners by its scope, the audacity of its leaders, and the close relationship it revealed between slave and free Negroes." And Kenneth Stampp refers to Vesey's "vast conspiracy which came to nothing after it was given away by a slave."[23]

This brings us back to Professor Wade's analysis of the conspiracy, to his conclusion that no such full-scale plot, in fact, took place, that *"at the most it was a vague unformulated plan in the minds or on the tongues of a few colored townsmen"* (italics added).

Wade's reconsideration of the Vesey plot must, on any showing, be taken seriously, for it raises serious questions with regard to all preceding interpretations.[24] Wade contends that "essential facts about the Vesey uprising" that have been "generally accepted by historians" are open to question because historians have relied on an official version—published by the city in 1822—which provided the only available facts, facts which, in his view, do not square with the original account of the case.[25] Moreover, he argues that a close reading of the two versions will show that the original transcript was doctored and that historians generally

[22]The relatives of those hanged were not even allowed to bury their dead, as the authorities regarded the bodies of slaves, even in death, as property. On request, the bodies of the executed men were turned over to surgeons for purposes of dissection. Lofton, *Insurrection*, p. 174.

[23]U. B. Phillips, *American Negro Slavery* (New York, 1936), p. 477; Herbert Aptheker, *American Negro Slave Revolts* (New York, 1963), pp. 268–69; Louis Filler, *Crusade Against Slavery* (New York, 1960), p. 92; Kenneth Stampp, *The Peculiar Institution* (New York, 1956), p. 135.

[24]There is one exception to this: Professor Thomas T. Hamilton of the University of Wichita, in a paper delivered to the Southern Historical Association in 1957, "raised the question whether the trials and executions stemmed from an actual conspiracy or from unsubstantial rumors supported by public hysteria." *Journal of Southern History*, XXIV (February 1958), p. 71.

[25]Wade, "The Vesey Plot," p. 149.

have focused on the broader meaning of the conspiracy as it related to resistance to the institution of slavery.

In questioning the existence of the plot, Wade relies to a considerable extent on letters written by a respected judge, who raised questions concerning the effects of popular excitement upon the trials, and letters written by the daughter of the judge, whose mood ranged from "frenzy to skepticism," from great certitude concerning the enormity of the plot to concern over the lengths to which the court had gone in punishing the accused. The daughter, Ana Hayes Johnson, remarked at one point that South Carolinians were possessed of "impetuosity and ardency of feeling which unavoidably lays them open to deception and, consequently, leads them on to error in action."[26] But Wade does not assert that either Judge Johnson or his daughter denied the existence of a plot; rather, he suggests that they were concerned over procedures followed and punishment exacted.[27]

Alluding to doubts expressed by Governor Thomas Bennett, Wade challenges the published record of the trial at a number of important points, though he admits that the governor "probably believed in a plot of some kind."[28] Wade quotes at length from the governor's message given to the Senate and House of Representatives of the State of South Carolina on November 28, 1822, pointing out that the governor questioned the secrecy surrounding the trial, the method of gathering testimony by the judges, the reliability of testimony concerning the nature of the plot, the disparity between the enormous scope of the plot and the meager resources of the rebels, and the belief that the leaders of the plot were acting in concert. In examining the points raised by the governor, Wade questions the involvement of an alleged nine thousand conspirators, basing his doubt on the fact that no "roster of names ever turned up." Since the plot supposedly involved slaves within a radius of from seventy to eighty miles of Charleston, he remarks that the lack of activity in the rural sections cast doubt on the extensiveness of the conspiracy.[29]

Further, Wade draws attention to ambiguities in the official record with respect to the matter of weapons and makes much of the fact that no cache of arms was found. He points out that the confessions of two of the accused were edited in the published version of the trials, which served to change the tone of the narrative. In the same vein, he cites the fact that the published account of the trial includes mention of a rebellion not even referred to in the original transcript. In Wade's opinion, the discrepancies seem deliberate since the printed version alleges that no facts would be suppressed and that the words of the witnesses would be used.

The burden of Wade's argument, then, is that the authenticity of the

[26]Quoted in *Ibid.*, p. 152.
[27]*Ibid.*, p. 151.
[28]*Ibid.*, p. 154.
[29]*Ibid.*

printed version of the trial is in doubt, that it contains enough questionable material to support the view that "the object of the trial was not to discover the extent of the plot but rather to awe the Negroes by a show of force." The very atmosphere, so charged with tension born of rumors from blacks and whites, was especially congenial to a racial explosion. When Devany and William Paul had their chance encounter on the wharf that day in late May, the catalytic agent was introduced. "Thus," Wade remarks, "Charleston stumbled into tragedy."[30]

How does Wade account for the tenacity of the myth of Vesey conspiring to lead thousands of slaves in an assault against the slavocracy? Opponents and apologists of slavery have since used the Vesey incident, he informs us, as part of the ammunition of their respective arsenals. The incident was used either as eloquent proof that the will to freedom is so natural a part of the human personality that "none would remain passively enchained" or as justification for the "stringent laws against Negroes" during slavery. No closer examination of the events of that sultry summer in 1822 seemed warranted, since scholars were in agreement that the revolt had taken place. The Vesey uprising had become "a convenient illustration of a larger view of bondage."[31]

Richard Wade considers it of great moment that the leaders of the insurrection had little or no plan of action and, with one exception, proclaimed their innocence to the very end. One is forced to wonder whether conspirators, if involved in an expansive plot, can reasonably be expected to admit guilt, particularly as long as all of the leaders have not been detected and arrested.[32] Could it be that the Vesey insurrectionists, to the extent that they were successful in mounting a large conspiracy, owed their success to iron discipline and a vow not to reveal important information to the authorities? Higginson, who spent weeks pouring over the official reports in Charleston, offers a different view from that of Professor Wade regarding both the plan and the refusal of the men who designed it to declare themselves a party to the plot. The details of the plan, Higginson writes, "were not rashly committed to the mass of the confederates; they were known only to a few, and were finally to be announced only after the evening prayer meetings on the appointed Sunday."[33] "Vesey showed great penetration," says Lofton, "and sound judgment" in the selection of his leaders. "The small number convicted, in comparison to the number of Negroes reported to be involved, seems to have been due to a determination on the part of the leaders to meet their fate without talking."[34]

[30] *Ibid.*, p. 156.

[31] *Ibid.*

[32] Higginson takes notice of the fact that the transcripts contain an admission on the part of the judges that they were unable to detect "more than a small minority of those concerned in the conspiracy."

[33] Higginson, *Travelers*, p. 12.

[34] John Lofton, "Denmark Vesey's Call to Arms," *Journal of Negro History*, XXXIII (October 1948), p. 417.

Portions of the official reports not cited by Wade perhaps go far toward explaining the refusal of most of the leaders to enter a plea of guilty. Rolla is described as a man who "was remarkable for great presence and composure of mind," one who exhibited "no signs of fear." Ned was "stern and immovable," even when "receiving the sentence of death." In Peter's countenance were "strongly marked disappointed ambition, revenge, indignation, and an *anxiety to know how far the discoveries had extended*" (italics added).[35] He is said to have responded with a "cryptic smile" when asked whether he really wanted to see his kindly master murdered. Moreover, Vesey addressed witnesses in an imperious manner and argued his case with great plausibility and art. Wade's charge that the reports fail to mention the discovery of a large cache of arms, however, must be reckoned with by those historians who assume that the arms had either been fashioned or secured for use.

Higginson takes a different view of Governor Bennett's attitude toward the court proceedings from that taken by Wade, who relies heavily on the governor's charge of excessive punishment and contends that the governor probably did not take the description of the plot provided by the city "very seriously." Higginson offers the view that the governor's attitude was colored by a desire to "smooth the thing over, for the credit and safety of the city." He contrasts the governor's "evasive tone" with the "frank and thorough statements of the judges." If a few people like the governor doubted the "enormity" of the plot, Higginson *avers*, the judges seem to admit that, had the whole thing been brought to a head, "the slaves generally would have joined in."[36] Lofton seems to support Wade's position that the governor was motivated by a sincere concern over the harsh punishment which was meted out to the insurrectionists. He does point out, however, that the governor was also concerned about securing the release of his own slaves.

A curious feature of Professor Wade's piece on the Vesey plot is the scanty information provided concerning the *dramatis personae*. Despite the fact that some considerable information regarding each leader of the insurrection is available, Wade, in the main, fails to incorporate this material into his assessment. He does not mention, for example, the fact that Vesey, though a fairly prosperous artisan, had every reason to hate slavery, especially since he had fathered many children by slave mothers. Considering the fact that the children and their mothers were doomed to a lifetime of slavery, it is not difficult to conceive of Vesey wanting to war against that institution.[37] "His temper," according to the court, "was impetuous and domineering in the extreme, qualifying him for the despotic rule of which he was ambitious." At another point, the record reveals that many Negroes "feared him more than their owners, and, one

[35]Quoted in Higginson, *Travelers*, pp. 24–26.
[36]*Ibid.*, p. 19.
[37]Dwight Lowell Dumond, *Antislavery: The Crusade for Freedom in America* (Ann Arbor, 1961), p. 114.

of them declared, even more than God."[38] No ordinary man, Vesey appears to have been a man possessing charismatic authority.

Most historians who have written at length on the Vesey insurrection have recounted much on the life of Peter Poyas, who was said to be Vesey's chief lieutenant. But all Wade tells us is that Poyas "had an excellent reputation and the implicit confidence of his master," in addition to being a first-rate artisan. At no time does Wade come to grips with the incident with which Poyas has been most often identified, his exhortation to the slaves to "not open your lips! Die silent as you shall see me do."[39] William Wells Brown comments that Poyas "was said to have a magnetism in his eye, of which his confederates stood in great awe; if he once got his eye upon a man, there was no resisting it."[40] On one occasion, according to a witness, Poyas was chained to the floor of his cell with another conspirator. When the men in authority came to extort the names of the men conspiring with the two slaves, Poyas is said to have leaned upon his elbow, looked at the man lying beside him, and urged quietly, "Die like a man," and then lay down again. He was obeyed. The records of the court indicate that Poyas, when on the gallows, repeated his charge of secrecy: "Do not open your lips; die silent, as you shall see me do."[41]

Other members of the upper echelons of leadership were scarcely less impressive. The transcripts, the original as well as the published versions, pay tribute to the abilities and disciplined natures of the men selected by Vesey to join in the uprising. It should not go unremarked that, according to the court, Vesey and his men had been planning the revolt for close to four years before they were betrayed. For a small group of "embittered" and "aggrieved" men to have kept such a plan a secret for that length of time appears to be an eloquent testament to their conspiratorial propensities. Such men, it seems, would not be likely to yield easily to pressure.

Wade's charge that "not a single roster of names was uncovered" stands as one not easily answered, given the information provided by his article. But when vital portions of the transcript not mentioned by Wade are quoted and discussed by Lofton, Higginson, and others—such as detailed information concerning the personalities and activities of leaders of the plot—then even Wade's charge regarding the roster of names appears to lose some of its force. One might reason, bearing in mind what is known about Poyas, Vesey, and other prominent figures of the incident, that as soon as Poyas and Mingo Harth were released from jail after their first arrest, rosters of names might have been destroyed, for at that time all of the leaders were still at large, still free to dispose of

[38]Quoted in Higginson, *Travelers*, pp. 6–7.

[39]Quoted in John Lofton, "Negro Insurrectionist," *Antioch Review*, XVIII (Summer 1958), p. 193.

[40]William Wells Brown, *The Black Man* (Boston, 1863), p. 144.

[41]Higginson, *Travelers*, pp. 9–10.

evidence that would not only seal their doom but compromise every member of the plot from the city to the countryside. Since, according to the court, each leader kept to himself the names of his proselytes, the destruction of rosters of names would indeed be a simple act to perform.[42]

Wade's contention that the published version of the proceedings of the court varied significantly from the original account seems to be unassailable. He and Thomas Hamilton are evidently the only historians to point out this discrepancy. Wade demonstrates that evidence in the original transcript was suppressed. But the suppression of information concerning slave revolts in the South, to be sure, was not confined to the Vesey case alone. According to Margaret Just Butcher, "accounts of innumerable slave revolts" were "suppressed as much as possible."[43]

There seems to be little question but that there were irregularities in the manner in which the proceedings of the court were conducted. But again, courts in the South during and since the antebellum era have not been noted for protecting the rights of Negroes, especially when the rights to be protected belonged to men allegedly involved in a conspiracy to overthrow slavery. Herbert Aptheker makes it quite clear that South Carolina laws were designed to protect the interests of the masters, not the rights of their slaves or former slaves.[44] "The fundamental principle

[42]Wade, in questioning the extensiveness of the plot, says that some of the accused, when confronted with each other, did not even appear to know each other. Perhaps a decision of the leaders to prepare and keep their own rosters would explain this. Moreover, such a decision on their part might indicate that the plot was a large rather than small one.

But there is the real possibility that rosters of names were not even needed in the conspiracy, for African national groups were deeply involved in the activity. Africans had means of keeping names—of relying on memory—that had deep roots in oral rather than written history, which at least greatly lessened, if not eliminating altogether, the need to write them down. Since the leaders of three of Vesey's military legions—Monday Gell, an Ibo; Gullah Jack, an Angolan; and Mingo Harth, a Mandingo—were born in Africa and had hundreds of native-born Africans under their direction, continuing familiarity with and use of African languages contributed to anti-slavery feeling that militated against revealing names. Indeed, the forced entry into South Carolina of thousands of Africans just before the suppression of the slave trade in 1808 meant there was an African cultural presence on which Vesey could rely for a variety of purposes.

We can be certain that the degree of concerted political action—Vesey encouraged ethnic solidarity under the larger umbrella of revolutionary purpose—was matched by and indistinguishable from movement toward cultural oneness. In this connection, there is no evidence that Gullah Jack, a sorcerer and Vesey lieutenant, was any less effective in compelling compliance with his desires whether relating to Ibos, the Mandingoes or to slaves born in America. In short, the matter of rosters was but one of numerous conundrums before the authorities. An excellent treatment of African national groups in the Vesey conspiracy is found in the Introduction of Robert Starobin, ed., *Denmark Vesey: The Slave Conspiracy of 1822* (Englewood Cliffs, 1970).

[43]Margaret Just Butcher, *The Negro in American Culture* (New York, 1957), p. 43.

[44]Herbert Aptheker, "Petitions of South Carolina Negroes" *Journal of Negro History*, XXXI (January 1946), pp. 98–99.

of all relationships between the slave and society," according to Dumond, "was that the slave was subject to control *but was not entitled to protection*" (italics added).[45] Thus South Carolina was not alone in fashioning laws to govern slaves that were at variance with those used to establish legal relations among whites.

It would have been far more instructive had Wade placed his discussion of the Vesey plot in the broader context of slavery as an institution. Had he done so, it is possible—even probable—that his case would have been appreciably weakened. For just as Carolinians were not unique in their handling of slave legal cases, neither were they different from others in inflicting upon slaves punishment quite disproportionate to the offense intended or committed. The reactions of the pro-slavery elements in Virginia during and following the Gabriel and Turner revolts certainly were equal to the behavior of the authorities responsible for the brutal mass hangings of the Vesey conspirators.[46]

It is worth noting as regards the Gabriel conspiracy that, though there was no question of the guilt of the slaves involved, the leaders, when arrested, behaved in a manner strikingly similar to that of Vesey, Poyas, and the other principals of the Vesey plot. Though Gabriel and his followers were prepared to battle for their freedom, they were willing to reveal little or nothing concerning their plans. James Monroe, then governor of Virginia, said of Gabriel: "From what he said to me, he seemed to have made up his mind to die, and to have resolved to say but little on the subject of the conspiracy."[47]

Is it not possible that Vesey, Poyas, Harth, and others associated with Vesey were simply using tactics similar to those used by Gabriel and his colleagues? The authorities, as in the Vesey case, were never able to determine the number of men involved in Gabriel's conspiracy. And there was that same secrecy prior to the revolt among Gabriel and his tough band that the authorities have attributed to the men who allegedly conspired to wreck Charleston. Indeed, the Gabriel plan for revolt was "kept with incredible secrecy" for quite some time, in the view of one high official in Virginia.[48]

Given the character of Vesey and the men around him, especially when considering what happened in Virginia in 1800, it is not unlikely that they had conceived and long nourished a plan that went beyond the "loose talk" stage. Whether innocent or guilty, ordinary men would, one would think, quake at the thought of facing the gallows. Considering the racial atmosphere of the antebellum South, is it not extraordinary

[45]Dumond, *Antislavery*, p. 117.

[46]Stampp, *The Peculiar Institution*, pp. 132–37.

[47]Quoted in Herbert Aptheker, *American Negro Slave Revolts* (New York, 1963), p. 222.

[48]*Ibid.*, p. 220.

that most of the ringleaders in question behaved as they did, displaying levity in some instances, scorn in others, and no fear throughout the proceedings?

Professor Wade closes his discussion of the Vesey plot with the observation that the men accused of having led a conspiracy in Charleston were not likely prospects for such a scheme. This conclusion is based on his theory that slaves in cities, being better off than severely oppressed field hands, were not as likely to revolt.

> The urban environment proved inhospitable to conspiracies because it provided a wider latitude to the slave, a measure of independence within bondage, and some relief from the constant surveillance of the master. This apparent freedom deflected the discontent, leading Negroes to try to exploit their modest advantages rather than to organize for desperate measures.[49]

As regards Wade's above statement, together with his contention that "a concerted revolt against slavery was actually less likely in a city than in a countryside," Stanley Elkins is in sharp disagreement:

> It is of great interest to note that although the danger of slave revolts—like Communist conspiracies in our own day—was much overrated by touchy Southerners; the revolts that actually did occur were in no instance planned by plantation laborers but rather by Negroes whose qualities of leadership were developed well outside the full coercions of the plantation authority-system. Gabriel, who led the revolt of 1800, was a blacksmith who lived a few miles outside Richmond; Denmark Vesey, leading spirit of the 1822 plot at Charleston, was a freed Negro artisan who had been born in Africa and served several years aboard a slave-trading vessel; and Nat Turner, the Virginia slave who fomented the massacre of 1831, was a literate preacher of recognized intelligence. *Of the plots that have been convincingly substantiated (whether they came to anything or not), the majority originated in urban centers* (italics added).[50]

It could well be, as the experiences of Gabriel and Turner demonstrate, that the greater the amount of freedom extended to sensitive Negro victims of oppression, the more, not less, they wanted to shatter all restrictions placed upon them. Was this true of Vesey? Did he seek to "right himself" and other Negroes by leading a vast conspiracy? To these questions, thanks to the probing work of Wade, future historians are not likely to offer the facile answers of historians who preceded them. What appears to be no less certain is that the evidence, when taken as a whole, will probably suggest to them, as it has to generations of scholars,

[49]Wade, "The Vesey Plot," *Journal of Southern History* (May 1964), p. 161.
[50]Stanley Elkins, *Slavery: A Problem in American Institutional and Intellectual Life* (Chicago, 1959), p. 138.

that Denmark Vesey did lead a conspiracy in Charleston, South Carolina.

Vesey's example must be regarded as one of the most courageous ever to threaten the racist foundations of America. In him the anguish of Negro people welled up in nearly perfect measure, and he stands today, as he did 143 summers ago, as an awesome projection of the possibilities for militant action on the part of a people who have—for centuries—been made to bow down in fear.

"Ironic Tenacity": Frederick Douglass's Seizure of the Dialectic

> *Everywhere in Africa, I have noticed that no greater affront can be offered a Negro than insulting his mother. "Strike me," cries a Mandingo to his enemy, "but revile not my mother!"*
>
> Mungo Park,
> *Travels in the Interior Districts of Africa*

Of all the travelers to Africa in the years of the Atlantic slave trade, none better captured the place of the African woman in the life of her people than Mungo Park. Weary and dejected, in dire need of food, Park was approached by a slave woman who offered him a "seasonable satisfaction" of nuts and departed before he could thank her. Sometime thereafter, he encountered another woman, one returning "from the labors of the field." This time offered "a supper of very fine fish . . . broiled upon some embers," he described the scene that followed:

> The rites of hospitality being thus performed towards a stranger in distress; my worthy benefactress . . . called to the female part of her family, who had stood gazing on me the while in fixed astonishment, to resume the task of spinning cotton; in which they continued to employ themselves [the] great part of the night. They lightened their labour by songs, one of which was completely extempore; for I was myself the subject of it. It was sung by one of the young women, the rest joining in a sort of chorus. The air was sweet and plaintive. . . . I was oppressed by such unexpected kindness; and sleep fled from my eyes.
>
> The women sang:
>
> > The loud wind roar'd, the rain fell fast;
> > The white man yielded to the blast;
> > He sat him down, beneath our tree;
> >
> > For weary, sad, and faint was he;
> > And oh, no wife or mother's care,
> > For him, the milk or corn prepare.
> >
> > Chorus

> The White Man, shall our pity share;
> Alas, no wife or mother's care,
> For him, the milk or corn prepare.
>
> The storm is o'er; the tempest past;
> And Mercy's voice has hushe'd the blast.
> The wind is heard in whispers low,
> The white Man, far away must go; —
> But ever in his heart will bear
> Remembrance of the Negro's care.
>
> Chorus
>
> Go, White Man, go; — but with thee bear
> The Negro's wish, the Negro's prayer;
> Remembrance of the Negro's care.[1]

Captives of the slave trade to North America and elsewhere in the New World, such women knew oppression that denied their humanity. To an impressive extent, Betsey Bailey, Frederick Douglass's grandmother, embodied their skill and spirit. Product of a tradition of work that has not been fully acknowledged, her role in slavery casts new light on the cultural environment of the young Douglass and calls for consideration of the nature of slave skills and the spiritual context in which they found expression.

At the center of slave culture in Maryland was Douglass's grandmother, whose little slave cabin had for him "the attractions of a palace" and "whose kindness and love stood in place of [his] mother's," from whom he was separated at a very early age.[2] So vivid were the impressions made on him by his grandmother, who resided in Tuckahoe County, Maryland, on one of Colonel Edward Lloyd's plantations, that his descriptions of her activities and attitudes in his autobiographies reveal an accuracy of detail that meets several tests for comparative analysis and enable us to search beneath appearances for the substance of reality so that we can understand the deeper influences on her and others in the slave community.

Douglass's description of her physical appearance prepares the ground for important revelations, his use of language serving that end with great precision. She is described as advanced in years, "as was evident from the more than one gray hair which peeped from beneath the ample and graceful folds of her newly and smoothly-ironed bandanna turban . . . a woman of power and spirit." Muscular and elastic in

[1] Mungo Park, *Travels in the Interior Districts of Africa* (New York, 1971), pp. 103–4; 295–96. Originally published in 1799. Describing what he saw at the frontier town of Joag in the kingdom of Bambara, from which many Africans were forcibly brought to North America, Park writes, most interestingly, that "to the westward of the town is a small river, on the banks of which the natives raise great plenty of tobacco" (p. 97).

[2] Frederick Douglass, *Life and Times of Frederick Douglass* (1881; rpt. New York, 1967), p. 30.

movement, on one long journey to a neighboring plantation, he tells us, using a Kimbundu term, the statuesque slave "toted" him, who "hardly seemed to be a burden to her."[3]

The prolonged and enforced absences of his mother and his exposure of but a few years to his grandparents—he says little of his grandfather—mirror the disruptive impact of slavery on the young Douglass, but he was fortunate to have had such a grandmother. His confidence in himself and his self-respect, despite the fierceness of opposing forces, owed much to her extraordinary example. In an important passage, he reveals something of her intelligence. Known to be a good nurse and "withal somewhat famous as a fisherwoman," she possessed still more skills:

> I have known her to be in the water waist deep, for hours, seine-handling. She was a gardener, as well as a fisherwoman, and remarkable for her success in keeping her seedling sweet potatoes through the months of winter, and easily got the reputation of being born to "good luck." In planting time, Grandmother Betsey was sent for in all directions, simply to place the seedling potatoes in the hills . . . for superstition had it that her touch was needed to make them grow.[4]

According to Talbot, fishing is the main occupation of African coastal peoples and many kinds of nets are employed, some "the self-acting sort either set right across a current so that the fish become entangled in the meshes, or, more ordinarily, so that this forms a chamber into which they can find their way, but from which escape is impossible." In particular:

> Seine nets are fairly common in the estuaries or on the seashore. . . . [A]mong the Ekoi [fishing] is looked upon as most exclusively women's work. . . . Each is supposed to give her husband one big fish from her hand and some to her father and mother. Before starting she usually rubs "lucky leaves" over her hand-net.[5]

It is likely that Betsey Bailey's ancestors were southern Nigerians, a coastal people steeped in fishing lore and tradition, quite possibly Ekoi. Her demonstrated ability at fishing is alone sufficient reason for studying slave women in relation to fishing and the making of nets. Moreover, the reference to her having been born to "good luck" appears to establish a mystical connection between agriculture and fishing, since the touch of

[3]*Ibid.*, 31–32. There is some controversy about the etymology of "tote." Whereas linguist Morris Goodman thinks that it is a Kimbundu term, the *Oxford English Dictionary* does not assign that etymology to the word. Yet it does not, in fact, offer an alternative explanation. Conversation with Morris Goodman, March 27, 1990.

[4]*Ibid.*, p. 28.

[5]P. Amaury Talbot, *The Peoples of Southern Nigeria* (London, 1926), pp. 917–19. In pathfinding research on the colonial period, Peter Wood, in *Black Majority* (New York, 1974), Chapter IV, shows how African skill in fishing led slaves to dominate in that area in South Carolina. Since Wood treats a variety of slave skills, all future work in this area must build on his.

the hand was associated with a favorable outcome in each skill. Her brilliance in agriculture could hardly have been more impressive, considering that she worked sandy, worn-out, desertlike soil that was notorious for its infertility. Douglass recalled that ruin and decay were everywhere visible "in this dull, flat, and unthrifty district, or neighborhood, surrounded by a white population of the lowest order, indolent and drunken to a proverb." Slaves of that district "seemed to ask, 'Oh! what's the use?' every time they lifted a hoe." But "exceeding care" was taken by Betsey Bailey in "preventing the succulent root [of the sweet potato] from getting bruised in the digging, and by placing it beyond the reach of frost by actually burying it under the hearth of her cabin during the winter months." That superstition might be a factor in performing well seems a real possibility, especially when working in a tradition of excellence at a particular skill. Apparently Douglass did not give serious consideration to that possibility.[6]

Douglass's grandmother was an invaluable source of African influences, but he was too young to have discussed such matters with her when in her care. In a rare reference to slave trade activity and to the peopling of the Lloyd plantation, he does write that "there were slaves on Mr. Lloyd's place who remembered being brought from Africa."[7] Douglass was aware of this by the late 1820s, approximately two decades after the suppression of the African slave trade. Though most slaves were brought to Maryland through Virginia, where the trade had ended in 1778, as late as the 1850s there was an African spiritual and artistic presence in Virginia, so more than being brought directly from Africa was a factor in that presence.[8]

Well into the nineteenth century, African traditions of spinning and weaving were alive in Virginia, as they were with Betsey Bailey and other slaves in Maryland. Since Maryland slaves were usually brought from Virginia, it is likely that their attitudes toward spinning were similar to those of Virginia slaves. In this regard, a former Virginia slave remarked: "Mother said dey would always spin in pairs—one would treadle whilst de other would wind de ball. You got to wind fast, too, an' take de thread right off de spindle, else it git tangled up. An' mamma tole me dey would all pat dey feet an' sing":

[6]Douglass writes, in regard to his grandmother's cultivation of sweet potatoes, that "superstition had it if Grandmomma Betty but touches them at planting, they will be sure to grow and flourish. This high reputation was full of advantage to her, and to the children around her. . . . She remembered the hungry little ones around her." Frederick Douglass, *My Bondage and My Freedom* (1855; rpt. Chicago, 1970), pp. 27–28. Of course, it is entirely possible that Betsey Bailey learned fishing or farming, or possibly both skills, from slaves who were not Nigerians, which would militate against the view that she was of Nigerian descent.

[7]Douglass, *Life and Times*, p. 50.

[8]For a discussion of African values in Virginia as late as the 1850s, see Sterling Stuckey, *Slave Culture: Nationalist Theory and the Foundations of Black America* (New York, 1987), pp. 31–36, 39–40.

Wind de ball, wind de ball
Wind de ball, lady, wind de ball
Don't care how you wind de ball
Wind de ball, lady, wind de ball
Ding, ding, ding, — wind de ball
Wind de ball, lady, wind de ball.[9]

Like the women encountered by Mungo Park in the interior of Africa, they lightened their labor with song.

Douglass makes no mention of his grandmother weaving, but he states that she made nets that were highly prized, which means that she did indeed weave, and extremely well, probably weaving nets from cotton, as was done in certain parts of Africa. And he informs us that slaves did the weaving at the home plantation of Colonel Lloyd. Since we know that slave women dominated weaving across the South, and since it is becoming increasingly clear that the slave trade extended into areas of Africa where weaving was common, we can conclude that many slaves were influenced by African traditions of weaving. There should be, on balance, a serious question as to who taught whom and no reason to question that the pattern as a whole was for slave girls to learn from slave women. There is much irony here, for in Africa weaving was mainly done by men, whereas in America it was overwhelmingly done by slave women. In any event, Douglass writes that on Colonel Lloyd's estate, "blacksmiths, wheelwrights, shoemakers, weavers, and coopers, were slaves."[10]

Significant numbers of slaves, on entering America, were taught certain skills by whites; others, sizable numbers again, were "taught" some skills they had mastered before; and still others, especially those who were to work as field hands, arrived in colonial America to perform some kinds of farming skills without being trained by whites. Certainly by the time of the American Revolution, the clear pattern had emerged of slaves teaching slaves almost all the plantation skills. Although Africans may have felt free to teach whites certain handicraft and farming skills in the seventeenth century, as the institution of slavery matured and racism deepened, few slaves were likely to assert knowledge of a particular skill rather than allow whites to think that they were teaching them that skill. Under the circumstances, it was probably difficult for

[9]Roscoe Lewis, *The Negro in Virginia* (New York, 1969), p. 90.

[10]Park comments, regarding the making of nets: "the small fish were taken in great numbers in hand nets, which the natives weave of cotton, and use with great dexterity." Park, *Travels*, p. 74. Equiano notes an exception to the general rule, writing: "When our women are not employed with the men in tillage, their usual occupation is spinning and weaving cotton, which they afterwards dye, and make into garments." Olaudah Equiano, *The Life of Olaudah Equiano, or Gustavas Vassa, The African, Written by Himself* in Arna Bontemps, *Great Slave Narratives* (1789; rpt. Boston, 1969), p. 78. For a discussion of the overall dominance of male weavers, see Talbot, *The Peoples of Southern Nigeria*, p. 939, and R. S. Rattray, *Religion and Art in Ashanti* (London, 1927), pp. 233–34. For a discussion of white and black mechanics in slavery, see Douglass, *Life and Times*, p. 38.

whites to admit that an African had taught them anything, for the slave's Africanness was a crucial element, so the rationale went, of his or her enslavement as an inferior.[11]

The more assimilated the African, the easier it would have been for whites to acknowledge his or her skills, for they could be, and were, attributed to the influence of whites. But whites on numerous plantations were confronted by skilled Africans who spoke a language with strong African influences in grammar and syntax. On this point there is a passage from Douglass that has been ignored by students of slave culture, one that relates to that culture in the particular and universal sense, with implications for a number of disciplines, not the least of them linguistics:

> There is not, probably, in the whole south, a plantation where the English language is more imperfectly spoken than on Col. Lloyd's. It is a mixture of Guinea and everything else you please. At the time of which I am now writing, there were slaves there who had been brought from the coast of Africa. They never used "s" in indication of the possessive case. . . . "Oo you dem long to?", means, "Whom do you belong to?" "Oo dem got any peachy?" means, "Have you got any peaches?" I could scarcely understand them when I first went among them, so broken was their speech.[12]

This was the language of field hand and artisan, of practically all of the slaves on the plantation, its force so influential that some whites were affected by it as well. Douglass's most profound insight into slave culture was developed among slaves speaking the "jargon" that he de-

[11]An indication of how difficult it would have been for a white person to acknowledge a slave's ability at agriculture or handicrafts is found in an overseer's attitude toward slaves. William Howard Russell writes of his visit to a Louisiana plantation a few years before emancipation: "The first-place I visited with the overseer was a new sugar-house, which negro carpenters and masons were engaged in erecting. It would have been amusing had not the subject been so grave, to hear the overseer's praises of the intelligence and skill of these workmen, and his boast that they did all the work of skilled labourers on the estate, and then to listen to him, in a few minutes, expatiating on the utter helplessness and ignorance of the black race, their incapacity to do any good, or even to take care of themselves." William Howard Russell, *My Diary North and South* (New York, 1863), p. 104.

[12]Douglass, *My Bondage*, p. 59. Although Colonel Lloyd's plantation was in the Maryland interior, there were numerous plantations across the South, similarly situated, that contained large numbers of slaves who spoke English as broken as that heard by Douglass. One such North Carolina plantation, containing hundreds of slaves, was visited by Edward Warren before slavery came to an end. Warren writes that "these antiquated darkeys spoke a sort of gibberish, which was a medley of their original dialect and the English language, and to me was perfectly unintelligible." Edward Warren, *A Doctor's Experiences on Three Continents* (Baltimore, 1885), p. 200. I have no doubt that rich rewards await scholarship in this area. Such scholarship, incidentally, should take into account the language of blacks in the North as well, especially that of runaway slaves. As late as the 1850s, Douglass reports, some spoke a language similar to what he had heard decades earlier in Maryland. Of Shields Green, a runaway who later joined John Brown at Harpers Ferry, Douglass writes: "He was a man of few words, *and his speech was singularly broken*, but his courage and self-respect made him quite a dignified character." Douglass, *Life and Times*, p. 317 (italics added).

scribed. In fact, it is when referring to slave artisans that he identifies the spiritual anchor of the slave community. Nowhere are his powers of observation, and his ability to understand, greater than in this passage:

> The reader has already been informed of the handicrafts carried on here by slaves: "Uncle" Toney was the blacksmith, "Uncle" Harry the cartwright, and "Uncle" Able was the shoemaker and these had assistants in their various departments. These mechanics were called "Uncles" by all the younger slaves, not because they really sustained that relationship to any, but according to plantation etiquette, as a mark of respect, due from the younger to the older slaves.[13]

Douglass builds on this reference to African etiquette on the plantation:

> Strange and even ridiculous as it may seem, among a people so uncultivated and with many stern trials to look in the face, there is not to be found among any people a more rigid enforcement of the law of respect to elders than is maintained among them. I set this down as partly constitutional with the colored race and partly conventional. There is no better material in the world for making a gentleman than is furnished by the African.[14]

Douglass's thesis that slaves enforced the law of respect for elders affirmed that self-generative quality in them that preserved the central tenet of their faith. In a remarkable statement, he argues that an elder "shows to others, and exacts for himself, all the tokens of respect which he is compelled to manifest toward his master." "Others," in this context, is a clear reference to other slaves: "So uniformly are good manners enforced among slaves, I can easily detect a 'bogus' fugitive by his manners."[15]

From the age of seven or eight, on Colonel Lloyd's plantation, he observed slaves "direct from Guinea . . . and many who could say their fathers and mothers were stolen from Africa. . . . Such . . . was the community, and such the place, in which my earliest and most lasting impressions of slavery, and of slave-life, were conceived." In that community and place, a younger slave approached an elder artisan "with hat in hand," and "woe betide him if he failed to acknowledge a favor of any sort, with the accustomed 'tank'ee.'"[16]

Little did Douglass know that the workshop was at the center of the compound of some traditional African societies, that in Africa there were artisans greatly respected for their skill. He was not aware, for example,

[13]Douglass, *Life and Times*, p. 42.

[14]*Ibid.*

[15]Douglass, *My Bondage*, p. 54. William Channing Gannett wrote of Sea Island blacks: "Orphans are at once adopted by connections, and the sick are well nursed by their friends. The old are treated with great reverence, and often exercise a kind of patriarchal authority. Children are carefully taught 'manners,' and the common address to each other, as well as to the 'buckra people,' is marked by extreme courtesy." William Channing Gannett, "The Freedmen at Port Royal," *North American Review*, CI (July 1865), p. 7.

[16]Douglass, *My Bondage*, pp. 70, 67, and 54.

that the heritage of the slave blacksmith was more complex than that of his European counterpart, whose tradition of work was undoubtedly a source of influence on the plantations. Not only did blacksmithing extend into the distant African past, it rose to such heights in some African cultures that it was thought a divine gift: "A figure wrought in iron is not a simple abstraction," writes Lester Wunderman, "if the smith who forged it is believed to have descended from his remote predecessor who brought the secret of iron making from heaven itself."[17] Often the blacksmith was also a goldsmith, as in Guinea, or a mediator between the living and the dead, as in Mali, both areas being among those affected by the slave trade. Moreover, his role in Africa as supplier of the instruments of agriculture—repeated on the plantations of the South, but under circumstances of forced labor—made the blacksmith a pivotal figure in the eyes of his people.[18]

Martin Delany, a contemporary of Douglass, had a more complex reality in mind than Douglass when thinking of slave artisans. Though some persons even now regard his views as extremely provocative, there is growing evidence, drawn from the African background, that Delany's position, on balance, is worthy of the most serious consideration. Alluding to indigenous African cultures, he asserts that Africans "Though pagans for the most part in their own country [were] required not to be taught to work, and how to do it; but it was only necessary to bid them work, and they at once knew what to do, and how it should be done." Despite evidence that at times slaveholders called in white mechanics to train slaves, Delany's argument that "[t]he greater number of the mechanics of the South are also black men" is not disputed by historians.[19]

His overall position is one that Douglass would have had the greatest difficulty accepting at the time he got to know slave artisans in his youth,

[17]Quoted in Jean Laude, *African Art of the Dogon* (New York, 1973), p. 13.

[18]*Ibid.*, p. 42. Speaking of iron, Park comments regarding the debt of the Moors to West Africans: "They are likewise sufficiently skillful to convert the native iron, which they procure from the Negroes." He states, further, that "Negro slave merchants . . . are called Slatees; who, besides slaves, and the merchandize which they bring for sale to the whites, supply the inhabitants of the maritime districts with native iron." Finally, he makes this crucial statement: "In their early intercourse with Europeans, the article that attracted most notice was iron. Its utility, in forming the instruments of war and husbandry, made it preferable to all others; and iron soon became the measure by which the value of all other commodities was ascertained." Park, *Travels*, pp. 37, 39, 225. Also, see Camara Laye, *The African Child* (1954; rpt. London, 1959), p. 22.

[19]Quoted from "The Political Destiny of the Colored Race" in Sterling Stuckey, ed., *The Ideological Origins of Black Nationalism* (Boston, 1972), p. 266. Delany's contention that Africans did not have to be trained to work finds striking confirmation in one source. Edward L. Pierce reports that "a tax-commissioner, now at Port Royal, and formerly a resident of South Carolina, told me that a native African belonging to his father, though a faithful man, would perpetually insist on doing his work in his own way, and being asked the threatening question, 'A'n't you going to mind?' would answer, with spirit, 'No, a'n't gwine to!' and the master desisted." Edward L. Pierce, "The Freedmen at Port Royal," *Atlantic Monthly*, XII (September 1863), p. 301.

for he was convinced that he "could not have been dropped anywhere on the globe, where I would reap less, in the way of knowledge from my immediate associates, than on this plantation."

> Even "Mas' Daniel," by his association with his father's slaves, had measurably adopted their dialect and their ideas, so far as they had ideas to be adopted. . . . Mas' Daniel could not associate with ignorance without sharing its shade; and he could not give his black playmates his company, without giving them his intelligence, as well. Without knowing this, or caring about it at the time, I, for some cause or other, spent much of my time with Mas' Daniel, in preference to spending it with most of the other boys.[20]

Perhaps at this time, when Douglass had been exposed to an array of slave work skills, he did not question how they came to perform such skills. It appears that he never made the leap that Delany made in thinking, for example, that slaves taught whites how to cultivate rice, which is, on the basis of present evidence, the most logical explanation for its successful cultivation as early as the 1690s in South Carolina. It was Delany's view that

> from their knowledge of cultivation—an art acquired in their native Africa—the farming interests in the North and planting in the South were commenced with a prospect never dreamed of before the introduction on the continent of this most interesting, unexampled, hardy race of men. . . . Hemp, cotton, tobacco, corn, rice, sugar, and many other important staple products, are all the result of African skill and labor in the southern states of this country. . . . [21]

Douglass was no more prepared to accept African origins for skills in agriculture than to acknowledge such origins for handicraft skills. Yet time and again he leads us in the direction of Africa for deeper understanding.

We know from Lewis C. Gray that cotton was cultivated by slaves in Maryland, as elsewhere in the South, but, blinded by racism, Gray never suspects that cotton was widely cultivated in sections of Africa from which Africans were forcibly taken to North America. In Nigeria, it was so abundant that it grew wild in certain regions, it is repeatedly referred to by anthropologists and travelers as being spun and woven into fabrics in various African traditional societies.[22] Even had Africans not taught

[20]Douglass, My Bondage, pp. 59–60.

[21]Delany, "Political Destiny," p. 216. See Peter Woods's discussion of Africans and rice in Black Majority, Chapter II.

[22]Lewis C. Gray, History of Agriculture in the Southern United States (Washington, D.C., 1933), pp. 183, 232, 888, 893. See Melville and Frances Herskovits, Dahomey (New York, 1938), pp. 45–46; Talbot, Southern Nigeria, p. 939; and Rattray, Ashanti, pp. 232–34. Park writes, especially of the West African town of Pisania: "I observed, likewise, near the towns . . . cotton and indigo. The former of these articles supplies them with clothing, and with the latter they dye their cloth of an excellent blue colour." Of the Jaloffs, he notes that superstitions, manners, and government resemble those of the

whites how to cultivate rice or cotton, evidence is abundant that scores of thousands of them did not need to be taught either of those skills, since they possessed them from childhood.

Of all the skilled slaves discussed by Douglass, except for his grand-mother, nowhere does he write as revealingly as when discussing Barney, a white-haired old man "of a brownish complexion, and a respectful and dignified bearing." Referred to as "Old Barney," he carried all sorts of skills behind his title of coachman:

> He was much devoted to his profession, and held his office as an honorable one. He was a farrier as well as an ostler, and could bleed horses, remove lampers from their mouths, and administer medicine to them. No one on the farm knew so well as Old Barney what to do with a sick horse. . . . [23]

Barney's son worked with him, and there were other apprentices under his guidance as well.

Art historian Robert F. Thompson recalls the response of "a priest near Whydah in Dahomey" to a photograph "of an equestrian figure in wood": "That rider sits with force. The force of the horse is seen. He has the speed and the power of the horse in his body." Thompson consid-ers it "especially African" to believe that "a rider acquires the very force of his mount," and he draws our attention to the annual Damba cere-mony in "the divisional capitols of Gonja, in what is now Ghana, where members of the ruling state perform . . . motions of horseback riding as both horse and rider. In other words, horse and rider can be, at least in some African civilizations, conceived of as one."[24] In areas of Africa as diverse as those of the Sonninke, Mossi, and Chadic regions, one finds examples, in metal, of the rider on his mount that date back a thousand years, six centuries before the Atlantic slave trade was launched. It is not surprising, therefore, that Delany observed of slaves:

> Nor were their skills as herdsmen inferior to their other proficiencies, they being among the most accomplished trainers of horses in the world. Indeed, to this class of men may be indebted the entire country for the improvement in the South in the breed of horses. And those who have travelled in the southern states could not have failed to observe that the principal trainers, jockeys, riders, and judges of horses were men of African descent.[25]

Mandigoes "but excel them in the manufacture of cotton cloth; spinning the wool to a finer thread, weaving it in a broader loom, and dying it a better colour." And: "As the Moors purchase all their clothing from the Negroes, the women are forced to be very economical in the items of dress. In general, they content themselves with a broad piece of cotton cloth, which . . . hangs down like a petticoat. . . . The King is distinguished by the fineness of his dress: which is composed of blue cloth, brought from Tombuctoo." Park, *Travels*, pp. 14, 24, 233.

[23]Douglass, *Life and Times*, p. 61.

[24]From Robert F. Thompson's commentary on *A Spiritual Ordering: The Metal Arts of Africa*, a documentary film produced by the Sewall Art Gallery, Rice University, Hous-ton, Texas, and the African American Institute of New York City, 1983.

[25]Delany, "Political Destiny," p. 217.

It is interesting to note, in this connection, that Douglass could not have been unaware of Delany's views on Africans and horses, handicrafts, and agriculture, for at the time Delany drafted his statement on slave skills, they were locked in a heated dispute over emigration, which is the issue raised by Delany in his important essay on slave skills and emigration. Why Douglass didn't consider Delany's explanation for the brilliance of slave skills, at least in some form, is a matter that merits consideration.

But to argue that slaves retained certain African work skills is to confront the reality that they practiced them under radically different circumstances in America. Gone was the rite of puberty as a means of introducing skills in an environment in which pride is taken in the flowering of youth. Under slavery in America, severe restrictions were placed on slave activities, and the idea of the slave family was little more than that. Disappearing also were those differences in African spiritual outlook that were tied to ethnicity as the process of Pan-Africanization— Du Bois called it a "mingling of heathen rites"—ran its course.[26]

As ethnic differences were increasingly subordinated by force of circumstances, a new form of Africanness centering on the primacy of unity in slavery came to prevail. In this atmosphere, many Africans, perhaps most, discovered that they had shared similar work habits in agriculture and handicrafts—across ethnic lines—in the ancestral home. Work skills, then, were an important grounding for a sense of Africanness that was achieved in slavery in ways not achieved in Africa. Under such circumstances, work songs were created out of a deeper sense of Africanity than has heretofore been acknowledged. Moreover, when it is borne in mind that Africans, in addition to sharing certain work skills, entered America with roughly similar spiritual and artistic attitudes, the depths of Africanity on which they drew are better understood.

Douglass had no illusions that the environment in which slave skills flourished was Christian. In fact, no one argued more powerfully than he that the great majority of slaves were denied access to Christianity. With slaves in mind, and following in the tradition of Richard Allen, David Walker, and Henry H. Garnet, he says of Christians, North and South, in the Appendix of his Narrative: "They love the heathen on the other side of the globe. They can pray for him, pay money to have the Bible put into his hand, and missionaries to instruct him; while they despise and totally neglect the heathen at their own doors."[27]

African work skills were not despised. They were the foundation of

[26]W. E. B. Du Bois, The Souls of Black Folk (1903; rpt. New York, 1973), pp. 250–64.
[27]Frederick Douglass, Narrative of the Life of Frederick Douglass (1845; rpt. Cambridge, 1960), p. 159. Richard Allen was a bishop of the African Methodist Episcopal Church, which had branches in the South; David Walker, the son of a free mother and a slave father and eminent among the abolitionists, lived for approximately forty years in Wilmington, North Carolina; and Henry Highland Garnet was a former slave in Maryland and a Presbyterian divine. All thought that slaves were overwhelmingly heathen. Now we can add the name of Frederick Douglass. Those scholars who insist that the slave popula-

slavery and found expression in much the same way as African spiritual and artistic values—as necessary to one's continuing sense of humanity, as a means of ordering one's world to prevent chaos from welling up from despair. Since labor was required to feed, clothe, and shelter the slave as well as the master, an intense irony obtained wherever the African was enslaved, and the text of much slave cultural life was writ large by that condition. It was a matter, in Douglass's case, of relating music as well as work skills to that text.

Since Douglass's treatment of slave music is his most direct contribution to our understanding of black culture, it is peculiar that it remains largely unexamined. His reflections on slave songs led W. E. B. Du Bois to entitle the last chapter of *The Souls of Black Folk* "Of the Sorrow Songs,"[28] but even Du Bois did not go much further in his treatment of Douglass on slave songs. In any case, the complex inner core of black music that consists of joy and sorrow received masterly attention from Douglass, who anticipated by more than a century many of the essentials of James Baldwin's wonderful treatment of the subject in *The Fire Next Time*. But it was sometime after slavery that Douglass began more fully to understand the music of his youth. Six years after his escape, he states: "I did not, when a slave, fully understand the deep meaning of these rude and apparently incoherent songs. I was, myself, within the circle, so that I could then neither hear nor see as those without might see and hear."[29]

In his reflections on slave handicrafts, Douglass was never to match his judgments on black music, possibly because he was "within the circle" of song and not intimately involved with slave artisans in the plantation

tion was mainly Christian face the fact that almost no one in antebellum America thought so—certainly not slaves and slaveholders; certainly not prominent black and white religious leaders. This is not to deny that a creative minority of slaves gave transcendent expression to Christianity, profoundly affecting the faith. Black religious leaders, including Douglass, were aware of this. In fact, as we see from the following, Douglass's emphasis was about right: "I was not more than thirteen years old when I felt the need of God, as a father and protector. My religious nature was awakened by the preaching of a white Methodist minister, named Hanson. . . . I cannot say that I had a very distinct notion of what was required of me; but one thing I knew very well—I was wretched, and had no means of making myself otherwise. . . . I consulted a good colored man, named Charles Johnson and, in tones of holy affection, he told me to pray, and what to pray for. I was, for weeks, a poor, broken-hearted mourner, traveling through the darkness and misery of doubts and fears. I finally found that change of heart which comes by 'casting all one's cares' upon God, and by having faith in Jesus Christ, as the Redeemer, Friend, and Savior of those who diligently seek Him. . . . The desire for knowledge increased, and especially did I want a thorough acquaintance with the contents of the Bible. I have gathered scattered pages from this holy book, from the filthy street gutters of Baltimore, and washed and dried them, that in the moments of my leisure, I might get a word or two of wisdom from them." Douglass, *My Bondage*, pp. 129–31.

[28] Du Bois, *Souls*, pp. 250–64.

[29] Douglass, *Narrative*, p. 37.

setting. There is also the fact that music reaches the mind and emotions, and so much in slave settings worked to confirm in Douglass the sentiments of a given song. But the depth of understanding that he was later to express undoubtedly owed much to his own agony as a slave and to what he knew other slaves experienced. "Slaves were expected to sing as well as to work," he tells us, adding: "A silent slave was not liked, either by master or overseer. 'Make a noise there! Make a noise there!,' and 'bear a hand,' were words usually addressed to slaves when they were silent." Under such circumstances, seldom did they not sing.[30]

We can, therefore, scarcely imagine the degree and variety of singing that Douglass heard. His description of some of the music—or is he referring to most?—is similar to Baldwin's treatment of black music, especially this passage that begins his discussion of a number of musical genres under a single, nameless heading:

> The slaves selected to go to the Great House Farm, for the monthly allowance for themselves and their fellow-slaves, were peculiarly enthusiastic. While on their way, they would make the dense old woods, for miles around, reverberate with their wild songs, revealing at once the highest joy and deepest sadness. They would compose and sing as they went along, consulting neither time nor tune. The thought that came up, came out—if not in the word, in the sound;—and as frequently in the one as in the other. They would sometimes sing the most pathetic sentiment in the most rapturous tone, and the most rapturous sentiment in the most pathetic tone.[31]

In that passage, Douglass captures the essence of black music, from the spirituals to jazz. Baldwin's comment on black music could very well have been influenced by Douglass:

> White Americans seem to feel that happy songs are *happy* and sad songs are *sad*. . . . Only people who have been down the line, as the song puts it, know what this music is about. I think it was Big Bill Broonzy who used to sing "I Feel So Good," a really joyful song about a man who is on his way to the railroad station to meet his girl. She's coming home. It is the singer's incredibly moving exuberance that makes one realize how leaden the time must have been while she was gone. . . . This is the freedom that one hears in some gospel songs, for example, and in jazz. In all jazz, and especially in the Blues, there is something tart and ironic, authoritative and doubled-edged. . . . White Americans do not understand the depths out of which such an ironic tenacity comes. . . .[32]

Douglass probed the depths of such "ironic tenacity," to use Baldwin's phrase, and what he has to tell us is relevant, once more, for the

[30]Douglass, *Life and Times*, p. 54.
[31]Douglass, *Narrative*, p. 36.
[32]James Baldwin, *The Fire Next Time* (New York, 1962), pp. 60–61.

music of his people since as during slavery: "Such is the constitution of the human mind, that, when pressed to extremes, it often avails itself of the most opposite methods. Extremes meet in mind as in matter. . . . Slaves sing more to *make* themselves happy, than to express their happiness."[33] With that he offers the best explanation yet of the source of that genius in black art that allows the music of sadness to contain its seeming opposite in the sound of joy. What connects that sadness and joy is the courage to live, the capacity to confront tragedy without wincing and thereby allow the human spirit to assert itself undiminished.

As described by Douglass, the emotional tones of the sacred and secular, as well as their contexts of expression, were often the same. Because slave institutions, owing to the challenge of slavery, were often fluid and formless, taking shape in one place then disappearing, only to reappear as slaves assembled elsewhere, that which was sacred coursed throughout much of the slave community. Only with the lapse of time has context more clearly and separably defined the sacred and secular in black musical life. No one has done as much as Douglass to help us understand this reality.

Douglass blurred the line between the sacred and the secular, in the process noting the principles that inform slave music as a whole. One is not sure whether the sacred or the secular predominated among the slaves he heard singing, though there is reason to think that the former was sovereign. In any case, a lot of singing was being done to work rhythms also, and songs were created in that context that were no less spiritual. And we know that spirituals were sung in work contexts, pushing them, with the threat of the lash as punishment, closer than ever to the blues. Douglass describes songs created during work that have all the power of religious appeal, that stretch irony to such tautness that suddenly the singer is overcome with sadness as tension snaps within. In all such songs of allowance day and the great house farm, he writes, "there was ever some expression in praise of the great house farm; something which would flatter the pride of the owner, and, possibly draw a forcible glance from him:

> I am going away to the great house farm,
> Yea! O yea! O yea!
> My old master is a good old master,
> O Yea! O Yea! O Yea!"

The irony is rich, the illusion of respect for the master a shield thrown up almost as a means of softening the blow that the song delivered:

[33]This view, taken from *My Bondage and My Freedom*, does not appear in the *Narrative*. It is obviously the result of Douglass's having pondered the "deeper meaning" of slave music for some time. See *My Bondage*, p. 77. On hearing this section of Douglass read, Melville critic and mathematician Joshua Leslie remarked: "He has seized the dialectic." Conversation with Leslie, November 1989.

This they would sing, with other words of their own improvising—*jargon to others but full of meaning to themselves*. . . . In the most boisterous outbursts of rapturous sentiment, there was ever a tinge of deep melancholy. . . . I have sometimes thought, that the mere hearing of these songs would do more to impress truly spiritual-minded men and women with the soul-crushing and death-dealing character of slavery, than the reading of whole volumes of its mere physical cruelties. They spoke to the heart and to the soul of the thoughtful.[34]

Thus, Douglass was astonished to find people in the North who thought the singing of slaves "evidence of their contentment and happiness. It is impossible to make a greater mistake. Slaves sing most when they are most unhappy."[35]

Nothing more clearly revealed the spiritual wasteland inhabited by slaveholders than their hearing slaves sing, indeed forcing them to sing, without being reformed by what they heard. Douglass's assertion that the singing of slaves was constant is a powerful indictment of the slaveholder's deafness to the humanity of the slave. "Every tone was a testimony against slavery and a prayer to God for deliverance from chains." He found that, on hearing those "wild notes," his spirit was depressed and he was filled with "ineffable sadness." For Douglass, slave music was the means by which he traced his "first glimmering conception of the dehumanizing character of slavery. I can never get rid of that conception. Those songs still follow me, to deepen my hatred of slavery, and quicken my sympathy for my brethren in bonds."[36]

An "elastic spirit" was the irreducible source of slave creativity, and it was not to the credit of those who bade slaves sing and dance. "We are told . . . that their masters frequently give them wherewith to make merry," Douglass writes, and admits that sometimes the slave does dance, sing, and "appear to be merry." He thought it proved "that though slavery is armed with a thousand stings, it is not able entirely to kill the . . . spirit of the bondman." It was no thanks to the slaveholder that that spirit rose and walked abroad, extracting "from the cup of nature occasional drops of joy and gladness. No thanks to the slaveholder, nor to slavery, that the vivacious captive may sometimes dance in his chains; his very mirth in such circumstances stands before God as an accusing angel against his enslaver."[37]

[34]Italics mine. The reference to jargon in the italicized portion of the sentence is all-important in light of Douglass's earlier remarks, discussed previously, regarding speech so African influenced that he at first could not understand it. His treatment of the subject, in *My Bondage and My Freedom*, is under a heading entitled "Jargon of the Plantation." *My Bondage*, pp. 59, 76.

[35]Douglass, *Narrative*, p. 38.

[36]*Ibid.*, p. 37. The melancholy feeling experienced on hearing slaves sing was felt by Douglass on hearing, "during the famine of 1845–6," the "wailing notes" of Irish song that "much affected" him. Douglass, *My Bondage*, p. 76.

[37]*Ibid.*, pp. 340–41.

Douglass did not know that slaves were under African religious influences that were the source of their manners. His view was that the slave, cut off from Christianity, was nevertheless "endowed with those mysterious powers by which man soars above the things of time and sense, and grasps, with undying tenacity, the elevating and sublimely glorious idea of God."[38] Though Douglass had no apparent knowledge of how the slave's conception of God provided the primary context for slave art, his treatment of sacred and secular music implies such knowledge. His achievement is the more impressive because he stepped across a cultural threshold a world away to call slave art proper to the slave without fully understanding why.

Trying to extract some joy and gladness from desolation was the engine of slave creativity that seldom ceased. What the slaveholder sought to use for his own purposes slaves generally used for their own. Out of the necessity to confront the injustice of their lives, they created art that addressed and responded to the nature of their experience. Douglass thought, in this context, that the songs of the slave represented "the sorrows of his heart; and he is relieved by them, only as an aching heart is relieved by its tears."[39] He thought artistic expression the chief means by which slaves responded to the horror of their condition. Where the work of slaves was most decisive — in the fields — slavery was most brutal. The overseer strutted, walked, or rode about, "dealing blows, and leaving gashes on broken-spirited men and helpless women," a business so disgraceful "that, rather than engage in it, a decent man would blow his brains out." The overseer's cruelty and coarseness, "rank as weeds in the tropics," punctuated the rhythms of work, and out of that hell much of slave art was created.[40] The slave woman and man, in such an environment, could well appreciate a song such as "Sometimes I Feel Like a Motherless Child":

> Sometimes I feel like a motherless child,
> Sometimes I feel like a motherless child,
> Sometimes I feel like a motherless child,
> A long ways from home;
> A long ways from home;
> True believer
> A long ways from home
> A long ways from home

The refrain — "A long ways from home" — flows like an undercurrent through the song, deepening the pain of experience, reminding one, at one's lowest point, of origins:

[38]*Ibid.*, p. 339.
[39]Douglass, *Narrative*, p. 38.
[40]Douglass, *My Bondage*, p. 81.

> Sometimes I feel like I'm almost gone,
> Sometimes I feel like I'm almost gone,
> Sometimes I feel like I'm almost gone,
> A long ways from home;
> A long ways from home;
> True believer
> A long ways from home
> A long ways from home.[41]

Douglass has given us our best sense of how much work influenced the slave's creative process. His emphasis on the degree to which it conditioned a great deal of music and established its context, when coupled with what we know of the relationship between art and work in Africa, where art has been so deeply functional, gives us a new perspective on the process of slave creativity. And thanks to him, we have a better awareness of the politics of slave artistic expression, of the degree to which consciousness of oppression was inevitable for the slave, especially for the field hand. Wherever song was heard between sunup and sundown, one was likely to find some level of work and awareness, by white and black, that the plantation economy was dependent on slave brawn and skill: "there was generally more or less singing among the teamsters, at all times. It was a means of telling the overseer, in the distance, where they were and what they were about."[42]

It is small wonder, with such a tradition of work and art behind them, that after slavery blacks could voice, in a new but related form of oppression, an unusual blend of pride:

> Dis ole hammer
> Ring lak silver
> Shine lak gold, baby,
> Shine lak gold.
>
> Take dis hammer
> Throw it in de river,
> It'll ring right on, baby,
> Ring right on.

and disaffection:

> Captain, did you hear
> All yo' men gonna leave you,
> Next pay day, baby,
> Next pay day?[43]

[41]The lyrics are taken from Paul Robeson's *Songs of My People*, RCA Victor (recorded on Jan. 7, 1926), LM-3292.

[42]Douglass, *Life and Times*, p. 54.

[43]Sterling A. Brown, Arthur P. Davis, and Ulysses Lee, eds., *The Negro Caravan* (New York, 1941), p. 466.

Slave art was used for general indictments of slavery, subtly ex-
pressed, and for explicit attacks on slavery, at times during holidays,
through song with percussive accompaniment—"Jubilee beating." At
such times, improvisation was a hallmark of performance. Douglass's
description of "Juba" beating is superb, with its emphasis on the corre-
spondence between word and hand, the one confirming the rhythm of
the other: The Jubilee beater "sings his merry songs, so ordering the
words as to have them fall pat with the movement of his hands. . . .
Among a mass of nonsense and wild frolic, once in a while a sharp hit is
given to the meanness of slaveholders." Douglass chose this example of
song, with accents beat against the body in rhythmic and ironic accom-
paniment:

> We raise de wheat,
> Dey gib us de corn;
> We bake de bread,
> Dey gib us de crust;
> We sif de meal,
> Dey gib us de huss;
> We peel de meat,
> Dey gib us de skin,
> And that's de way
> Dey take us in.
> We skim de pot,
> Dey gib us the liquor,
> And say dat's good enough for niggers.[44]

Douglass thought it "not a bad summary of the palpable injustice and
fraud of slavery, giving—as it does—to the lazy and idle, the comforts
which God designed should be given solely to the honest laborer."[45]

The relaxed atmosphere on the plantation during holidays—slaves
were encouraged *not* to work on such occasions—led to an extraordinary
number of slaves coming forth with fiddles: The fiddling and dancing
and the beating of Jubilee were "going on in all directions." That Juba
beating often took the place of the fiddle suggests the rhythmic uses to
which the fiddle was put in slave hands. But slave culture, on the occa-
sion of holidays, was very much under the influence of the master class
and was used as part of a larger plan, for "keeping the minds of slaves
occupied with prospective pleasure, within the limits of slavery."[46] At
such times, the married slave could visit his wife; the mother and father
could see their offspring; the young slave could go courting; the drunken
slave could secure plenty of alcohol; and the man of religion could pray,
preach, and exhort:[47]

[44]Douglass, *Life and Times*, p. 146.
[45]*Ibid.*, p. 147.
[46]*Ibid.*
[47]*Ibid.*

These holidays are conductors or safety valves to carry off the explosive elements inseparable from the human mind, when reduced to the condition of slavery. But for these, the rigors of bondage would become too severe for endurance, and the slave would be forced up to dangerous desperation. Woe to the slaveholder when he undertakes to hinder or to prevent the operation of these electric conductors. A succession of earthquakes would be less destructive, than the insurrectionary fires which would be sure to burst forth in different parts of the south, from such interference.[48]

Holidays were part of "the gross fraud, wrongs and inhumanity of slavery." The fraud reached its pervasive high (or low) point when large numbers of slaves were encouraged to get drunk as a means "to disgust [them] with their temporary freedom, and to make them as glad to return to their work, as they were to leave it. By plunging them into exhausting depths of drunkenness and dissipation, this effect is almost certain to follow." Thus, scenes of debauchery often reached scandalous extremes in which "multitudes might be found stretched out in brutal drunkenness, at once helpless and disgusting."[49]

Douglass was exposed to the best and the worst of the character of his people, seeing it develop, or fail to, under the least advantageous conditions. Such influences within the slave community were important in his early development, those of his mother and grandmother foremost among them, though he spent virtually no time with his mother and relatively little with his grandmother. That both his mother, who could read, and his grandmother, who possessed numerous skills, were field hands suggests the need for reconsideration of the nature of the relationship between that group of slaves and others, especially when considering the knowledge of agriculture that large numbers of Africans brought to the plantations of the South. There is, in short, reason to believe that field hands, who also have not received proper credit for their artistic achievements, were far more enlightened than scholars have led us to believe.

According to poet Andrienne Rich, "Frederick Douglass wrote an English purer than Milton's."[50] In such language, when reflecting on the life of his grandmother, he sang a tragic song, and we are left with one of the great sketches of woman in history. Her history was one of great gifts, yet her towering figure stands assaulted—and immortalized—as the ultimate emblem of the inhumanity of slavery. Her vast contribution to the wealth of slaveholders is as difficult to measure as the suffering slavery brought to her over a period of generations. During much of her life she represented, unbroken from Africa, certain traditions of work that were shared by significant numbers of slaves. Her character, under the oppression of slavery, could well have been the source of Douglass's

[48]Douglass, *My Bondage*, p. 196.
[49]*Ibid.*, pp. 196, 197.
[50]Rich, *Poems: Selected and New, 1950–1974* (New York, 1975), p. 151.

elegance of spirit, her acuity of mind a likely and important source of his genius.

More than anything else that fueled his hatred of slaveholders was their treatment of her. She had served "old master" from youth to old age, rocking him in infancy, caring for him in childhood. She "was the source of all his wealth . . . had become a great-grandmother in his service." At his death, she had "wiped from his icy brow the cold death-sweat, and closed his eyes forever."

> She was nevertheless left as a slave—a slave for life—a slave in the hands of strangers; and in their hands she saw her children, her grandchildren, and her great-grandchildren, divided, like so many sheep, without being gratified with the small privilege of a single word, as to their or her own destiny. . . . The hearth is desolate. The children, the unconscious children, who once sang and danced in her presence, are gone. She gropes her way, in the darkness of age, for a drink of water. . . . The grave is at the door. And now, when weighed down by the pains and aches of old age, when the head inclines to the feet, when the beginning and ending of human existence meet, and helpless infancy and painful old age combine together—at this time, this most needed time for the exercise of that tenderness and affection which children only can exercise toward a declining parent—my poor old grandmother, the devoted mother of twelve children, is left all alone, in yonder little hut, before a few dim embers.[51]

The prevailing historical wisdom about the state of African skills in the era of the slave trade must be reconsidered in light of growing evidence that Africans were perhaps second to none in cotton and rice cultivation, in fishing and animal husbandry, in weaving and blacksmithing—areas of importance in the workshop and field of the plantation South. When we add what has been discovered of African music, dance, and sculpture in the era of the trade, the force of African historical reality will surely assert itself in new and profound ways.

From what we know of Douglass's observations regarding slave skills, we can be assured that in coming years more will be discovered of African influences on slave labor. Simply to know more of such influences in Maryland is to know more of such matters in Virginia and in other regions of the South, for slaves in Maryland and Virginia were, via the domestic slave trade, sold farther south and to the Southwest. Not only has Douglass provided us with a new agenda—and implicitly, an approach—for scholarship on slave skills, he has put his finger on the crux of spirituality for his people by identifying respect for the elders as a cardinal tenet of their faith. With the exception of Herman Melville, no other American intellectual of the slave era was as perceptive on this point as he.[52]

[51]Douglass, *Life and Times*, pp. 99–100.

[52]Eugene Genovese, in *Roll, Jordan, Roll* (New York, 1974), pp. 388–98; and Charles Joyner, in *Down By the Riverside* (Urbana and Chicago, 1984), pp. 70–80, provide impor-

Yet Douglass chose not to draw on the insights of Delany in his discussion of slave skills. It is hard to avoid the conclusion that he sought to avoid complicating a strategy of liberation already difficult enough to carry to a successful conclusion, fearing perhaps that he might compound the problem by contending that slaves, and therefore the overwhelming majority of blacks in America, were in numerous ways African. Still, for him it was primarily a matter of emphasis, not one of exclusion, a matter of failing to suggest possible African origins in those areas that were indispensable to the economy of the nation in his day. Even though he knew little of the evolution of the African qualities identified, in areas of spiritual and artistic importance he did not avoid calling them African.

Even with his silence on those matters raised by Delany, Douglass is emerging as a truly important theorist of black culture, especially through his thought on slave music, which he sees rooted in economic and political oppression, under continuing African influence while taking on a life of its own, continually renewing itself at the fount of improvisation. Moreover, in realizing that a great deal of slave music exuded spirituality, he makes an abolitionist case for the force of moral suasion in the midst of slaveholders, and an aesthetic case for the sovereign influence of the sacred in slave music at work and at play, on sacred *and* secular occasions. Just as there is for him no clear line between sadness and joy in slave music, there is for him little division between sacred and secular music under conditions of oppression.

Perhaps Douglass's most lasting theoretical contribution, his reflections on music, contains language that comes as close to suggesting an African *approach* to music as one might find. He speaks of "the natural disposition of the Negro to make a noise in the world" as a factor in the quality and degree of singing heard in slavery. His pioneering comments on slave speech help us appreciate seeming peculiarities of sound associated with slave singing that, though universal in spiritual appeal, sounded "wild."[53] As important as the question of origins is to understanding slave music, Douglass's writings are more important for what they tell us of the artistic *response* of Africans to the tragedy of slavery in North America. He does that with such accuracy of ear, sympathy of feeling, and depth of understanding that he appears to have command of that which is timeless in slave musical art.

tant statements on African influences on slave handicrafts. They are among the few historians to do so to date. See Joshua Leslie and Sterling Stuckey, "The Death of Benito Cereno: A Reading of Herman Melville on Slavery," *Journal of Negro History*, 67 (Winter 1982), pp. 287–301. For a detailed discussion of the role of elders in slave culture, and of African antecedents to that role, see Chapter I of Stuckey, *Slave Culture.*

[53]Douglass, *Life and Times*, p. 54.

The Skies of Consciousness: African Dance at Pinkster in New York, 1750–1840

Sacred dancing is one of the noblest expressions of Africa, as it is of all cultures at their peaks.

André Malraux

Of the forms of folk expression, except for the tale, slave dance was the most difficult for slaveholders to suppress. Melville Herskovits noted the tenacity of this form but did not explain in detail why it was so. And while he and a few other anthropologists have written thoughtfully on certain aspects of slave dance in the Americas, there was, until recently, no explanation for why dance was vital to the formation of a common vision for African ethnic groups in the American South.[1] Because the oppression of blacks in the North was, however painful, not draconic, and the number of slaves there slight compared with the South, the issue of a common vision among northern slaves has hardly been a concern of scholars. Instead, they have tended to treat the slave cultural experience in the North, to the extent that it has been treated at all, as if it had little or no connection with the slave South. And since dance on the plantations of the South, despite its powerful presence in the sources, has been practically ignored until recently, it should not surprise that, when mentioned at all with respect to northern slavery, it has almost invariably been referred to only in passing.

Yet dance can be an extremely subtle means of perpetuating values before the very eyes of those looking on in contempt, or with fascination—or some combination of the two. When the oppressor had no handle on its meaning, as was the case in this country, opportunities for using it as a cultural weapon were enormously enhanced. At the subtle

[1]Herskovits refers "to the rich returns to be gained from systematic scientific analysis, on the basis of comparative strategies, of the tenacity of African dance styles and the effect of acculturation on New World Negro dancing." See Melville Herskovits, *The Myth of the Negro Past* (Boston, 1941), p. 270. For one of the better essays on dance in the Americas, see John F. Szwed and Morton Marks, "The Afro-American Transformation of European Set Dances and Dance Suites," *Dance Research Journal* (Summer 1988), pp. 29–36.

but highly complex level of rhythm, African dance long remained a virtual mystery to most whites.[2] Even when not intended as an act of resistance, through polyrhythms that were integral to African cultures, dance was a bulwark of protection for itself and more. In short, it could constitute an act of resistance. Its great strength, once under way, is that it is performed almost as a reflex action, the almost self-activating movements being recalled more quickly than the mind can command or even fully control. The physical act of dance, at times so sacred, perpetuates form, cultural meaning, and one's resolve to endure.

Those taken from African cultures and enslaved here and elsewhere were not likely, in the main, ever to cease being dancers. For them, to dance in youth meant always being dancers, at heart if not in body. Such cultural *momentum* — sacred dance evolved over millennia in black Africa — easily carried over into slavery. To be sure, proscriptions against dance, in contrast to those against speaking a foreign tongue or learning to read or to write, were extremely difficult, if not impossible, to impose. At times projecting an elusive but complex vision of the sacred, slaves rose to dance in America. The vigor of the dancers and their faces — which often conveyed a certain joy — not uncommonly meant that dance to them was a form of spiritual recreation, which compounded the problem of understanding for those outside slave culture, inclining them to underestimate a persistent concern of this essay, the gravity of much of slave dance.

Context was all-important with respect to how dance was received. There was more tolerance for slave dance in the North than in the South, where there was a greater tendency to discourage, if not all forms of group dance among slaves, at least the principal dance of the slave era, the Ring Shout.[3] Moreover, problems internal to slave communities in the North were on nothing like the scale of those confronting slaves in the South where slavery was severe and slaves were found in great numbers. But what was common to all Africans in America was the rending of spirit that occurred during the long Atlantic voyage, the painful awareness of death behind and around one. Interestingly — and tragically — a large number of Africans made to undergo the middle passage, especially many who would later be involved at the Pinkster Festival, were but children.

[2]A factor here was the association of Africans with heathenism, if not savagery, the assumption being that, except for a tiny minority of white observers, without the advent of Christianity culture could not begin with blacks. This, in fact, was a view that was shared by leading black intellectuals of the slave era. In time, however, African dance rhythms would have an enormous impact on the Western world. Malraux notes this in arguing that "Africa has transformed dancing throughout the world — this is its first contribution to the art of dancing." See André Malraux, "Behind the Mask of Africa," *The New York Times Magazine*, May 15, 1966, p. 30. For a discussion of African religion as heathenism, see Sterling Stuckey, *Slave Culture: Nationalist Theory and the Foundations of Black America* (New York, 1987), especially Chapters I and III.

[3]Stuckey, *Slave Culture*, Chapter I.

* * *

Beginning with the first settlement of the Dutch in colonial New York
and for generations thereafter, especially from the 1750s to the mid-
nineteenth century, the Pinkster Festival was celebrated. In time, slave-
holders in New York allowed their slaves to have a "king" from their
ranks who would rule blacks during the festival. But Pinkster was more
noted for what blacks brought to it than for what was there before.
In a world of oppression, holiday festivals served as a "safety valve"—
Mikhail Bakhtin's explanation for phenomena in medieval Europe that
in some degree bear an interesting relationship to festivals in North
America generally, but especially to New York's Pinkster Festival, long
dominated culturally by blacks. Of European festivals, Bakhtin writes:

> All these forms of protocol and ritual based on laughter and consecrated by
> tradition existed in all the countries of medieval Europe; they were sharply
> distinct from the official, ecclesiastical, feudal, and political cult forms and
> ceremonials. . . . If we fail to take into consideration this two-world condi-
> tion, neither medieval cultural consciousness nor the culture of the Renais-
> sance can be understood. To ignore or to underestimate the laughing people
> of the Middle Ages also distorts the picture of European culture's historic
> development.[4]

While the Parade of Kings in Cuba, not dissimilar to Pinkster, may
have been born of the slaveholder's perceived need for a safety valve to
prevent an uprising, no such argument holds for slavery in the northern
part of America, for the North was not a slavocracy, dependent mainly
on slave labor for economic gain. One must, therefore, look beyond
Bakhtin's safety-valve theory to understand why whites in New York
allowed blacks to have a "king" who was the delight of many white
youngsters and was even accorded a measure of respect by some white
adults. A more likely explanation for the latitude given to New York
blacks was the supreme confidence of the overlords. There was no better
confirmation of that confidence than laughter that seemed to warm like
sunlight on festive occasions.

With respect to Pinkster, the good cheer seems definitely to have
been provided by activity of the slaves that was calculated, thanks to the
collaboration of slave and master, to achieve something of a mood of
levity. Such was the activity of the Pinkster king, who by the Revolution-
ary period had donned the attire of the harlequin. An important figure,
Bakhtin notes, in medieval festivals, the harlequin of Pinkster managed
an unusual dignity despite his costume, which was described as "graphic
and unique to the greatest degree, being that worn by a British Brigadier
of the olden time." Indeed, the description of him reminds one of Benito
Cereno, whose attire was no less incongruent with his surroundings on
the slave ship *San Dominick*. The slave-king wore an ample "broadcloth
scarlet coat, with wide flaps almost reaching to his heels, and gayly

[4]Mikhail Bakhtin, *Rabelais and His World* (Bloomington, 1984), pp. 5, 6. Originally
published in 1965.

ornamented everywhere with broad tracings of bright golden lace. . . . "
There were "yellow buckskin, fresh and new, with stockings blue, and
burnished silver buckles to his well-blacked shoe; when we add to these
the tricornered cocked hat trimmed also with lace of gold . . . we nearly
complete the rude sketch of the Pinkster king." Such a living portrait
was designed to evoke laughter and possibly jeering, and probably did,
when the Pinkster king was first encountered. This undoubtedly contrib-
uted to the happy mood for whites when a "colored harlequin" appeared
at Pinkster sites.[5] But a special pain was unavoidable for the Pinkster
king with the coming of the Revolution and the defeat of the British.
Emblematic of a people, that pain was shared by them. During Pinkster,
for that reason and more, a place should be found on the other side of
laughter, or perhaps at its lower registers, for sadness.

While slavery was not nearly as essential to the economic success of
New York as it was, say, to South Carolina or Maryland in the colonial
period, it was nonetheless the basis for substantial wealth and comfort:
"The leading merchants of New York City, who were also often the
leading citizens," writes James Rawley, "sought profits in the importa-
tion of slaves." They secured profits not only from that but also, together
with other successful New Yorkers, from enslaving blacks. By the end of
the colonial period, slaves constituted a not insignificant one-seventh
of New York's population. Overwhelmingly, they lived in agricultural
regions, only one-fourth of the total being employed as domestics and
artisans. Regarding domestics, a merchant advised: "For this market,
they must be young, the younger the better if not quite children." Slave
labor as a whole, therefore, "promoted the growth of the economy" as
well as "the stratification of the society."[6] In addition, the large number
of young male and female imports, most of whom were born in Africa,
was of great cultural relevance, since primary values, aesthetic and other-
wise, are determined by the time of puberty through contact with one's
elders and are drawn on in meeting new realities.[7] Moreover, the fact
that there was no shortage of female slaves in New York at once broad-
ened, and gave a certain symmetry to, the culture of blacks.

Slaves from the countryside had as much if not more influence on

[5]Dr. James Eights, "Pinkster Festivities in Albany Sixty Years Ago," in John Munsell,
Collections on the History of Albany (Albany, 1865), Vol. 2, p. 325; A. J. Weise, *History
of the City of Troy* (Troy, New York, 1876), p. 63. Unless otherwise indicated, references
from Munsell will be from Volume 2 of *Collections*. For a description of Don Benito's
attire and his relationship not only to his environment on board the *San Dominick* but to
an African king wearing a brigadier general's attire, see Sterling Stuckey, "Follow Your
Leader: The Theme of Cannibalism in Melville's Benito Cereno," in Robert Burkholder,
ed., *Critical Essays on Benito Cereno* (New York, 1992).

[6]James W. Rawley, *Transatlantic Slave Trade* (New York, 1981), p. 390.

[7]See Camara Laye, *The African Child* (New York, 1989), in which one discerns early
work contact of children and adults, especially with respect to blacksmithing and the
harvesting of rice, and rituals accompanying such work skills among the Malinke people
of West Africa. The volume, which treats traditional African customs, was originally
published in 1954.

Pinkster than those from cities, a consideration with profound implications for the conventional historical view that thinly spread aggregates of slaves were at a decided cultural disadvantage vis-à-vis the master class. Moreover, the view that the greater the proximity of slave-to-master, especially when slaves are outnumbered, the greater the cultural dominance of the master class should be recalled in light of the findings in this study, much of which treats the cultural roles at Pinkster of slave domestics who usually numbered no more than one or two per household in cities where Pinkster was held.[8] Thus, our findings for Pinkster relate in fundamental ways to the nature of slave culture and slavery as a whole, North and South.

More should be said of the slave trade to have a better sense of the relationship of African-born imports to Pinkster prior to and following the trade's suppression. For example, between 1701 and 1774, according to James G. Lydon, 43 percent of Africans brought into northern slavery were direct imports from Africa, the close to three thousand to New York being roughly two thousand more than Herskovits thought had entered in that time.[9] Moreover, the number of Africans entering New York by the time Pinkster was in flower—by the middle of the eighteenth century, roughly—appears to have been considerable. The New Jersey governor's comment in 1762 that "great Numbers of Negroes are landed in the Province every year in order to be run into New York and Pennsylvania besides overstocking this country with slaves" suggests, as do the sources generally, that African influence was direct in the most precise sense, which explains references in the sources to African languages being used for song and for other purposes at Pinkster.[10]

[8]"There was no uniform method of housing slaves in New York," writes Edwin Olson. "With but a pair of Negroes to provide quarters for, the average slaveowner usually found sufficient room for them in the attic or basement of his home." Not surprisingly, housing reflected the hierarchy of relations in slavery between slave and master, a matter about which slaves were not unaware. See Edwin Olson, "Social Aspects of the Slave in New York," *Journal of Negro History*, Vol. 26 (1941), p. 68.

[9]For all his excellence as a student of slave culture in the Americas, Herskovits underestimated not only the number of African imports into the North but also their cultural impact on other slaves and, for that matter, upon white people. For example, he did not realize the extent to which Africans retained African languages in the North, using them for a number of cultural purposes; nor was he aware of the powerful influence of African dance on other slaves and its centrality in the recreation of whites. Basing himself on a consideration of the volume of imports into the North and South, he takes the going view that numbers are of great importance in determining the degree to which African values are lost or retained, a view about which this essay raises serious questions. See Herskovits, *Myth*, pp. 44, 45.

[10]Rawley, *Slave Trade*, pp. 388, 389. Rawley is not alone in being unable to write with a degree of certainty about African ethnic groups in New York. Phillip Curtin is even less convinced of African importations into New York and New Jersey combined, settling for a total of 930 "over the whole period 1715–67," the rest, a total of 4,551, coming from the West Indies. If Curtin is right, then African culture was much stronger than we have been led to believe, and I believe that, based on the evidence in this and other work, to be the case. Curtin's figures, of course, are at considerable variance from those of Lydon. See Phillip Curtin, *The Atlantic Slave Trade* (Madison, Wisconsin, 1969), p. 143.

Certain artists not previously identified with Pinkster are likely to have been participants in that festival. Those who routinely performed, for example, on the streets of a city like Albany, long the main arena for Pinkster activity, would almost certainly, considering the absence of logistical problems, have participated in the festival. It is well to keep in mind that, by contrast, the Pinkster king was known to travel from one Pinkster site to another in a single day, a journey on which he could easily have been accompanied, when the distance was not great, by other Albany slaves. His entourage would have consisted of artists in their own right since almost all slaves danced and were sensitive to the relation of dance to music.

If artists lived close to Pinkster grounds and performed near them over periods of months, one can easily imagine them at Pinkster helping to define the events of the day. For instance, Munsell writes of those "whose memory and whose affections go back to Albany, as it was a half century ago, when in summer afternoons wives and husbands smoked their pipes on stoops; when every corner was vocal with the concerts of whistling negroes; and when the annual festivities of Pinkster Hill were next to the Fourth of July, the event of the year."[11] Munsell makes the association, though not direct, between whistling blacks — whistling is often done to dance in black culture — and Pinkster. The association reinforces the view that whistlers, in relatively large numbers and almost certainly being danced to, were at the festival in Albany.

Data from Gabriel Furman's *Antiquities of Long Island* confirm the strength of the inference, for at Pinkster on Long Island into the nineteenth century there was such whistling that "to ridicule *whistling*," a music that helped preserve the festival, the music was referred to as "Negro Pinkster Music." There was much dance to its virtuoso rhythms, dance that appears to have been well suited for the street corner, the Pinkster field, or for parades. Here is a portrait of the dance and the whistling:

> With hurried step and nodding knee,
> The negroes keep their jubilee;
> While Cuffee, with protruding lip,
> Bravuras to the darky's skip.
> [Whistles][12]

Evidence from different sources argues strikingly similar cultural preferences and responses at sites some distance apart, for Long Island is well over a hundred miles south of Albany and was much too far away for participants to have moved from that site to Albany, or the reverse, in a given Pinkster celebration. That the music of Pinkster, by the last half of the eighteenth century, was thought of as black music reflects the chang-

[11]Munsell, *Collections*, p. 12.
[12]Gabriel Furman, *Antiquities of Long Island* (Long Island, 1874), p. 267.

ing content and form of a holiday that "was a species of negro jubilee upon Long Island at the same time that it was observed as a festival by the white population, and eventually became entirely left to the former. . . . " But Furman notes that "it never was with us the perfect saturnalia that was for a long period exhibited in its observance at Albany."[13]

While for whites the Fourth of July was more popular than Pinkster, that was never the case for blacks. Pinkster was for them the favorite of all holidays, one that allowed a degree of "freedom" that others did not. Referring to Pinkster, Edwin Olson writes that "it was the holiday looked forward to with the greatest anticipation by the slaves," lasting from three days to a week, providing them with more time off than at Christmas and New Year, two other holidays enjoyed by them. "When the long-awaited opening day arrived, slaves from the countryside made their way to the nearest town or city—New York City, Kingston, Poughkeepsie, to name but a few—to join with the urban colored in the carnival."[14] This means that for decades slaves within a considerable radius participated in Pinkster.

With the passing of time, cultural preferences, sacred and secular, were essentially the same for slaves as continued oppression and smallness of numbers encouraged unity rather than divisions in their ranks. In interesting degree, the opportunity was there for them to give added shape and content to certain of their artistic and spiritual traditions. For example, Olson remarks that while "matters of feeding, housing, clothing and attending to the physical welfare of slaves were shouldered by masters, *that of recreation was the slaves' own concern* (my emphasis)." He adds that the recreation "pictured the bright side of slavery," and there is no reason to think whites thought otherwise, for slaves found it safe not to be viewed as unhappy, so why not wear the mask when going about serious business as when simply making merry?[15]

During Pinkster at Albany, King Charley, an Angolan, presided and did nothing to threaten the sense of security of whites. Though among the many made to undergo the Atlantic voyage when quite young, he reigned over the festivities, in spite of his peculiar attire, with much charm and the bearing of royalty. With the assistance of a master of ceremonies who for a while provided the beat, on a kettle drum, "for the singing, dancing, and parading which enlivened the occasion," Charley was known to join in the dancing.[16] That the parade was also done to slave drumming meant that it too, together with dance, a vital part of

[13]*Ibid.*

[14]Olson, "Social Aspects," p. 71.

[15]*Ibid.* In fact, slaves strained to amuse whites during Pinkster, to such an extent that a model for "minstrelsy," it has been argued, was established in the North as whites were provided with "a huge amount of unalloyed fun." This possible link appears to have validity, the at times faked mirth of blacks preparing the way for whites to fake being black. See Munsell, *Collections*, p. 56.

[16]Olson, "Social Aspects," pp. 71–72.

parading, was a means of achieving a certain oneness as slaves, whatever their ethnic origin, moved to the singular beat of the drummer.

To have danced among his people in the last half of the eighteenth century, especially as king, meant that Charley had to have possessed dignity of bearing and skill at that art, and that presupposes rhythm-consciousness that was enhanced by his ability at drumming, too. Such was his command of the event, and such in particular the power of the music and dance, that Pinkster was described as the "great festival of the negroes . . . when every family of wealth possessed one or more slaves . . . [that] took place usually in May."[17]

With artistic resources that included drumming, Charley moved from one Pinkster site to another. Usually referred to in relation to Albany, he was "ubiquitous" at Troy, New York, during Pinkster as well. Though it is not clear precisely when Africans began participating in Pinkster anywhere in New York, it follows that King Charley, because of his reputation in Troy, which was considerable, probably frequented that location about as long as he was active in nearby Albany, which was but five miles away. It is written that during Pinkster at Troy he "was seated on a huge log, over the ends of which, skins were tightly drawn. By beating this great drum, he timed the movements of the dancers, and otherwise gave directions to their amusements."[18] Thus, music reinforced dance and dance music, the most vital of African instruments regulating the process.

King Charley's dance rather than his drumming is more often re-marked in the sources. It was considered to have been of the Congo variety, a form that shared, with most others that were African, move-ment in a circle. That he was from Angola, many of whose people over the centuries have shared with Kongo people an elaborate religious mythology represented by circularity, gives us some clue to the meaning of dance within circles formed at Pinkster. So powerful are the bonds that link circularity to Kongo beliefs concerning the sun's movement, which is counterclockwise for them, and the stages of life from birth to death that circularity in almost any form might serve to remind a signifi-cant number of slaves of religious values that were proper to them.[19] Since the Pinkster king was at ease with Congo dance, there is reason to believe that he was well-informed about the sacred meaning of dance during the festival.

The festival began on the Monday following the Whitsunday or Pen-tecost of the Catholic and Episcopal churches. Still, it inspired little of pious concern among whites as the spirit of good cheer and humor, prominent features of carnivals, began in anticipation of the celebration. And even then, prior to the official opening of the festival, attention was

[17]Munsell, *Collections*, p. 323.

[18]Weise, *Troy*, p. 64.

[19]Robert F. Thompson and Joseph Cornet, *The Four Moments of the Sun* (Washington, D.C., 1981), Chapters I and II.

focused mainly on the slaves. Munsell described the event as "the carnival of the African race, in which they indulged in unrestrained merriment and revelry," and this view of Pinkster has been the going thesis for more than two centuries but was recently challenged by Shane White, who argues that the Pinkster festival was "a complex syncretization of African and Dutch cultures forged on the Hudson River."[20] His position, therefore, should be considered near the outset of our discussion despite the widely held view that "Crowds of white people thronged the [Pinkster] common to observe the merrymaking" of the blacks.[21]

A document especially important to White was printed in 1803, presumably authored by one who, at that time, observed Pinkster as distinct from, he charges, accounts of the festival by old people who observed the festival in youth. Relying on "Pinkster in Albany, 1803: A Contemporary Description," White seeks to depreciate the value of previous scholarly treatments of Pinkster and the sources on which those treatments are based. Apparently, 1803 is an important year for him because it was closer to the time when the festival is said to have been at its height, in the last half of the eighteenth century. The document in which he has such faith was originally published anonymously in the *Albany Centinel*.[22]

The White source argues, regarding Pinkster dance, that "the whole consists in placing the body in the most disgusting attitude and performing, without reserve, the most lewd and indecent gesticulation" that gives way to an embrace of partners "terminating in a sort of masquerade capture, which must cover even a harlot with blushes to describe."[23] The anonymous writer continues in a similar vein:

> These sports continue three days, and sometimes for four days and nights successively; during which and throughout the whole extent of the encampment, every vice is practiced without reproof and without reserve. It is said that the married negroes consider themselves as absolved, on these occasions, from their matrimonial obligations. But however this may be, with respect to many, all restraints are flung off, and nature, undisguised and without a veil, on every side is exhibited.[24]

[20]Shane White, "Pinkster in Albany, 1803: A Contemporary Description," *New York History*, Vol. 70, No. 2, p. 195. In introducing his document, White claims: "Arguing from a black nationalist point of view, [Sterling] Stuckey insists on both the 'oneness' of black culture in the twentieth century and on its origins in Central and West Africa" (White, "Pinkster," p. 193). I am tempted to accuse White of engaging in a practice as despicable as red baiting, of attempting to prejudice his audience by pandering to its sense of whiteness. The sources—and the methodology that he brings to them—long ago led Stuckey to conclude that slaveholders' did not own the souls of black people, could not block their capacity to create, which is the highest form of self-generative activity. In fact, slaves tended the fires of artistic creation, North and South, even more certainly than they worked the crops.

[21]Weise, *Troy*, p. 64.

[22]White, "Pinkster," p. 195.

[23]*Ibid.*, p. 198.

[24]*Ibid.*, pp. 198–99.

It was said *by whom* "that the married negroes consider themselves absolved, on these occasions, from their matrimonial obligations?" And who, since the document is unsigned, said that "all restraints are flung off, and nature, depraved nature, undisguised and without a veil, on every side is exhibited?" White poses neither question; nor does he question the bizarre contention, considering documentation on Pinkster and scholarship on slavery, that hundreds of children were permitted to witness such "vice." Moreover, there is the suggestion that blacks were not alone guilty of such obscenities: Not simply "[h]ere lies a beastly black and there lies a beastly white, sleeping or wallowing in the mud or dirt," but this vague precision, "There at the foot of the hillock a company are fighting. Yonder at the mouth of a bower, a party are dancing whilst within and behind it. . . . "[25] White considers it "unfortunate" that the anonymous author is "silent on other activities and sports that occurred." Apparently he is unaware that a demagogue, charging "extortion" and insinuating possible rape, is hiding behind anonymity, determined that whites put an end to the festival:

> When these days of fun are ended, King Charles, with his attendants, descend from the Hill, patrol the principal streets, calling at one door after another, and demanding tribute, which demand he enforces by such a horrid noise and frightful grimaces, that you are glad to bestow something to get rid of him, especially if you have a delicate wife or timid children.[26]

It hardly matters to White that King Charley was supposedly well over eighty by that time. It is preposterous on its face, therefore, to argue that he could have behaved in such a manner or have been regarded with such fear.[27]

Despite its subhuman characterization of slaves, this chief document, White argues, "provides evidence of their cultural adaptability and inventiveness. . . . " One wonders what such terms mean to him. Still, ploughing ahead, he argues that slaves created "something new from the detritus of the original Dutch settlement of the area." With that, one wonders anew what his terms mean to him. Other than irrational behavior, is any other the focus of attention in the document? Indeed, the following instance of such behavior is introduced without a hint of doubt about its veracity: We are told that the Pinkster king demanded a levy of two shillings "upon every tent occupied by a white man. . . . and if any individual refuse[d] to comply, his tent, by the direction of the king, [was] instantly demolished." One wonders who obeyed—to say nothing

[25]*Ibid.*, p. 199.

[26]*Ibid.*

[27]In fact, King Charley was said to have lived to be one hundred and twenty-five years of age by the time of his death in 1823, which means, according to that age—and it is not challenged in the sources—that he would have been over one hundred when threatening to rape some slaveholder's wife. Allowing for almost certain exaggeration with respect to his great age, I have taken off twenty years, estimating that he was probably closer to eighty-five than one hundred five years of age in 1803. See Munsell, *Collections*, p. 56.

of who gave—such a "directive" since no American slave in his or her right mind would have.[28]

There is question as to whether the document even concerns Albany, but this was not a matter of concern to White, who introduces it and a covering note to the *Centinel* by one "A. B." that contains this: "The narration appears to have an allusion to this city. . . . " Most disturbing of all to scholars is the topic sentence of the note to the *Centinel*: "The enclosed manuscript was found a few days since in one of the streets of the city."[29] Thus, an entire case is built on a "document" that was picked up off the streets. As if to support his approach to slavery, White refers us to writing on "slave culture" that but deepens one's concerns about his sources.[30]

A resident of Albany, Absalom Aimwell, Esq., presented a different view of Pinkster, possibly in response to the document just discussed, in "PINKSTER ODE, ALBANY, 1803." The Ode was "Most Respectfully Dedicated To CAROLUS AFRICANUS, REX: Thus Rendered in English: KING CHARLES, Captain-General and Commander in Chief of

[28]White, "Pinkster," pp. 194, 195, 198. Though no other Pinkster document asserts that Charley had authority over whites, White does not mention this. In fact, documents that mention considerable difficulties that led authorities to end Pinkster in Albany never go nearly as far as the anonymous one, but White does not tell us this. For example, Furman writes: "His [Charley's] will *was law among all the negroes*, and if there was any dispute, as would frequently be the case in so large an assemblage for such people kept together for so long a period, he had only to decide, and the matter was settled, and his fiat, whatever it might be, was quietly submitted to" (emphasis mine). Furman, "Long Island," pp. 268–69. Also, see Alice Morse Earle, *Colonial Days in Old New York* (New York, 1897), pp. 198–99, for a discussion of the "Toto Dance" that stops short of what White presents as fact.

[29]White, "Pinkster," p. 195.

[30]Sadly, he refers the reader to work of Peter Kolchin, whose grasp of such matters is virtually nonexistent. Kolchin's clichéd attempt to treat cultural matters is found in *Unfree Labor* (Cambridge, Massachusetts, 1987). While there are references to "good-intentioned" and "high-minded" and "benevolent" and "humanitarian" and "well-disposed" masters, consider his estimate of slave character in the folk tale: "Unlike the folklore of many other peoples, slave tales contain few depictions of courageous or noble behavior; there are no dragon slayers, giant killers, or defenders of the people, in short no heroes." Such extremes of stereotyping are exposed in the "Brer Gilyard" cycle. "That big old dragon would do in Brer Rabbit for sure," Brer Fox says in one Gilyard tale in which Brer Rabbit characteristically defends "the people": "And pretty soon Brer Gilyard fell over and stretched out, stiff dead from the snake's poison. Brer Rabbit had won the battle for the freedom of his children and his friends. . . . [H]e went to Brer Gilyard, took the keys from around his waist, and unlocked the doors of all the cages. Then he counted his children to make sure they were all there. And the other little creatures thanked Brer Rabbit for saving their lives." An hour or so later, "Brer Rabbit rocked back and forth in his chair on his piazza in front of the big gum tree, and he thought and he thought. 'I've got it. I've got it, Brer Groundhog,' he said at last. 'We'll go down to Brer Gilyard's cave and bring out his gold and diamonds and give it to the poor creatures.'" There are no nobler or more heroic tales in the history of folklore anywhere than Brer Rabbit tales, in which dance and music are often prominent. Indeed, he uses dance and music—he was the supreme master of both forms—to conquer the enemies of freedom. Therefore, to ignore dance and music in slave

the Pinkster Boys."[31] It is a remarkable tribute to a black person from a white American, one that casts new light on King Charley and his followers. Aimwell is a "contemporary" with a grasp of subtleties of African musicianship. His emphasis on the strumming, percussive approach to playing the banjo at Pinkster, his insistence that we be attentive to its sound—

> Now hark! the Banjo, rub a dub,
> Like a washer-woman's tub;

resonates remarkably with this reference from Furman to its sound:

> The music which usually accompanied this dance was the "banjo drum," formed of a hollow log, with a skin of parchment . . . on which they beat with a stick, making a rough, discordant sound.

Focusing on the king, the "Ode" continues:

> All beneath the shady tree
> There they hold the jubilee.
> Charles, the king, will then advance,
> Leading on the Guinea dance,
> Moving o'er the flowerey green,
> You'll know him by his graceful mien;
> You'll know him on the dancing ground,
> For where he is folks gather round;
>
> And when You know him, then you'll see
> A slave whose soul was always free.
> Look till the visual nerves do pain,
> You'll never see his like again.[32]

Dr. James Eights had fond memories of days on Pinkster Hill. "Under the careful guidance of a trusty slave," he writes of his youth, "forth we were ushered into the den-sley thronged streets, and never shall I forget the scene of gayety and merriment that there prevailed—joyous groups of children, all under the protecting care of some favorite old dame or damsel. . . . "[33] Unlike the bulk of Pinkster documentation, there is no

tales is an engregious error. But Kolchin has little or no conception of the relation of the tale to dance or song or sacred rites. See William John Faulkner, *The Days When the Animals Talked* (Chicago, 1977), pp. 72–178. For an additional response to the view that Brer Rabbit was not a moral being, see Joshua Leslie and Sterling Stuckey, "The Death of Benito Cereno: A Reading of Herman Melville on Slavery," *Journal of Negro History* (Winter 1982), pp. 295–96. Noreece Jones, in his wise insistence that we not forget first principles, reminds us that slavery was, after all, slavery. Moreover, he demonstrates the moral bankruptcy of the master class more effectively than any recent student of the subject. See Noreece Jones, *Born a Child of Freedom, Yet a Slave* (Middletown, Connecticut, 1990).

[31] Absalom Aimwell, "Pinkster Ode, Albany, 1803," p. 31.

[32] *Ibid.*, pp. 33–34; Furman, "Long Island," p. 268.

[33] Eights, "Pinkster Festivities," p. 324.

hint of prejudice in his account. To the children, black and white, King Charley does appear to have been a kind of king, and Pinkster for them a time of happiness.

Eileen Southern believes Eights visited the Pinkster grounds at Albany sometime during the mid-eighteenth century, when the festival was said to have been flourishing, and he placed African "leadership," leadership that he admired as much as Aimwell, at the center of his discussion.[34] While it is true that a variety of forms of entertainment—athletic events and other games and circus performances involving fiery hoops, tigers and lions, clowns, and the like—were available, blacks captured and held the attention of those in attendance, which was not unusual during holiday celebrations in New York and elsewhere in the North in colonial and antebellum days. Eights writes of African dance:

> The dance had its peculiarities, as well as everything else connected with this august celebration. It consisted chiefly of couples joining in the performances at varying times, and continuing it with their utmost energy until extreme fatigue or weariness compelled them to retire and give space to a less exhausted set; and in this successive manner was the excitement kept up with unabated vigor, until the shades of night began to fall slowly over the land, and at length deepen into the solemn gloom of midnight.[35]

African music on that occasion was likewise "singular in the extreme," and not just because the instrument on which it was played was African. Rather, the style of playing the instrument, the style of singing, and the cry on that occasion were African:

> The principal instrument selected to furnish this important portion of the ceremony was a symmetrically formed wooden article usually denominated an *eel-pot*, with a cleanly dressed sheep skin drawn tightly over its wide and open extremity. . . . Astride this rude utensil sat Jackey Quackenboss, then in his prime of life and well known energy, beating lustily with his naked hands upon its loud sounding head, successively repeating the ever wild, though euphonic cry of *Hi-a bomba, bomba, bomba*, in full harmony with the thumping sounds. These vocal sounds were readily taken up and as oft repeated by the female portion of the spectators not otherwise engaged in the exercises of the scene, and accompanied by the beating of time with their ungloved hands, in strict accordance with the eel-pot melody.[36]

In African fashion that remains a feature of black performance style in America, the slave "audience" was part of the performance, its rhythmic clapping while singing simultaneously propelling dancers, replenished from that "audience," throughout the performance.

This activity took place in a large area in which the Pinkster king had been present, according to Eights, "slowly moving before us and approaching the centre of the ring." But Eights's attention was for a while

[34]Eileen Southern, ed., *Readings in Black American Music* (New York, 1971), p. 41.
[35]Munsell, *Collections*, p. 326.
[36]*Ibid.*

focused on the dancers, the tempo having greatly quickened, the dancers dancing furiously and swiftly, "the manifold stimulating potions, they from time to time imbibed, vibrated along their brains," adding "a strengthening influence to all their nerves and muscular powers. . . ."[37] As was common in the South when slaves worked in the fields while singing, sweat ran down from the dancers to darken the dust at their feet. Such was the vigor of movement, according to Eights, that "the eye at length, becoming weary in gazing on this wild and intricate maze, would oftimes turn and seek relief by searching for the king, amid the dingy mass. . . . " And he was found "moving along with all the simple grace and elastic action of his youthful days, now with a partner here, and then with another there. . . ."[38] In the center of the ring, the king was dancing, a pattern not unknown to Africans. The dance, as described by Eights, does not appear to have been the Ring Shout, the sacred dance so prominent in the South and by no means unknown in the North during and following slavery. That couples participated within the circle at Pinkster rules out the Shout but not the religious quality of such dance with partners in this country and abroad.

There is remarkable correspondence between Eights's description of maze-like dancing within a circle at Pinkster and dance on the plantations of the South. According to Constance Rourke, that superb student of black culture, "The climax of the minstrel performance, the walk-around, with its competitive dancing in the mazes of a circle, was clearly patterned on Negro dances in the compounds of the great plantations, which in turn went back to the communal dancing of the African."[39] Remarkably again, Rourke provides evidence that suggests a connection among Pinkster, ring dance, and the South: "The ancestry was hardly remote. Many who heard the minstrels in the Gulf States or along the lower Mississippi must have remembered those great holidays in New Orleans early in the nineteenth century when hundreds of Negroes followed through the streets a king chosen for his youth, strength, and blackness."[40]

Ring dance with a partner was also in evidence in the Caribbean in the nineteenth century. Monica Schuler, in her fine study of the Kongo people in Jamaica, at one point turns to the Yoruba and describes a ring dance that bears an obvious relationship to Pinkster dance formations and practices: "The Yoruba have a 'country dance'—Etu, or the Nago dance—which appears today to be primarily a social dance although references in Etu songs to deities such as Shango and Agaga indicate a former religious function." According to Schuler, dancing was done in a circle, "everyone to their partner. . . . Everyone taking turns dancing in the center of the ring." Now regarded as mainly a social dance, it was

[37]*Ibid.*
[38]*Ibid.*
[39]Constance Rourke, *American Humor* (Tallahassee, 1986), p. 88.
[40]*Ibid.*, pp. 88–89.

considered religious then, a not uncommon phenomenon for African dance, and it is likely that social dances were mixed with sacred ones within the ring at Pinkster.[41]

In an extraordinary passage that supports Eights, Rourke, and Schuler on dance, circularity, and Africa, Aimwell writes of the Pinkster king dancing in the center of a *revolving* circle:

> And now they move around the ring,
> To see again the jovial king.
> Charles rejoices at the sight
> And dances, bowing most polite.[42]

This revolving circle was but one of many in northern slavery, not in New York alone but especially in Pennsylvania, both of which, as we know, drew heavily from the shipments of African imports brought into New Jersey in the 1760s. And we know that New Jersey slaves were competitors in dance contests that included ring dance. Moreover, the revolving circle at Pinkster with the Pinkster king in the center not only relates to slave dance in Jamaica but to Temne- and Mende-influenced ring dance this century in Georgia. The presence of that distinctive pattern at widely varying times and places suggests common influences or places of origin or, in some instances, both.

Munsell, in whose *Collections on the History of Albany* the Eights document is found, writes that the dances "were the original Congo dances as danced in their native Africa," a clear statement that more than one dance was done by the blacks on Pinkster Hill and persuasive evidence of the importance of circularity in dance at Pinkster. There is, however, no reason to assume that all the dances were Congo dances. African peoples shared too many dance characteristics across ethnic lines for there to have been one form of dance to the exclusion of all others, and very few, if any, dance formations would have been frozen in time, the impulse to improvisation alone opening the way to ethnic intermingling of dance movement.[43]

Since Pinkster was but formally considered religious by whites, it provided the occasion for religious expression by blacks when it was not likely to be understood as such by whites, in part because there is room for spiritual recreation in African religion.[44] Moreover, there is no indi-

[41]Monica Schuler, *Alas, Alas, Kongo* (Baltimore, 1980), p. 83.

[42]Aimwell, "Ode," p. 42.

[43]Munsell, *Collections*, p. 56. Indeed, the impulse to improvisation, an engine of creativity, opened the way for African appropriation of European forms as well, the degree of imagination employed determining if in some instances those forms were Africanized, enabling Africans to be more at home with them.

[44]W. E. B. Du Bois, in a discussion of the constraints on slave social life and the response engendered, provides brilliant insight into the sources of the resulting spiritual latitude insisted upon by slaves. His remark that "one can see in the Negro church to-day, reproduced in microcosm, all the great world from which the Negro is cut off by color prejudice and social condition" is greatly illuminating and perceptive. In the black church

cation that anyone at Pinkster other than the blacks chose the dances danced or the songs sung, which argues that dance and song and drum rhythms were at times sacred, for the sacred was the dominant mode of African artistic expression. Fortunately, there is direct testimony from blacks with respect to Pinkster and religion. Quoting ex-slave John J. Williams and commenting on Pinkster at Albany, Howell and Tenney, write:

> Mr. Williams says, "Pinkster Day" was in Africa a religious day, partly pagan and partly Christian, like our Christmas day. Many of the old colored people, then in Albany, would dance their wild dances and sing in their native languages.[45]

The ex-slave was so convinced that Pinkster was African that he assumed it originated in Africa, but what is more important is the reference to the religious nature of the celebration. His somewhat suspect reference to Christianity in Africa should not be dismissed out of hand, for the African religious attitude is essentially synthetic, marked by a willingness to absorb that which is valuable in other faiths.

For a good period of time in New York State, African languages were spoken and sung in the presence of whites, apparently without great protest from them. Moreover, slaves continued to make African drums from materials not unlike those used for that purpose in various parts of Africa. Munsell supports Dr. Eights in regarding the Pinkster drum being African aesthetically, recalling that "As a general thing, the music consisted of a kind of drum, or instrument constructed out of a box with sheepskin heads. . . . "[46] The use of so important a material object to lay the foundation for dance in the presence of their "king" was a reminder of an irretrievable past for some Africans and a source of pain, despite the holiday mood, not simply for those who were born in Africa.

In perhaps the most precise reference to dance steps during Pinkster at Albany, Munsell writes that King Charley "generally led off the dance, when the Sambos and Philises, juvenile and antiquated, would put in the double-shuffle heel-and-toe breakdown."[47] The emphasis on shuffling movement, so characteristic of much of African dance, is an indication of the signature quality of what was observed in dance. And one notes in that passage that age was hardly a factor in determining who danced, the very young and very old joining in, in the process perpetuating the

was found the music, the preacher, and, what Du Bois calls, the "frenzy," and those combined form the heart of what is here referred to as spiritual recreation, for with the frenzy comes sacred dance. See W. E. B. Du Bois, *The Souls of Black Folk* (New York, 1969), pp. 214–16. Originally published in 1903.

[45]Howell and Tenney, *BI-Centennial History of Albany* (New York, 1886), p. 725.
[46]Munsell, *Collections*, p. 56.
[47]*Ibid.*

form—a pattern repeated elsewhere in the North and especially in the South among slaves.[48]

The dance movement described was also performed in New York City during Pinkster celebrations, especially in the opening decades of the nineteenth century. The elements of the movement seemed to involve, at a rudimentary but fundamental stage of development, something of the quality of what would later be called tap and appears, considering the description of the heel-and-toe movements, to be similar to what one finds in the movement of the feet during the shuffling motions of the Ring Shout.

There is reason to believe that, in the degree of emphasis given to improvisation and in the freedom with which dance steps were done, dance in New York's Catherine Market was probably not that different from dance in Albany or Troy. In the Catherine Market, Africans more easily appropriated some European forms and danced them alongside African dances, sometimes on request and for payment.[49] Competitive dance there accentuated individual expression and spurred experimentation with particular forms. Individuals rather than groups held sway, competing for money from white observers. But individual dancers had entourages of sorts and, much like artisans who carry their tools, carried with them special dance boards designed for high levels of inventive artistry. The practice of experimenting with dance through friendly exchanges of ideas—later fundamental to jazz—was the creative base on which such experimentation rested. A premium was placed on intricacy of movement when dancers in the market danced on a "board . . . or shingle, as they called it," that was "large in width" and from "five to six feet long," the object being not to fall off the shingle. A slave was at each end, holding down the shingle, as dance occurred. Such dance was prominent in New York City by the opening decade of the 1800s.[50]

In a sense, the competition extended far beyond individuals to encompass communities of slaves. There was strong representation of Long Island slaves who were not only competitive economically but also artistically. They came to the market with their shingles and assistants-at-dance. New Jersey slaves also danced in the market, as did, in time, those from New York City, who eventually were said perhaps to have been dominant. There was, whether one lived in New York City or

[48]Slave girls and women played particularly important roles in preserving and perpetuating the Ring Shout on the plantations of the South, and it should go without saying that the larger ratio of women to men in the North meant that their influence was certainly no less great there. See Stuckey, *Slave Culture*, Chapter I, for a discussion of the role of slave women in perpetuating African dance in America.

[49]A powerful African tradition in dance existed in New York City and owed much to the influence of Pinkster, which continued throughout the antebellum period. There was, with the increase in Irish immigrants in the city, increasing contact between them and blacks, both living in the Five Points district.

[50]Thomas F. De Voe, *The Market Book* (New York, 1969), p. 344. Originally published in 1862.

elsewhere, a great deal to talk about before and following Pinkster and much preparation through practicing when Pinkster was months away. When back on Long Island, it was a favorite pastime of slaves to dance on shingles on barn floors.

The holiday mood could be the occasion for dancing a breakdown or a European dance in circumstances in which the quality of the audience, while not hostile, was less than ideal: "So they would be hired by some joking butcher or individual to engage in a jig or breakdown. . . . "[51] At such times, slaves might dance the jig of the Irish or one of their own dances—which were often grouped together by whites under that nomenclature—but to their own sense of rhythm, usually to the sounds of "Juba."

When slaves danced the "Juba" in the market, and we can assume they did since they relied on its rhythms for percussive effects for other dances, once more the circle was formed. When entering it to "Juba" rhythms, regional differences in style were at times evident, but these differences, as with dance, were less significant than points of similarity. For instance, "New Jersey negroes . . . were known for their plaited forelocks tied up with tea-lead," a hairstyle that is associated with Senegalese young men. "The Long Islanders usually tied theirs up in a cue, with dried eel-skin. . . . " Tying of the hair—in more recent times it is done with a string—is a centuries-old tradition in West Africa.[52]

In any case, those in the center of the circle and those forming it provided a richly African tableau. Thomas Talley describes "two dancers in a circle of men" with the following lines being patted:

> Juba circle, raise de latch
> Juba dance dat Long Dog Scratch
> Juba! Juba![53]

Though that description of the "Juba" was based on its performance in the South, it was an African dance formation—one possibly named after Juba, the city in the Sudan—and rhythmic pattern, though drums were not used to get the percussive effects. While there might have been some slight differences in dance steps and even the number of slaves in and within the circle, for there were variations of this kind in specific regions, indeed on the same plantation when the Ring Shout was done, the dance itself would have been recognized as the "Juba," the means defining it as such.

According to Fredrick Douglass, slaves in Maryland explored the theme of injustice to "Juba" rhythms, and there is no reason to believe

[51]*Ibid.*, p. 344.

[52]Joshua Leslie, who taught in Nigeria and traveled widely during his eight years in West Africa, was consulted regarding the hairstyles of African men. Conversation with Joshua Leslie, winter 1993.

[53]Stearns, Marshall and Jean, *Jazz Dance* (New York, 1964), p. 28.

New York slaves were less capable of doing so, masking their critiques behind equally intricate percussive and verbal interplay. Some might have, as in Maryland, raised questions about, or even cursed, whites to the rhythms of "Juba": "Their music or time was usually given by one of their party, which was done by beating their hands on the sides of the legs and the noise of the heels."[54] There is irony here of another sort, for New York slaves, as they danced "Juba," were aware of how much northern whites, for whatever emotional and psychological reasons, depended on their dance as well as their labor.

That the majority of slaves in the New York market were not supplicants seeking gifts from whites meant that there was an interesting conjunction of slave labor and art on Pinkster holidays. To some extent, slave initiative in the economic sphere was comparable to their artistic initiatives. In fact, there is reason to believe that money received for dance performances was not their primary source of income in the market place on holidays. De Voe writes:

> The first introduction in this city of public "negro dancing" no doubt took place at this market. The negroes who visited here were principally slaves from Long Island, who had leave of their masters for certain holidays, among which "Pinkster" was the principal one; when, for "pocket money," they would gather up everything that would bring a few pence or shillings, such as roots, berries, herbs, yellow birds, fish, clams, oysters . . . and bring them with them in their skiffs to this market; then, as they had usually three days holiday, they were ever ready, by their "negro sayings or doings," to make a few shillings more.[55]

We know that slaves in colonial America and later possessed impressive knowledge of the uses to which plant life might be put; similarly, their skill at fishing is no less familiar to scholars in the field. Like dance, some work skills were self-generative, products of the work heritage of West and Central Africa. Away from, though hardly beyond reach of their masters, slaves in the market probably felt freer—though maybe sadder—at Pinkster than at other times.[56] The bittersweet was inevitable, and slaves used dance to give form to feeling and reflection. Moreover, from the earliest "public" dance in slavery the inner gaze of the dancer entered realms hardly conceived of by white onlookers. The "unspoken" of later performances found expression in African languages at Pinkster and other festivals in the North, for to have expressed disaffection in English would have provoked violent reprisals. African languages, much

[54]Douglass, Frederick, *The Life and Times of Frederick Douglass* (1881; rpt. New York, 1967), p. 146.

[55]De Voe, *Market Book*, p. 344.

[56]The most distinguished work on slave work skills has been done by Peter Wood for South Carolina slaves whose skills were mainly brought from Africa, as were those of many slaves in the North. See Peter Wood, *Black Majority* (New York, 1974), Chapters I–V.

heard in New York prior to the nineteenth century, insulated slaves from reprisals for expressions of protest in song, tale, and conversation.[57]

Respect for slave performances mingled with a certain contempt was a necessary corollary of slavery no matter how gifted the slave. After all, the chains of bondage were not stricken from the slave by virtue of his or her talent; nor the culture of the slave, if acknowledged at all, regarded by most whites as being on a par with theirs. This was the case though the master class was notoriously inept in the arts. Individual whites, however, especially close observers of slave festivals from youth, characteristically marveled at slave ceremonies during Pinkster and at other times.

In fact, it is difficult to distinguish between dance at Pinkster and dances generally done by blacks, and there should be no effort to do so, for it is unthinkable that the better dancers, slave and free, did not come together whenever it was possible to do so. Free blacks, who were usually present at Pinkster celebrations, emerged as major dancers, after emancipation in New York, especially by the 1840s, a period that coincided with the rise of white minstrels mimicking great black dancers and singers. At times, there was competition between the leading black dancer in New York City, William Henry Lane, and John Diamond, a white dancer described as one of "the greatest jig dancers that the world ever knew."[58] There is general agreement that it must have been Lane that Charles Dickens saw in the Five Points district of the city. Dickens wrote:

> Single shuffle, double shuffle, cut and cross-cut; snapping his fingers, rolling his eyes, turning in his knees, presenting the backs of his legs in front, spinning about on his toes and heels like nothing but the man's fingers on the tamborine; dancing with two left legs, two right legs, two wooden legs, two wire legs, two spring legs, — all sorts of legs and no legs — what is this to him?[59]

Crediting the influence of the Irish jig, Marshall and Jean Stearns add that the presence of the single and double shuffle indicates black elements, that "comparison of Lane's dancing to fingers on a tamborine . . . furnishes the best clue to what made the performance outstanding: rhythm."[60]

[57]I have discussed African languages in New England and Pennsylvania in *Slave Culture*, pp. 22, 80. There is further discussion of African languages later in this essay.

[58]Stearns, *Jazz Dance*, p. 46.

[59]*Ibid.*

[60]*Ibid.* The findings in this essay with respect to African culture in this country make the more persuasive Robeson's seemingly bold reflections on the relation between African and black American culture; he has written: "What links the American Negro to this culture? It would take a psycho-anthropologist to give it a name; but its nature is obvious to any earnest inquirer. . . . His peculiar sense of rhythm alone would stamp him indelibly as African." "I Want To Be African," in *Paul Robeson, Selected Writings* (New York, 1976), p. 56. This essay was originally published in 1935 in E. G. Cousins, ed., *What I*

Lane began dancing early, in Rhode Island, his place of birth, and brought to New York considerable knowledge of dance in New England, where there was a tradition of African dance as strong as that in New York, its Election Day ceremony serving much the same function for blacks there that Pinkster served for New York blacks. It is almost certain that Lane drew on both traditions, adding important influences from the Irish. But what made his dancing so special? still others asked. And the answer given by a British critic was not different from that of the Stearnses': "the manner in which he beats with his feet."[61]

Lane may well have been a bridge, at least in the North, between slave dance and tap, dancers on shingles helping with the initial breakthrough. But as great as he was, there were dancers in the slave community in the South at the time he rose to fame, and in the North decades before, who were at least as good if not better. Though Munsell never saw Lane perform, in the 1840s he did see Diamond, who for a while was said to have bested Lane. Munsell's words, this time in full context, enable us to more fully appreciate the quality of African dance during Pinkster and the indebtedness of subsequent generations of dancers who imitated African steps: "Charley generally led off the dance, when the Sambos and Philises, juvenile and antiquated, would put in a double-shuffle heel-and-toe breakdown, in a manner that would have put Master Diamond and other *cork*-onions somewhat in the *shade*."[62]

A brilliant re-creation of Pinkster is found in James Fennimore Cooper's *Satanstoe*, a historical novel in which considerable attention is given to the festival. *Satanstoe* contains a representation of the festival that is remarkable for the degree to which a number of its elements correspond to those set forth by Bakhtin. In the process, Cooper reveals understanding of African culture as a transforming force internally and in relation to the larger society. Indeed, African performance with respect to dance reinforces Munsell's position regarding the sophistication of slave dancers at Pinkster.

Based on his knowledge of the early history of New York, Cooper places Pinkster activities in *Satanstoe* in 1757, some two decades before the American Revolution, a time when it was not easy for whites, to say nothing of blacks, to think of themselves as Americans. But it should be noted, when considering Cooper's account of Pinkster, that in certain sections of New York the celebration lasted decades following its being outlawed in Albany. "To the Negroes," according to Olson, "it continued to be their greatest festival until the Civil War period," which raises the possibility that Cooper visited Pinkster grounds well after the sup-

Want from Life (London, 1934). Reference to boxing appears, for example, in Eights, "Pinkster Festivities," p. 326.

[61]Charles Dickens, *American Notes* (Baltimore, 1972), p. 139. Originally published in 1842.

[62]Munsell, *Collections*, p. 56.

pression of the festival in Albany in 1811.[63] We know that New York
City and the surrounding area harbored Pinkster, and we know that
African-born blacks were seen in the hundreds in the city as late as the
1820s, at times participating in all-black parades down Broadway. With
so much African activity, Pinkster and otherwise, taking place in New
York in his time, Cooper was ideally situated to test his impressions
of its past nature against living cultural realities. Furthermore, there is
evidence in the sources of a closeness between blacks born in Africa and
those born in North America that makes credible his treatment of their
interaction in *Satanstoe*.[64]

Cooper reminds us of the considerable area over which Pinkster cele-
brations were held by describing, with the approach of Pinkster, the
excitement generated in the countryside. Indeed, a young man about
twenty-five miles from the city is so eager to get to Pinkster festivities
there that he forgoes breakfast to "be up with the sun, and off . . . in
order that [he] might enjoy a stroll along the wharves before it was time
to repair to the common, where the fun was to be seen." Not long
thereafter, he "saw a gray-headed negro, who was for turning a penny
before he engaged in the amusements of the day. . . . He cried 'White
wine, white wine!' in a clear, sonorous voice; and I was at his side in a
moment." Within minutes, a friend who saw him purchase wine sought
wine from the same man, from "the nigger who is now coming back
across the square. . . . "[65]

The young men met another in New York City and headed for "The
Pinkster fields . . . up near the head of Broadway, on the common."
After strolling along the wharves and admiring the vessels, the three
encountered a scene that recalls Munsell's remarks about stoops in Al-
bany, for they are said to have "passed up Wall street, on the stoops of

[63]Olson, "Social Aspects," p. 71.

[64]For closeness between slaves born in America and African-born blacks, see the discus-
sion in Stuckey, *Slave Culture*, p. 200. Important contact between the two groups—
together with Africans from the Caribbean—is demonstrated in the following excerpt
concerning Emancipation Day in New York and "glorious dreams of liberty":

> The side-walks were crowded with the wives, daughters, sisters, and mothers of the
> celebrants, representing every State in the Union, and not a few with gay bandanna
> handkerchiefs, betraying their West Indian birth; neither was Africa itself unrepre-
> sented, hundreds who had survived the middle passage, and a youth in slavery
> joined in the joyful procession. The people in those days rejoiced in their nationality
> and hesitated not to call each other "Africans" or "descendants of Africa. . . . " It
> was a proud day in the City of New York for our people, the 5th day of July, 1827.
> It was a proud day for Samuel Hardenburgh, Grand Marshall, splendidly mounted,
> as he passed through the west gate of the park, saluted the Mayor on the City Hall
> steps, and took his way down Broadway to the Battery, &c. It was a proud day for
> his Aids, in their dress and trappings . . . it was a proud day never to be forgotten
> by young lads.

Dr. James McCune Smith, introduction to *A Memorial Discourse by Reverend Henry
Highland Garnet* (Philadelphia, 1865), pp. 24–25.

[65]James Fennimore Cooper, *Satanstoe* (New York, 1845), pp. 56, 57, 58.

which, no small portion of its tenants were already seated, enjoying the sight of the negroes, as, with 'shining' faces they left the different dwellings, to hasten to the Pinkster field."[66] The attention to what blacks were doing, before even reaching Pinkster ground, signaled a departure from principles of carnival outlined by Bakhtin that would, together with others, cease to apply when the young men arrived and became spectators at the festival. Cooper provides a description of what was observed once they reached Pinkster field:

> By this time, nine-tenths of the blacks of the city, and of the whole country within thirty or forty miles, indeed, were collected in thousands in the fields, beating banjoes, singing African songs, drinking, and worst of all, laughing in a way that seemed to set their very hearts rattling within their ribs. Everything wore the aspect of good-humor, though it was good-humor in its broadest and coarsest forms. Every sort of common game was in requisition, while drinking was far from being neglected. Still, not a man was drunk. A drunken negro, indeed, is by no means a common thing. . . . Hundreds of whites were walking through the fields, amused spectators. Among these last were a great many children of the better class, who had come to look at the enjoyment of those who attended them, in their ordinary amusements. Many a sable nurse did I see that day, chaperoning her young master, or young mistress, or both together, through the various groups; demanding, and receiving from all, the respect that one of these classes was accustomed to pay to the other. A great many young ladies between the ages of fifteen and twenty were also in the field, either escorted by male companions, or, what was equally certain of producing deference, under the care of old female nurses, who belonged to the race that kept the festival.[67]

Cooper refers to a slave nurse "explaining the meaning of the different ceremonies, to a cluster of interested listeners. . . . " This is convincing, for all accounts of Pinkster festivals, whether in New York City or elsewhere, focus almost exclusively on whites observing blacks, which argues that blacks held the key to the nature of their observance of the occasion.

Since Pinkster field was large, it is not likely that dance, while dominant, was the only really interesting or, for that matter, puzzling ceremony, for there is not only the reference in Cooper to *ceremonies* being explained, apparently to whites, there is also mention of slaves born here receiving instructions about their heritage from African-born slaves. Cooper provides a fascinating description of how certain aspects of African culture, when introduced at Pinkster, were not entirely understood by other blacks. The description suggests, as do others, that "sport" at Pinkster might have ranged from esoteric physical exertion—

> A party of native Africans kept up for half an hour. The scene seemed to have revived their early associations, and they were carried away with their own representation of semi-savage sports—

[66] *Ibid.*, p. 59.
[67] *Ibid.*, pp. 60–61.

to discussions, at the urging of American-born blacks, that involved
African religious folklore and African verbal expression:

> The American-born blacks gazed at this group with intense interest also,
> regarding them as so many ambassadors from the land of their ancestors, to
> enlighten them in usages and superstitious lore, that were more peculiarly
> suited to their race. The last even endeavored to imitate the acts of the first,
> and, though the attempt was often ludicrous, it never failed on the score of
> intention and gravity.[68]

Affection and respect were accorded the Africans by American-born
blacks, who sought to be even more like them. There is no question—
recall the reference to "superstitious lore"—that African religion was a
subject of intense and respectful interest among those engaged in the
ceremony, and it behooved the Pinkster king to keep abreast of such
lore. But there was one aspect of African culture on which the king, as
Munsell reminds us in his discussion of Diamond, needed no instruction:
Cooper indicates that some blacks were "making music by beating on
skins drawn over the ends of hollow logs, while others were dancing to
it, in a manner to show that they felt infinite delight. This, in particular,
was said to be a usage of their African progenitors."[69]

We are told that "a holiday like this could not fail to draw great
crowds of persons to witness the sports. . . . every body had a desire to
get a glance at the sports of the Pinkster field. . . . " More dance, it
seems, than games of sport and, not infrequently, religious scenes that
were impenetrable to whites were prominent features of Pinkster. Be-
sides, the popularity of more conventional games of sport, had they
captured the attention of the spectators in a major way, would have
merited more than the few sentences concerning sports such as boxing
found in Pinkster documentation.[70]

In any event, the protagonist meets about twenty young officers from
England "strolling out to the scene of amusement, as [he] walked into
town." He looked at them admiringly, "and not without envy, as they
passed . . . in pairs, laughing and diverting themselves with the gro-
tesque groups of blacks that were occasionally met, coming in from their
sports." There is special irony here, since the blacks were coming in
from ceremonies that were sources of happiness for whites, yet whole
groups of them, at least for some whites, were "grotesque."[71]

While Albany was too far away for there to have been contact be-
tween slaves celebrating there and those in New York City, there is
no basis, certainly none that has been demonstrated, for suspecting a
fundamental shift in African values from one region to the other. Their
domination of the festival in both places, especially through dance and

[68]*Ibid.*, p. 65.
[69]*Ibid.*, p. 60.
[70]*Ibid.*, p. 74.
[71]*Ibid.*, pp. 73, 74.

music, suggests that the cultural similarities of blacks in both regions outweighed differences between them. Though there is no mention in Cooper of a Pinkster king for New York City, it is possible that King Charley, despite the distance between Albany and New York, may have visited the city and appeared at the celebration. What could well be as likely is that New York City had its own Pinkster king or his equivalent, slave or free, for we know that black men well into the nineteenth century, on the occasion of grand processions, were known to conduct themselves like "royalty" there.[72]

While that is a matter that merits further study, there is reason to believe, on the basis of an extraordinary recent finding, that New York City at one time had its own Pinkster king. In a recently discovered cemetery in the city, the "Negros Burial Ground," which dates back to colonial New York, a skeleton of a black "buried in a British Marine officer's coat" was found. The fact that there is no evidence in the sources of any black other than King Charley wearing such a uniform suggests that the dead man may well have been a Pinkster king.[73]

What is certain is that King Charley, presiding over the most vigorous of all Pinkster celebrations at Albany, was well aware that conviviality and mirth, on the occasion, rested in no small part on a foundation of discipline for which he, of all the blacks, was responsible. His example was one from which all benefited in the holiday season, as the "Pinkster Ode" makes clear:

> Let us with grateful hearts agree
> Not to Abuse our liberty
> Tho' lordlings proud may domineer
> And at our humble revels jeer
> Tho' torn from friends beyond the waves
> Tho' fate has doomed us to be slaves
> Yet on this day, let's taste and see
> How sweet a thing is liberty
> What tho' for freedom we may sigh
> Many long years before we die
> Yet nobly let us endure
> The ills and wrongs we cannot cure.[74]

There is no question that the festival had different meanings for slave and master. Sensitive reading in the "Pinkster Ode" is never finer than when slaves reflect on being "torn from friends beyond the waves," for holidays are well suited for polarizing pain that results from death or from other forms of separation. Moreover, the fact that a portion of Pinkster Hill was used as a cemetery for blacks was a reminder to them of ancestors and loved ones buried there. In fact, the following section

[72]I here refer to Samuel Hardenburgh, the Grand Marshall of the Emancipation Day parade discussed in footnote 64 above.
[73]*New York Times*, August 9, 1992.
[74]Aimwell, "Ode," p. 35.

of the "Ode" concerns that cemetery and builds to four of the saddest
lines in all of literature:

> Now if you take a farther round
> You'll reach the Afric's burying ground.
> There *as* I *rambled* years ago,
> To pass an hour of love-lorn woe;
> I found a stone at Dinah's grave,
> On which was carv'd the following stave.
> Here lie Dinah, Sambo wife,
> Sambo lub her like he life;
> Dinah die 'bout sik week go,
> Sambo massa tell he so.[75]

Because dance was the chief means by which African religious values
were retained—the most dramatic and powerful manifestation of African
sensibility—and the music accompanying it no more recognizable for its
religious significance, the presence of dance and music in the festival
meant more to blacks than to anyone else. More than that, neither dance
nor music was so active a part of the lives of white New Yorkers, who
often seemed riveted before African dance and music. Consequently,
when African dance, with all its rhythmic and physical intensity, entered
the Pinkster celebration, occupying the center of the field, it fundamen-
tally altered the nature of the celebration.

What is surprising is the apparent ease with which whites yielded
that field, becoming spectators. No doubt the pathway to tolerance of
and fascination with black dance was to some degree smoothed by the
presence of laughter, which tended, as Bakhtin has noted, to deflect
one's attention from the sacred: "The basis of laughter which gives form
to carnival rituals frees them completely from all religious and ecclesiasti-
cal dogmatism, from all mysticism and piety."[76] Given such a reality, the
presence of blacks dancing and singing in the Pinkster field, even at times
with religion on their minds, would have a different effect on whites
than it would have during the normal course of events when they might
have religion on theirs.

Pinkster became, in James Fennimore Cooper's words, "the great
Saturnalia of the New York blacks."[77] Considering his description of the
vitality of the blacks in the Pinkster field near Broadway, the Albany
celebrations must have been very powerful. Especially in Albany, Pink-
ster had characteristics that are common to carnivals irrespective of time
and geographical location. All accounts of the festival are in agreement
that normal life was largely set aside as the Pinkster holiday began. But
a universal principle of carnival, described by Bahktin, was not in effect:

[75]*Ibid.*, pp. 42–43.
[76]Bakhtin, *Rabelais*, p. 7.
[77]Cooper, *Satanstoe*, p. 55.

While carnival lasts, there is no other life outside it. During carnival time life is subject only to its own laws, that is, the laws of its own freedom. It has a universal spirit; it is a special condition of the entire world, of the world's revival and renewal, in which all take part. Such is the essence of carnival, vividly felt by all its participants. It was most clearly expressed and revealed in the Roman Saturnalia, perceived as a true and full, though temporary, return of Saturn's golden age upon the earth. The tradition of the Saturnalias remain unbroken and alive in the medieval carnival, which expressed this universal renewal and was vividly felt as an escape from the official way of life.[78]

How, then, was a principle thought universal in carnivals breached at Pinkster? Bakhtin tells us that "Carnival is not a spectacle seen by the people; they live it, and everyone participates because its very nature embraces all the people."[79] At Pinkster, however, whites became spectators when blacks arrived, and then the celebrations took on the character that is focused on in the documentation. Moreover, life is never so happy, at Pinkster or any other holiday festival. On such occasions, dark clouds inevitably streak the skies of consciousness.

Bakhtin does not treat the confluence of traditions, in this case of African and European, precisely the subject considered by Cooper: "The features that distinguish a Pinkster frolic from the usual scenes at fairs, and other merry-makings, however, were of African origin."[80] In a passage that anticipates André Malraux's conception of the flow of African tradition in America, Cooper writes that, as late as the 1840s, there were not "many blacks among us of African birth" but notes that "the traditions and usages of their original country were so far preserved to produce a marked difference between this festival [Pinkster] and one of European origin."[81]

Alice Morse Earle, summing up much of the literature on the subject, is in agreement:

> The week following Whitsunday has been observed with great humor and rejoicing in many lands, but in none more curiously, more riotously, than in Old New York, and to some extent in Pennsylvania and Maryland; and, more strangely still by an alien, a heathen race, — the negroes. . . . Nowhere was it a more glorious festival than at Albany, among the sheltered, and the cherished slave population in that town and vicinity.[82]

[78]Bakhtin, *Rabelais*, pp. 7–8.
[79]*Ibid.*, p. 7.
[80]Cooper, *Satanstoe*, p. 60.
[81]*Ibid.*
[82]Earle, *Old New York*, p. 196. Earle argues that Pinkster in Maryland and Pennsylvania were dominated by slaves, an intriguing point of view that surely is worthy of further research. The Pennsylvania reference is especially intriguing, for we know of large numbers of slaves, at the beginning of the nineteenth century, gathering annually in Philadelphia to dance and sing during fairs: "In that field could be seen at once more than a thousand of

According to Earle, when the Common Council of Albany, in 1811, "prohibited the erection of booths and all dancing, gaming, and drinking at that time; and when the negroes could not dance nor drink, it was but a sorry holiday, and quickly fell into desuetude."[83] But dance does not end anymore than it begins with festivals, and Albany, as brilliantly as it kept the festival, held no monopoly on it in time and space. Moreover, the boundaries that enclosed Pinkster hardly marked the limits of slave dance. Slaves brought dance to the festival and took it with them when they departed.

both sexes, divided into numerous little squads, dancing, and singing, 'each in their own tongue,' after the customs of their several nations in Africa." John Fanning Watson, *Annals of Philadelphia* (Philadelphia, 1850), p. 265. African traditions were at least as strong in Pennsylvania as in New York, and no doubt easily as strong in Maryland. For consideration of African artistic and work skills in Maryland, see Sterling Stuckey, "Ironic Tenacity: Frederick Douglass' Seizure of the Dialectic," in Eric Sundquist, ed., *Frederick Douglass: New Literary and Historical Essay* (New York, 1990), pp. 23–46. There is a real need to investigate Earle's suggestion regarding the existence of Pinkster in Pennsylvania and Maryland.

[83]Earle, *Old New York*, p. 196. Labor and cultural historian David Roediger argues convincingly, with strong implications for Pinkster at Albany, that "Racially mixed Black-led entertainments provoked the special wrath of the agents of the new industrial morality, who especially disliked the mixing of Blacks and working class whites." See David Roediger, *The Wages of Whiteness* (London, 1991), p. 102.

PART II
CLASSICAL BLACK NATIONALISM

The essays on classical black nationalism, while complementing those on slavery, reappear at an important time, for no aspect of the history of black people in America is being more greatly misrepresented than the deep humanism of antebellum nationalist theorists. W. E. B. Du Bois and Carter G. Woodson, who helped extend the humanism of classical black nationalism into this century, are the subjects of the last essay in this section.

Classical Black Nationalist Thought

The precise details of certain experiences that bear directly on black nationalism will remain forever enshrouded in obscurity—the degree to which Africans during the seventeenth and eighteenth centuries continued to think positively of their ancestral home; the extent to which they preferred living apart from white people; the length of time the majority of them remained essentially African in America; and the exact nature of Pan-African acculturation, the process by which differences between Africans from various parts of Africa, the West Indies, and North America were virtually destroyed on the anvil of American slavery.[1] But we *do* know something of the broad contours of these developments, and that is more than sufficient to suggest that many of the ingredients of black nationalism, together with the conditions necessary for their perpetuation, were very much in evidence by the time the forces of slavery were becoming, as the third decade of the nineteenth century opened, more entrenched than ever.

The effort to consolidate and deepen the slave system, a movement which made great strides in the three decades before the outbreak of the Civil War, suggests that the desire for autonomy among a significant number of blacks, surely as old as the 1600s, may well have crystallized into ideology some years before the crucial decade of the 1850s, some time before the violent—but edifying—clash of arms. The evidence in this essay supports that hypothesis, for it indicates that black nationalist

[1]The most brilliant clues to more precise answers to these questions can be found in the books of Du Bois and in the essays of Paul Robeson. Both men, but Robeson especially, derive their sense of the African American's "nationality" every bit as much from an internal as from an external exploration of his condition in America, demonstrating that despite the tremendous blows taken by the African in America the essential ingredients of a black nationalism have been, though largely unrecognized, present all along. The author wants to suggest at this point that the originators of the ideology that we refer to as black nationalism emphasized the need for black people to rely primarily on themselves in vital areas of life—economic, political, religious, and intellectual—in order to effect their liberation. As formulated by African American ideologists of the 1830s—and later by "Sidney" in the 1840s—this attitude probably owed more to African traditions of group hegemony (which persisted in some forms during slavery) than to any models from European thought or experience. The tendency, for example, for the earliest ideological nationalists to leap beyond the limits of the African American to embrace the totality of African humanity indicates their almost elemental, instinctual recoil from the constraints of a narrow nationalism—a development made possible by the strange detribalizing process which enabled

ideology, contrary to the view advanced in certain quarters, developed at least two decades before Martin Delany became nationally known for his advocacy of black hegemony. It is appropriate that some of the forces which made possible that flowering of black nationalist thought at least be tentatively proposed.

I

There is some evidence that the American Revolution and the Haitian Revolt not only contributed to an intensification of the desire among many "free" and slave blacks for liberation but awakened in some the desire for unity in their ranks and control over their own destinies, for *independence* from an oppressive, racist society. Surely such impulses were, in varying degrees, presupposed in the actions of Paul Cuffee the emigrationist, Richard Allen the Church Father, and in the activities of the Africans involved in the founding of mutual aid and benefit organizations which sprang into being, interestingly, at the time America was in the process of becoming a nation.

The parallel between the growth of the American nation and the development of African American infrastructures is not meant to be drawn too sharply. But considering the position of oppressed blacks and the ambiguity of the major documents used by white settlers to rationalize rebellion and to begin their nation, it is small wonder that a certain tension, with creative potential for the promotion of nationalist sentiments, was set up in the minds of some blacks. It was obvious to black leaders that their people were not meaningfully included in the new nation, particularly since the great majority of them were still slaves. Despite the fact that the Declaration of Independence (and the Constitution) in some ways helped to promote the countervailing value of freedom, the freedom at issue was freedom for whites. Therein, but certainly

black people for the first time in their history to think of the oneness of African peoples and to perceive practically the whole of the African continent as a single entity.

I have deliberately avoided the various categories of black nationalism which have been coined in our time — cultural nationalism, revolutionary nationalism, religious nationalism, and so on. I have done so with respect to revolutionary nationalism because in antebellum America almost any form of advocacy of black control was revolutionary. While I attribute very great importance to the cultural dimension, I avoid the term cultural nationalism precisely because the nationalists included in this volume stopped short of an ideology of cultural nationalism (which in fact did not come in America until the emergence of W. E. B. Du Bois at the turn of the century). Had a nationalist of antebellum America realized the enormous importance of black culture and been cognizant of its radical opposition to the culture of the larger society, that awareness, articulated into theory, would have been as revolutionary a development as calling for a massive slave uprising. For evidence of the historical lineaments of black nationalism, see W. E. B. Du Bois, *Dusk of Dawn* (New York, 1940), and Sterling Stuckey, "The Cultural Philosophy of Paul Robeson," *Freedomways*, Vol. 11, No. 1 (1971).

not exclusively, lay the seedground for black nationalist organizations and sentiment. And it was precisely in such ironic soil that an ideology of black nationalism eventually took root.

What was implicit, uncertain for the founders of the African organizations during the period from roughly the 1780s to the second decade of the nineteenth century had by 1813 become pronounced and sure for certain slaves on an island off the coast of South Carolina, men who sang of *independence* and freedom and referred to themselves as Africans. Considering the fact that South Carolina continued to receive imports of slaves, many directly from Africa, after the abolition of the slave trade in 1808, and bearing in mind the relative isolation of the islands off the coast of Charleston, the slaves who sang their Hymn of Freedom must surely have been in many ways much more African than the great majority of blacks in other parts of the country. As their song makes clear, they were at least as nationalistic as the men who made the American "Revolution." Moreover, their spirits had not been broken and their concern for their women and children was apparently undiminished by the slave experience:

> Look to Heaven with manly trust
> And swear by Him that's always just
> That no white foe with impious hand
> (Repeat)
> Shall slave your wives and daughters more
> or rob them of their virtue dear.
> Be armed with valor firm and true,
> Their hopes are fixed on Heaven and you
> That truth and justice will prevail
> And every scheme of bondage fail.[2]

A few years later, the nationalist or separatist thrust of the Hymn of Freedom was expressed in a broader, more concrete way in the city of Charleston when "free" and slave black Methodists broke from the white Methodist church and established a branch of the African Methodist Episcopal Church. Denmark Vesey, the leader of the slave conspiracy at Charleston in 1822, had been a participant in the separatist church movement. His conspiracy, on a number of levels, contained elements of black nationalism: He compared the slaves to the Israelites, which suggests that he perceived them as a separate people under white American oppression; he used the Haitian Revolution, the supreme antebellum example of black nationalism, to encourage people of color to resist oppression; and his co-conspirators in a real sense reflected the Pan-African composition of his movement, for Africans from at least three different tribes were active in his plot. Easily the most colorful and

[2]Quoted in John Hammond Moore, "A Hymn of Freedom—South Carolina, 1813," *Journal of Negro History*, Vol. L, No. 1 (January 1965), pp. 52–53.

influential of this last group was Gullah Jack, an Angolan said to have been a conjurer.[3]

In spite of impressive evidence of black nationalism among enslaved blacks, the slave South did not offer as many opportunities as the North for slave or "free" blacks to frame their thoughts into statements calling for a transformation of values and the creation of institutions designed to enable black people to move from oppression and dependency to liberation and autonomy. But if there were blacks who, by virtue of their relative isolation from white American values, were potential black nationalists, they were the southern slaves. This was so in part because the new infusions of Africans from Africa and the West Indies (where they greatly outnumbered their white owners) not only led to a more significant African presence in America but reinforced the Africanness of slaves born in this country. Overall, the southern slave, ever forming the creative, radiating center of the black ethos in America, through music and dance, through folktales and religion, projected much that was African into an essentially European environment.[4]

In the North, the fact that almost all blacks, as late as the second decade of the nineteenth century, referred to themselves as either "Africans" or "free Africans" demonstrates that they marked themselves off — and were marked off by force of circumstances — from the larger society. They considered themselves Africans (though most apparently had lost a great deal of their Africanness) even as they made distinctions in the degree of "civilization" between themselves and their people in the ancestral home. There is little evidence that, for blacks generally, being American was considered desirable, even if attainable, until well into the nineteenth century.[5]

What, then, was the sense of reality out of which the ideology of black nationalism was fashioned? A consciousness of a shared experience of oppression at the hands of white people, an awareness and approval of the persistence of group traits and preferences in spite of a violently anti-African larger society, a recognition of bonds and obligations between Africans everywhere, an irreducible conviction that Africans in America must take responsibility for liberating themselves — these were

[3]See John O. Killens, ed., *The Trial Record of Denmark Vesey* (Boston, 1970); and Robert S. Starobin, *Denmark Vesey* (Englewood Cliffs, 1970).

[4]For a discussion of African influences on African American art during slavery, see Sterling Stuckey, "Through the Prism of Folklore: The Black Ethos in Slavery," *Massachusetts Review*, Vol. IX, No. 3 (Summer 1968).

[5]This very point is in need of investigation, though there are already important leads which indicate that black people were quite "African" in their music, folktales, and religion during most of the slave era. The writer, currently attempting to reconstruct the history of the names controversy among blacks, has already found much to support the view that the majority of blacks did not begin to think of themselves as Americans until the post–Civil War period. For a brilliant discussion of the presence of Africa in America during slavery, see W. E. B. Du Bois, ed., *The Negro Church* (Atlanta, 1903), especially Chapters I–IV.

among the pivotal components of the world view of those who finally framed the ideology.

Why did the working out of black nationalist theory take place in the North? Perhaps because the limits of freedom there, broader than in the South, afforded blacks more opportunity to theorize on the condition of their people. No doubt because, as the nineteenth century opened, people of color had already established something of an intellectual tradition in that section of the country."[6] As America approached the fourth decade of the new century with sectional differences about to explode into bitter hostilities, all that remained was for the nationalist perspective on the condition of black people to be fashioned into theory. With a deep dedication to African peoples at the center of their consciousness, with the contradictions between American practice and preachment starkly evident in the post "Revolutionary" period, two black men, Robert Alexander Young and David Walker, speculated on the status of African peoples in a way which broke beyond the shackles which America sought to impose on the African mind.[7] They created black nationalist ideology.

II

Robert Alexander Young, using his own funds, published his *Ethiopian Manifesto* in February of 1829. Brief as that document is, it contains essential elements of black nationalism. Young's statement reflected his deep concern over the place occupied by African peoples throughout the world. There is in Young's *Ethiopian Manifesto*, as there is in David Walker's *Appeal*, something of the primordial, the suggestion of profound beginnings, intimations of the coming sovereignty of certain ideas. But there is also clear-cut evidence of the confusion of other, only half articulate beliefs. Just when one thinks it possible to get at certain ideas stripped of their strange hues and accents, failure inevitably ensues, for both the *Ethiopian Manifesto* and Walker's *Appeal*, published months apart, like all first births, remain in some ways enveloped in a special aura of mystery.

What is clear, on a reading of Young, is that he was religious to the

[6]The early African American intellectual tradition is presented in Dorothy Porter, *Early Negro Writing* (Boston, 1971). Not since Aptheker published his *A Documentary History of the Negro People in the United States* have we had a documentary of the quality of the Porter volume.

[7]I am deeply indebted to Mr. Russell Maylone, Curator of special collections at Northwestern University, for securing Young's *Ethiopian Manifesto*. Failing to find the pamphlet at a number of outstanding collections of Negro materials, I turned to Mr. Maylone, who not only located the library at which the *Ethiopian Manifesto* could be found but had a copy xeroxed and forwarded to Northwestern *within four days*. That rare document can be found at the main section of the New York Public Library.

point of being oracular, in a way strikingly suggestive of Nat Turner. Not only does he envision the coming of a black messiah—an incontestable expression of black nationalism—but there are references to signs and seasons which remind one of the slave preacher of Southampton County, Virginia.[8] There is also about Young's personality something of the studied, willed quality which calls Turner to mind.

The *Ethiopian Manifesto* contains one of the earliest extant calls for the reassembling of the African race, one of the first formulations of the imperative need for Africans, severely oppressed and locked in degradation, *to become a people* (Martin Delany would later refer to them as a broken people), *"a nation in themselves"* (italics added). Moreover, though he somewhat overstated his case in arguing that his thought was not influenced by other men—not borrowed "either from the sense of white men or of black"—there are not a few concepts put forth by Young which were indeed indigenous to African or Ethiopian peoples in America, especially the allusion to a God of the Ethiopians, a conceptualization with far-reaching cultural as well as political and religious implications. From a reading of the text, it is evident that Young seems to make practically no distinction between African peoples throughout the world. For him all people of African ancestry were Africans irrespective of their place of birth. Pan-Negroism (or Pan-Africanism) was a first principle of his brand of nationalism.[9]

III

David Walker presented a great many more of the ideas which would later become associated with black nationalism. Indeed, it is likely that his *Appeal to the Colored Citizens of the World* contains the most all-embracing black nationalist formulation to appear in America during the nineteenth century. Indeed, there is scarcely an important aspect of African American nationalist thought in the twentieth century which is not prefigured in that document. While it is true that there is a certain diffuseness about Walker's formulation of the place of Africans in the world, there is nonetheless a comprehensiveness of approach, a penetration of insight and a daring of conception regarding the need for African peoples to rule themselves which mark his *Appeal* as unmistakably nationalist in ideology.

Published in September of 1829, the *Appeal* went through three printings, with the second and third editions appearing in less than a

[8]Within the American context, Young's messiah would be considered black, even though his father, according to Young, was a white man and his mother black.

[9]For a first-class discussion of early Pan-Negroism, see Hollis Lynch, "Pan-Negro Nationalism in the New World Before 1862," in Okon E. Uya, ed., *Black Brotherhood* (Lexington, Massachusetts, 1971).

year. Two decades following the initial appearance of that document, Henry Highland Garnet republished it together with his *Address to the Slaves*, which indicates the esteem in which Garnet held Walker. It appears Garnet was strongly influenced by the nationalism of Walker, and that other of his contemporaries found Walker's thoughts on the need for black autonomy of some interest. The *Appeal* itself is the best argument for the essential soundness of this view.

But there is a more important question to pose: How does one account for the failure of so many scholars to credit the *Appeal* with being, in its own right, one of the most important black nationalist statements of the nineteenth century? Perhaps the main reason for this has been the emphasis devoted to Walker's cry for people of color to rise up and destroy their oppressors, an attention which serves to obscure the nationalist dimensions of the *Appeal*. It is also likely that a tendency on the part of scholars to interpret the past in the burning light of current concerns contributed to their failure to focus on the nationalist concepts that pervade the *Appeal*.[10] Considering the fever pitch to which integrationist sentiment was brought in this country following World War II, it is small wonder that Walker has not been considered a major nationalist. Related to the neglect of the nationalist dimension in Walker is simply the unwarranted assumption referred to at the outset: the belief that major black nationalist ideologists did not exist before the advent of Martin Delany.[11]

David Walker's *call for the establishment of a black nation* (he had recognized the need for the creation of black infrastructures in an earlier piece in *Freedom's Journal*) is surely one of the first such formulations on record. In another reference to the need for black hegemony, he could not have been more explicit: "Our sufferings will come to an *end*, in spite of all the Americans this side of *eternity*. Then we will want all the learning and talents among ourselves, and perhaps more, *to govern ourselves*" (last italics added). Walker's heavy emphasis on the need for people of color to transcend an ignorance born of oppression is still another aspect of black nationalism, as would be demonstrated by a long line of subsequent nationalists. Many of them would display a profound regard for knowledge, and most would posit that, in Walker's words, "learning originated" with their ancient ancestors, the Ethiopians and the Egyptians. It is not being advanced that this view was peculiar to nationalists—rather, it is being argued that for nationalists knowledge has been held in especially high esteem.

[10]A notable exception to this general rule is Herbert Aptheker. Aptheker in 1956 published "Consciousness of Negro Nationality to 1900," in *Toward Negro Freedom* (New York, 1956). He correctly noted that a "passionate sense of nationality pervades the entire body of David Walker's famous Appeal . . . to the Coloured Citizens of the World," p. 106.

[11]Harold Cruse, perhaps more than anyone else, has promoted this misconception. See Cruse's *The Crisis of the Negro Intellectual* (New York, 1967), p. 5.

David Walker's intense interest in history, especially the history of African peoples, is another feature of his thought that has been echoed for over a century in the thought of other nationalists. In addition to espousing the view that his ancestors in Ethiopia and Egypt had been responsible for the beginnings of civilization, he said, in one of the most important observations ever made on the role of the black historian, that "the Lord shall raise up coloured historians in succeeding generations, to present the crimes of this nation to the then gazing world." In each vital area, Walker stressed the importance of African peoples shouldering the responsibility for their liberation, though he did not discount—and here again is a cardinal tenet of nineteenth-century black nationalism—assistance from whites. Thus, whatever the degree and quality of support from whites in countering, for example, the racism of Thomas Jefferson, Walker thought it unthinkable that people of color should not take the lead in their own defense. He explained it this way:

> For let no one of us suppose that the refutations which have been written by our white friends are enough—they are *whites*—we are *blacks*. We, and the world wish to see the charges of Mr. Jefferson refuted by the blacks *themselves* . . . for we must remember that what the whites have written . . . is other men's labours, and did not emanate from the blacks.

Walker's nationalism illustrates almost perfectly a black nationalist tendency to exaggerate the degree of acquiescence to oppression by the masses of black people. Where else among black people can one find such gloomy and devastating, such stereotypical portraits of black humanity as among nationalists? One sees this dimension of nationalism expressed in some considerable measure in the *Appeal*, in Garnet's *Address to the Slaves*, and in Delany's "Political Destiny of the Colored Race." (Perhaps such a view of African peoples reached its grim consummation in the writings of Alexander Crummell, especially in the years following the Civil War.)

If David Walker in his *Appeal* brooded over the degradation of his people, if he excoriated them for their apathy and cowardice—and in this respect the same can be said of Garnet in his *Address to the Slaves*—there was no greater believer than he in the inherent worth, the redeeming power, of black humanity. Though he thought God on the Africans' side, he urged them to make a determined effort of their own to overthrow their oppressors. Hence his almost desperate call for an end to disunity in their ranks. That theme, the presence of disunity and the need for unity, so deeply grounded in the *Appeal*, is a distinguishing feature of the literature of black nationalism.

An original dimension of Walker's nationalism, and perhaps his greatest contribution to Pan-African theory, is expressed in those sections of the *Appeal* in which he focused on Africans around the world, on their attributes, the nature of their oppression, the ties between them,

and *the imperative need for universal African revolt*. An advocate of the view that people of African descent everywhere were Africans, Walker insisted that the happiness and glory of all "coloured people under Heaven, shall never be fully consummated, but with the *entire emancipation of your enslaved brethren all over the world*."

Walker's attitude toward his people in the diaspora, the great scattering of Africans throughout much of the Americas as a result of centuries of slave trading and slavery, was in one crucial respect not peculiar to him: A very significant number of "free" and very likely a far greater number of enslaved blacks considered themselves and Africans elsewhere in the Americas members of one African family. What is different with Walker is not his conception that Africans everywhere are one but his great emphasis on the need for unity between black peoples throughout the world.

An especially notable feature of the African, one which would play a decisive role in history, was Walker's belief, which mounted to the level of mythology, that the African was endowed with physical strength and fighting power clearly superior to that of the white man. The desired Pan-African revolt could be more easily achieved, he was certain, if the black man but knew his power. Other black nationalists, in varying degrees, affirmed this view with such consistency that the hypothesis is especially associated with their ideology. Henry Highland Garnet, Alexander Crummell, and Martin Delany are but a few who subscribed to some variant of the Walker thesis. In short, nationalists tended to give greater emphasis to the matter of black strength, possibly because they have generally had greater faith in the potential and power of their people than those leaders and theorists who wanted to see people of color absorbed into American life.

Among the many characteristics of Walker's *Appeal* which anticipate twentieth-century nationalists, especially Nation of Islam partisans, are the following: a conception of the white man as the devil—which immediately brings Elijah Muhammad to mind, even though Walker, unlike Elijah, made certain exceptions; an attitude toward white women—"I would not give a pinch of snuff to be married to any white person I ever saw in all the days of my life"—which is also close to that of contemporary nationalists; and a concern about his possible fate for having written the *Appeal*—the possibility of being assassinated—which is similar to Malcolm X's remarks while writing his autobiography. These and other considerations simply serve to impress upon one the seeming timelessness of certain nationalist concerns among black people. But they do not constitute the burden of Walker's message, which was the unity of fate, the oneness of destiny, the Pan-African future of black people. To pave the way for the freedom of the African, he considered his life of little consequence. In 1830, a year following the publication of the *Appeal*, he was found dead, possibly the victim of poisoning.

IV

The next important black nationalist theorist to appear after Young and Walker was the Reverend Lewis Woodson of Pittsburgh, a man who, according to historian Floyd Miller, used the pseudonym Augustine. Woodson contributed significantly to the further development of black nationalist ideology, especially between 1837 and 1841. Moreover, according to Miller, it was from Woodson that Martin Delany received much of his training in the ideology of black nationalism.[12] Woodson pursued his quest for black liberation on a number of fronts and, like his nationalist contemporaries, will prove to be an elusive target indeed for those seeking to attach a simplistic definition to his variety of black nationalism.

In his "Moral Work for Colored Men," Woodson devoted major attention to the means by which the moral elevation of his people might be achieved. Though his picture of black humanity is not as cheerlessly, as bleakly drafted as those drawn by Young, Walker, and Garnet, his prescription for the rehabilitation of his people is no less devoid of appreciation for the creative dimension of African American culture. Like Walker and Garnet, who reflected at length on the characteristics of the masses of blacks, Woodson seemed unmindful of slave songs, folktales, religion, and dance. In a word, he seemed to be unaware of the distinctive black ethos or life style in slavery.

Still, Woodson's observations on the character development of his people are frequently brilliant. This quality is very much in evidence in his references to the need for people of color to lead themselves. "So long as we admit of others taking the lead in our moral improvement and elevation," he wrote, "we never can expect it to be according to our wish or desire." Though acutely aware of the perils of dependency, and though convinced that his people would move to liberate themselves, he affirmed a representative black nationalist position in refusing to deny aid from friends or allies, "to whom I cling with most unyielding tenacity, but as showing the proper and lawful use of them."

Deeply concerned over *disunity* within the ranks of his people—the perennial concern of black nationalists—Woodson's views on this question are especially arresting but not very original, considering the preoccupation of Young and Walker with this issue. His call for a General Convention of representative black leaders, his recognition of the need for enduring institutions—these concerns, principally owing to the clarity and fullness with which he puts them forth, appear to be important contributions to the ideology of black nationalism. "Without a na-

[12]See Floyd Miller, "The Father of Black Nationalism: Another Contender," *Civil War History* (December 1971), pp. 310–19. Miller has done some of the most important detective work in the field of African American history. His discovery of numerous sections of Delany's *Blake* (Boston, 1970) was a major achievement.

tional institution of some description," he observed in one letter to *The Colored American*, "our affairs can never attain any degree of consistence or permanence. There can be no *head* or *centre* around which we may rally. Our *numbers, means* and *capacity*, will remain useless, for want of something to combine and concentrate them." It could well be, however, that Woodson's most distinctive contribution to the development of nationalist ideology was his exhortation to his people to move to the countryside, to form separate settlements—a partial prescription for their ills also recommended by Garnet, who shared his views in this regard.

V

As effective an ideologist of black nationalism as Woodson was, he was not the equal of a young nationalist who was responsible for one of the most sophisticated statements of black nationalism, framed in four letters, ever made. Appearing in the pages of *The Colored American*, these remarks, in response to William Whipper's attacks on those who were making "complexional distinctions," were signed by a person who referred to himself simply as "Sidney," and they were all written in February and March of 1841. In trying to discover who Sidney was, the writer searched for a black man with that last name, settling, in the first instance, on Thomas S. Sidney, a former classmate of Henry Highland Garnet and Alexander Crummell at the African School in New York. Such a choice seemed natural enough, especially since Thomas Sidney was, as the decade of the 1840s opened, gaining a reputation as a brilliant and radical young intellectual. And since the author of the letters possessed a fresh, aggressive intelligence, it seemed reasonable to conclude that Thomas S. Sidney was their author. But it was discovered that Thomas S. Sidney died in 1840, *before* the appearance of the letters in question.

Recalling that Sidney had referred to his presence at the Albany Convention in 1840, the roster of leading participants published in *The Colored American* was reviewed, but, alas, no one named Sidney was listed. Perhaps a Sidney was among those less-influential participants whose names were not published; if so, then what would have been the point of withholding the first name? The search for Sidney appeared to lead into a cul-de-sac. While it was clear that the letters were written by someone at the convention who preferred to disguise his identity, it seemed no less certain that a major intellectual at the convention, indeed of black America, was the author of the letters. Two pivotal figures at the Albany meetings seemed to be likely choices, Alexander Crummell and Henry H. Garnet, both of whom had known Thomas Sidney for more than a decade. Had one written the letters and, as a tribute to his recently departed friend, signed the name Sidney? While that is a possi-

bility, a somewhat remote and peculiar one at that, more evidence was obviously needed.

An examination of the letters, it was thought, might reveal additional clues, and it did, except that the evidence adduced from a close reading of the material suggests, once again, that either Garnet or Crummell might have written the letters. Sidney's relatively sparse references to religion and his style of writing suggest that perhaps Garnet rather than Crummell was using the pseudonym. References to the contending forces of black autonomy and those propelled by a "cosmopoliting spirit," a contest also discussed in the section of this essay in which Garnet is considered, are also very similar to Garnet's assessment of the black condition for what appears to have been roughly the same period. While a fairly esoteric reference to a battle waged by Presbyterians in Sidney's first letter shifts one's attention to Garnet, who was a Presbyterian divine of impressive learning, certain passages in another letter, while they express sentiments to which Garnet subscribed, are so close to the language and spirit of an Albany Convention Report by Crummell that it is possible to conclude that he and Sidney were one. But why would either man have elected to disguise his identity behind a pseudonym? The answer cannot be supplied at this time.

What *is* certain is that the man who offered the unusually perceptive remarks on black nationalism was mainly concerned with revealing the historical and philosophical bases for people of color coming together to solve their problems. His approach was preeminently from the inside. Sidney believed that people of African ancestry must rely on their own energies, their own perceptions, their own fathers' example in order to sunder their bonds.

VI

Neither Woodson nor Sidney exercised the black nationalist influence of Henry Highland Garnet. Indeed, perhaps no other figure in antebellum America was as influential as Garnet in advancing black nationalist ideas and projects. Born into a family of rebellious black slaves, and said to have been of royal African lineage, this man who delighted in his African heritage was, following his *Address to the Slaves* in 1843, second only to Frederick Douglass among black leaders of antebellum America.

Garnet's *Address to the Slaves*, failing to win approval at the Buffalo Convention of 1843, was not published until 1848. At that time, he personally published the *Address* together with Walker's *Appeal*. The *Address*, which stirred a major controversy within the Negro Convention movement, and aroused the ire of some influential white abolitionists, must be considered nationalistic on a number of grounds. For one thing, the literature of black rebellion contains few documents in which the collective oppression, the common history of blacks is as vividly, as

passionately recorded. For another, their dreadful subjection, as described by Garnet, had led to the development of a certain servile mentality which only rebellion, he implied, could undo—a view reiterated by nationalists during subsequent periods.

In Garnet's case, his questioning of the manhood of the enslaved had telescoped Walker's more extended treatment of that subject. Garnet's expression of pride in Africa, his commitment to keep the faith with the millions of ancestors who perished in the slave trade and slavery, and his profound grasp of the relationship between the suffering and misery of his people and the wealth of America contributed to his belief that there was nothing at all wrong with the slaves' rising up to overthrow American slavery. But he also made it clear beyond doubt that *all* black people must be prepared to support the movement of the slaves to break their bonds, that there must be unity among the oppressed.

Following the Buffalo Convention, Garnet gave expression to another vital feature of nationalism: the right of the oppressed to think and act for themselves. Unable to win approval for his *Address* at the Buffalo Convention, he later had to defend the document against white critics. The assault against him came from Maria Weston Chapman, editor pro tem of *The Liberator*, who upbraided him for not having sought the advice of certain friends before embarking on such a violent strategy of liberation, one very much at odds with the Garrisonian preference for moral suasion as an instrument of social change. Garnet returned a classic line: "I can think on the subject of human rights without 'counsel,' either from the men of the West, or the women of the East." The real basis, therefore, of the split of interest between Garnet and the Garrisonians over his *Address* was, in his view, the presumption on the part of whites that they could think *for* black people.

While living in New York, Garnet had very early exposure to Africans from the West Indies and from the continent of Africa. This doubtless helped to make interest in Africans everywhere a natural development for him. As indicated in his numerous speeches, it is evident that he felt a strong sense of solidarity with Africa's transplanted children. Having visited at least two West Indian islands—Cuba in the 1840s and Jamaica in the following decade—he was of a generation of outstanding blacks who had a considerable degree of contact with their West Indian brothers *on West Indian soil*. In sum, his view that "Hayti is *ours*, Jamaica is *ours*, and Cuba will soon be *ours*" (italics added) evolved out of the fabric of his own life: A tradition of respect in his family for the African heritage, early contact with Afro-West Indians and Africans in the United States, and visits to the islands had impressed upon him the concord of interests of African peoples. These factors, together with Garnet's realization that Pan-Negro cooperation was necessary to effect the final liberation of peoples of African descent, had been central to his thought well before the decade of the 1850s.

Garnet's thought, over a period of decades, touched on a little-ap-

preciated dimension of American history, the extraordinary fluidity of the historical process with respect to the ascent and fall from fashion of first one and then another black liberation strategy. Black people in the North as early as the 1830s and 1840s, he noted in the 1850s, went through periods during which forces of integration and black nationalism (though these terms were not used until much later), grappled on a major scale for authority within black communities. Judging especially from what he has to say about such matters, there is reason to believe that "cosmopoliting" forces were very strong on occasion, sometimes nearly carrying the day before being rolled back a distance by the forces of black autonomy. Not infrequently this battle between contending world views was played out under cover of arguments over what people of color should call themselves.

The nationalist and integrationist movements of antebellum America foreshadow the present not only with respect to the struggle over names sometimes being a surface manifestation of fundamental ideological differences, but also in the realm of the arts. Then, as now, African Americans debated whether they should be concerned primarily about themselves or about universals. "Sidney's" references to the "cosmopoliting spirit" of certain African Americans, to their emphasis on universals— and Garnet's remarks on the same subject—read as if they were framed in the 1970s, just as William Whipper's attacks on all-black organizations appear to be of equally recent vintage. In any event, for roughly two decades, Garnet was in the thick of struggles between cosmopolites and advocates of black hegemony, warning the former group that they were mistaken in trying to escape their color, that they would one day realize they had erred.

It is worth noting, with regard to Garnet's activities on behalf of the African Civilization Society, that he drew the fire of many of the most distinguished leaders of people of color not mainly because he was an advocate of black people's having control over their institutions—rather, he was attacked before, during, and following a speech in Boston because his selective emigrationist activities were thought by some to be intimately tied to the American Colonization Society, a charge so damaging that few men would care even to debate the matter publicly.

But Garnet had long been defending his views on emigration. In 1849, he had aroused the ire of no less an assailant than Frederick Douglass, whose reflections on Garnet's interest in emigration initiated what became an especially bitter and protracted exchange between the two men. Their feud over emigration was no doubt fueled by an earlier passage of arms following Garnet's call for a slave rebellion in his *Address to the Slaves*, an exhortation which Douglass had steadfastly opposed.

For years a staunch opponent of emigration, Garnet had not joined Alexander Crummell in raising objections to the anti-emigration resolution which was introduced at the Albany Convention of 1840. In the

same year, in a brilliantly crafted statement before the American Anti-Slavery Society, Garnet had put forth the view that he would always oppose emigration. But roughly a decade later, he and Crummell were in essential agreement regarding the need for selective emigration of people of color to West Africa, a position more consonant with Garnet's nationalist stance and his early exposure to and interest in African peoples.

Just as Garnet came under severe criticism from certain quarters following his Buffalo call to violence, and just as his commitment to involvement in the politics of the Liberty party had met with a chilly reception in white and black anti-slavery circles, so too did his attitude toward emigration to Africa arouse widespread opposition. As in his advocacy of other causes once unpopular but later more widely accepted by black leaders, Garnet saw yet another of his causes, emigration, achieve substantial endorsement from black leaders, especially as the decade of the 1860s opened with great interest in emigration to Haiti.

Garnet was a serious advocate of black people's possessing the land, of their founding towns and settlements for the purpose of controlling their lives.[13] Moreover, he encouraged his people to patronize other blacks with services to offer. And like David Walker, "Sidney," Woodson, and Delany, he saw no contradiction in people of color struggling to achieve control of their destinies while seeking the franchise, while attempting to remove the proscriptions imposed on them by the "free institutions" of the northern state. On the contrary, such measures, far from being reformist in slaveholding America, complemented efforts to help people of color achieve the desired autonomy.[14]

The fact that Alexander Crummell, a life-long nationalist, was called upon to chair the committee at the Albany Convention which drafted "certain instructions or recommendations to the people on petitioning" for the franchise in New York State is an illustration of the important role which he and other nationalists of antebellum America played in fighting for the ballot. As the Albany minutes reveal, there was no small admiration among distinguished blacks for America's "free institutions," even though there was intense hatred of slavery and oppression. While Garnet and Crummell at times praised American institutions, both men on other occasions could and did subject those institutions, which were warped by slavery and racism, to withering assault.

[13]For a discussion of Garnet's views on black people founding towns and villages, see Henry H. Garnet, *A Memorial Discourse*, with an introduction by James McCune Smith (Philadelphia, 1865), p. 39.

[14]The African American quest for the ballot during the slave era was a radical—no mere reformist—move. To seek the ballot in most northern states was, at times, to risk one's life, for to agitate or organize for the ballot in a country like the United States was sufficient to enrage the great bulk of white Americans. Like the slave who relied on day-to-day resistance to oppose his bondage, those blacks who fought for the ballot were rejecting the country's attempt to assign them to a permanent place of degradation.

VII

"The Political Destiny of the Colored Race on the American Continent" was Martin Delany's most trenchant statement on black nationalism and must be considered one of the seminal political documents in American history. Drafted in 1854 for the emigration conference in Cleveland, the statement was his report to the delegates at that conference. The severity of conditions confronting African Americans in the North during the decade of the 1850s doubtless contributed significantly to his tone of hard opposition to the oppressors of blacks and of profound skepticism regarding the future of his people in the United States. The fugitive slave law of 1850, practically giving any white person license to turn over a black to slaveholders, was a somber and accurate index of black–white relations in the decade.

The very harshness of the times caused Delany, at least until the Civil War and Reconstruction years, to give up on American political processes. He had earlier, true to nationalist form, attended meetings of the convention movement, seeking through less radical means than emigration to better the lot of people of color. He would later renew these concerns, though under quite different circumstances. In an important sense, then, his attitude over the long haul toward the possibility of freedom's being won in America is not necessarily reflected in "The Political Destiny of the Colored Race." As with Garnet, Woodson, and Alexander Crummell, Delany was more an emigrationist at certain times than at others—a perfectly sane attitude, especially when one considers the tremendous odds against any black leader, no matter how profound his program. It was not exceptional for a nationalist leader to try first one and then another strategy for breaching the walls of captivity.

Before the emergence of Delany into national prominence, no recognized *ideologist* of black nationalism had placed as much emphasis as he on the need for black people to have land to set aside for purposes of establishing their own nation outside the boundaries of America. David Walker, in fact, had steadfastly opposed even limited emigration to Liberia, so convinced was he that the Liberian experiment was but another instrument of the slave overlord's dominance of millions of blacks in the South. While it is true that Woodson eventually expressed interest in emigration, he was not very influential in national African American circles and so had little impact, save through Delany, on his people. Alexander Crummell, later a giant in African American life and a believer in selective emigration was out of the country throughout the decade of the 1850s, which meant that his growing prestige as a thinker could scarcely yield practical results from thousands of miles away in Liberia. And while it is true that Garnet as early as 1849 had come out for limited emigration, he continued to believe that his people would secure their freedom in America.

Delany's emigration philosophy was predicated on a disaffection with

American life that appeared to be much greater than that of other ante-
bellum emigrationists, though the gap between them had closed consid-
erably by the beginning of the decade of the 1860s. It was precisely this
disaffection which led Delany to emphasize the importance of a territo-
rial base away from white America. His almost total absence of faith in
the possibility of the black man's winning freedom in America grew out
of his belief that the whole history of white people was bent toward
crushing "the colored races wherever found." More than that, the gov-
ernment of the United States, he remarked in "The Political Destiny,"
was the enemy of black people. There is reason to believe that Delany,
certainly during the slave era, suffered somewhat less from the attrac-
tion-repulsion attitude toward America that was characteristic of so
many black leaders of his time and later. Not surprisingly, he extended
his grim view of the government and nation to whites generally, though
he made it clear that all whites were not antagonists of his people. But
those who favored the liberation of blacks, he was quick to add, were
not running the country.

When Delany joined Garnet's African Civilization Society, he pro-
ceeded to lead a movement to purge that organization of its white offi-
cers, a position consonant with the precepts, if not the actions, of every
important black nationalist of the period. Garnet, who headed the Soci-
ety, had permitted whites to play important roles in the organization, a
decision for which he paid dearly, especially in light of the charge that
his white associates were agents of the American Colonization Society.
Delany had said often enough that he cared little or nothing for the
opinions of white men. His move against white officers of the African
Civilization Society squared perfectly with that sentiment.

In "The Political Destiny of the Colored Race," Delany put forth the
view that his people should emigrate to the West Indies and to Central
and South America. Though he later emigrated to Canada, he was by no
means certain that people of African ancestry were safe there since he
thought the Anglo-Saxon wanted to dominate all people of color within
reach. In any case, his knowledge of Latin America was not very accu-
rate. Not only did he not understand, for example, the state of Brazilian
race relations, but his information regarding the number of black people
in Latin America was far from accurate.[15]

Nevertheless, Delany's observations on people of color generally
mark him as one of the most original political thinkers of his day. This
is all the more evident when his extremely advanced position vis-à-vis
the American Indian is taken into account. In fact, he was way ahead of
his black contemporaries in this latter respect. In both "The Political
Destiny of the Colored Race" and *Blake: The Huts of America*, his novel,
he displayed a respect for and a sense of solidarity with Indians that
were altogether remarkable. His attitude toward Indians was an aspect

[15]Hollis Lynch, "Pan-Negro Nationalism," p. 52.

of his overall views on the racial factor in human history. In "The Political Destiny" he foresaw a racial cleavage of apocalyptic scope:

> It would be duplicity longer to disguise the fact that the great issue, sooner or later, upon which must be disputed the world's destiny will be a question of black and white, and every individual will be called upon for his identity with one or the other.

"The problem of the twentieth century," Du Bois would later remark in *The Souls of Black Folk*, "is the problem of the color line. . . . "

Delany made explicit what most nationalists of his time had merely implied. He argued that just as other peoples had special traits, so too did the African American. Moreover, he emphasized the desirability of people of color cultivating their esthetic and spiritual qualities. He referred to the need for black people to develop and build upon their special gifts so that they might not only further nationalist goals but "instruct the world" as well. Unfortunately, apart from an occasional remark about slave singing, there is little evidence that Delany had any real understanding of the art or religion of the masses of black people. Thus he too missed a singular opportunity to add to political and economic nationalism a form of nationalism which awaited theoretical articulation and propagation, an artistic and cultural nationalism more deeply grounded in the African heritage than other expressions of nationalism. By carefully rearranging the peculiarly African in light of American exigencies, and by building from such a cultural base, the antebellum nationalist might have helped break the cycle of contests between assimilationists and nationalists and thereby elevated the struggle of his people to a higher and less confused plane.

While the tradition of black pride extends about as far back as written records left by blacks; while at times attacks on blackness elicited graceful but forceful returns from men such as Benjamin Banneker in the late eighteenth—and angry and aggressive rejoinders from men like David Walker in the early nineteenth—century; while Garnet was quietly proud of his Africanness and insisted that those among his people who tried to flee their blackness were making a terrible mistake; while these and other expressions of black pride were shared by not inconsiderable numbers of black people from time to time in the slave era, it remained for Martin Delany to provide a fuller dimension to blackness by giving it more attention than his contemporaries. This he did to the extent of becoming, in a somewhat measured way, a celebrant of blackness.[16] But as "The Political Destiny" makes eminently clear, if Delany was proud of blackness and other characteristics of his people, he could with equal

[16]One can detect Delany's unmistakable satisfaction with blackness in two superbly researched volumes on him. For exhaustive treatments of Delany, see Dorothy Sterling, *The Making of an Afro-American: Martin Robison Delany, 1812–1885* (Garden City, 1971); and Victor Ullman, *Martin R. Delany: The Beginnings of Black Nationalism* (Boston, 1971).

zeal subject certain of their traits, as he conceived them, to ruthless criticism. Perhaps it is not unfair to say that black nationalists, more than any other group of African American ideologists, have been able to combine in terrible and uneasy tension the most devastating criticisms of, and the most sublime faith in, their people. This tendency is especially evident in Walker and Garnet. But it is no less fair to note that, in the main, nationalists were perhaps more consistently critical of the masses of blacks than other ideologists.

Delany almost rivaled Walker and Garnet in describing the degradation of black people. In "The Political Destiny" he said, rather mildly for him, that they were suffering from a great disease, political in nature, one requiring "a healing balm to a sorely diseased body—a wrecked but not entirely shattered system." He proposed a remedy, emigration, and provided a vision of a better day for those fortunate enough to leave these shores and to settle in more congenial surroundings "where our political enclosure and national edifice can be reared, established, walled, and proudly defended on this great elementary principle of original identity."

As one ponders seminal theoretical works by blacks of the slave era, it becomes evident that with few exceptions the terms "black nationalists" and "integrationists," when thought of as mutually exclusive, are not simply inadequate as means of understanding the individuals being labeled but prevent us from understanding major ideologies and movements. For instance, the view advanced by Harold Cruse that Martin Delany was the prototype black nationalist and Frederick Douglass the prototype integrationist is not merely a rank oversimplification but a barometer of the extent to which he lacks familiarity with the sources.[17] Not only can one trace black nationalism and integrationism back to previous originators more than a decade before either Douglass or Delany rose to prominence, but it is in error to contend that there was not something of the *integrationist* in Delany and much of the *nationalist* in the young Douglass. The ideologies and programs of these men overlapped.

As their writings indicate, most nationalists refused to allow themselves to be tied to a single approach. It was not unusual for them, Walker and Garnet being cases in point, to pursue multiple paths to the ultimate goal, which was not necessarily the establishment of a black

[17]Anyone who has studied the Negro Convention Movement should know that the leaders of that movement cannot be easily cataloged, tucked away in discreet niches. Thus those who indulge in the scholarly pastime of denouncing Douglass as an integrationist betray the paucity of their grasp of the history of his period—and signal a certain sloppiness regarding their treatment of more recent history? A cursory reading of William Whipper makes it quite clear that he was no mean advocate of a colorblind America. If any antebellum black was the prototype "integrationist," it was William Whipper, certainly not Frederick Douglass. For a pathfinding treatment of the Negro Convention Movement, see Howard H. Bell, *The Negro Convention Movement*, Ph.D. dissertation, Northwestern University, 1953.

nation. As important and vital as that objective was to them, as deeply committed to black autonomy as they were, the final goal was *the freedom of their people.*

If that freedom could have been effected without ridding the land of white people, nationalists, as rational men, would not have been displeased. On the other hand, if freedom could come to their people only through the elimination of whites, with God's help, then antebellum nationalists would no doubt have favored acting on that reality.[18] The fact of the matter is that major nationalist theoreticians have been exceedingly humanistic. In fact, a strong tendency to reach beyond themselves toward union with mankind has been a marked characteristic of most nationalist theoreticians from David Walker to Paul Robeson. The nationalists' concern for their fellow man should be kept in mind in order to avoid doing violence to the meaning of historic black nationalism.

From the appearance of the *Ethiopian Manifesto* and *The Appeal to the Colored Citizens of the World* in 1829 to the 1860s there were no monolithic conceptions of black nationalism projected by major nationalist figures. Where are the antebellum—or for that matter later nineteenth-century—nationalists who did not, on a reading of the turbulent times, try first one formula and then another, or whose works *and actions* did not suggest more than one possible solution to the problem of African oppression in America? Almost all were willing to settle for a place in American life, provided their people, as black people, had significant control over their destinies. But there has also been the clearly expressed willingness of some nationalists even to transcend color, provided white Americans were no longer obsessed with America's remaining a white country. It was when such options were thought unavailable that the nationalist was more likely to favor a separate black nation either adjacent to the United States or elsewhere in the world, usually in Africa.

When nationalists advocated the total removal of their people from America—and few indeed have been those who have thought this strategy either realistic or desirable—it should not be said that even they, considering centuries of oppression of African Americans, were less realistic than believers in the American Dream. Moreover, the record seems to suggest rather the opposite: that those people of color (and their white allies) who believed in the absorptive powers of America were vastly more deluded than those blacks who decided to depend mainly on their own people, their own energies in a hostile land.

[18]Theodore Draper has remarked, sweepingly enough, that black nationalists, following a "fantasy," want to get rid of white people. Only by drawing upon nationalist literature of the twentieth century, and even then while ignoring representative nationalist writings, can he provide a defense for this intemperate assertion. Surely the nationalist position over the long haul has been anything but what Draper, not bothering to honor or to seek to understand the sources, would have us believe. See Theodore Draper, *The Rediscovery of Black Nationalism* (New York, 1969), especially Chapter XI.

A Last Stern Struggle:
Henry Highland Garnet and
Liberation Theory

At least one generation of Garnets had died in Maryland slavery and two more, by the time of Henry Highland Garnet's birth in 1815, faced that possibility. Indeed, oppression in the Garnet family was aggravated as births and deaths took place, leaving an influence on Henry that he later drew on in formulating his strategy for making slaves aware of the consequences of continued degradation in slavery. His grandfather had gone through the whole process of captivity in Africa, the middle passage, and enslavement in America, where he also saw his offspring, Henry's father, enslaved. On the death of their owner, the threat of imminent division of the family led the father, using the pretext of attending a funeral, to secure passes for the family to travel from the plantation. With his wife and children at his side he drove a covered wagon from the plantation and, traveling mainly on foot, escaped from Maryland into Wilmington, Delaware, where contact was made with Thomas Garrett, a Quaker noted for assisting slave runaways. With Garrett's help the Garnets moved on to Pennsylvania before reaching New York City in 1825. Thus, in a single act of daring, under George Garnet's leadership, the cycle of oppression in slavery was broken for the Garnet family.

To New York blacks Henry Garnet's father gave no evidence in bearing or appearance that he had ever been a slave. Alexander Crummell, whose parents lived next door to the Garnets, had rarely met anyone more grand or stately in character and stature, "a perfect Apollo, in form and figure; with beautifully moulded limbs and fine and delicate features; just like hundreds of grand Mandingoes I have seen in Africa; whose full blood he carried in his veins." The absence of servility in freedom suggests an earlier refusal by George Garnet to accept in spirit any notion of inherent inferiority, which resulted in part from the character of his own father—he was said to have been a chief—with whom he apparently lived for some years and whose fate, together with his own, might explain his sober demeanor. A certain reticence on matters of slavery in the presence of youths, however, was common for former slaves, which could account for how little is known of the Garnet family

in Maryland. The principal source is Crummell, who knew Henry's parents well, but not well enough to elicit from them information about their lives as slaves.

Not long after their arrival in New York, George Garnet led the family in a ceremony that was carried out on countless occasions in antebellum America and following emancipation in 1865—a "baptism to liberty." He spoke directly to each member of the family, beginning with his wife: "Wife, they used to call you Hennie. . . . But in future your name is Elizabeth." Touching his daughter: "Your name is not Mary any longer, but Eliza." Then he took Henry on his knee: "And my dear little boy . . . your name is Henry. My name is George Garnet." This ceremony, a conscious effort to reclaim an identity—a certain power of definition for the family—could scarcely have occurred in a more propitious place, for it was said that blacks in New York took pride in their African heritage "and hesitated not to refer to themselves as free Africans." It would seem that George Garnet, though he had not known freedom before, entered among them with a high level of consciousness, able to meet enormously difficult challenges, which more than any other factor inspired Henry's faith in the utility of self-exertion.

The Garnets were not in New York for more than two years when a frightening incident hastened Henry's maturation and left him poised to fight, possibly to kill, for freedom. A relative of Colonel Spencer, the former owner of the Garnets, had traced them to their doorstep and asked for George Garnet, which led the father to leap from a window twenty feet above ground to the Crummell yard. Though he escaped, his daughter was later apprehended but released after convincing the authorities that she was not a runaway. Away at sea as a cabin boy, Henry returned to discover his family scattered and living in various residences on Long Island. For some time, infuriated, he walked the streets of New York with a knife as protection if approached by slave catchers. Such developments reminded the Garnets, along with other free blacks, of the continuing bond between them and slaves. From that time on, Crummell thought, Henry bore the responsibilities of a man.

The spirit of nationalism was strong in the religion of New York blacks and reflected in mutual aid societies such as the New York African Society for Mutual Relief, the New York African Marine Fund, and the Clarkson and Wilberforce benevolent societies—all of which were prominent in the opening decades of the nineteenth century. Around the banners of such organizations, with the New York African Society for Mutual Relief in the lead, thousands of New York blacks, including young Henry and many of his friends, gathered on July 5, 1827, to celebrate Emancipation Day in New York State. James McCune Smith, a participant in the parade, left a record of the day: "The side-walks were crowded with the wives, daughters, sisters and mothers of the celebrants representing every state in the Union, and not a few with gay bandanna handkerchiefs, betraying their West Indian birth; neither was

Africa itself unrepresented, hundreds who had survived the middle passage . . . joined in the joyful procession. The people of those days rejoiced in their nationality and hesitated not to call each other African or descendants of Africa."

African interaction was recognizable in New York, Pennsylvania, and New England from the mid-eighteenth century throughout the slave era and was essential to the formation of a single people out of a multiplicity of African ethnic groups in the North as well as the South. Indeed, ethnic interaction was common in black America and did not go unnoticed by observers of the times. What caught their eye at celebrations such as Emancipation Day—the variety of African peoples—was perhaps no less noticeable and hardly less consequential than when blacks had contact with each other in the normal course of events. In any case, apart from his links with Africa through members of his family, the presence of such disparate groups of Africans provided Henry with a broader conception of the possibilities for African unity in America and in the world.

Henry was twelve at the time of the parade and, though he understood little of the culture of those parading, the experience for him and the other participants had the effect of heightening whatever sense of oneness they possessed. A principal source of his nationalism, it appears, was rooted in that awareness, in the knowledge that he and his family were of African descent and *of* those in the parade. Related to the cultural interaction of participants in the parade in ways not fully understood was the assumption by black leaders of responsibility for their people everywhere. In the First African Baptist Society of Albany, New York, Reverend Nathaniel Paul, immediately after Emancipation Day, stated the prevalent thesis of black leaders regarding enslaved Africans: "The progress of emancipation, though slow, is nevertheless certain. . . . I therefore have no hesitation in declaring from this sacred place, that not only throughout the United States of America, but throughout every part of the habitable world where slavery exists, it will be abolished."

A measure of the potential for sophistication of New York blacks was the society of Garnet's classmates at the New York African Free School, established by the New York Manumission Society, whose membership included Alexander Hamilton. But the circle of Garnet's associates was charmed in its own right, for seldom had so talented a group of young black scholars been assembled in America, among them Crummell, who became an eminent pastor; Ira Aldridge, who gained fame abroad as a Shakespearean tragedian; Thomas S. Sidney, a precocious young scholar who died at an early age; and Samuel Ringgold Ward, who established a reputation as a logician of liberty. In youth they formed, together with others of talent, a network of relationships in which Garnet was at the center, one that in due course, given his uncommon ability, all but guaranteed him a place of leadership in black America. Moreover, Theodore S. Wright, the distinguished black Pres-

byterian minister who baptized and took Henry under his wing, helped direct the youth toward a path of future distinction and probably had some influence on his desire to become a minister.

Following their matriculation at the African Free School, Garnet, Sidney, and Crummell continued to study together. On invitation in 1835 from Noyes Academy, they traveled some 400 miles to Canaan, New Hampshire. It was a particularly trying time for Henry, who was suffering from a lame leg, for rarely would a hotel or an inn sell the youths food, and nowhere could they find shelter. Shortly after their arrival at Noyes—on the Fourth of July—a group of farmers from a wide region of New Hampshire resolved to put an end to the school, and they did so the following month, seizing the building "with ninety yoke of oxen" and dragging it "off into a swamp about a half mile from its site." This violent act led Henry and his band of friends, including eleven other blacks in attendance, to prepare for an expected attempt on their lives. Under Henry's leadership—he was then nineteen—they moulded bullets and, as night fell, waited in darkness. The pain of a bad leg burned steadily in Garnet's consciousness, compounded by his recollection of the long tension of his escape from slavery and his return from sea to find his family scattered by slave catchers. Such ruminations, even as he attempted to cheer up his classmates, ended as one swift rider passed their boardinghouse, firing at it as other lawless elements held back in the dark, an assault rebuffed as Garnet's shotgun "blazed through the window."

When the black students left Canaan, the mob gathered on the outskirts of the village and fired a cannon at the departing wagon. For his part Garnet had drawn strength from his past as he had from the blast of fire that halted the raiders that night in New Hampshire. Inheritance and experience were forming a leader in whom thoughtfulness and a willingness to take risks were present in fine measure, which helps to explain his readiness, within a decade of his experience at Canaan, to call slaves to resistance.

On hearing that the Oneida Institute in Whitesboro, New York, was open to black youth, Garnet repaired there and remained for three years, studying under Beriah Green, a fine teacher of "intellectual and moral philosophy" who believed in the capacity of blacks for scholarship. Garnet also studied Greek, logic and rhetoric, the sciences of government, and the New Testament. Despite the opportunity for systematic study, poor health prevented him from availing himself of it. At Oneida he was largely thrown back on his own intellectual resources, cultivating an original cast of mind, the most striking feature of which was a certain prophetic quality. Related to that was a quality of intuition, wrote Crummell, "by which, without any labored processes of reasoning, and free from all metaphysical verbiage, he invariably reached, as by a straight and sudden dash, the clearest conception of his argument." As

early as his African Free School days, Henry's brilliance apparently set him apart from even the brightest students around him.

Garnet's association with abolitionists through the African Free School (thanks to the New York Manumission Society), Noyes Academy, and the Oneida Institute had a powerful effect on him, leading him to accept some whites as allies in the struggle, all the more since he had met Thomas Garrett, whose role in his family's escape to freedom had been indispensable. But that meeting and his attendance at the African Free School had been arranged by his parents, the one a factor in his freedom, the other enabling him to begin his formal education, and both making it possible for friendly whites to come into his life without him seeking them out. Yet something of the suffering of blacks in the North as well as the South was witnessed by the Garnets, within the context of white American indifference, for Henry to see the negative aspects of black–white relations more than balance those that were positive. His awareness of an antislavery white minority and a proslavery majority was an argument for the view that the oppressed must take responsibility for liberating themselves, which was the continuing example of his father, who sometimes proceeded him as a speaker on abolitionist platforms—on which Beriah Green was also present—in the late 1830s.

At a meeting commemorating the seventh anniversary of the American Anti-Slavery Society, Green arranged for his former student to address leading white abolitionists on the question of slavery. At roughly the same time Garnet came to the attention of the national black community as a theorist of black liberation during a nationalist–integrationist debate over the proper strategy for effecting liberation. In *The Colored American* he warned William Whipper and other advocates of integration—the spirit of which "ran all over the free states"—that one day they would realize that blacks have a better understanding of their cause than others and, therefore, if the work is to be done they must do it themselves. Using the pseudonym "Sidney" in response to Whipper's argument that only color-blind leadership could win freedom for blacks, Garnet declared self-exertion "the great law of our being." No matter how hard white abolitionists worked, the condition of his people would "remain the same . . . unmitigated, until we awaken to a consciousness of a momentous responsibility. . . . We occupy a position, and sustain relations which they cannot possibly assume. They are our allies—*Ours* is the battle."

The history of all liberation movements, including the American Revolution, Garnet argued, confirmed the wisdom of the position that the oppressed must free themselves. It would not be otherwise for his own people, a view widely supported by blacks in the antebellum period but one to which Garnet gave special resonance in his exchanges with Whipper. Not only did he agree that "who would be free themselves must strike the blow," but he found the strength to do so self-generative,

its source in his people. In the most comprehensive terms he affirmed
self-exertion as "the course hallowed by the efforts, and prayers, and
benedictions of receding age, and the living energy and undying fervor
of youth—the mode in which our best men, the living and the dead,
have labored—not ineffectually—for years, in behalf of the rights of the
people."

Garnet was pastoring in Troy, New York, when he pointed out in a
speech before the Liberty party in 1842 that profound obligations to
assist in the liberation process rested with whites. The efforts of the
Liberty party and its abolitionist supporters were in fact contributing to
the slaves' sense that "their claims to liberty and happiness" might be
established by law, which leaves in doubt how blacks could win the
battle through a legislative process dominated by whites. Nevertheless,
western abolitionists with their belief in political action based on the
Constitution as an antislavery document, in contrast to the Garrisonians
who thought their efforts were doomed to failure, gave the slaves reason
to believe they would one day "sit under their own vine and their own
fig tree." The slaves knew they had "friends in the North in whom they
may *confide* in case they are driven to desperation." Prefiguring in almost
precise detail a conclusion that Frederick Douglass would draw a few
years later, Garnet argued that it was that safety valve that prevented "a
general insurrection of the slaves from spreading carnage and devastation
throughout the entire south." But more powerful forces ruled out the
"deliverance" of slaves by violence: "No, the time for a last stern struggle
has not yet come (may it never be necessary.) The finger of the Almighty
will hold back the trigger, and his powerful arm will sheathe the sword
till the oppressor's cup is full."

Why he changed his mind so quickly is unclear, but within a year
Garnet had embraced a revolutionary stand. Impatience with the pace of
racial progress, despite the relatively short lapse of time between the
Liberty party speech and his "Address to the Slaves of the United States,"
was perhaps a factor, but the pace had been slow all along. A more
decisive influence, it is likely, was his reading or rereading of David
Walker's *Appeal*, issued in Boston in 1829 and widely banned in the
South, for there he met a stern God whose sword, if not flashing, was
ready to be unsheathed. Perhaps reading the *Appeal*, in which Walker's
criticism of the oppressor is unflinching, caused Garnet to call the slaves
to resistance. In doing so, though only twenty-eight, he spoke with the
authority of an older man, legitimizing that authority by invoking the
ancestors.

His address, delivered at Buffalo, New York, in 1843, at the Na-
tional Colored Convention, has not received the attention it deserves,
which makes it the more regrettable that we do not have a text either of
Douglass's response or of Garnet's response to Douglass, which lasted
an hour and a half and which some contemporaries have called Garnet's
greatest speech. One suspects that there has been so little analysis of the

address because scholarship generally holds that any major revolt would have been crushed, its chances of success having been almost nonexistent. When one considers, however, the fear that raced through the white South as a result of Nat Turner's revolt (though the revolt helped to cut off debate over the possibility of emancipating Virginia slaves), the fear in white Charleston that attended the Vesey conspiracy (though the conspiracy was brutally suppressed), and the fear that Walker's *Appeal* sent coursing through the white South (leading legislatures to ban its entry into a number of states), one can better appreciate Garnet's rationale in urging slave resistance. Moreover, the adoption of his views on slave resistance as those of the convention, with some obligation to circulate the document, would have strengthened black radicalism at the time and, it is likely, hastened the day of Douglass's adoption of a more militant strategy of black liberation.

Garnet himself, before his leg was amputated in 1840, had planned to go south to foment revolt. In any case, it was clear to him, from the revolts and conspiracies of the antebellum period, that a rising of thousands of slaves might not have been required to achieve his purpose; that resistance of the Nat Turner variety in three or four sections of the South simultaneously or in some degree of succession might have been a warning against slavery so stark as to force renewed debate, and possibly action, on slavery in Virginia and elsewhere. Indeed, Garnet allowed for such a possibility by invoking the names of Vesey and Turner as well as that of Toussaint. His exhortations were premised on the belief that the slaves' failure to bring a halt to their oppression guaranteed their offspring being heir to it, a subject considered in his earlier response to William Whipper:

> We behold our ancestors in the earliest situation in the country subjected to the most cruel wrongs and inhuman severities. Tracing their condition through successive generations, each and every succeeding one receiving to itself the accumulated sufferings and indignities of all the preceeding. . . . We come down to our times and find ourselves enfeebled in soul, power and capacity, with minds without culture . . . with such an amount of oppression upon us as to awaken a bitter sense of consciousness . . . of that oppression which is destroying with fearful certainty and unerring precision.

His concern with consciousness, with the need for slaves to realize in the clearest manner possible the master's dependence on them and therefore the absurdity of slavery, was brilliantly developed by the time he called on slaves, if need be, to die for freedom. The burden of that concern was the continuing and mounting cost of slavery, a concern that became more compelling with time, for the longer slavery persisted the more acute the consciousness of those who grasped the nature of their suffering, the more intolerable, therefore, their condition. Such a conception of consciousness recognized, crucially, that the source of African disaffection was originally an interior one: "Two hundred and twenty-

seven years ago, the first of our injured race were brought to the shores of America. They came not with their own consent, to find an unmolested enjoyment of the blessings of this fruitful soil."

The effects of oppression built in collective memory from the time blacks were wrenched from the African homeland. This was Garnet's meaning when he reminded slaves that their ancestors had come "with broken hearts, from their beloved native land, and were doomed to unrequited toil and deep degradation. Nor did their bondage end with emancipation by death." Just as a profound sense of oppression was retained by many slaves, their sense of freedom before enslavement was retained as well; together they were combustibles of liberty, as in the Garnet family's encounter with slavery. Garnet's father was born on the same plantation as his son, inheriting the condition of *his* father, who before being taken prisoner in a tribal war had been free in Africa. "But the fires of liberty were never quenched in the blood of the family; and they burst forth into an ardent flame in the bosom of George Garnet, the son of the native African warrior."

The experience of the Garnets was not unique; rather, it was Henry's ability to formulate it in spiritual and psychological terms that led him to argue at Buffalo that "years have rolled on, and tens of thousands have been borne on streams of blood and tears, to the shores of eternity." Since the passage of time only multiplied suffering, death as a consequence of seeking freedom might result less from a lack of forethought, as Thomas Jefferson argued, than from recognition that the alternative might be a life of never knowing freedom, of which Garnet was deeply conscious. The whole cycle of spiritual pain and unrest was captured in a single sentence: "Succeeding generations inherited their chains, and millions have come from eternity into time, and have returned again to the world of spirits, cursed and maimed by American Slavery." That perception was a source of Garnet's demand: "You had better all die— *die immediately*, than live slaves and entail your wretchedness upon your posterity. If you would be free in this generation, here is your only hope." He continued: "But you are a patient people. You act as though you were made for the special use of those devils. You act as though your daughters were born to pamper the lusts of your masters and overseers. And worse than all, you tamely submit while your lords tear your wives from your embraces and defile them before your eyes. In the name of God, we ask, are you men? Where is the blood of your fathers? Has it all run out of your veins?" Garnet added: "Awake, awake; millions of voices are calling you! Your dead fathers speak to you from their graves."

Douglass's opposition to Garnet's address was the decisive factor in its rejection. That the two were engaged in discussion of the merits of slave resistance added to the importance and dramatic tension of the debate, to which both brought impressive skills. Douglass could hardly have been better prepared to present the case of moral suasion, having

spent two years in the company of abolitionists of the stature of William Lloyd Garrison and Wendell Phillips. He argued for moral suasion "a little longer" in opposing Garnet, in whose person and address he found "too much physical force." He wished to avoid the insurrection that would occur if the advice "either of the address or the gentleman Garnet be followed." However, two years after the address at Buffalo, Douglass wrote: "But for these Holidays the slave would be forced to the wildest desperation; and woe betide the slaveholder, the day he ventures to remove or hinder the operation of those conductors! I warn him that, in such an event, a spirit will go forth in their midst, more to be dreaded than the most appalling earthquake."

Although Garnet's economic views were more fully developed at a later time, they had begun to flower as he entered public life earlier in the decade and help to explain the urgency of his plea for a slave revolt. In laying the foundation of much of the nation's wealth, the slaves demonstrated how much the master needed them. In fact, the basis of all that the master class valued, including its leisure, was made possible by slave labor. It was precisely their labor that "contributed greatly in supporting the science and literature of the South." It was absurd, therefore, for whites to argue that blacks were not prepared for freedom: "We are told that the slaves could not take care of themselves if they were free . . . when now they take care of themselves, and their masters too, and that under the blighting influence of slavery." Consequently, Garnet also encouraged slaves to demand wages, which was tantamount to a call to insurrection.

Despite the fact that his was perhaps the most genuinely creative mind in the cause of black liberation, Garnet was never able fully to consolidate his political influence in the national black community because radicals, no matter how deep their thought and broad their sympathies, lack strong political standing if not supported by large numbers of the rank and file of their people. Without such support their very strength leaves them vulnerable in some respects. Such is the reality against which Garnet's attempts to foster slave resistance and black autonomy generally in the 1840s must be viewed—the period during which his independence, as it would later, cost him politically and materially.

No leader of the black masses emerged anywhere in the North. The opposition blacks faced, together with the relative thinness of the black population, made the notion of a genuinely mass movement essentially a fiction. Not only were all branches of the federal government opposed to black liberation, but all except a handful of northern whites embraced the prevailing notions of black inferiority. Few black leaders, however, were more effective than Garnet in relating to ordinary blacks on most matters. Despite his learning, as teacher in the colored school in Troy, as minister there and in New York City and Washington, D.C., as abolitionist, and as spokesman for causes ranging from temperance and peace to that of the Liberty party, he did not hold himself aloof.

Whatever the subject under discussion, Garnet was said to have treated it with such lucidity that no one listening "could go away mystified or in doubt as to the cause which had been advocated," an approach that contributed to his effectiveness in winning a following among former slaves wherever he had contact with them. At Troy not a few joined his church and remained there rather than continue their journey along the Underground Railroad into Canada. A contemporary of his observed that every refugee and fugitive "was welcome to his board, and could command his purse." Such a combination of qualities later contributed to a level of popularity in New York that placed him at the head of the black community as its spokesman, especially during the 1860s, in matters affecting his people. And there as elsewhere the young of both sexes were drawn to him and spent many "long hours in the joyous converse he would pour out sparklingly, hour after hour, amid his friends."

The inspiration of David Walker contributed to Garnet's ability to relate to his people. He was so impressed by Walker's *Appeal* that he made a pilgrimage to Boston to meet Walker's widow and to see firsthand where and how Walker had lived, reporting that Walker had deliberately chosen a life of austerity out of concern for the less fortunate. Walker's selfless devotion to the liberation of his people was the stuff of revolutionary spirits, and from available evidence it seems clear that he served as an important model for Garnet. In his personal life Garnet, like Walker, hated "avarice" and opposed wealth. Crummell said of him: "The great fault in his character was in that direction. . . . There was a princeliness in his largeness which not seldom landed him into poverty."

The publication under Garnet's editorship of Walker's *Appeal* and his own *Address* in a single volume in 1848 represented an effort by Garnet to reassert the need for slave rebellion at a time when growing militancy in the black community, inspired in part by his stance at Buffalo, coincided with growing sentiment in Europe favoring rebellion of the oppressed. With the republication of his *Address*, what was thought incendiary five years earlier was no less so, given the conditions of the times and especially the impact Walker's *Appeal* might have in combination with it. Still, it was as though the moment was somehow lost, as Garnet's delivery of the precise address at a Troy, New York, meeting of the Colored National Convention in 1847 also indicated. In a sense there is about the Troy speech the suggestion of a scene from the past being rehearsed, or so it seems to us today. But such was not the case then, considering the intensity of emotions the speech engendered.

In Douglass's view Garnet became his antagonist some years after the Buffalo encounter, probably sometime in 1847 or the following year. But it appears their differences were rooted mainly in the Troy encounter and, circumstantial evidence suggests, in Garnet's revival of his call for slave resistance. In this regard it is well to note that Douglass's attitude toward Garnet was radically different a few years earlier. In October 1845, while lecturing in the British Isles, Douglass called Garnet "the

most intellectual and moral colored man that is now in our country." And they were on cordial, even confidential terms when Garnet, sometime in 1847, in speaking to Douglass of John Brown, lowered his voice to a whisper. But that subject could hardly have failed to revive memories for both men of the Buffalo convention and the narrow margin by which the Garnet blueprint for slave resistance was rejected.

Over a period of years the nature of the relationship between the two changed as each grew in stature and commanded larger followings. By 1847 Garnet and Douglass were almost peerless among black leaders generally. Under such circumstances their differences over questions of pivotal import all but ensured some hostility between them, especially since, whether by design or not, they were contesting for leadership of their people. And though he apparently did not say so in print, Garnet had every reason to resent the influence Douglass exercised among blacks in opposing his calls for slave resistance, all the more since that opposition was approved in influential white abolitionist circles. That so many of the theses Douglass had so brilliantly advanced were derivative must have been a source of irritation to a man of Garnet's cast of mind and character, coloring his estimate of Douglass, who challenged black leaders while admitting to "something like a slavish adoration" of the Garrisonians.

Douglass's role at Troy caused Garnet, perhaps as never before, to wonder about him. It was then, on the second day of the convention, that Garnet read "an eloquent and impressive Address to the Slaves of the United States," apparently with no less conviction than at Buffalo four years earlier. The issues raised by him were referred to a Committee on Abolition, headed by Douglass, which was to consider "the best means of alleviating Slavery and Caste in the United States." The committee's report affirmed moral suasion and denounced violence. That Garnet was the object of the report's attack was hardly disguised; his language — "rather *die freemen, than live to be slaves*" — answered with "this great nation is thundering in the ear of our enslaved fellow countrymen the terrible fiat, *you shall be slaves or die!*" With that as background, the committee proceeded to attack advocates of violence in purely contemptuous terms, finding slave insurrection "the perfection of folly, suicidal in the extreme and abominably wicked." Arguments for such a course were "absurd, unavailing, dangerous and mischievous ravings." It was the sort of statement, decisively influenced by Douglass, that Garnet had in mind when he referred to "poison" emanating from a lofty source as far as influence and ability were concerned.

But the pages of Douglass's *North Star* remained open to Garnet, as in 1848 when he addressed the concerns of humankind as a whole, advising that the highest good in society is found in educating colored and white, rich and poor, in the same institutions — a repudiation of both racial and class privilege and a move in the direction of a more general leveling of peoples. Conscious of revolutionary currents of the

time, and certainly prepared for them, Garnet spoke in explicitly radical terms: "This age is a revolutionary age, the time has been when we did not expect to see revolutions; but now they are daily passing before our eyes and change after change, and revolution after revolution will undoubtedly take place until all men are placed upon equality." That revolution must be economic as well as political was an ideal that was being explicitly affirmed in German and French radical circles through efforts to change the social order of those countries.

Garnet was no less influenced by the thought of white intellectuals in the economic than in the political sphere, but he made his own analysis and formulated a position applicable to his people and to whites as well. Like Walker he put the authority of God behind his belief in economic equality, asserting that when revolutions have run their course, "then and only . . . then, will all enjoy that liberty and equality that God has destined us to participate in." Economic determinism leading to equality was for him predicated upon Divine sanction, an equality as much the will of God as the political equality grounded in the Declaration of Independence. His celebration of such an ideal marked him off from most abolitionists of the period and illustrated his desire for fundamental economic change.

Shortly after his remarks on revolution in the *North Star*, Garnet elaborated upon his views concerning economic justice, defining the relationship between white workers and African slaves and between those workers and blacks with the advent of emancipation. His observations on the subject were elicited by an attack from Sidney Howard Gay, editor of *The National Anti-Slavery Standard*, on Gerrit Smith, an abolitionist of considerable standing in white and black America and Garnet's close friend. Gay accused Smith of being a land monopolist and charged that he did not believe in antislavery as much as he claimed—in fact, that "the overthrow of the monopoly of which he is so distinguished a representative is the first and real road to the destruction of the monopoly of laborers." Garnet argued that Smith had sought "to break every yoke":

> His language is, "I regard Land Monopoly, *take the world together*, as a far more abundant source of suffering and debasement, than is slavery." Take the world together, and you will find this remark to be true. In many parts of the world, where there is no chattel slavery, there do the iron heels of Land Monopolists grind out the life of the suffering poor. Behold Ireland! her mournful history records volumes. There is no slavery there, but the oppressions of Land Monopolists have engendered a lank and haggard famine, and the famine has swept away its thousands.

Garnet did not think his people could be completely free as long as whites were under the control of monopolists. The monopoly in land and labor of slaveholders had to be shattered as the first step toward

freedom for blacks in America. Slavery was the most extreme expression of monopoly, one attended by efforts to control the whole being, physical and psychological, of slave men, women, and children: "Look around you, and behold the bosoms of your loving wives heaving with untold agonies! Hear the cries of your poor children! Remember the stripes your fathers wore. Think of the torture and disgrace of your noble mothers." Formerly "property," Garnet found in slavery a powerful reason for opposing monopolists. While he did not refer specifically to capitalist control of labor, that had more to do with the language of the times and the stage of capitalist development in America than with want of personal distaste for the capitalist ethic. In any event he argued that blacks after slavery, under the yoke of monopolists, would still be grievously oppressed. And since he understood that the interests of those whose labor was controlled by monopolists would be interrelated following as during slavery, he would hardly have differed with Marx's assertion, in *Das Capital*, that "labor in the white skin can never be free so long as labor in a black skin is branded."

With a concern for the whole of humankind that was emblematic of most antebellum nationalists, Garnet argued that "the chains of the last slave on earth may be broken in twain and still, while the unholy system of landlordism prevails, nations and people will mourn: But the moment that this widespread and monstrous evil is destroyed the dawn of the gospel day will break forth, and the world will have rest." The agony of economic oppression was worldwide and tied to spiritual unrest and thus a central problem confronting the Christian world. "The history of the human race is but one continued struggle for rights," Garnet had declared in 1841, before either Hegel or Marx had come to the attention of American intellectuals. And that struggle was an outgrowth of the need for spiritual as well as physical liberation, spiritual liberation resulting from forcing the oppressor to respect one's humanity, which would lead an irresistible current to sweep away "time-sanctioned oppression and aged tyranny."

That the exploitation of one segment of humanity by another constituted the main source of the world's problems followed from Garnet's thesis that only with the cessation of such practices would the world know peace, a genuine religious life for humankind beginning at that point. It is precisely this view one must keep in mind if one is to understand Garnet's attitude toward the African Civilization Society and its efforts, in the 1850s, to initiate commercial ventures in a capitalist world. One must also note that Garnet would have stood little chance of bettering the economic lot of blacks in America and elsewhere through attempting to destroy capitalism. Unprepared spiritually to accept the fruits of capitalism for himself, he sought to bend the means of capitalism to the needs of his people. In dealing with the world as it was, he sought to transform it from within through the African Civilization Society and

its effort to destroy the market for American cotton, and from without through slave uprisings aimed at destroying slavery and with it billions of dollars in "property."

Garnet's conception of the source of prejudice against blacks — formed before racism in America, some believe, had taken on a life of its own — seems strikingly modern in its possibilities for class analysis but modern also in the degree to which he underestimated racism as a force in its own right. From as early as 1841, and for some time thereafter, he held that the condition of his people, not their color, caused whites to discriminate against them, a view in some respects contradicted by the realities of race confronting blacks of talent that led some to seek a home in Europe or in Canada rather than remain in so racist a country.

Garnet also had in mind a fundamental distinction between types of oppression and their relationship to color. Talking to free blacks after the war, he said: "You know it is better to work for Mr. Cash than Mr. Lash. . . . The more money you make, the lighter your skin will be. The more land and houses you get, the straighter your hair will be." He is, in part, speaking symbolically and understood that free labor, even though enslaved by the cash-nexus, is freer than slave labor. While among the first to sympathize with those suffering from economic exploitation in Europe and North America — he was considered a friend of white workers in New York — he nonetheless knew that the total physical enslavement of blacks in the Americas was without parallel in modern world history. Moreover, in bourgeois society physical characteristics do take a back seat to money. Much like a radical labor leader in our time, Garnet saw little alternative to fighting for better wages and living conditions for his people.

Though David Walker, in attacking avarice, laid the basis for compatibility between nationalism and socialism within the nationalist tradition, Garnet brought the two together in language that seems more modern than that of Walker. Unlike Walker, whose opposition to greed was applied specifically to the exploitation of people of color, Garnet's treatment of the subject was more easily applied to the oppressed of whatever color or circumstance and for that reason was more flexible theoretically. His formulation that exploited whites and blacks have similar interests, while insisting on the right of blacks to help determine the destiny of the country, contributed to liberation theory for all because it maximized possibilities for cooperation across racial lines without sacrificing the souls of black people. In that light Garnet had gone far toward reconciling the claims of nationalism and socialism with respect to America.

The gaining of independence by Liberia was probably responsible for Garnet favoring emigration by 1849. As with a number of questions of ideology, he formulated a distinctive position on emigration that later became the cornerstone of his African Civilization Society. While the

argument that blacks could never be free in America without significant emigration was conventional among black emigrationists, Garnet argued that blacks could win freedom in America with or without emigration, a position based on a conception of struggle on two fronts, the one at times reinforcing the other. But in some sense his support of selective movement out of America was evidence of growing disillusionment with racial conditions in America, for shortly thereafter he visited England and for a while considered remaining there.

The occasion of his departure for England drew a cutting attack from Douglass in the *North Star*. He charged Garnet with hypocrisy for urging violence at home while asking England for "moral aid" in the fight to abolish slavery—as if morality, as Garnet later pointed out, were inconsistent with a revolt of slaves. Another thrust was designed even more specifically for Douglass's English readership: "The man whose convictions do not go with his words is not fit to plead this cause. . . . his feelings towards us so far as we have been able to learn them, are those of bitter hostility. His cause here has been that of an enemy. . . . We prefer an open enemy to one in disguise."

Still, there was one respect in which Douglass's opinion of Garnet had not changed despite the lapse of years. When in Ireland he had said that Garnet had "no taint of European blood" to lead whites to assume his ability derived from other than African sources. Later, as if to prove that the anger directed at Garnet was somewhat extreme, Douglass lamented that no one of Garnet's ability was around to advance the cause. Douglass was not surprised by James McCune Smith's estimate of Garnet's performance abroad: "Here was a gentleman of splendid physique, polished manners, extensive learning, well up, especially in English poetry, ably filling the pulpits of their best divines, and bearing all the laurels in eloquence, wit, sarcasm, interlarded with soul-subduing pathos . . . and this gentleman an African of pure lineage, with no admixture of Saxon blood as the source of his unquestionable talent and genius."

Garnet did not hesitate to call for moral aid, urging England to cease purchasing the products of slave labor. Such a boycott might have delivered a deathblow to American slavery if similar articles were produced by free labor in Africa and Australia. Moreover, Garnet attacked the American Colonization Society, explaining that the men who complained that the laws of the land were against blacks and that blacks should leave America "would be first to transport them!"; and that no agent of the society would "attempt to appear at a meeting of coloured people in any city of the free states." He assured his audience that "whoever asserted that the coloured people or their true friends entertain any other sentiments than the deepest contempt and abhorrence for colonizationists asserts that which is entirely false." It was an argument consistent with his beliefs since youth and remained so years later when he headed

the African Civilization Society and insisted, in contrast to leaders of the American Colonization Society, that blacks could indeed achieve freedom and equality in America.

The temptation to remain in England was not strong enough for Garnet to resist an opportunity, which came in 1852, to do missionary work in Jamaica on invitation from the United Presbyterian Church of Scotland. By going to the West Indies his return to the United States was practically assured, though he remained in Jamaica somewhat longer than he must have anticipated. For some time he had moved among West Indians in New York, and in Cuba he had seen African slaves unloaded at the port of Havana. But the Jamaican stay provided Garnet with his first opportunity to live and work among West Indians over a sustained period of time, which contributed to his sense of the possibility for unity among people of African descent first inspired by his experiences as a youth in New York and as a cabin boy at sea. Illness ended his stay in Jamaica, and he returned to America early in 1856 to recuperate. Shortly thereafter Garnet succeeded Theodore Wright as pastor of Shiloh Presbyterian in New York City.

The period following his recuperation was one of intense activity. As Garnet established himself in his new post at Shiloh he discovered that black leaders generally had embraced views he had helped pioneer. Not only were the forces of black nationalism gaining strength among them but emigration sentiment, despite opposition from Douglass, was much stronger with Martin Delany, whom he came to respect, at the helm. Predictably, Garnet clashed with opponents of emigration, having in fact lived that creed in Jamaica and having been, by the time of his most serious debate over the subject, an emigrationist for nearly a decade.

A particular need to defend emigration resulted primarily from a cruel accusation against Garnet at a Boston abolitionist meeting in the summer of 1859 that he was a colonizationist. The charge prompted J. Sella Martin, in introducing him in Boston a few weeks later, to call attention to his "twenty-five years of sacrifice to the cause of the colored people in this country" and to note that he "now comes to remove the aspersions cast upon him in the late New England convention and to vindicate by his own statements, the position he occupies with regard to this movement."

It seemed, at the very start, like history coming full circle. Challenged from the audience by a black abolitionist objecting to meetings of colored men, Garnet was reminded of similar challenges twenty years before and expressed the belief that "we are in an age of progression" when colored people meet. "I tell you, my friends that we have been too long depending upon other people. Years have passed away and we have been looking to the Abolitionists to raise us. . . . I believe that God has a certain work for them to do, and that is to prepare the public mind for the full and free discussion of the subject. . . . the rest of the work we have to do ourselves." Denying that he was a colonizationist, Garnet

counterattacked: "Any man that says I am behind my back is an assassin and a coward; any man that says it to my face is a liar, and I stamp the infamous charge upon his forehead! I have hated the sentiments of the American Colonization Society from my childhood." But he had not abandoned his faith in the value of emigration to Africa which would lead to the establishment of a Negro nation. He had long since, for that matter, resolved to express his honest convictions on those subjects, as he later put it, "if taken to the stake." In a rare personal reference to his material circumstances Garnet concluded:

> It was said by a Boston friend, who has often taken me by the hand and sat by the same fire-side, and walked with me on the streets, and mused with me in sacred places: "I knew Garnet when he was poor and had not a cent in his pocket." I would say to him that if he knew me twenty-five years ago, when I was poor, he knows me today as the same poor man. And I expect to be a poor man till slavery is abolished. If slavery is not abolished before I die, I shall die a poor man. But in all my poverty my house has been open to the flying fugitive . . . and I have never received a penny for what I gave them, but divided with them my last crust.

He was on the side of the worker as well as the slave, as his final remark that evening indicated: "I care not a straw for the Scribes, Pharisees, and hypocrites; the common people will hear me."

In the fall of 1859, before John Brown's raid at Harpers Ferry, Garnet predicted that the freedom of his people was near: "I believe the sky is brightening, and though I may not live to see it, the day is not distant when, from the Atlantic to the Pacific, from Maine to California, the shouts of redeemed millions shall be heard." An ability to grasp the shape of things before they were palpable to others gave him an edge as a thinker and leader. Something of that quality enabled him to know that blacks, in the presence of land and labor monopolists, following emancipation, would be "heavy-laden with an up-hill course before them." Garnet understood that as well as any leader of his time in this country or abroad. And his solution to the fundamental problem that confronted his people remains no less relevant to the one confronting their descendants in our time.

Black Americans
and African Consciousness:
Du Bois, Woodson, and the Spell
of Africa

". . . A formidable task lay ahead for those who would attempt to establish the Negro's humanity by reclaiming his heritage, for the heritage of Negroes had been systematically scored for centuries . . . "

Contrary to the beliefs of all too many scholars, relatively large numbers of African Americans have for centuries identified with Africa. This identification has been reflected in Back-to-Africa movements, missionary efforts, historical–cultural references, and what I here refer to as the rhetoric of African recognition—that is, the acceptance and affirmation of one's African origins.

The major focus of this essay is on W. E. B. Du Bois and, to a lesser extent, Carter Woodson, two of this century's leading advocates of African consciousness among African Americans. These men, however, were not alone in their concern with African history and culture. Others—Martin Delany and Alexander Crummell during the nineteenth century, John Edward Bruce and Arthur Schomburg during the twentieth, to name a few—spent much of their lives in search of the African past. Though the latter two were not as well equipped by training to unravel what was a conundrum for most Americans in the early part of the century, their views are nevertheless mentioned, for both men played significant roles in promoting the study of African history and culture.

It is beyond the scope of this essay to attempt an exposition and interpretation of the full corpus of thought on Africa entertained by Du Bois and Woodson. My purpose is to present the most salient views of Du Bois and Woodson on Africa and test them at certain critical points against the findings of modern scholarship. In the process, I hope to determine the extent to which these men provided a better understanding of the history of Africa. Moreover, the views of Du Bois and Woodson are presented against that backdrop of African consciousness among many Negroes which persisted, despite efforts at repression, over the centuries.

With respect to Du Bois's writings on the psyches of persons of African descent, I want to suggest, through the introduction of fairly representative examples of his thinking on the subject, an analogy between his views and the Negritude school(s) of thought.

Finally, I have not entered into a discussion of either the Garvey movement or the New Negro movement. But certainly a more complete treatment of the conflict between Garvey and Du Bois over the African question is much needed and long overdue. And an examination of the artistic views held by Du Bois vis-à-vis poets like Langston Hughes, Claude Mckay, and Countee Cullen would certainly throw into sharper relief the particular variant of "Negritude" espoused by Du Bois.

> *The spell of Africa is upon me. The ancient witchery of her medicine is burning my drowsy, dreamy blood. This is not a country, it is a world—a universe of itself and for itself, a thing Different, Immense, Menacing, Alluring. It is a great black bosom where the Spirit longs to die. It is a life so burning, so fire encircled that one bursts with terrible soul inflaming life. One longs to leap against the sun, and then calls, like some great hand of fate, the slow, silent, crushing power of almighty sleep—of Silence, of immovable Power beyond, within, around. Then comes the calm. The dreamless beat of midday stillness, at dusk, at dawn, at noon, always. . . . Africa is the Spiritual Frontier of human kind."*
>
> From W. E. B. Du Bois's "Little Portraits of Africa," 1924.

However terrible the shocks through which slaves went before and after their arrival in America, articulate ones among the race throughout the centuries identified with Africa. In making this identification, they spoke for a large segment of the inarticulate masses. Benjamin Banneker, writing at a time when mockery was made of the Negro's color and ancestral home, wrote to Thomas Jefferson in 1791 that he "freely and cheerfully" acknowledged the fact that he was of "the African race, and in that color which is natural to them of the deepest dye."[1] Forty years later David Walker, in his militant *Appeal*, urged the slaves to revolt, exclaiming, "if any are anxious to ascertain who I am, know the world that I am one of the oppressed, degraded and wretched sons of Africa, rendered so by the avaricious and unmerciful among the whites."[2] Between Banneker's letter and Walker's *Appeal*, an event took place which probably had much to do with the way many nineteenth-century Negroes were later to view Africa—in 1816 the American Colonization Society was founded for the purpose of transporting free Negroes back to Africa. St. Clair Drake has observed:

[1] Herbert Aptheker, *A Documentary History of the Negro People in the United States* (New York, 1951), Vol. 1, p. 25.
[2] *Ibid.*, p. 97.

I have a theory that the word African began to drop out after the American Colonization Society was started in the hope of getting Negroes forcibly or persuasively back to Africa. At this point it was probably safer to drop the word African and use colored. If you talk too much about being an African, maybe someone will ask you why you don't go *back* there. The point that I have been trying to make is that there was a time when there was an acceptance of the idea of African origins, and at the mass level it persisted through the years (italics added).[3]

Drake is probably correct in his theory that after the formation of the American Colonization Society many Negroes tended to eschew use of the word "African" and opt for "colored." Nevertheless, the use of the word "African" was much in evidence throughout the nineteenth century, having frequently been used by Negro abolitionists and intellectuals — notably Henry H. Garnet and Alexander Crummell — and Reconstruction leaders such as Richard Cain and Bishop Henry M. Turner. Indeed, these men not only frequently referred to Negroes as Africans but made a more significant identification with Africa by advocating at one time or another emigration to Africa.[4] In this regard, Crummell and Turner had lasting influence.

Free Negro identification with Africa at the turn of the nineteenth century seemed to be, as it had been during earlier periods, closely related to how Negroes were faring in America. During the 1850s, increasingly large numbers of Negroes became disenchanted with race relations and either looked to Africa or to Central America as a place of refuge — in much the same way that embattled Jews have looked to Israel in our time. The harsh decades from 1870 to 1900 doubtless contributed to the efficacy of Bishop Turner's Back-to-Africa movement, and to the growth of African consciousness along historical lines by the close of the century. "Unquestionably as the lines of race hardened in the opening years of the century," August Meier has written, "there was an increasing tendency to use Negro history to foster race pride and group solidarity as the basis of advancement by collective action and as an antidote to prejudice and discrimination."[5] As an expression of this growing interest in the heritage of people of African descent, there was a veritable proliferation of Negro history groups. Prominent among such groups were the American Negro Historical Society (1897), the Negro Society for Historical Research (1912), and the Association for the Study of Negro Life and History (1915).

It should be recalled that the influence of social Darwinism was not

[3]St. Clair Drake, "The Meaning of Negritude: The Negro's Stake in Africa," *Negro Digest*, XIII, No. 8 (June 1964), p. 39.

[4]For a fascinating discussion of African American identification with Africa during the latter part of the nineteenth century, see August Meier, *Negro Thought in America* (Ann Arbor, 1963), Chapter XIV.

[5]*Ibid.*, pp. 261–62.

inconsiderable in America during the last quarter of the nineteenth century and the early decades of the twentieth century, the period during which Negroes were becoming increasingly interested in their history. Glorifiers of the Anglo-Saxon race sat in some of the most important seats of learning, propounding the thesis that only the Teutonic nations were able to maintain states in which freedom could flourish. James K. Hosmer (*Short History of Anglo-Saxon Freedom*, 1890) and John W. Burgess (*Political Science and Comparative Constitutional Law*, 1890) celebrated the Anglo-Saxon virtues and sought to establish the view that "government of the people and by the people is of ancient Anglo-Saxon origin."[6] Rejecting the notion that Africans and Asians could govern themselves, Hosmer concluded that "The inevitable issue is to be that the primacy of the world will lie with us. English institutions, English speech, English thought, are to become the main features of the political, social, and intellectual life of mankind."[7]

People of color, to be sure, were unfit and not likely to survive. But the traducers of people of African descent in the Western world had long been active. Drake has written:

> The article on the Negro in the 1797 issue of the Encyclopedia Britannica presented a list of alleged racial Negro characteristics which included treachery, cruelty, impudence, intemperance, and a penchant for stealing, lying, debauchery, and profanity. Negroes are said to be strangers to every sentiment of compassion and . . . an example of the corruption of man when left to himself.[8]

Thus a formidable task lay ahead for those who would attempt to establish the Negro's humanity by reclaiming his heritage, for the heritage of Negroes—slave as well as African—had been systematically scored for centuries. While it would be easier for Negro scholars and writers to demonstrate Negro achievement in America—Nell, William Wells Brown, and George Washington Williams had long since documented Negro achievements from the colonial period to the Civil War— the job of discovering African achievement would, for a number of reasons, be much more formidable.[9] For one thing, previous identification with Africa among nineteenth-century free Negroes had taken, in the main, missionary or emigrationist lines. For another, European expansion into Africa during the nineteenth century had been attended by considerable anti-African propaganda. "This expansion," according to Drake, "came at a period when the coincidence of certain factors made

[6]Richard Hofstadter, *Social Darwinism in American Thought* (Boston, 1964), pp. 174–75.

[7]*Ibid.*, p. 174.

[8]St. Clair Drake, "An Approach to the Evaluation of African Societies," *Africa from the Point of View of American Negro Scholars* (Paris, 1958), p. 16.

[9]Aptheker, *Documentary History*, Vol. 1, Preface.

an extremely derogatory appraisal of Africa almost inevitable." Among
these factors were "the tide of humanitarian sentiment," the theory of
the "survival of the fittest," the movement to "set out to 'save Africa for
Christ,'" the attempt to partition Africa and break native resistance, and
"the rapid increase of literacy, which laid the base for a penny press
selling sensationalism."[10]

The members of the various American Negro historical associations
were not unmindful of this propaganda. They, like other American Ne-
groes growing up in the early part of the twentieth century, probably
heard of Africa in church when ministers appealed for financial aid to
support missionary work in Africa.[11] The president of the Negro Society
for Historical Research, John Edward Bruce, in some ways anticipating
Cheikh Anta Diop, declared that the history of whites prior to 850 B.C.
was a "monumental fraud," "a total blank." The white man "stole his
alphabet," and derived his knowledge of science and religion from an-
cient African civilization, which bore more than favorable comparison
in many respects to modern Europe.[12] The secretary of the society, Ar-
thur A. Schomburg, urged Negroes to learn Arabic "because much of
our life is undoubtedly wrapped up" in the history, customs, and tradi-
tions of Africa. Negro history should be taught in the public schools
because "it is the season for us to devote our time to kindling the torches
that will inspire us to racial integrity."[13]

The most impressive and scholarly work done by Negroes to recover
the African past and instill pride in Negroes, however, was done by
Carter Woodson and W. E. B. Du Bois. Though both were better
equipped by training than men like Bruce and Schomburg, there was no
question that they were out to prove, through the application of science
to history, the essential humanity of people of African descent.[14] This
desire led both men to attack Negro stereotypes born of the slave experi-
ence as well as those more directly related to European expansion into
Africa at the close of the nineteenth century.

As one of the first Negro scholars thoroughly grounded in the scien-
tific method of handling historical materials, Carter Woodson was a
leader in the effort to present a more faithful representation of the Ne-

[10]Drake, *Africa and American Negro Scholars*, p. 17.

[11]Rayford Logan, "The American Negro's View of Africa," *Africa from the Point of
View of American Negro Scholars* (Paris, 1958), p. 218.

[12]Meier, *Negro Thought*, p. 263.

[13]*Ibid.*, p. 262. Schomburg's suggestion that Negroes learn Arabic has come to partial
fruition at least in the Nation of Islam movement, as the Muslims teach the Arabic language
in their "universities." Perhaps Schomburg's impact was made not so much as a result of
his propagandizing in behalf of refashioning the image of Negroes as through his impressive
collection of works by and about Negroes. In this regard, he left a legacy of inestimable
value.

[14]Commenting on Woodson, Kelly Miller has said that, "His dominant purpose was to
turn his historical training and preparation to the best racial account." See Carter Wood-
son, *The Negro in our History* (Washington, D.C., 1922), Preface.

gro's past. It might be said that his concern over the harm being done to the American Negro's psyche by racist propaganda led him to explore the African roots of that past. L. D. Reddick, writing in *Crisis*, has described the forces which led Woodson to realize the need for a racial revision of the writing of the history of people of African descent:

> Woodson saw clearly what American culture was doing to the psyche of the Negro. Racist elements were strong whether one looked at literature, newspapers, science or social science. Historically, most of the nation's scientists—social as well as natural—had gone along with the theory that the Negro was a more "animal-like" physical type and definitely inferior mentally. Actually, the whole context of this consideration was subjective; yet, to the man in the street, the words of an eminent biologist, anthropologist or psychologist meant "scientific proof."[15]

It was this "scientific proof" that Woodson set out to challenge. In his most noted work, *The Negro in Our History*, he devotes four chapters to African history and one to African art. Writing in 1922, a time in which few American historians evinced an interest in African history, Woodson discusses, among other things, the geography of Africa, the myth of African inferiority, and the misrepresentations of travelers, public functionaries, and missionaries in Africa. Concerning the missionaries, he reports that among a few there was "some tendency toward fair-mindedness" and an attempt "to rise unto an appreciation of the African's contribution to civilization." Many of them, however, "use exaggerating language, contradicting themselves in praising Africans in one place and denouncing them in another." The missionary's account of the African cannot, in the main, be relied on, for "it would be unwise to expect that the partisans of a particular religion seeking to uproot another can be depended upon to report definitely on the virtues of the people whom they would proselyte." Woodson observed that if the missionary had a good impression "of the natives' religion and morals" he would necessarily "be disqualified for missionary effort." He argues that "the books written by most of these missionaries, therefore, are largely worthless in arriving at an appreciation of African culture."[16]

Implicit in Woodson's criticism of the accounts of travelers, public functionaries, and missionaries was his own deep appreciation of African civilization. He believed that black Africans had not only distinguished themselves in developing and maintaining empires of the stature of Ghana, Mali, and Songhay but were, in large measure, responsible for the birth of Egyptian civilization. For Carter Woodson, "History seems to indicate that that country [Egypt] was first settled by a Negro tribe that mingled later with Mediterranean people coming from the north." Egypt was "the land of mixed breed or persons comparable to Negroes

[15]L. D. Reddick, "As I Remember Woodson," *Crisis*, LX (February 1950), p. 178.
[16]Woodson, *The Negro in Our History*, pp. 6–7.

passing" in America. "One-third of the Egyptians," in his view, "were distinctly black."[17]

Woodson based much of his thinking on black African influence in Egypt on the works of the distinguished anthropologist Franz Boas, particularly Boas's *The Mind of Primitive Man*, and Leo Frobenius's *The Voice of Africa*. Though railed at by many who thought he was making too much of black African achievements, Woodson's insistence that Egypt was greatly influenced by black Africa has since been corroborated by many distinguished Africanists, notably Basil Davidson and Immanuel Wallerstein. To be sure, few serious students of Africa today deny this influence, though there is some disagreement as to the extent of black African participation in the construction of Egyptian civilization.

Carter Woodson devoted considerable attention to African empires in his writings; this was especially true as regards his treatment of Ghana. "More than any other American," says Rayford Logan, "Woodson . . . made known the medieval kingdom of Ghana so that it evoked real meaning when the Gold Coast became self-governing on March 6, 1957."[18] His *The African Background Outlined*, according to Melville J. Herskovits, represented a serious attempt "to comprehend the entire picture of the Negro, African and New World, in its historical and functional setting."[19]

Woodson's discussion of African institutions does not for the most part vary significantly from what anthropologists such as Herskovits have subsequently written concerning traditional African life and customs. He clearly demonstrated that there was nothing simple and "backward" about the organization of African societies with respect to the training of children, the conception of religion, the morals of the people, and the forms of political organization. And Woodson fully realized the need for American Negroes to understand and appreciate these aspects of the African past. "For," as Herskovits has remarked concerning this matter, "no group in the population of this country has been more completely convinced of the inferior nature of the African background than have the Negroes."[20]

Woodson, speaking of general reactions among Negroes, framed the problem in 1937, in these terms:

> Negroes themselves accept as a compliment the theory of a complete break with Africa, for above all things they do not care to be known as resembling in any way these "terrible Africans." On the other hand, the whites prate considerably about what they have preserved of the ancient cultures of the "Teutons" or "Anglo-Saxons," emphasizing especially the good and saying

[17]See Basil Davidson, *The Lost Cities of Africa* (Boston and Toronto, 1959), pp. 25–34; and Immanuel Wallerstein, *Africa: The Politics of Independence* (New York, 1961), p. 13.

[18]Logan, *Africa and American Negro Scholars*, p. 220.

[19]Melville Herskovits, *The Myth of the Negro Past* (Boston, 1958), p. 2.

[20]Quoted in *ibid.*, p. 31.

nothing about the undesirable practices. If you tell a white man that his institution of lynching is the result of raising the "hue and cry" among his tribal ancestors in Germany or that his custom of dealing unceremoniously with both foreigners or Negro citizens regardless of statutory prohibitions is the vestigial harking back to the Teuton's practice of the "personality of the law," he becomes enraged. And so do Negroes when you inform them that their religious practices differ from those of their white neighbors chiefly to the extent that they have combined the European with the African superstition.[21]

Just as Woodson detected African influences in American Negro religious practices, so did he view New World Negro artistic expression as being under the strong influence of Africa, which was, in his view, the "natural setting." Indeed, Woodson held to a view of the Negro much like that held by later proponents of Negritude. "It is generally agreed now," he wrote, "that the Negro has more of a spiritual makeup than other races. He has not permitted his mind wholly to dominate his body. He feels things deeply and he can express them emotionally." The Negro's art could be explained by "his temperament" or "his natural gifts."

> Art . . . tends to reproduce itself. Nothing is ever destroyed altogether. And what the Negro accomplished in Africa was not lost. His art tended to revive in the slave on the American plantation. It appeared in the tasks, proverbs and riddles of the plantation Negroes. The tribal chants of the African paved the way for the spirituals, the religious expression of the slave.[22]

No one else popularized interest in Africa among American Negroes as much as Woodson. He could number scholars and large segments of the Negro people among his followers. The interest in Africa inspired by Woodson was accomplished through the annual meetings of the Association for the Study of Negro Life and History, which he headed; through his Negro History Week celebrations, which he began promoting in 1926;[23] and through the pages of the *Journal of Negro History*. In addition to the meetings of the Association and Negro History Week as vehicles for imparting information on Africa was *The Negro in Our History*, a book which had gone through eight printings by the end of World War II. Though undistinguished in style and organization, this book, as Rayford W. Logan pointed out in 1945, "conveyed to more persons, white and black, pertinent information about the Negro than has any other single volume."[24]

In the year Carter Woodson established the Association for the Study of Negro Life and History, the Home University Library brought out

[21]*Ibid.*
[22]Woodson, *The Negro in Our History*, p. 628.
[23]Logan, *Africa and American Negro Scholars*, p. 220.
[24]Rayford Logan, "Carter G. Woodson," *Phylon*, VI (Fourth Quarter 1945), p. 316.

W. E. B. Du Bois's slim little volume *The Negro*. If Woodson had a greater impact on American Negroes in the promotion of African history, Du Bois's influence on Africans and the American academic community was destined to be far greater. Very early in his life, while but a child on his great-grandmother's knee, he had his first introduction to Africa. It is of no small significance that his introduction was cultural:

> With Africa I had only one direct cultural connection and that was the African melody which my great-grandmother used to sing. Where she learned it, I do not know. Perhaps she herself was born in Africa or had it of a mother or father stolen and transported. But at any rate, "coming to the valleys of the Hudson and Housatonic, black, little, and lithe, she shivered and shrank in the harsh north winds, looked longingly at the hills, and often crooned a heathen melody to the child between her knees, thus:
>
> > *Do bana coba, gene me, gene me!*
> > *Do bana coba, gene me, gene me!*
> > *Ben d'nuli, nuli, nuli, ben d'le."*[25]

If the significance of this strange music did not surface upon the consciousness of Du Bois until later, his "African racial feeling" came exclusively from his "later learning and reaction," his "recoil from the assumptions of the whites," and his "experience in the South and at Fisk." He felt himself "African by 'race,'" "an integral member of the group of dark Americans who were called Negroes."[26] By the time he entered Harvard in 1888, Du Bois, largely due to his experiences at Fisk University, had already developed an interest in Negro American culture much superior to that of most Negro students. So close were Africans and Negroes linked together in his mind that he chose for his Harvard commencement address the topic "Jefferson Davis and the African," which was later changed to "Jefferson Davis As a Representative of Civilization."[27] In his master's thesis—"The Suppression of the Slave Trade"—Africa and the American Negro were again linked. This study was published in the Annual Report of the American Historical Association as "The Enforcement of the Slave Trade Laws." But

> The first of the major Du Bois historical works which earned for him the title of historian was through the publication of the volume, *The Suppression of the African Slave Trade to the United States of America, 1638–1870*, in partial fulfillment for the degree of Doctor of Philosophy awarded in 1895 at Harvard University. Du Bois was 24 years of age when he worked on this subject. There were 12 chapters and appendices embracing colonist and state legislation and typical slave trade cases in 335 pages, with voluminous footnotes and a bibliography.[28]

[25]W. E. B. Du Bois, *Dusk of Dawn* (New York, 1940), p. 114.

[26]*Ibid.*, p. 115.

[27]Charles Wesley, "W. E. B. Du Bois: The Historian," *Journal of Negro History* (July 1965), p. 149.

[28]*Ibid.*, p. 150.

The study won a place as the first volume of the Harvard Historical Series. Daniel P. Mannix and Malcolm Cowley remark in *Black Cargoes* that *The Suppression of the African Slave Trade* "has not been superseded as an account of the political struggles over the trade."[29] Du Bois based the study on national and state historical sources, colonial statutes, congressional documents, personal narratives, and reports of antislavery societies. Reviews of the book in the *American Historical Review*, 1897; the *English Historical Review*, 1897; the *Annals of the American Academy*, 1897; the *Atlantic Monthly*, 1897; and the *Nation*, 1897, were, on the whole, quite favorable.[30]

At this point in his intellectual development, Du Bois had not evinced a serious interest in African history as such. While at Harvard, Albert Bushnell Hart had directed his attention to the history of the Negro, but there was at Harvard at that time little knowledge of or interest in the history of Africa. Four years prior to the publication of his doctoral dissertation, however, Du Bois had resolved to "make a name in science, to make a name in literature and thus to raise my race."[31] This decision, before long, led him to deepen his interest in Africa. By 1900, Du Bois was in London writing the resolutions for the first Pan-African conference. In an address written for the occasion, Du Bois identified those present as "men and women of African blood" and declared that the history of the world, "both ancient and modern, has given many instances of no despicable ability and capacity among the blackest races of men."[32]

Du Bois called for the cessation of sacrificing African natives to "the greed of gold," cautioned against robbing them of their liberties, debauching their family life, and repressing their aspirations. He spoke of "the ruthless economic exploitation and political downfall of less developed nations," and called on Britain, Germany, and France to look to the best in their traditions and promote "progress and prosperity" in their colonies. The identification of Negro American and African, which Du Bois earlier had made an integral part of his thinking, was expressed on the political plane in a passage which brought together people of African descent throughout the world:

> Let the nations of the world respect the integrity and independence of the free Negro states of Abyssinia, Liberia, Haiti, and the rest, and let the inhabitants of these states, the independent tribes of Africa, the Negroes of the West Indies and America, and the black subjects of all nations take courage, strive ceaselessly, and fight bravely, that they may prove to the world their incontestable right to be counted among the great brotherhood of mankind.[33]

[29]Daniel Mannix and Malcolm Cowley, *Black Cargoes* (New York, 1962), p. 288.
[30]Aptheker, *Documentary History*, Vol. II, p. 753.
[31]W. E. B. Du Bois, *An A B C of Color* (Berlin, 1963), pp. 20–21.
[32]*Ibid.*, p. 21.
[33]*Ibid.*, p. 23.

His championing of Pan-Africanism dates from that address which followed by fifteen years the Congress of Berlin. At a time when practically the whole of Africa was under European domination, Du Bois was affirming the essential humanity of Africans and calling for an end to the exploitation of that continent. But it would not be until some fifteen years later that he would attempt to set forth the contributions to world history of the "blackest races of men."

In 1906, Franz Boas spoke at Atlanta University. Du Bois was never the same after hearing the words of the great anthropologist. It was Boas who brought the history of Africa to his attention:

> Few today are interested in Negro history because they feel the matter settled: the Negro has no history. . . . I remember my own sudden awakening from the paralysis of this judgment taught me in high school and in two of the world's great universities. Franz Boas came to Atlanta University where I was teaching history in 1906 and said to a graduating class: You need not be ashamed of your African past; and then he recounted the history of the black kingdoms of the Sahara for a thousand years. I was too astonished to speak. All of this I had never heard and I came then and afterwards to realize how the silence and neglect of science can let truth utterly disappear or even be unconsciously distorted.[34]

In 1915, Du Bois's *The Negro* appeared. Including chapters on Ethiopia and Egypt, African culture, the slave trade, and the West Coast of Africa, the book was in many ways, up to that time, the most impressive one written by an American in the field of African history. Writing in the preface to the book, Du Bois pointed out that "the time has not yet come for a complete history of the Negro peoples." Noting the fact that archaeological research had just begun in Africa, Du Bois contended that "racial prejudice against darker peoples" was "too strong in so-called civilized centers for judicial appraisement" of Africa. Dr. Du Bois essayed to present "such short general statement of the main known facts and their fair interpretation as shall enable the general reader to know as men a sixth or more of the human race."[35]

The Negro was of interest to the scholar as well as to the general reader. Small in size but large in quality, the book utilizes the theories of Franz Boas and Guiseppi Sergi. Additional writers on whom Du Bois relied in varying degrees were Ibn Batuta, Leo Africanus, Leo Frobenius, H. Barth, W. D. Cooley, Lady Lugard, and E. W. Blyden, to name a few. Most Africanists today will probably not subscribe to Du Bois's view—borrowed from Boas—that black African people were the first to smelt iron, but his assertion that Egypt was influenced by black Africans is agreed upon by a significant number of scholars, and his outline of West African empires seems, in the main, consonant with the best of

[34]W. E. B. Du Bois, *Black Folk: Then and Now* (New York, 1939), Preface.
[35]W. E. B. Du Bois, *The Negro* (New York, 1915), Preface.

modern scholarship. At the time Du Bois wrote of these empires, few
scholars were willing to believe they even existed.

Dr. Du Bois, in addition to challenging the Aryan myth of superior-
ity, took issue with those who espoused the view that Islam was responsi-
ble for the creation of West African states, a position still subscribed to
by some scholars:

> Islam did not found new states, but modified and united Negro states al-
> ready ancient; it did not initiate new commerce, but developed a widespread
> trade already established. It is, as Frobenius says, "easily proved from chron-
> icles written in Arabic that Islam was only effective in fact as a fertilizer and
> stimulant."[36]

Efforts to ascribe the artistic products of Yoruban civilization to the
white race also came in for considerable criticism, as did similar efforts—
so fashionable at the time *The Negro* was written—to attribute every
evidence of sophisticated achievement to the inspiration of white peo-
ple.[37] Du Bois, in concluding, sets forth the thesis of class conflict and
the unity of the white and black working classes for the establishment of
a better society. "Writing vigorously and succinctly," Wesley remarks,
"Du Bois presented facts about African history and culture which were
unknown in 1915, a time when the concept of racial inferiority and
African savagery were rampant and dominant in the thought of the
American people."[38]

In the preface to *Black Folk: Then and Now*, a work published in
1939, Du Bois commented that he wanted "to do again, and I hope
somewhat more thoroughly, the task which I attempted twenty-three
years ago in a little volume of the Home University Library, called *The
Negro*." He tells us the reader that some of the material of *The Negro* is
incorporated in *Black Folk: Then and Now* but that the new book is "an
entirely new production and seeks to bring to notice the facts concerning
the Negro, if not entirely according to the results of thorough scholar-
ship, at least with scholarship as good as I am able to command with the
time and money at my disposal."[39] Du Bois does not hide the fact that,
in addition to his role as an historian, he will be the advocate of people
of African descent, observing:

> I do not for a moment doubt that my Negro descent and narrow group
> culture have in many ways predisposed me to interpret my facts too favor-
> ably for my race; but there is little danger of long misleading here, for the
> champions of white folk are legion. The Negro has long been the clown of
> history; the football of anthropology; and the slave of industry. I am trying
> to show here why these attitudes can no longer be maintained. I realize that

[36]*Ibid.*, pp. 50–51.
[37]*Ibid.*, pp. 65–66.
[38]Wesley, "Du Bois: The Historian," p. 65.
[39]Du Bois, *Black Folk*, Preface.

the truth of history lies not in the mouths of partisans but rather in the calm Science that sits between. Her cause I seek to serve, and wherever I fail, I am at least paying Truth the respect of earnest effort.[40]

Du Bois was concerned, therefore, not only about the history of people of African descent, but, in addition, with the relationship of these facts upon race prejudice in the modern world. Utilizing materials unavailable at the time *The Negro* was written, he seeks to re-evaluate Africa and its civilization in the light of these more recent findings. There is a somewhat detailed discussion of the word "Negro," one in which Du Bois points out the fallacy of restricting it to certain groups of Africans. The black and brown people of Ethiopia, Egypt and North Africa, according to the American standard, would be regarded as Negroes, not whites as certain writers designate them.

In essential agreement with Carter Woodson, Du Bois, in *Black Folk: Then and Now*, attacks the practice of designating Hamitic peoples as white. It is his view that millions of Negroids — "some of them the blackest of men" — under cover of the term "Hamite," were "characteristically transferred to the 'white' race by some eager scientists." He contends that a "Hamite" is simply a mulatto of ancient Negro and Semitic blood."[41] Thus, according to Du Bois, the civilizations of North Africa, owing to the infusion of Negro blood, must be considered at least in part Negroid civilizations, a position not only attested by contemporaries such as Franz Boas but one which is supported by later scholars such as Immanuel Wallerstein of Columbia University:

> Suffice it to say now, for the purpose of discussing the African past, that the best evidence of today seems to indicate a very great racial intermingling, in Africa as elsewhere, over the past five thousand years, and that the "Egyptians" or "Hamites" of yesteryear might well find themselves classified as Negroes today, in precisely those countries where such classifications matter. Suffice it further to note that many of the archaeological remains of which we shall speak, at first credited to "Arabs" or "Hamites," have on closer, or less biased, inspection, turned out to be unmistakably Negro-African in origin.[42]

In his chapter, "The Trade in Men" Du Bois sets forth a number of interesting theories. He ascribes the decline of African culture to the slave trade, which, he contends, robbed Africa of from a fourth to a third of its population. "Whole regions were depopulated, whole tribes disappeared," and "the character of the people developed excesses of cruelty instead of the flourishing arts of peace." "And yet," Du Bois avers, "people ask today the cause of the stagnation of culture in that land since 1600!" There are, to be sure, many Africanists who today would question Du Bois's position regarding the number of people lost

[40]*Ibid.*
[41]*Ibid.*, p. 6.
[42]Immanuel Wallerstein, *Africa: The Politics of Independence* (New York, 1961), p. 13.

to the slave trade, their figures being considerably more conservative than his. Yet few deny the contention that the impact of the trade, however much it accelerated commerce and stimulated the growth of new kingdoms, wreaked considerable havoc among the people whom the trade affected most.[43]

Du Bois speaks of the "great and significant" contribution of the labor of blacks that the trade made available to the rise of Western industry and the growth of capitalism, a position that Eric Williams was later to develop in some considerable detail in his *Capitalism and Slavery*. Whatever the contribution of brawn, however, the human loss was staggering:

> Raphael painted, Luther preached, Corneille wrote, and Milton sang; and through it all, for 400 years, the dark captives wound to the sea amid the bleaching bones of the dead; for 400 years the sharks followed the scurrying ships; for 400 years America was strewn with the living and dying millions of a transplanted race; for 400 years Ethiopia stretched forth her hands unto God.[44]

Something of the poet—of the historian and prose writer at his best—is reflected in the above passage. He is more clearly the advocate in *The World and Africa*. This work includes a number of chapters on African history, chapters which are in some respects quite similar to those found in *The Negro* and *Black Folk: Then and Now*. The edition published in 1965 contains essays on Pan-Africanism, the relationship between Africa and China, and a variety of additional pieces which appeared originally in newspapers. In the foreword of the 1946 edition, however, Du Bois describes *The World and Africa* as "not so much a history of Negroid peoples as a statement of their integral role in human history from prehistoric to modern times."[45] The 1965 edition is that and more: Du Bois sees the future of the African people linked with World socialism. In this regard, it is interesting to note, Du Bois urges Africans to base their socialism on the socialism of former African societies and concludes:

> Awake, awake, put on thy strength, O Zion! Reject the weakness of missionaries who teach neither love nor brotherhood, but chiefly the virtues of private profit from capital, stolen from your land and labor. Africa, awake! Put on the beautiful robes of Pan-African socialism.[46]

[43]Robert I. Rotberg in *A Political History of Tropical Africa* (New York, 1965) estimates that tropical Africa "was deprived of about fifty million inhabitants because of the traffic in slaves." His estimate of the trade's damage to the fabric of African society, though not as high as Du Bois's, is high enough to suggest that Africa lost her most "creative, adaptive and reproductive resources—the young and healthy." Rotberg's treatment of the racist implications of the trade is much the same as that found in Du Bois's *Black Folk: Then and Now*. See especially pages 152–53 in Rotberg's *Tropical Africa*.

[44]Du Bois, *Black Folk*, p. 144.

[45]W. E. B. Du Bois, *The World and Africa* (New York, 1965), Foreword. Originally published in 1956.

[46]*Ibid.*, p. 310.

In discussing the work of Du Bois, Carter Woodson, and others in the writing of African history, August Meier concludes:

> Most significant was the work of Du Bois. Not only was he aware of the complexity and sophistication of contemporary African culture but also— acting more on mystic racial yearnings than on scientific investigation—Du Bois was the precursor of the Africanist Melville J. Herkovits in tracing the American Negro culture and institutions to African origins.[47]

Did his "mystic racial yearnings" cast him in the role of precursor to the later Negritude movement? As early as 1899, he wrote:

> I am the Smoke King.
> I am black.
> I am darkening with song,
> I am hearkening to wrong;
> I will be black as blackness can,
> The blacker the mantle the mightier the man.
>
> I am carving God in night,
> I am painting hell in white.
> I am the Smoke King,
> I am black.[48]

The celebration of blackness—the attempt to transmute its negative attributes into positive ones—appears time and time again in the writings of Du Bois. Six years before the publication of *The Souls of Black Folk*, Du Bois gave what was perhaps the first indication that he felt the Negro possessed certain peculiar artistic qualities that America could ignore only at her peril. The Negro, said Du Bois in a paper submitted to the American Negro Academy, had given America its only original music, "its only touch of humor and pathos amid its mad money-getting plutocracy." Du Bois then believed in a "race spirit," which he considered "the greatest invention for human progress." (Du Bois's belief in racial integrity was, in this respect, similar to that of Schomburg who, a few years later, was to speak of "kindling the torches which inspire to racial integrity.")

The Negro's artistic gifts, according to Du Bois, were due to subtle psychic differences which characterized all men, dividing them into races.[49] He was later to develop this thesis at some length in a book— *The Gift of Black Folk* (1924)—the very title of which calls to mind the views of the Negritude school of writers. Before the appearance of this book, however, Du Bois published the *Souls of Black Folk*, a work which affected not only American Negroes but Africans as well. Saun-

[47]Meier, *Negro Thought*, p. 264.
[48]"The Song of the Smoke" from W. E. B. Du Bois, *Selected Poems* (Accra, 1964), p. 12.
[49]Meier, *Negro Thought*, p. 194.

ders Redding reports that Peter Abrahams of South Africa said that until he read this book, "he had no words with which to express his Negro-ness." Abrahams himself wrote that the book had "the impact of a revelation . . . a key to the understanding of my world."[50]

The dualism so prevalent in the thinking of Léopold Senghor, Aimé Césaire, and other proponents of Negritude is expressed by Du Bois in the opening chapter of *Souls:*

> It is a peculiar sensation, this double-consciousness, this sense of always looking at one's self through the eyes of others, of measuring one's soul by the tape of a world that looks on in amused contempt and pity. One ever feels his two-ness,—an American, a Negro; two souls, two thoughts, two unreconciled strivings; two warring ideals in one dark body, whose dogged strength alone keeps it from being torn asunder.

And there is the same longing for a higher synthesis of which Senghor speaks in referring to cross-cultural fertilization:

> He [the Negro] would not Africanize America, for America has too much to offer the world and Africa. He would not bleach his Negro soul in a flood of white Americanism, for he knows that Negro blood has a message for the world.[51]

Allusions to Negro blood often appear in the writings of Du Bois, just as Senghor often refers to African blood. But Du Bois, in theory as in practice, was opposed—as opposed as any figure in world history—to the view that one people (or race) should have advantages over another.

The Negro never lost his African temperament or style of life, he asserts in *The Gift of Black Folk*. He refers to a "peculiar spiritual quality" which the Negro has brought into American life and civilization, "a certain spiritual joyousness, a sensuous, tropical love of life," as against New England reason which was cool and cautious; "a slow and dreamful conception of the universe" together with "an intense sensitiveness to spiritual values"—all qualities which, in his view, "tell of the imprint of Africa on Europe in America." There is no denying or explaining away, Du Bois remarks, "this tremendous contact of the North and South, of black and white, of Anglo-Saxon and Negro."[52]

The qualities of "Negritude," of being Negro, developed "Deep in the forest fastness and by the banks of low, vast rivers, in the deep tense quiet of the jungle" where "the human soul whispered its folk tales, carved its pictures, sang its rhythmic songs, and danced and danced." Describing the music of the slave—the spiritual—Du Bois hears "the

[50]Quoted in W. E. B. Du Bois, *The Souls of Black Folk* (Greenwich, Connecticut, 1961), Forethought. Originally published in 1903.

[51]*Ibid.*, pp. 16–17.

[52]W. E. B. Du Bois, *The Gift of Black Folk* (Boston, 1924), p. 320.

sorrow of riven souls suddenly articulate," the "sobs of raped daughters, the quiver of murdered bodies, the defiance of deathless hope." It is great art born of suffering and tragedy.[53]

In another passage from *The Gift of Black Folk* Du Bois describes the slave laborer as a product of the tropics who possessed "sensuous receptivity to the beauty of the world" and was therefore not "easily reduced to the mechanical draft-horse which the northern European laborer became." Though often accused of laziness, "the slave brought to modern manual labor a renewed valuation of life."[54]

Du Bois—in affirming the emotional nature of Negroes, in his use of culture as a basis for group solidarity, in zealously attempting to rediscover the historic roots of the Negro people, in positing the notion that Negroes (wherever they live) have a certain "style" of life, and in his allusions to primitive African socialism—was a precursor of Negritude. Much like Césaire, his "Negritude" theories were not hammered into a comprehensive system of thought. And like Césaire, they appear to derive more from his personal stand as a writer, student of history and culture, and black man caught between two worlds.

As Charles Wesley has written, most of Du Bois's works—even his novels—have included some material on the African background. In addition to books and articles in which mention was made of Africa, for many years Du Bois promoted a pageant based on the African past, a pageant designed for children. It appears that his mind conceived practically every conceivable use to which African history could be put, including teaching it in Sunday school to youngsters.

This is not the place for an assessment of his work in fathering and promoting the Pan-African movement. Let it suffice to say, as has Martin Kilson, that he "had a deep spiritual attachment to and belief in Africa and her peoples, and in his dedication to Pan-Africanism there was no sacrifice too great for him to bear nor any road too difficult for him to

[53]W. E. B. Du Bois, "What Is Civilization? Africa's Answer," *Forum*, LXXIII (February 1925), pp. 185–86.

[54]Du Bois, it should be pointed out, was not alone in arguing that Negroes possessed different traits from those of whites. Nor was it he alone who would use culture and history as bases for racial unity and as springboards to collective social action—as do the Negritude writers today. Benjamin Brawley, in particular, spoke of a special "Negro Genius" which was expressed in the "fervid oratory" of Frederick Douglass, the "sensuous poetry" of Paul Laurence Dunbar, the "picturesque style" of Du Bois, and the "elemental sculpture" of Meta Fuller. Only suffering could produce great art, and the Negro's tragic background was evinced in the wails of the old melodies and the plaintive quality of the voice of the Negro. There was "something very elemental about the heart of the race, something that finds its origin in the African forest. . . . There is something grim and stern about it all too, something that speaks of the lash, of the child torn from its mother's bosom, of the dead body riddled with bullets and swinging all night from a limb by the roadside." Quoted from Meier, *Negro Thought*, these excerpts from Brawley appeared originally in the *Southern Workman*, XLIV (May 1915), pp. 305–8.

travel."[55] He has been hailed as the "Father" of Pan-Africanism by heads of African countries, and his influence has been recognized by African leaders from Kenyatta to Nkrumah.

It can be said in perfect justice that generations of Negro intellectuals changed their negative views of Africa due to the influence of Du Bois.[56] He left the United States in his nineties and returned to Africa to become a citizen of Ghana and set in motion a project of which he had long dreamed—the writing of an Encyclopedia Africana. When he died at 95, he had at least lived to see a number of stages in the project completed. More important, however, he had left behind a historic record which today corroborates the view which he espoused in 1900 at the London Pan-African conference, that the "world's history, both ancient and modern, has given many instances of no despicable ability and capacity among the blackest races of men."

[55]Martin Kilson, "The Rise of Nationalist Parties and Organizations in British West Africa," *Africa from the Point of View of American Negro Scholars* (Paris, 1958), p. 47.

[56]Harold Isaacs, *The New World of Negro Americans* (New York, 1963), Sec. III, Chapter V.

PART III
POETRY AND THE NOVEL

These essays treat the arts during and since slavery. The crossing of disciplines to reveal origins and relationships is largely the same for literary criticism as for slave art in the previous essays. This is especially the case for the essays that treat Benito Cereno, *in which African ways of handling and interpreting reality influence Melville's art to a degree never imagined, let alone demonstrated, until recently. Mathematician and critic Joshua Leslie collaborated with me on the first of the Melville essays. The section opens with a consideration of the poetry of Sterling Brown.*

The Poetry of Sterling A. Brown

Unlike the others, the poet had not introduced himself. He had simply said, "Ma Rainey," and continued in a way that indicated an unusual affinity between author and poem, between voice and word. It seemed the most natural and impressive delivery I had ever heard:

> I talked to a fellow, an' the fellow say,
> "She jes' catch hold of us, some kindaway.
> She sang Backwater Blues one day . . .
>
> "An' den de folks, dey natchally bowed dey heads an' cried,
> Bowed dey heavy heads, shet dey moufs up tight an' cried,
> An Ma lef' de stage, an' followed some de folks outside."

And then those lines which say so much, which enable one to *feel* so much, about the great blues singer and her followers:

> Dere wasn't much more de fellow say:
> She jes' gits hold of us dataway.

It was a weekend in the summer of 1962 at a resort near Detroit, just on the other side of the Canadian border. We were listening to a recording being amplified throughout the grounds of poets reading their works. Just standing at that early hour on a Sunday morning would have been, under most circumstances, an achievement, but this time I was startled upright and determined to get to the record player to discover whose voice it was. The voice belonged to Sterling A. Brown. I wondered then and later how a Williams College Phi Beta Kappa, a Harvard man, a college professor, and eminent writer could have a voice with so much of earth and sky and sunlight and dark clouds about it; a voice unafraid, an instrument blues-tinged.[1]

With W. E. B. Du Bois in Ghana, Brown was even then the dean of American Negro scholars, a man noted especially for his brilliant de-

[1]Sterling A. Brown was born in Washington, D.C., in 1901. He has taught at Virginia Seminary, at Lincoln University (Missouri), at Fisk, and, since 1929, at Howard University. From 1936 to 1939 he was Editor of Negro Affairs for the Federal Writers' Project. He was also a staff member of the Carnegie-Myrdal Study of the Negro. He has, in addition to having authored scores of scholarly articles, published *The Negro in American Fiction* (1938), *Negro Poetry and Drama* (1938), and, with Ulysses Lee and Arthur P. Davis, edited the noted anthology *The Negro Caravan* (1941).

fenses of Negro character in literature. But for decades he had operated
almost exclusively on the Howard campus, and there was some reason
to wonder whether the Negro literati at Howard and at other centers of
learning had much conception of why he was important, apart from the
fact that he was known to be a man of learning with a rather inexplicable
interest in blues, jazz, and Negro spirituals. Even then—especially then,
for it was at the height of the civil rights movement—one sensed in
Sterling Brown's voice a connecting timbre, a feel for reciprocity between
past and present. If listened to, if called upon, some of us thought he
could speak to the spiritual state of his people. But civil rights leaders
were not overly interested in matters of culture or heritage.[2] And mem-
bers of the black bourgeoisie were scarcely in the mood to seek counsel
from poets, especially from one who might speak of slavery and provide
a glimpse of a future which, even in freedom, would not be easy. Besides,
the sixties seemed to belong to younger, "angrier" writers.

 Later in 1962 Sterling Brown lectured on folklore for Chicago's
Amistad Society and made a big impression on hundreds of people on
the South Side. After his lecture, before a small group, he read poems
until daybreak—from a sheaf of yellowed pages, some of them tattered
at the edges—poems never before anthologized, poems not found in
Southern Road—and they did not appear to be the least dated.

 Following his lecture and poetry reading (his first in Chicago), Brown
returned several times—"my best audiences are in Chicago," he has said.
Each time, whatever the age group or racial composition of the audience,
his reading was singularly successful, which buoyed his spirits, for he
had in fact wondered perhaps more than he ever let us know how the
younger generation would relate to his poetry.[3] It was evident that de-
spite his great gifts as a poet, he was troubled by a not inconsiderable
lack of recognition. Those who knew and respected him assumed that
he had fallen silent, had stopped writing poetry, shortly after the appear-

[2]A number of leading figures in SNCC were interested in cultural questions. Mike
Thelwell, Charlie Cobb, Stokely Carmichael, Bill Mahoney, and Courtland Cox—all stu-
dents of Brown at Howard—possessed more than a little knowledge of the folk heritage of
African America, which was not altogether unrelated to that consciousness within SNCC
which led to the call for black power.

[3]Actually, few people relate to younger people as well as Sterling Brown, who some-
how, despite his age, does not seem "old." Hoyt Fuller, editor of *Black World*, has captured
a number of Brown's qualities: "Settle him down, loosen his tie, provide him with some
congenial and intelligent company, and turn him on. The stories flow. Out of his fascinat-
ing past, a life filled with both raw and genteel adventures in that mad, rich, vibrant world
on the mellow sidelines of America, he serves up a living history of the past forty years.
. . . Who are the others who can sit among a roomful of men and women young enough
to be their children and meld in spirit and mood with no hint of pomp and no suggestion
of paternalism? . . . His books are where the minds are which have been touched by his
vivid stories, his subtle and unsettling legends, his images of yesterday designed to guard
against undue folly today." Hoyt W. Fuller, "The Raconteur," *Black World* (April 1967),
p. 50. Brown's poetry readings to the young were no less successful than his renderings of
the extraordinary stories to which Fuller alluded.

ance of *Southern Road*. That assumption, together with sadly deficient criticism from some quarters, helped to fix his place in time—as a not very important poet of the past.[4]

A man who has gone his own way most of his life, Brown has not been noted for asking favors, for seeking the easy way out by playing games with critics or with other people of influence. Among his favorite lines are these from Robert Frost's "In Dives' Dive":

> It is late at night and still I am losing,
> But still I am steady and unaccusing.

However, Sterling Brown was once taken far more seriously than he is today—and by critics who had done their homework. That was roughly forty years ago, and those critics had offered high praise.

I

Alain Locke, perhaps the chief aesthetician of the New Negro movement and clearly its most effective defender, acknowledged that numerous critics, on the appearance of *Southern Road*, had hailed Brown "as a significant New Negro poet." For Locke, that was not sufficient: "The discriminating few go further; they hail a new era in Negro poetry, for such is the deeper significance of this volume." Locke identified the principal objective of Negro poetry "as the poetic portrayal of Negro folk-life," suggested that such portraits should be "true in both letter and spirit to the idiom of the folk's own way of feeling and thinking," and declared that with the publication of *Southern Road* it could be said "that here for the first time is that much-desired and long-awaited acme attained or brought within actual reach."[5] As the folk-poet of the New

[4]As a consequence of such a judgment, editors of anthologies and professors of Negro literature apparently assumed that the only Brown poems worth reading were those which had appeared in previous anthologies. How else, after all, can one account for the same Sterling Brown poems in anthology after anthology? Perhaps a second printing of *Southern Road* would have militated against such a trend. Frederic Ramsey, Jr., distinguished folklorist and jazz authority, was employed at Harcourt, Brace and Company at the time the decision was made not to order a second printing of *Southern Road*. Ramsey "Protested the book's going out of print, and can remember the answer that came back from the head of the sales department: 'It wouldn't pay us.' Possibly not." Frederic Ramsey, Jr., editor, "Sixteen Poems of Sterling A. Brown Read by Sterling A. Brown," *Folkway Records*, album no. FL9794, 1973.

Southern Road constitutes slightly less than one-third of Sterling Brown's poetry. A few years following the publication of *Southern Road*, Brown submitted his second manuscript to Harcourt, Brace and Company, to be entitled *No Hiding Place*; it was rejected. The rejection of that manuscript, said to be on a level with *Southern Road*, remains something of a mystery. There is reason to believe, however, that more than possible sales considerations figured into the decision.

[5]Alain Locke, "Sterling Brown: The New Negro Folk-Poet," in Nancy Cunard, *Negro Anthology* (New York, 1969), p. 111.

Negro, Brown was for Locke the most important of Negro poets. This folk-poet appellation was an appropriate one, for Brown had recognized and begun to mine the rich veins of Negro folklore and found there almost boundless artistic possibilities for exploring the human condition.

Not meaning to ascribe perfection and complete maturity to Brown's art, Locke described him as "a Negro poet with almost complete detachment, yet with a tone of persuasive sincerity, whose muse neither clowns nor shouts. . . . " In Locke's view Brown had been able to create with the naturalness and freshness integral to folk balladry, and he called attention to "Maumee Ruth," "Sam Smiley," "Dark of the Moon," "Johnny Thomas," "Slim Greer," and "Memphis Blues" as convincing proof that a Negro poet could "achieve an authentic folk-touch."[6]

Locke was fond of "Maumee Ruth," a poem in which Brown, as he did on a number of occasions, linked North and South, countryside and city; a poem which Locke considered as uniquely racial as "Southern Road," the title poem with work-song rhythms:

> White man tells me—hunh—
> Damn yo' soul;
> White man tells me—hunh—
> Damn yo' soul;
> Got no need, bebby,
> To be tole.

In Locke's opinion a number of Negro poets had been too reluctant to show their own people in a truer light, though they had become increasingly bold and were no longer "too gingerly and conciliatory to and about the white man. The Negro muse weaned itself of that in McKay, Fenton Johnson, Toomer, Countee Cullen, and Langston Hughes. But in Sterling Brown it has learned to laugh at itself and to chide itself. . . . "[7] Locke considered Brown a finer student of folk-life, more thoughtful, more detached, more daring, than the others. Here was a poet who had gone further still and had explored, "with deeply penetrating genius," fundamental and abiding qualities of Negro feeling and thought, establishing "a sort of common denominator between the old and the new Negro."[8]

Louis Untermeyer, in a review of *Southern Road*, warned against ranking other poets of the New Negro movement with Brown. But for those who "insist that such strains have been played before by the darker-minded of Brown's race, I would reply that Brown achieves a detachment which Claude McKay, for all his ardor, or Countee Cullen, for all his fluency, never achieves."[9] Untermeyer, in his appreciation of Brown's

[6]*Ibid.*, p. 112.
[7]*Ibid.*, p. 114.
[8]*Ibid.*, p. 115.
[9]Louis Untermeyer, "New Light from an Old Mine," *Opportunity* (August 1932), p. 250.

detachment, pointed to one of Brown's characteristics which should be pondered by many of the new black poets, Brown's mastery of a first principle of his craft: The poet should not shout or scream but, through singular command of language, perspective, mood, and event, win his way toward triggering a desire to shout *in the reader*. Brown's detachment, according to Untermeyer, allows him "to expostulate without ranting, or even raising his voice. . . . " "Only the most purblind—or prejudiced—will refuse to admit," thought Untermeyer, the strength and power of *Southern Road*.[10]

While he found "Odyssey of Big Boy" and "Frankie and Johnny" not to his liking, Untermeyer considered *Southern Road* as a whole "not only suffused with the extreme color, the deep suffering and high laughter of workers in cabins and cottonfields, of gangs and gutters, but it vibrates with a less obvious glow—the glow which, however variously it may be defined, is immediately perceived and ultimately recognized as poetry."[11] "Brown," Untermeyer concluded, "has expressed sources and depths which a pioneer like Dunbar might have felt but could never voice. . . . Thus 'Southern Road' reveals old material and a new utterance. Another light has emerged from the dark, unexhausted mine."[12]

The reviewer for the *New Republic* praised Brown for genuine originality in handling folk materials, noted the absence of pretension in his work, and hailed his "forthright use of realistic Negro material" as a characteristic worthy of emulation by those following him.[13] The reviewer for the *Nation* shrewdly realized that Brown's poems on the folk Negro experience were not conventional dialect renderings of that reality but were written in the natural, vigorous speech of the contemporary Negro. The *Nation* critic had put his finger on an aspect of Brown's poetry that has been misunderstood by a number of critics.[14]

That Brown's treatment of the folk Negro was destitute of maudlin sentimentality and outlandish humor, hallmarks of most traditional dialect poetry, was altogether clear to William Rose Benét. Commenting on *Southern Road* in the *Saturday Review of Literature*, Benét also called the reader's attention to Brown's qualities as a narrative poet: "The fact that Brown is so good a narrative poet has inclined me toward him," he

[10]*Ibid.*

[11]*Ibid.*

[12]*Ibid.*, p. 251.

[13]The *New Republic* (July 27, 1932), p. 297.

[14]The *Nation* (July 13, 1932), p. 43. It should be noted that Sterling Brown has no objections to his poetry's being called dialect, providing it is understood that he rejects, through his poetry, the constricted definition earlier given to dialect by James Weldon Johnson—that is, that dialect has but two stops: humor and pathos. Brown has shown the remarkable resources of the language, demonstrating that dialect has as many stops as there are human emotions. Brown, in fact, has given us the first real look at the written language, in all its variety and richness, linked as it should be to the real-life people who created it. Thus, if the term *dialect* is to be used at all in describing much of the work of Brown, it should be understood that his is a wholly new conception.

wrote. Benét found a command of real pathos and grimness in Brown's treatment of "Sam Smiley," the buckdancer and veteran of foreign wars who, on returning home, put to use, without color discrimination, his martial skills; Sam Smiley, who in the end:

> Buckdanced on the midnight air.

Brown's ability to "strike out original simile," as in "Tornado Blues" (from "New St. Louis Blues"):

> Black wind come a-speedin' down de river from de Kansas plains,
> Black wind come a-speedin' down de river from de Kansas plains,
> Black wind come a-roarin' like a flock of giant aeroplanes—

impressed the reviewer. Benét also considered "peerless" some of the verses in the three "Slim Greer" poems, a series in which he thought humorous Negro fables were related with "inimitable unction."[15]

In several "Slim Greer" stanzas, Brown shows the reader how the suggestive powers of language can call reality into play with uncommon force, revealing terrible potential for turbulence beneath mirth that is in the final analysis no more than surface deep. Slim Greer seeking to pass for white romancing the southern white woman was faced with an especially deadly moment of racial truth when his love

> Crept into the parlor
> Soft as you please
> Where Slim was agitatin'
> The ivories.
> Heard Slim's music
> An' then, hot damn!
> Shouted sharp—Nigger!"
> An' Slim said, "Ma'am?"

And the reviewer found, in the last section of Southern Road, "Thoughts on Death," "Against That Day," and the sonnet "Rain" to be "entirely uncolloquial . . . unusually well-fashioned." The overall estimate was glowing: Brown's work had "distinctly more originality and power than that of Countee Cullen, and more range than that of Langston Hughes." Of the younger Negro poets, he closed, "I consider Sterling A. Brown to be the most versatile and the least derivative."[16]

The New York Times printed a lengthy review of Southern Road which also drew attention to the E. Simms Campbell illustrations. The reviewer found race on every page, "but it is 'race' neither arrogant nor servile. There is pathos, infinite pathos; but everywhere there is dignity that respects itself." The reviewer, unafraid of Negro bitterness, called the reader's attention to "Maumee Ruth," finding in it sentiments that have been expressed "from the earliest poetry of the Hebrews down to

[15]William Rose Benét, "A New Negro Poet," the Saturday Review of Literature, May 14, 1932, p. 732.
[16]Ibid.

the present day." He also trenchantly observed that the gayety found in *Southern Road* is "on the whole gayety restrained."[17] One must differ with the assertion that race is on every page, but that objection is little more than quibbling since race is indeed prominent in *Southern Road*. The *New York Times* review could scarcely have offered a finer tribute, one worth quoting in full: "*Southern Road* is a book the importance of which is considerable. It not only indicates how far the Negro artist has progressed . . . but it proves that the Negro artist is abundantly capable of making an original and genuine contribution to American literature . . . there is everywhere art; such a firm touch of artistry as is only seldom found among poets of whatever descent."[18]

That James Weldon Johnson introduced *Southern Road* when it first appeared in 1932 suggests something of the powerful effect which Sterling Brown's poetry had upon him. Perhaps by then Johnson had realized that, while his earlier strictures about dialect poetry had been correct enough when applied to the verse of others, they were simply not applicable to the poetry of Sterling Brown. Citing Brown's use of ballads and folk epics, he suggests that when the raw material upon which the poet works is radically different from the excessive geniality and optimism, the sentimentality and artificiality found in poetry based on the minstrel tradition, one is on the threshold of a breakthrough in poetic experimentation and achievement. Brown, Johnson tells us, mastered the spirit of his materials to the point of absorption and, "adopting as his medium the common, racy, living speech of the Negro in certain phases of *real* life," re-expressed that spirit with artistry and greater power.

If my reading of Johnson is correct, then his statement that "Mr. Brown's work is not only fine, it is also unique" is all the more comprehensible. Unique as well, Johnson correctly notes, are many of Sterling Brown's poems, which "admit of no classification or brand, as, for example, the gorgeous 'Sporting Beasley.'" In that poem, the "Slim Greer" cycle, and in others, Johnson added, "[Brown] gives free play to a delicious ironical humor that is genuinely Negro." Johnson ventured to classify "Sporting Beasley," calling it "Sterling-Brownian." He concluded his remarks with the observation that while there are "excellent poems written in literary English and form" in *Southern Road* "it is in his poems whose sources are the folk life that [Brown] makes, beyond question, a distinctive contribution to American poetry."

And so it was a remarkable achievement for a young poet: Not one of the major reviewers hailed Brown as a poet of promise, as a talented young man awaiting creative maturity; on the contrary, he was regarded as a poet of uncommon sophistication, of demonstrated brilliance whose work had placed him in the front rank of working poets here and elsewhere. And the critics had been correct in noting that the maturity of

[17]"A Notable New Book of Negro Poetry," the *New York Times Book Review*, May 15, 1932.

[18]*Ibid.*, p. 13.

Sterling Brown's poetic vision, the success with which he focused and ranged it over the varied terrain of southern Negro experience, venturing now and again into higher latitudes such as Chicago, was not a result of unpracticed, intuitive genius. To be sure, most of Brown's years before the completion of his manuscript were helpful in preparing him for *Southern Road*.

II

In ways both subtle and obvious Sterling Nelson Brown, distinguished minister and father of the poet, influenced his son's attitude toward life and literature. Born a slave in eastern Tennessee, the elder Brown, unlike many of similar origin, was not ashamed of his slave heritage, nor was he ashamed of the rural Negro descendants of slaves. The sense of continuity with the past and the considerable attention devoted to the folk Negro in Brown's poetry probably owe almost as much to his having been the son of such a father as they do to the valuable experiences which the young poet had in the South following his graduation from Williams College and Harvard University.[19]

Fortunately Sterling A. Brown, exposed to the critical realist approach to literature of George Dutton of Williams and the realism that characterized some of the best of American poetry of the twenties, especially the work of Edward Arlington Robinson, Robert Frost, and Carl Sandburg, was all the more prepared to take an uncondescending, that is to say genuinely respectful, attitude toward the folk whom he encountered in the South. And there he discovered a wealth of folk material waiting to be fashioned into art, and a number of quite ordinary people who, thanks to his artistry, would teach us unusual things about life. Brown realized the need to explore the life of the southern Negro below the surface in order to reveal unseen aspects of his being, his strength and fortitude, his healing humor and his way of confronting tragedy. As a young man he began meeting and talking to a variety of people, some of whom, such as Big Boy Davis, a traveling guitar player after whom the character in "Southern Road," the title poem, is modeled, would win permanent places in our literature. The fact that Brown, with his sharp eye, fine ear, and excellent mind, spent so many of his early years in the South helps us understand the sensibility behind a volume which reads like the work of a gifted poet who has lived a lifetime.

Just as Brown's creation of folk characters presents individualized portraits revelatory of interior lives, his uses of the great body of Negro music, of the spirituals, blues, jazz, and work songs, extend rather than reflect meanings. Sadly enough, there is reason to believe that many students of Negro literature, as I have implied, are unfamiliar with most of the poems in *Southern Road*. Numerous major poems have never

[19]See Sterling Nelson Brown, *My Own Life* (1924).

been anthologized; and some, such as "Cabaret," have only recently been brought to our attention by critics.[20] Yet a specialist on the "Harlem Renaissance," of which Brown was not a part, *places him in that movement* with a number of references, including one to "Memphis Blues," while omitting mention of "Cabaret," perhaps the single most important New Negro movement poem dealing with the exploitation of Negro performing artists, especially members of orchestras and chorus lines, during the twenties and since.[21]

Though "Cabaret" is by no means the only significant Brown poem that numerous scholars do not seem to know exists, it deserves attention because of its brilliant multi-level interplay between appearance and reality: between life as Negroes live it and life as projected onto them by white audiences. "Cabaret" stands as a starkly eloquent emblem of the frustrations, cleverly masked, of Negro entertainers before the bizarre expectations of white patrons of black arts of the twenties. The inexorably grim logic of the poem unfolds to the accompaniment of Negro music in a Chicago black-and-tan club in 1927. The poet employs symbolically the blues, jazz, the corruptions of Tin Pan Alley, the perversions of genuine Negro music, the dirty misuse of Negro chorus girls and musicians—all set against the rural tragedy of a desperate people in the terrible flood of 1927.

Though I had the rare pleasure of hearing Brown recite the following lyrical, gut-bucket stanzas—recite them magnificently—to my knowledge "Kentucky Blues" has never been anthologized:

> I'm Kentucky born,
> Kentucky bred,
> Gonna brag about Kentucky
> Till I'm dead. . . .
>
> Ain't got no woman,
> Nor no Man O' War,
> But dis nigger git
> What he's hankering for—
>
> De red licker's good,
> An' it ain't too high,
> Gonna brag about Kentucky
> Till I die. . . .

[20]Stephen Henderson's *Understanding the New Black Poetry* (New York, 1973) contains "Cabaret." Henderson's criticism of Brown in *Black World* was perhaps the first sensitive and scholarly treatment of Brown's poetry by a Negro since the generation of Locke and James Weldon Johnson. In providing a level of criticism worthy of the seriousness of Brown's art, Jean Wagner, in *Black Poetry* (Urbana, 1973), joins Henderson. For Henderson's essay on Brown's poetry, see "A Strong Man Called Sterling Brown," *Black World* (September 1970).

[21]See Nathan Irvin Huggins, *Harlem Renaissance* (New York, 1971), pp. 78, 221, 222, 225–27, 228. But Brown has challenged the very conception that a "Harlem Renaissance" took place: "The New Negro is not to me a group of writers centered in Harlem during the second half of the twenties. Most of the writers were not Harlemites; much of

The narrator of "Kentucky Blues" would be completely at home in "Memphis Blues," whose last grim stanza closes with a brilliantly conceived reference to another art form, not unknown for qualities of stoicism:

>Memphis go
>By Flood or Flame;
>Nigger don't worry
>All de same—
>Memphis go
>Memphis come back,
>Ain' no skin
>Off de nigger's back.
>All dese cities
>Ashes, rust. . . .
>De win' sing sperrichals
>Through deir dus'.

As a student of the relationship between past and present, of the effects of time and circumstance upon human beings, Sterling Brown has demonstrated, as well as any artist known to this writer, how music and myth function in the lives of ordinary people. In but a portion of a single stanza from "Ma Rainey," perhaps *the* blues poem, Brown manages to capture in a few lean lines the essence of the blues singer as repository, as explicator of the values of her people, as Priestess.

>O Ma Rainey,
>Sing yo' song;
>Now you's back
>Whah you belong,
>Git way inside us,
>Keep us strong . . .

And in "Strange Legacies," we encounter perhaps the greatest of all Negro folk heroes:

>Brother,
>When, beneath the burning sun
>The sweat poured down and the breath came thick,
>And the loaded hammer swung like a ton
>And the heart grew sick;
>You had what we need now, John Henry.
>Help us get it.
>
>So, *if we go down*
>*Have to go down,*
>*We go like you, brother,*
>*'Nachal' men.* . . .

the best writing was not about Harlem, which was the show-window, the cashier's till, but no more Negro America than New York is America." Sterling A. Brown, "The New Negro in Literature, 1925–1955," in *The New Negro Thirty Years Afterwards*, edited by Rayford Logan et al. (Washington, 1955), p. 57.

But in "Children's Children" the poet turns to discontinuities, to a poignant breakdown in racial memory:

> When they hear
> These songs, born of the travail of their sires
> Diamonds of song, deep buried beneath the weight
> Of dark and heavy years;
> They laugh.
>
> They have forgotten, they have never known,
> Long days beneath the torrid Dixie sun
>
> With these songs, sole comfort.

As remarkable as many of the poems in this volume are, they can, like arresting but isolated portions of a vast canvas, be done full justice only when seen within the framework of the overall artistic conception. This is so because Sterling Brown, despite the impressive range of characterization and technique revealed in this volume, builds from a unified, integrated conception of reality. The happy effect of such architecture is that individual poems, however much they dazzle when read apart from others, gain new and deeper meaning, and a new resonance, when the entire volume is read.

Given the experiences of his people in America, it is especially worth noting that Brown has been able to take attributes that appear greatly susceptible to stereotypical treatment—cheating, flight, laughing, dancing, singing—and, never losing control of them, in fact utilizing them repeatedly, to establish the irreducible dignity of a people. So powerful is his vision of their humanity, so persuasive his powers of poetic transmutation, that his utilization of the most distinctly Negroid accents serves to enlarge, rather than diminish, that humanity. In a word, Brown makes no concessions to white prejudice or to Negro pretense.

If Sterling Brown speaks of tragedy, he also holds out the ultimate hope of triumph, the possibility of which, paradoxically, is heightened, not lessened, by the tough-minded quality of his way of reckoning events and determining what is important in life. His disclosures of largely unappreciated qualities, though they range over myriad concerns, are on balance values, sacred and secular, hidden in the hearts of a people. "Strong Men" gives us a better sense of what the long haul has meant, of how a people has not merely survived but projected its sense of what is meaningful than any other poem in African American literature. The vision which informs this poem is essentially the same which courses through a volume offering no easy optimism and no quick victories but all the determination in the world. And so there is a promise of eventual relief. The poet's vision is, in the end, tragic—triumphant.

In spite of all, whatever his setbacks, whatever his triumphs, Sterling Brown has maintained through it all possession of his soul and kept the faith with his fellows, living and dead. He is an artist in the truest sense: The complete man, he has attempted to master the art of living. One is

reminded, when thinking of him, of Lionel Trilling's reference to certain "men who live their visions . . . who *are* what they write."[22]

As Sterling Brown reveals the world of *Southern Road*, he leads us ultimately, through the Negro, to a conception of the nature of man. In his work, there is a noticeable absence of the questionable poetic ideal of being "difficult," which too frequently has come to mean, in our time, impenetrability. Yet Brown's genius is such that as he sculpts simple, plain speech into poetry, as he unveils the value ensemble of a people, the reader will discover, almost in a flash, that he has entered a world as wondrously complex as life itself.

[22]See Lionel Trilling's introduction to George Orwell, *Homage to Catalonia* (New York, 1952), p. viii. Daisy Turnbull Brown, the wife of Sterling Brown, has helped him live this vision — in his poetry as in life. She is introduced in several poems in the last section of *Southern Road*, including "Thoughts of Death":

> Death will come to you, I think,
> Like an old shrewd gardener
> Culling his rarest blossom . . .

and the magical "Mill Mountain":

> . . . We have learned tonight
> That there are havens from all desperate seas,
> And every ruthless war rounds into peace.
> It seems to me that Love can be that peace . . .

The Death of Benito Cereno:
A Reading of Herman Melville
on Slavery

(with Joshua Leslie)

On the 27th of December, 1804, off the cost of South America, slaves on board the Spanish vessel Tryal *revolted, killing eighteen Spaniards, some with daggers and others by tying them and throwing them alive into the sea. The intellectual and spiritual resources drawn on in attempting to achieve their objective of remaining free were of an order rare for slave revolts and are placed at the center of Herman Melville's* Benito Cereno, *which in striking degree follows the historical example of the revolt that, in the end, was crushed.*

> *"Pray, heaven!" cried Yoomy, "they may yet find a way to loose their bonds without one drop of blood. But hear me, Oro! were there no other way, and should their masters not relent, all honest hearts must cheer this tribe of Hamo on: though they cut their chains with blades thrice edged, and gory to the haft! 'Tis right to fight for freedom, whoever be the thrall."*
>
> Herman Melville,
> *Mardi*

A kindly American captain named Delano, commanding a large sealer off the coast of Chile on a gray morning, spotted a vessel without colors and apparently in distress. The captain ordered the whale boat of his *Bachelor's Delight* stocked with provisions for those on the vessel in the distance. As the sealer approached the *San Dominick*, Delano noted that its true character "was plain—a Spanish merchantman of the first class, carrying negro slaves." He also noted that the *San Dominick* seemed launched "from Ezekiel's valley of dry bones."

Upon boarding the vessel there seemed to him general disorder caused by terrible hardships suffered by all on board, "except for the conspicuous figures of four elderly grizzled negroes . . . in venerable contrast to the tumult below them." Sitting unperturbed, like the African elders, were six young warriors, polishing hatchets.

The aristocratic Spanish captain of the *San Dominick*, Don Benito Cereno, had at his side a small black slave named Babo, whose countenance revealed an extraordinary mixture of sorrow and affection as he looked up into his master's face. Delano came to regard Babo as an ever present crutch for Don Benito. Yet, despite Delano's keen attention to detail and despite Don Benito's strange behavior, he never discovered on his own that a revolt had taken place and that Babo was in fact the master of the ship and Don Benito his servant.

* * *

In the West African frontier town of Kajaaga, visited by Mungo Park, a female slave displayed refinement of character and generosity of spirit in the course of her daily rounds:

> Towards evening as I was sitting upon the bentag, chewing straws, an old female slave, passing by with a basket upon her head, asked me *if I had got my dinner*. As I thought she only laughed at me, I gave no answer; but my boy, who was sitting close by, answered for me; and told her, that the King's people had robbed me of all my money. On hearing this, the good old woman, with a look of unaffected benevolence, immediately took the basket from her head, and showing me that it contained ground-nuts, asked me if I could eat them; being answered in the affirmative, she presented me with a few handfuls, and walked away, before I had time to thank her for this seasonable supply. . . . I reflected with pleasure on the conduct of this poor untutored slave, who, without examining into my character or circumstances, listened implicitly to the dictates of her own heart. Experience had taught her that hunger was painful, and her own distresses made her commiserate those of others.[1]

Once again, when in distress—weary, dejected, hungry—Park was befriended, this time by a woman "returning from the labours of the field" who showed him "great compassion" by offering him a place to sleep and by providing him with a supper of "very fine fish . . . broiled upon some embers."[2]

> The rites of hospitality being thus performed towards a stranger in distress; my worthy benefactress . . . called to the female part of her family, who had stood gazing on me the while in fixed astonishment, to resume their task of spinning cotton; in which they continued to employ themselves [the] great part of the night. They lightened their labour by songs, one of which was completely extempore; for I was myself the subject of it. It was sung by one of the young women, the rest joining in a sort of chorus. The air was sweet and plaintive. . . . I was oppressed by such unexpected kindness; and sleep fled from my eyes.[3]

[1]Mungo Park, *Travels in the Interior Districts of Africa* (New York, 1971), pp. 69–70. Originally published in 1799.

[2]Struck by the ease with which Park related to Africans and by the reception they gave him, Melville later wrote: "I walk a world that is mine; and enter nations, as Mungo Park rested in African cots." Herman Melville, *Mardi* (Evanston and Chicago, 1970), p. 368.

[3]Park, *Travels*, pp. 197–98.

Park was so moved by the kindness of African women that he placed the words of the song composed about him at the front of his *Travels in the Interior Districts of Africa*, so that as Melville opened the volume, his eyes fell on the following "Negro Song":

I

The loud wind roar'd, the rain fell fast;
The White Man yielded to the blast;
He sat him down, beneath our tree;
For weary, sad, and faint was he;
And ah, no wife, no mother's care.
For him, the milk or corn prepare.

Chorus

The White Man, shall our pity share;
Alas, no wife or mother's care.
For him, the milk or corn prepare.

II

The storm is o'er; the tempest past;
And Mercy's voice has hush'd the blast.
The wind is heard in whispers low,
The White Man, far away must go; —
But ever in his heart will bear
Remembrance of the Negro's care.

Chorus

Go, White Man, go: — but with thee bear
The Negro's wish, the Negro's prayer;
Remembrance of the Negro's care.[4]

That the attitude toward generosity of the kind offered was less that of charity than of human obligation is certain from a literal translation of the song. The sentiments of the women were more modest and, therefore, more fundamentally human than the construction suggested by the overjoyed and grateful Park. Actually, they did not ask to be remembered for their kindnesses. They had sung:

[4]*Ibid.*, n.p. The song precedes Chapter One. The clue to Mungo Parks' importance to Melville in the novella is found in the following rumination of Captain Delano: "Ah! thought Captain Delano, these perhaps, are some of the very women whom Ledyard saw in Africa, and gave such a noble account of." See Herman Melville, *Benito Cereno* in Richard Chase, ed., *Herman Melville Selected Tales and Poems* (New York, 1950), p. 36. Except for Professor Egbert Oliver's discussion of Ledyard, Mungo Park and the African mother's nursing her child on the *San Dominick* and Seymour Gross's piece on Melville's substitution of Ledyard for Mungo Park, we know of no important mention of Mungo Park in relation to the novella, to say nothing of an attempt to deal with the impact of Park's findings on Melville's consciousness and craft in *Benito Cereno*. See Egbert S. Oliver, ed., *The Piazza Tales* (New York, 1962), pp. 235–36; and Seymour Gross, "Mungo Park and Ledyard in Melville's *Benito Cereno*," *English Language Notes*, III (December 1965), pp. 122–23.

The winds roared, and the rains fell
The poor white man, faint and weary
Came and sat under our tree
He has no mother to bring him milk
No wife to grind his corn.

Chorus
Let us pity the white man
No mother has he. . . .[5]

For the gentle black female described by Mungo Park to have be-
come, in Melville's *Benito Cereno*, an advocate of all whites being de-
stroyed suggests that some inhuman cruelty had been done her; that she
had been exposed to the forces of darkness and had cohabited with evil.
Since she did not know that evil in Senegal she must have found it in
Peru and Alabama. Knowing that Negro women in the New World did
not find the sort of generosity they lavished on the traveling Mungo
Park, Melville presents them as greater avengers of the wrongs of slavery
than the men of warrior age—a deeply ironic comment on their oppres-
sion as they experienced a descent of the spirit unknown to them at
home.

The irony is more acutely recognized when considering what Melville
knew from reading Park—that no one was more respected than the
African mother. And we know from the original account of the revolt
that there were nine black mothers with infants on board the slave ship
off the coast of South America. Thus, from Melville's perspective, the
cultural dissonance caused by an assault upon the inviolate must have
rung shrilly in the souls of the slaves on board the *San Dominick*. For
Park observed "that an African will sooner forgive a blow, than a term
of reproach applied to his ancestors: 'Strike me, but do not curse my
mother,' is a common expression among the slaves."[6]

Reasons for this reverence appear in *Benito Cereno*: The women
display an instinct to preserve the race at all cost and against all sorts—
to do what is necessary for the slaves on the boat to survive. Melville,
choosing his words with great care, offers an obtrusive comment in the
novella:

> The uncommon vigor of the child at length roused the mother. She started
> up, at a distance facing Captain Delano. But as if not at all concerned at the
> attitude in which she had been caught, delightedly she caught the child up,
> with maternal transports, covering it with kisses.[7]

[5]Park, *Travels*, p. 197.
[6]Harold H. Scudder, "Melville's Benito Cereno and Captain Delano's Voyages," *Publi-
cations of the Modern Language Association* (hereafter *PMLA*), XLII (June 1928), p. 514;
Park, *Travels*, p. 47.
[7]Melville, *Benito Cereno* (New York, 1950), p. 36.

When the crew of the *Bachelor's Delight* attempts to repress the Africans, the women raise "a wailing chant, whose chorus was the clash of steel." Their songs inspired the men, particularly the Ashanti warriors on board, to acts of military valor. Melville understood that principle of Ashanti cultural life,[8] commenting:

> that, in the various acts of murder, they sang songs and danced—not gaily, but solemnly; and before the engagement with the boats, as well as during the action, they sang melancholy songs to the negroes, and that this melancholy tone was more inflaming than a different one would have been, and was so intended.[9]

The African qualities of the hatchet-polishers, the young Ashanti warriors on the *San Dominick* who enjoyed combining work with pastime, were brilliantly captured by Melville. Just as other Africans, according to Park, "lightened their labour by songs,"[10] the warriors in *Benito Cereno* punctuated their sharpening of hatchets with periodic assertions of determination, clashing them overhead like cymbals signaling the height of their movement.

> Though occasionally the four oakum-pickers would briefly address some person or persons in the crowd below, yet the six hatchet-polishers neither spoke to others nor breathed a whisper among themselves, but sat intent upon their task, except at intervals, when, with the peculiar love in negroes of uniting industry with pastime, two and two they sideways clashed their hatchets together, like cymbals, with a barbarous din.[11]

The slave ship written about by Captain Delano contained Africans ranging from infants to those past fifty, providing various handles for Melville to grasp in structuring an African community and its hierarchy on board the *San Dominick*. Melville probed the center around which so much of the African's world is organized in noting the importance of the oakum-pickers. They were African elders who—"crouched sphinx-like, one on the starboard cathead, another on the larboard, and the remaining pair face-to-face on the opposite bulwarks above the main chains"—chanted while working "like so many gray-headed bagpipers playing a funeral march."[12] In Africa, old men past the age of warriors derive their moral authority from communal respect for the aged. This respect is rooted in specific ancestor worship, for the aged are the closest to the ancestors, soon to become ancestors themselves. Thus, from the African

[8]For the African cultural background to the war song sung by the women, see Frederick Augustus Ramsayer and Johannes Kuhne, *Four Years in Ashantee*, English trans. (New York, 1975), pp. 52, 209–10.

[9]Melville, *Benito Cereno*, p. 85.

[10]Park, *Travels*, p. 198.

[11]Melville, *Benito Cereno*, p. 84.

[12]*Ibid.*

world view, as Melville knew, the propensity of the aged is to protect the collective interest.[13]

Newton Arvin tells us that Mungo Park "was almost certainly one of Melville's literary masters," that the name of Park together with names of other great travelers "scintillated before him like constellations during his whole boyhood, as names of great soldiers do before other boys."[14] Melville's admiration for Park at so impressionable an age must surely have militated against his absorbing the anti-Negro opinion so prevalent in antebellum America. For one of his sensibility, as a white youth who was growing up in New England, reading Park must have been a fateful, spiritual occurrence.

Perhaps most significant, Park considered the Negro's humanity axiomatic and regarded cultural and physical differences among the races as utterly minor. He did not see any differences between Negro life and European as a consequence of genetic factors. He found black Africans superstitious and led by false religions but basically fine in contrast to the Arabs or the Moors, whom he found inhospitable—cheating, lying, and violent. But even there his estimate was born of an awareness of the force of culture in shaping habits, preferences, and one's general stance in relation to one's world.[15]

Given the racial baggage Melville carried just by living in America, it is likely that he suffered considerable conflict in his soul while reading Park. It is, therefore, astonishing to learn that a prominent school of criticism holds that such a man viewed the Negro through the eyes of Captain Delano. Close textual criticism of *Benito Cereno* reveals that Melville had contempt for Delano, who is fooled by any and every thing because of his underestimation of Negro intelligence.[16] Delano's thoughts

[13]Frederick Douglass noted the respect of slaves for elders: "Strange, and even ridiculous as it may seem, among a people so uncultivated, and with so many stern trials to look in the face, there is not found, among any people, a more rigid enforcement of the law of respect to elders, than they maintain. I set this down as partly constitutional with my race, and partly conventional." Frederick Douglass, *My Bondage and My Freedom* (New York, 1968), p. 69. Originally published in 1855. Newbell Puckett has written of southern blacks that: "It is considered bad luck to . . . 'sass' the old folks. This latter idea may have at one time had a real meaning, since the old folks were 'almost ghosts,' and hence worthy of good treatment lest their spirits avenge the disrespect and actually cause bad luck to the offender." Newbell Puckett, *Folk Beliefs of the Southern Negro* (Chapel Hill, North Carolina, 1926), p. 394.

[14]Newton Arvin, *Herman Melville* (Westport, Connecticut, 1972), pp. 7–8. Originally published in 1950.

[15]See Park, *Travels*, pp. 133–34, 149–50.

[16]The bulk of *Benito Cereno* criticism breaks down into two large, overlapping schools which perceive Babo as (1) the diabolical, and/or (2) savage leader of a culturally inferior people. Among the legion of critics who take this view are Julian Rice, "The Ship as Cosmic Symbol in Moby Dick and Benito Cereno," *Centennial Review of Arts and Sciences*, XVI (Spring 1972), pp. 138–54; Scott Donaldson, "The Dark Truth of the Piazza Tales," *PMLA*, LXXXV (October 1970), pp. 1082–87; Charles Nicol, "The Iconography of Evil and Ideal in Benito Cereno," *American Transcendental Quarterly*, No. 7, Part I (Summer

on blacks, as presented by Melville, were a conglomerate of mid-nine-teenth-century American racist views — from the romantic racialism that dominated a certain sector of the liberal New England consciousness:

> When at ease with respect to exterior things, Captain Delano's nature was not only benign, but familiarly and humorously so. At home, he had often taken rare satisfaction in sitting in his door, watching some free man of color at his work or play. If on a voyage he chanced to have a black sailor, invariably he was on chatty and half-gamesome terms with him. In fact, like most men of a good, blithe heart, Captain Delano took to negroes, not philanthropically but genially, just as other men took to Newfoundland dogs.[17]

to the biological racism that also characterized the American mind:

> For it was strange, indeed, and not very creditable to us white skins, if a little of our blood mixed with the Africans, should, far from improving the latter's quality, have the sad effect of pouring vitriolic acid into black broth; improving the hue, perhaps, but not the wholesomeness.[18]

Thus, Melville fused with considerable ease the various currents of American racism in the personality and thought of Delano either as uncertainties or as convictions. In spite of all Captain Delano's apparent warmth and generosity toward Negroes, he had not one micro-second

1970), pp. 25–31; Howard Welch, "The Politics of Race in Benito Cereno," *American Literature*, XLVI (January 1975), pp. 556–66; Eleanor Simpson, "Melville and the Negro, From Typee to Benito Cereno," *American Literature*, XLI (March 1969), pp. 19–39; Stanley T. Williams, "Follow Your Leader," *The Virginia Quarterly Review*, XXIII (Winter 1947), pp. 61–76; and David D. Galloway, "Herman Melville's Benito Cereno; An Anatomy," *Texas Studies in Literature and Language*, IX (Summer 1967), pp. 239–52. Sidney Kaplan, ironically, is the father of much of that misguided criticism. In positing racism in Melville, he inadvertently furnishes the above scholars and many more with the racist critical framework they use to attribute evil to Africans in rebellion against enslavement on board the *San Dominick*. See Sidney Kaplan, "Herman Melville and the American National Sin: The Meaning of 'Benito Cereno,'" *Journal of Negro History*, XLI (October 1956), pp. 311–38; XLII (January 1957), pp. 11–37. Sterling A. Brown argued that Babo and his cohorts rebelled as men and women will and were in no sense evil in his *The Negro in American Fiction* (Washington, 1937). Since that time a number of critics have elaborated upon that point of view, among them Joyce Adler, "Melville's Benito Cereno: Slavery and Violence in the Americas," *Science and Society*, XXXVIII (Spring 1974), pp. 19–48; Allen Gutman, "The Enduring Innocence of Captain Amassa Delano," *Boston University Studies in English*, V (Spring 1961), pp. 35–46; Jean F. Yellin, *The Intricate Knot* (New York, 1972); Joseph Schiffman, "Critical Problems in Melville's Benito Cereno," *Modern Language Quarterly*, XI (September 1950), pp. 317–24; and Glen C. Altschuler, "Whose Foot on Whose Throat? A Re-examination of Melville's Benito Cereno," *College Language Association Journal*, XVIII (March 1975), pp. 383–93. Though we did not read Professor Altschuler's piece until after completing our essay, it should be noted that he offers a solution to the Satyr figure problem in the novella that is like our own.

[17]See George M. Frederickson, *The Black Image in the White Mind* (New York, 1971), Chapters 3 and 4, for the best treatment of the subject.

[18]Melville, *Benito Cereno*, p. 84.

of hesitation in using all his means to re-enslave them. Nor did he have any moral or ethical problem in proposing to purchase one of Don Benito's slaves. Unable to imagine Africans capable of subtlety or even of guile, he found his assumptions put to a severe test when he encounters Babo, the gifted and confident leader of the blacks on board the slave ship.

Ironically, as Delano's ship was sighted, Babo assured the Africans there was nothing to fear, then engaged his chief lieutenant, Atufal, in a discussion of the course of action to be taken. Counseled to sail away, he reflected alone before declaring to all that whites should act as though still in command and blacks as their slave subordinates if the captain of the ship in the distance boarded the *San Dominick:*

> . . . Again and again he harangued the Spaniards and his companions, informing them of his intent, and of his devices and of the invented story that this deponent was to tell; charging them lest any of them varied from that story; that these arrangements were made and matured during the interval of the two or three hours, between their first sighting the ship and the arrival on board of Captain Amassa Delano.[19]

Thus, a well-instructed "clamourous throng of whites and blacks" met the American captain and "in one language, and as with one voice, all poured out a common tale of suffering."

> The scurvy, together with the fever, had swept off a great part of their number, more especially the Spaniards. Off Cape Horn they had narrowly escaped shipwreck; then, for days together, they had lain tranced without wind, their provisions were low; their water next to none; their lips that moment, were baked.[20]

What Delano considered "less good-natured qualities" induced by misery was more likely felt strength brought on by the struggle for freedom itself.[21] The tension between the need to feign enslavement and the determination to maintain control over the Spanish crew was present from the second Delano set foot on the *San Dominick* until the time of his departure many hours later. Unable to grasp either polarity, Delano could not understand the behavior of the whites or the blacks. Small wonder that he became impatient of the "hubub of voices," the "indocility of the blacks," and the "inefficiency of the whites."[22] A revolt was in process and a drama being enacted by Spaniards as well as slaves on orders from the real captain of the ship, Babo, to convince Delano that "confusion" and "alarm" proceeded from causes entirely unrelated to African disaffection with slavery.

Melville demonstrates that self-controlled activity directed toward

[19]*Ibid.*, p. 19.
[20]*Ibid.*, p. 7.
[21]*Ibid.*, p. 9.
[22]*Ibid.*, pp. 8–10.

liberation dominated the action of the blacks, and in the process reveals his respect for Africans and their political talents. After Raneds, the lone navigator among the Spaniards, other than Don Benito, is killed after his harmless gesture was misinterpreted, the oakum-pickers caution their comrades against responses disproportionate to the danger posed. Raneds was handing Don Benito a quadrant when cut down by Africans who were suffering from lack of water and excessive heat on the fifth day of a period of calm before contact with Delano's *Bachelor's Delight*.

Later, an ambiguous gesture from Delano drew a response of masterly authority from the oakum-pickers.

> The casks were being hoisted in, when some of the eager negroes accidently jostled Captain Delano, where he stood by the gangway; so that, unmindful of Don Benito, yielding to the impulse of the moment, with good-natured authority he bade the blacks stand back; to enforce his words making use of a half-mirthful, half-menacing gesture. Instantly the blacks paused, just where they were, each negro and negress suspended in his or her posture, exactly as the work had found them—for a few seconds continuing so— while, as between the responsive posts of a telegraph, an unknown syllable ran from man to man among the perched oakum-pickers.[23]

As the hatchet-polishers half-rose, a cry of alarm came from Benito Cereno. Mistaking the cry for a signal to destroy him, Delano started to spring for his boat. But he paused as the oakum-pickers rose from their stations at both ends and sides of the ship and began to force each white and Negro back "with gestures friendly and familiar, almost jocose, bidding him [Delano] in substance, not be a fool." Immediately, the hatchet-polishers resumed their seats—"quietly," Melville tells us, "as so many tailors." The final touch elicited by the oakum-pickers' efforts to restore order could not have been better calculated to set Delano at relative ease. As the hatchet-polishers took their seats, at once the hoisting in of casks was resumed, "white and blacks singing at the tackle."[24]

Though the oakum-pickers' effort to restrain blacks excited by the arrival of the supplies was not altogether successful—a couple of Africans accidentally fell against Delano while awaiting the unloading of the precious cargo—they left no doubt of their authority among the inhabitants of the *San Dominick*. The oakum-pickers had prevented Delano from being killed unnecessarily and had done so with such skill that it never crossed his mind that they were giving orders to whites as well as blacks as they descended into the crowd.

Melville's positioning of the oakum-pickers underscores their role as sentinels who watched over the ship from each pivotal angle so that revolutionary order might be maintained and the slaves' objective of liberation fulfilled. Though Delano rightly sensed that a controlling influence emanated from them, he underestimated the degree of control.

[23]*Ibid.*, p. 44.
[24]*Ibid.*

Since he did not know its object he repeatedly erred in analyzing the behavior of Africans on board the slave ship. On one such occasion.

> [His] attention was drawn to something passing on the deck below; among the crowd climbing the landward bulwarks, anxiously watching the coming boat, two blacks, to all appearances accidentally incommoded by one of the sailors, violently pushed him aside, which the sailor someway resenting, they dashed him to the deck, despite the earnest cries of the oakum-pickers.[25]

Delano saw only mindless capriciousness on the part of the Africans when the sailor was thrown to the deck. Although the Africans misinterpreted the sailor's actions in the first instance, they rightly construed his behavior as dangerous when he displayed resentment. This confrontation threatened to destroy the delicate balance of African objectives, for more than a little of the security won from appearing subjects of the whites had to be sacrificed to prevent the sailor, through continued defiance, from breaking the hold on him and thereby jeopardizing security altogether. Had the blacks heeded the cries of the oakum-pickers, they would in this case have courted the greater "disorder" of having an openly resentful sailor on their hands.

When a Spanish boy, not overheard by the elders, was struck by a slave boy for attempting to inform Delano of the real state of affairs on the slave vessel, Delano concluded that the oakum-pickers' authority had been ignored. But the telescoping of opposing roles in single personalities made "disorder"—the failure of the African boy to obey the oakum-pickers by not striking the Spanish boy—essential if the conspiracy were not to be exposed.[26]

"If Don Benito's story was, throughout, an invention," Delano remarks in the novella, "then every soul on board, down to the youngest negress, was his carefully drilled recruit in the plot; an incredible inference." Delano was wrong only in not having imagined, far more incredibly, that all were actors in an artificial world created by Babo. So when his suspicions recur in a new and more obscure form and lead him to seek out a sailor to question, "a queer cry" came forth from the oakum-pickers,

> prompted by whom, the negroes, twitching each other aside, divided before him; but as if curious to see what was the object of this deliberate visit to their Ghetto, closing in behind, in tolerable order, followed the white stranger up. His progress thus proclaimed as by mounted kings-at-arms, and escorted as by a Kaffir guard of honor. Captain Delano, assuming a good-humored, off-handed air, continued to advance; now and then saying a blithe word to the negroes, and his eye curiously surveying the white faces, here and there sparsely mixed in with the blacks, like stray white pawns venturously involved in the ranks of the chess-men opposed.[27]

[25]*Ibid.*, p. 32.
[26]*Ibid.*, p. 18.
[27]*Ibid.*, p. 34.

The cry of the elders reminds all, as the stranger moves into their midst, that Babo's strategy must be carried out. So when Delano queries a whiskered sailor and the answers confirm the invented story, he returns to the poop "feeling a little strange at first, he could hardly tell why, but upon the whole with regained confidence in Benito Cereno." The "old whiskerando" had fallen mute when Africans around him, not addressed by Delano, began responding to the captain's questions. The demand made of the sailor to act superior to the Africans without disobeying them caused him to mix, Melville tells us, an "ursine air" with a "sheepish one."[28]

Delano's inability to pierce the illusion and get to the substance of the problem on the *San Dominick* was exhibited most glaringly when an old sailor addressed him in the first English heard on the ship— "lowly, but with such condensation of rapidity, that the long, slow words in Spanish, which had preceded and followed, almost operated as covers for the brief English between."[29] While speaking to Delano the sailor had thrown him a knotted rope but Atufal was behind Delano at the time, "standing quietly." "The next moment, the old sailor rose, muttering, and followed by his subordinate negroes, removed to the forward part of the ship, where in the crowd he disappeared."[30] The sailor, subtly attempting to convey the complexity of developments on the ship, had passed on to Delano an extraordinarily elaborate combination of knots: "double—bowline—knot, treble—crown—knot, backhanded—well-knot, knot-in-and-out-knot, and jamming knot" only to have an African elder move forth "with a kind of attorney air" to control events.[31]

> In tolerable Spanish, and with a good natured, knowing wink, he informed him that the old knotter was simple-witted, but harmless; often playing his odd tricks. The negro concluded by begging the knot, for of course, the stranger would not care to be troubled with it. Unconsciously, it was handed to him. With a sort of conge the negro received it, and turning his back, ferreted into it like a detective custom-house officer after smuggled laces. Soon, with some African word, equivalent to pshaw, he tossed the knot overboard.[32]

In this situation, a slave approached a white male, disrupted his concentration, and jettisoned the object of his attention as a piece of garbage. Delano never grasped that the elder, in convincing him that he

[28]*Ibid.*, pp. 33–34.

[29]*Ibid.*, p. 40.

[30]*Ibid.*

[31]Paul Robeson, who possessed a deep knowledge of African cultures and knew several African languages, including Arabic, put his finger on the basis of the elders success in the above incident and all others in *Benito Cereno*. He remarked that, had he been born in Africa, he would have liked in his mature years to have been a wise elder, "for I worship wisdom and knowledge of the ways of men." Paul Robeson, *Selected Writings* (New York, 1976), p. 54.

[32]Melville, *Benito Cereno*, p. 40.

was being favored, seriously affronted the old sailor. In effect, it was as if Delano had never been accosted, as if the event had been erased from his consciousness.

Melville's treatment of the satyr figure in the novella reinforces our assessment of Delano's character. The figure uppermost and central on the "shield-like sternpiece" of the slave vessel is first described by Melville as "a dark satyr in a mask, holding his foot on the prostrate neck of a writing figure."[33] A possible interpretation is that African oppression of whites, no doubt of Benito Cereno, is thereby symbolized. Indeed, uncontrollable passions of blacks exploding against whites seem depicted there on the sternpiece. Yet, in the end Melville provides the reason for African revolt as Babo pursues Benito Cereno into Delano's boat, dagger in hand.

> But the weapon was wrenched away, and the assailant dashed down into the bottom of the boat, which now, with disentangled oars, began to speed through the sea. At this juncture, the left hand of Captain Delano, on one side, again clutched the half-reclining Don Benito, heedless that he was in a speechless faint, while his right foot, on the other side, ground the prostrate negro. . . . Glancing down at his foot, Captain Delano saw the freed hand of the servant aiming with a second dagger—a small one, before concealed in his wool—with this he was snakishly writhing up from the boat's bottom.[34]

As Melville removes the masks, a fanatical Delano is revealed, his foot on Babo's neck, "his right arm pressed for added speed on the after oar, his eye bent forward, encouraging his men to their utmost." Shortly thereafter, a flash of illumination spreads across his mind, causing "scales" to fall from his eyes: He now sees Negroes "not in misrule, not in tumult, not as if frantically concerned for Don Benito, but . . . in ferocious piratical revolt."[35] The scales on his eyes resulted from his belief in the natural suitability of Africans for enslavement rooted in their alleged intellectual inferiority—a belief not challenged until it dawned on him that Africans controlled the ship.

During the period in which members of the American School of Anthropology were citing measurements of skulls to demonstrate the intellectual inferiority of the Negro,[36] Melville said of Babo:

> Some months after, dragged to the gibbet at the tail of a mule, the black met his voiceless end. The body was burned to ashes; but for many days, the head, that hive of subtlety, fixed on a pole in the Plaza, met, unabashed, the gaze of the whites.[37]

[33]*Ibid.*, p. 6.
[34]*Ibid.*, pp. 67–68.
[35]*Ibid.*, p. 68.
[36]Marvin Harris, *The Rise of Anthropological Theory* (New York, 1968), pp. 91–93.
[37]Melville, *Benito Cereno*, p. 91.

Approximately twenty years separated Melville's first reading of Mungo Park from the appearance of *Benito Cereno* in 1855. In the intervening years he returned to Park many times. In particular, his studies of Park's style of rendering perceptions of cultures undoubtedly enhanced his sensitivity to nuance and subtlety in African life.[38] Aware of underlying unities and guiding assumptions of West Africans, it is likely that Melville tested his knowledge of Africans on numerous levels as often as he could, especially since the attraction of Park's book was so great and since the thought of writing a story on the order of *Benito Cereno* had probably occurred to him years before he began to write it.

Since Melville, who was less than sanguine about American culture, explored with penetration the cultures of people wherever he traveled, his attention upon reading Park almost certainly and immediately focused on the African population in the United States. There he could have found, as he probably did along the Mississippi or in Virginia, a culture rich in an emotional and spiritual reality the hallmark of which was an irony strikingly similar to the African irony of which Park makes brief, but vivid mention in the one folktale recounted in his volume.[39]

The play of irony that informs Babo's activities on board the *San Dominick* is precisely that adopted by Brer Rabbit in his African American expression. It may be that Melville's knowledge of the historical rebellion by Babo and awareness of African irony through Park led him to characterize Babo as he did. Or, again, it may be that Melville's knowledge of the African American ironic sense, epitomized by Brer Rabbit, led him to choose this characterization. Probably, some combination of the two informed his portrait of Babo. What is certain is that Babo is so much like Brer Rabbit that it is perfectly logical that he should have come from Senegal, a thriving center for tales of the African hare, Brer Rabbit's ancestral model.[40]

The remarkable similarity of Babo's moral character as well as intellectual behavior to that of Brer Rabbit suggests that Melville has described a hero of the oppressed by invoking a West African model. Although there is no firm evidence that Melville knew of Brer Rabbit, he projects the most striking similarities between Babo, the Senagalese leader of the slave revolt, and Brer Rabbit, the supreme hero of African American folklore. In no sense does the success of Brer Rabbit or Babo depend on physical strength, for both are too small to confront their enemies physically. Babo's mastery of his world, like Brer Rabbit's mastery of his, depends upon superior intellectual powers. Not surprisingly, Melville takes the liberty of stressing Babo's slight stature when there is no mention of it in the historical document.

[38] Arvin, *Melville*, p. 81.

[39] Leon Howard, *Herman Melville* (Berkeley, 1967), p. 37; Park, *Travels*, p. 31.

[40] Mlle. Colardelle-Diarrasouba, *Le lièvre et l'araignée dans les contes de l'ouest africain* (Paris, 1975), contains excellent research and commentary on the West African hare, including Sengalese hare stories told in almost every section of that land of Babo's birth.

"As for the black—whose brain, not body," Melville writes, "had schemed and led the revolt, with the plot—his slight frame inadequate to that which it held, had at once yielded to the superior muscular strength of his captor, in the boat."[41] Brer Rabbit's intelligence was appreciated by those of the community of the oppressed little animals who symbolized slaves. But like Babo—"Ah, master, don't speak of me; Babo is nothing; what Babo has done was but duty"—Brer Rabbit would just as soon deny his intelligence.

> Oh, no, sir, I'm just a little innocent creature trying to make a living. I'm no match for you, Brer Fox. You and Brer Wolf are both powerful big creatures, and I hear that the bigger the head, the bigger the brain! So don't be afraid of me, little old me with my teeny-weeny brain.[42]

Both Babo and Brer Rabbit are supremely self-confident, willing to direct schemes the success of which depends almost entirely on the cleverness of conception. Their self-confidence at times mounts to daring as each creates worlds of illusion in order to dispirit and overcome the opposition. The closest thing in American literature to Melville's treatment of Babo's and his cohorts' use of illusion as a weapon against the oppressor is found in William John Faulkner's superb collection of tales, *The Days When the Animals Talked*—tales told to Faulkner by Simon Brown, who collected them in Virginia while still a slave.[43]

In "The Tiger and the Big Wind" Brer Rabbit directs the little animals in a drama designed to convince the Tiger, who controls the water and food in a time of famine, that all who are not tied to the face of the earth will be blown away by a cyclone. As the sound of the approaching cyclone, created by the desperate theatrics of the animals, comes alive in the ears of the reader, the forest inhabited by the animals is turned into a solitary world that is approaching its day of reckoning and judgment. In that atmosphere of terror, Brer Rabbit controlled the consciousness of the tiger, who, reduced to utter dependency, implored Brer Rabbit to tie him down to prevent his being swept from the face of the earth. Almost to the very end, the movement of Brer Rabbit's world parallels that of the *San Dominick* toward its rendezvous with fate under Babo's captaincy.[44]

The self-confidence of Babo and Brer Rabbit is linked to a shared sense of moral righteousness, which leads them to become forces of retribution that unsentimentally punish the purveyors of greed and cruelty. This intensity of feeling for the oppressed makes them seem unfeeling to those who do not share their commitment to liberty. That commitment, coupled with intellectual prowess, accounts both for their confidence and for the enormous respect they command among their

[41]Melville, *Benito Cereno*, p. 90.
[42]William John Faulkner, *The Days When the Animals Talked* (Chicago, 1977), pp. 112–13.
[43]*Ibid.*, pp. 3–8.
[44]*Ibid.*, pp. 89–94.

own, a respect which heightens the sense of horror of those who oppose Babo on board the *San Dominick*. Yet, the historical Babo exercised even greater command, for he kept an Olympian distance from almost everyone, issuing orders, including the all-important one that was carried out by Muri, his young son, never to let Don Benito out of his sight.[45]

In the novella, however, Melville increased Benito Cereno's psychic strain by bringing Babo rather than his son face-to-face with him until he can no longer endure Babo's presence. In the scene that best captures that strain, Babo, using the flag of Spain as an apron and stropping a razor, proceeds to shave the frightened Don Benito in Delano's presence:

> You must not shake so, master, see . . . master always shakes when I shave him. And yet master knows I never yet have drawn blood, though it's true, if master will shake so, I may some of these times. Now master . . . [46]

Melville, true to form, was generally faithful to the rebellion that took place on board the Spanish ship *Tryal*, but he took the liberty of fusing Babo and his son Muri and of transmuting certain vengeful actions committed by the whites into acts committed by the blacks in taking over the *San Dominick*. His treatment of the whites at the end of the novel demonstrates that, when their lives were threatened, they behaved with less regard for the humanity of others than did the rebelling slaves. According to Delano's *Voyages and Travels*, the following occurred after the whites suppressed the rebellion on board the *Tryal* in 1805:

> On going aboard the next morning with hand-cuffs, leg irons, and shackled bolts, to secure the hands and feet of the negroes, the sight which presented itself to our view was truly horrid. They had got all of the men who were living made fast, hand and feet, to the ring bolts in the deck; some of them had parts of their bowels hanging out, and some with half their backs and thighs shaved off.[47]

Melville uses this shaving incident in two ways. He has the slaves strip the flesh off Aranda's body and place his skeleton up on the mast-head, and he has Babo shave Benito Cereno in the barber's chair on board the *San Dominick*. In both instances it was as if he had provided the reader with a prevision of what the whites were actually going to do to blacks in suppressing the rebellion. In short, the skeleton of Aranda is an emblem of white barbarity, not African, as ordinarily asserted. The slaves' shaving down of Aranda's body is a symbolic reflection of a white historical act. Of this there can be little doubt, for Melville refers the reader to a little known battle in which the same sort of cruelty character-ized the vengeance taken by the Scots under the leadership of Charles Stuart in 1745 at Preston Pans.[48]

[45]Scudder, "Delano's Voyages," pp. 507, 518, 522, 524.

[46]Melville, *Benito Cereno*, p. 51.

[47]Scudder, "Delano's Voyages," p. 51.

[48]James Browne, *History of the Highlands and of the Highland Clans* (Glasgow, 1938), III, pp. 78–79.

> Nearly a score of the negroes were killed. Exclusive of those by the balls, many were mangled; their wounds — mostly inflicted by the long-edged seal-ing-spears, resembling those shaven ones of the English at Preston Pans, made by the poled scythes of the Highlanders.[49]

The subjective interpretation of evil is not useful, for many find Babo evil, just as others find the captain of the slave ship, Benito Cereno, and the liberal Delano evil. Defenders of a culture based on slavery will necessarily find the struggle against slavery evil. To the extent that they accept the values of the master, there will be slaves who will find their people's struggle for freedom evil. It is interesting to note that Babo is thought of as evil for continually challenging authority, just as Brer Rabbit is today thought of as evil for challenging authority.[50]

The slave experiences fear of death which condemns him to his oppression. That his willing faculty becomes external to his subjective consciousness and is embodied in another consciousness is the most extreme form of loss of dignity. In Hegel's *Phenomonology of Mind*, the slave begins in absolute dependence through fear and complete loss of dignity, regains his dignity through his labor, and, once conscious of this development, recognizes that he is the creative force and the master a parasite.[51] Though Babo seems to be a first-generation African, in the course of his life he represents a historical epoch and undergoes a radical transformation: Generations of slave experience seem joined in a single life. Indeed, Melville conveys the immediacy of the humiliating effects of slavery through the fusion of Babo and his son. Babo, therefore, represents the whole range of slave possibility from humiliation and loss of anything that approaches dignity to rebellion and willingness to risk life itself to regain his humanity in all its fullness.[52] As primeval man, expressing his essential right to be free against all odds and all others, Babo is waging an elemental struggle for liberty. This is essential good, not evil, for all the master holds dear — his leisure, comfort, wealth — is made possible by the slave.

For Melville, in *Benito Cereno*, slavery is a psychic and material crutch for the master class. In fact, his treatment of the master's dependence on the slave is an excellent representation in creative literature of the Hegelian position on that question.[53] The slaves on board the *San*

[49]Melville, *Benito Cereno*, p. 72.

[50]See the latest edition of Stanley Elkins, *Slavery: A Problem in American Institutional and Intellectual Life* (Chicago, 1976), for the view that Brer Rabbit was "at best one nasty little hustler," p. 283.

[51]See G. W. F. Hegel, *The Phenomenology of Mind* (New York, 1967), pp. 228–40.

[52]See Scudder, "Delano's Voyages," pp. 515–19, for Muri as a youthful slave. Melville, however, presents him as an elder in the novella.

[53]Melville offers numerous examples of Babo's holding up the physically and psychologically unstable Don Benito: Don Benito "fell heavily against his supporter;" "the black upholding the white;" "but the servant was more alert, who, with one hand sustaining his master . . . "; "his vital energy failed, so that the better to support him, the servant, placing

Dominick recognize the superfluity of the masters as evidenced by the killing of their owner, Aranda. In order to be free, they understood that the master had to be physically destroyed, as Babo tells us, to make their reenslavement impossible. Babo's position brings to mind Saint Just's argument before the National Assembly that the king must be killed not because he is a bad man but because he is king.

By making Don Benito suffer the humiliation of the captive, Babo demonstrates his mastery in the most effective way short of killing him: He needs him alive to pilot the ship to a black country.[54] Babo understands the deep attachment of Don Benito, as a former slavemaster, to the slave system and concludes that the only way to get him to use his skills for the benefit of the slave community is through terror. The one thing that the master class has at its command is the state machinery and the uses of statecraft, symbolized by the ship and by Benito Cereno's navigational skills. Though Babo succeeds in getting control of the human interrelations, he ultimately fails because he lacks mastery of statecraft. For that reason he remains, so long as he is not in a black country, dependent on Benito Cereno.

Melville's portrait of Babo, based on Delano's account of the *Tryal* insurrection, is a study of the Negro as hero. For that reason he cannot be accused of romanticizing slave ability, as so many abolitionists who wrote autobiographical statements for slaves were accused. The question then is whether this heroic figure is good or evil: To say he is evil is to argue that the struggle for liberty is evil. Nothing in Melville would support such a reading.

Don Benito, however, appears as a man who is wasting away from a disease more moral than physical—the more so since in Captain Delano's historical account he appears all too well and unappealing. Melville contrasts Don Benito's moral collapse to Delano's moral obtuseness. It escapes Delano that the only evil against which it is truly difficult to struggle is that in one's own soul, so that when he asks Don Benito, "What has cast such a spell upon you?" and is told, "The Negro," he does not understand.

his master's hand on his naked shoulder, and gently holding it there, formed himself into a sort of crutch." See Melville, *Benito Cereno*, pp. 14, 16, 32, 65, 66. We have been unable to find a specific reference to Hegel in Melville's work. However, the earliest reference to freedom as the recognition of necessity is from Hegel and Melville, introducing *The Bell-Tower* with lines of poetry "from a private Ms.," tells us: "Seeking to conquer a larger liberty, man but extends the empire of necessity." The Hegelian echo here is deafening. See *The Bell-Tower* in Chase, ed., *Herman Melville Selected Tales and Poems* (New York, 1950), p. 190.

[54]This is a sign that a Pan-Africanist cultural and political position, in fact, a perfect melding of the two, had been arrived at by Babo and his co-horts—an important development especially since a substantial number of them were characterized as "raw Africans" by Delano in the original account of the revolt. See Scudder, "Delano's Voyages," pp. 515–16.

The characterization of Don Benito reminds us that the impact on Europe of its colonization of the Americas was twofold: Colonialization provided a tremendous spur to European economic and political development; and its unleashed genocide and human oppression on an unprecedented scale. Benito Cereno symbolizes that duality: He is dressed in finery, but his moral traits are soft; there are repeated suggestions, especially his use of Babo as a crutch, of the decay of his internal being. In particular, we have a working-out of the analogy between the spiritual life of Europe and the state of the ship so devastating that one is left only with gray despair. Thus, Melville has Delano, in scrutinizing the *San Dominick*, note "corroded main chains" of an ancient style "even more fit for the ship's present business than the one for which she had been built."[55]

Babo is the fount of action in *Benito Cereno*: By his actions, he determines the nature of things. The world he wills is not one that the Europeans in *Benito Cereno* value. An essential difference between Babo and them is that they can manipulate insensate reality, but, unlike Babo, do not ground their actions in awareness of the human nature of others.

Captain Delano's *Voyages and Travels* leaves no doubt that an ingenious revolt was masterminded by a literate African by the name of Babo. His account also shows that an agreement was written up by Babo and Benito Cereno, signed in Spanish—a language that Babo understood—and in an African language.[56] Babo was probably an Arabic speaking marabout and member of the priesthood whose defeat, in the novella as in history, was due to the whites' control of guns and technology. Yet, he clearly was able to manipulate the negative environment of the New World with extreme finesse and intelligence, so when the odds of nature went against him it was like an expression of fate.

[55]Melville, *Benito Cereno*, p. 38.
[56]Scudder, "Delano's Voyage," p. 517. Like Babo, Atufal could also write in an African language, undoubtedly Arabic. It may be there were more Africans than Spanish sailors on the *Tryal* who could read and write.

"Follow Your Leader":
The Theme of Cannibalism in
Melville's *Benito Cereno*

Master told me never mind where he was or how engaged, always to remind him, to a minute, when shaving time comes. Miguel has gone to strike the half-hour afternoon. It is now master. Will master go into the cuddy?

Melville,
Benito Cereno

The solution to the problem of cannibalism in *Benito Cereno* involves concerns that are at the heart of the novella. Since that problem, represented by Alexandro Aranda's skeleton, shadows the work as a whole, it is not surprising that its solution has implications for aspects of the work that have received little or no critical attention to date. In other words, aspects of the novella that once seemed essential to the brilliance of its crafting but with little or no relation to Melville criticism will be shown to be deeply related to that criticism.

Though final resolutions are difficult to argue in a work of such complexity, one can argue that of all the problems before *Benito Cereno* critics, none quite compares — as an artistic construct — with that of Aranda's skeleton. It is a great mystery to be unraveled, and only a few scholars have attempted to begin the process. This overall reluctance probably has much to do with critics, until recently, having overwhelmingly viewed blacks in *Benito Cereno* as so evil and savage that it was enough merely to conclude that Aranda's body was cannibalized. Carolyn Karcher is incisive in this regard, arguing that Melville offers "innuendo which we are left to flesh out in accordance with our most primitive fears and fantasies."[1] Considering the place of Africans in the American mind, those fears and fantasies, as Melville must surely have anticipated, would encourage most readers to conclude that Africans cannibalized Aranda. But given the fiercely ironic nature of *Benito Cereno*, in which Melville continually reveals new means of ensnaring us with his magic,

[1]Carolyn Karcher, *Shadow over the Promised Land: Slavery, Race and Violence in Melville's America* (Baton Rouge, 1980), p. 142. I thank the eminent Africanist Ray Kea for assisting me in locating Ashantee sources published prior to the appearance of *Benito Cereno*. This essay is dedicated to the memory of my mother, the poet Elma Stuckey.

we should be suspicious of any tendency to confuse our conclusions with his. In addition, he was at home in cultures radically different from our own, the provincial as distasteful to him as assumptions of white superiority: "I walk a world that is mine; and enter many nations, as Mungo Park rested in African cots."[2]

That Africans practiced cannibalism on the *San Dominick* has been suggested by Sidney Kaplan, a distinguished critic especially noted for his enlightened stance on matters of race. More than forty years ago, Kaplan wrote that Melville adds "a strong hint that Aranda's body has been cannibalistically prepared," that the hint of cannibalism is additional evidence of Melville being anti-black in the novella.[3] To be sure, it is largely due to Kaplan that, over the past fifteen years, critics finally began to address this problem in Melville criticism.

John Herman McElroy's "Cannibalism in Melville's Benito Cereno" affirms Kaplan's thesis regarding Aranda's body having been cannibalized without affirming Kaplan's conclusion that Melville is anti-black in the novella. He argues that Babo ordered a ritualistic act of cannibalism on board the *San Dominick*, an act that is "passed over silently within the narrative but is hinted at consistently. This feature of controlled omission makes *Benito Cereno* one of Melville's most unusual and most brilliant performances."[4] But cannibalism is not silently passed over in the narrative. It is expressed so subtly that, as is so often the case when critiquing *Benito Cereno*, one can easily miss it, which is an even greater indication of Melville's skill.

In a more recent attempt to demonstrate ritualized cannibalism in the novella, Barbara J. Baines argues that Babo ordered an unsuspecting Don Benito Cereno, thinking he is eating food, to cannibalize Aranda. Thus, the Spanish captain, she writes, joined the blacks in malevolent communion. For Baines, Babo is evil personified, more intent on revenge than on being free of enslavement. Her elaborate case stands or falls on her certitude that the Africans prepared Aranda's body as a symbol of terror by cannibalizing it, and she advances this thesis despite her conclusion, in line with McElroy, that there is no "concrete evidence for [cannibalism] in the text."[5]

The symbol of Aranda's skeleton is so consistently and dramatically invoked that an analysis of the means by which Melville created it should lead to reconsideration of the work as a whole. This is so because the skeleton fuses past, present, and future for whites on the ship, darkly

[2]Herman Melville, *Mardi* (Evanston and Chicago, 1970), p. 368. Originally published in 1849.

[3]Sidney Kaplan, "Herman Melville and the American National Sin: The Meaning of *Benito Cereno*," *Journal of Negro History*, 41 (1956), pp. 287–301.

[4]John Herman McElroy, "Cannibalism in Melville's *Benito Cereno*," *Essays in Literature* (Spring 1974), pp. 206–14.

[5]Barbara J. Baines, "Ritualized Cannibalism in *Benito Cereno*: Melville's 'Black Letter' Texts," *ESQ*, Vol. 30 (Third Quarter 1984), pp. 163, 166.

insinuating its influence as it hovers above the action from beginning to end. Moreover, the cultural matrix with which Melville associates it leads him to ingenious artistic experimentation in the novella.

The skeleton's relationship to epochal oppression is suggested by its substitution for the figurehead of Christopher Colon, discoverer of the New World. In addition, the ship itself is emblematic of declining spiritual and political authority, its eerie sounds and scenes creating a mood appropriate to what has transpired and, with Amasa Delano's presence, what will occur. Within view, as Delano boarded the slave ship, beneath the canvassed figurehead of Aranda, "was the sentence, '*Sequid vuestro jefe*,' [Follow Your Leader]";

> while upon the tarnished headboards, nearby, appeared, in stately capitals, once gilt, the ship's name, *San Dominick*, each letter streakingly corroded with tricklings of copper-spike rust; while, like mourning weeds, dark festoons of sea-grass slimily swept to and fro over the names, with every hearse-like roll of the hull.[6]

If Delano saw the legend beneath the canvassed covering, he does not indicate as much — another instance of Babo's having calculated correctly in risking the presence of the American on the ship.

Aranda, the slaveowner, was killed; otherwise the slaves would not be free, also because the whites needed

> a warning of what road they should be made to take did they or any of them oppose [Babo]; and . . . by means of the death of Don Alexandro, that warning would best be given.[7]

It will be recalled that Babo assigns the task of dispatching and handling the body of Aranda to Ashantee men on the ship, Melville writing that "Babo commanded the Ashantee Martinique and the Ashantee Lecbe to go to commit the murder. . . . [T]hose two went down with hatchets to the berth of Don Alexandro. . . . " Aranda, brought half-dead to the deck, was finished off on orders from Babo but was not thrown overboard. Rather, on orders from Babo, "the body was carried below . . . nothing more was seen of it by the deponent for three days. . . . [8] It was, naturally, a matter of concern to Benito Cereno that Aranda's remains were taken below, concern that was heightened since others killed by the Africans were thrown overboard. Over the three-day period Don Benito, on numerous occasions, asked Babo "where they were, and, if still on board, whether they were to be preserved for interment ashore, entreating him so to order it. . . . "[9] But Babo, on the fourth day, as Benito Cereno came on deck at sunrise,

[6]Herman Melville, *Benito Cereno* in *Billy Budd and Other Stories* (New York, 1981), pp. 220–21.

[7]*Ibid.*, p. 293.

[8]*Ibid.*

[9]*Ibid.*, p. 294.

showed him a skeleton, which had been substituted for the ship's proper figure-head—the image of Christopher Colon, the discoverer of the New World; that the negro Babo asked him whose skeleton that was, and whether, from its whiteness, he should not think it was a white's; that upon discovering his face, the negro Babo, coming close, said words to this effect: "Keep faith with the blacks from here to Senegal, or you shall in spirit, as now in body, follow your leader, pointing to the prow."[10]

By succession, Babo took each Spaniard forward and asked "whose skeleton that was, and whether, from its whiteness" it was not that of a white. And each of the Spaniards, on seeing Aranda's remains, "covered his face." Each was warned that if an attempt were made to plot against the Africans, "they should, soul and body, go the way of Don Alexandro . . . a torment which was repeated everyday."[11] To reinforce the threat, Babo left Aranda's skeleton uncovered on the bow until Amasa Delano, the American captain, was spotted in the distance and it was thought strangers might board, at which point canvas was placed over it, as if for repairs. It was then that the unsettling inscription was written beneath it.

On hearing of the departed Aranda, Delano was led to conjecture what gave "the keener edge" to the Spaniard's grief, explaining that it was once his sad fortune to lose his brother at sea. He then vowed never to voyage again with one he loved "unless, unbeknown to him, I had provided every requisite, in case of a fatality, for embalming his mortal part for interment on shore."[12] The following exchange then took place:

> "Were your friend's remains now on board this ship, Don Benito, not thus strangely would the mention of his name affect you."
> "On board this ship?" echoed the Spaniard. Then, with horrified gestures, as directed against some specter, he unconsciously fell into the ready arms of his attendant, who, with a silent appeal toward Captain Delano, seemed beseeching him not again to broach a theme so unspeakably distressing to his master.[13]

Delano missed his one opportunity to discover that the canvas over the bow had concealed Aranda's remains. A stark unveiling of the figure-head occurred after he hailed the *Bachelor's Delight* and ordered the ports up and the guns run out to fire on the fleeing *San Dominick*. By this time, the cable of the fugitive vessel had been cut "and the fag-end, in lashing out, whipped away the canvas shroud about the beak, suddenly revealing, as the bleached hull swung round toward the open ocean, death for the figure-head in a human skeleton; chalky comment on the chalked words below, 'Follow Your Leader.'" This sight caused Benito Cereno to cover his face and to wail out "'Tis he, Aranda! My murdered, unburied friend!"[14]

[10]*Ibid.*, pp. 294–95.
[11]*Ibid.*, p. 295.
[12]*Ibid.*, p. 235.
[13]*Ibid.*, pp. 235–36.
[14]*Ibid.*, p. 284.

The last view of the figurehead, an eerie one, is offered just before crewmen from the *Bachelor's Delight*, after long pursuit of the *San Dominick*, board the ship for the final battle with the Africans.

> With creaking masts, [the *San Dominick*] came heavily round to the wind; the prow slowly swinging into view of the boats, its skeleton gleaming in the horizontal moonlight, and casting a gigantic ribbed shadow upon the water. One extended arm of the ghost seemed beckoning the whites to avenge it.[15]

The reader will note that a single African, an Ashantee, "prepared the skeleton of Don Alexandro," that at no time other than when the skeleton was substituted for the figurehead of Christopher Colon does Melville associate more than one African with it. Only Ashantees, one alone and two together, are mentioned in relation to handling the skeleton. This must be kept in mind in weighing the significance of the following passage from the novella:

> Yan and Lecbe were the two who, in a calm by night, riveted the skeleton to the bow. . . . Yan was the man who, by Babo's command, willingly prepared the skeleton of Don Alexandro, in a way the negroes afterwards told the deponent, but which he, so long as reason is left him, can never divulge.[16]

Though there were many things that Benito Cereno could never divulge, what he was told about the preparation of Aranda's remains must in due course be seriously considered.

In his treatment of the women on board the *San Dominick*, Melville draws on Mungo Park. In a famous passage in the novella, he has Delano observe a group of them—they outnumbered slave men on the vessel—and think to himself that, "like most uncivilized women, they seem at once tender of heart and tough of constitution. . . . Ah! thought Captain Delano, these, perhaps, are some of the very women whom Ledyard saw in Africa, and gave such a noble account of." While it is not clear if these women are meant to be Ashantees, there is less doubt about the ethnicity of the women in the following passage: "Why see," reflects Delano, "the very women pull and sing, too. These must be some of those Ashantee negresses that make such capital soldiers, I've heard."[17]

Interestingly, there is no mention of Ashantees in Delano's account of the revolt; nor are they mentioned in the depositions attached to Chapter XVIII of *Voyages*. It is likely that Melville detected an Ashantee presence on the *Tryal* from a single passage in the deposition submitted by Benito Cereno, though explicit reference to them is not made: "[T]he negresses of age, were knowing to the revolt, and influenced the death of their master. . . . They also used their influence to kill the deponent; that in the act of murder, and before that of the engagement of the ships

[15]*Ibid.*, p. 287.
[16]*Ibid.*, pp. 300–301.
[17]*Ibid.*, pp. 251, 275.

they began to sing, and were singing a very melancholy song during the action, to excite the courage of the negroes."[18]

It is likely that the reading of travel accounts about Africa led Melville to develop interest in Ashantee culture and customs. Without a grasp of Ashantee culture, it is doubtful that the reference to melancholy songs spurring Africans to greater valor could have been identified by Melville as an Ashantee practice, unless of course Melville had contact with Ashantees in the New World, which is certainly a possibility. In any event, his grasp of Ashantee culture led him to place Ashantees in key roles in the novella, as we know from the prominence of the hatchet polishers.[19]

There is reason to believe that an Ashantee king, who reigned in the early nineteenth century, was a source of inspiration for Melville's creation of important and related dimensions of *Benito Cereno* that are tied to the primary concern of this essay. Certain features of Benito Cereno's attire, though clearly South American, owed much to somewhat analogous ones worn by the king in question. The Spaniard, Melville writes, was dressed in "a loose Chili jacket of dark velvet"; moreover, he wore

> white small clothes and stockings, with silver buckles at the knee and instep; a high-crowned sombrero, of fine grass; a slender sword, silver mounted, hung from a knot in his sash—the last being an almost invariable adjunct of a South American gentlemen's dress to this hour. . . . [T]here was a certain precision in his attire curiously at variance with the unsightly disorder around.[20]

Though the toilette of Don Benito was consonant with the fashion of the day for South Americans of his station, it was unusual for the setting—indeed, to the point of Don Benito almost having the appearance of a buffoon. This Melville makes clear by remarking that, considering the nature of the voyage, "there seemed something so incongruous in the Spaniard's apparel, as almost to suggest the image of an invalid courtier tottering about London streets in the time of the plague."[21]

The Ashantee king about whom Melville read in T. Edward Bowdich's *Mission From Cape Coast Castle to Ashantee* was dressed as incongruously, considering his surroundings, as Don Benito Cereno and, therefore, was said to have "walked abroad in great state one day, an

[18]*Ibid.*, p. 341. The Ashantee nature of such singing is treated by Joshua Leslie and Sterling Stuckey in "The Death of Benito Cereno: A Reading of Herman Melville on Slavery," *Journal of Negro History* (Winter 1982), p. 290.

[19]The role of the hatchet polishers, in relation to the revolutionary order maintained on the *San Dominick* by the Africans is explored by Leslie and Stuckey in *ibid.*, pp. 287–301.

[20]Melville, *Benito Cereno*, p. 231.

[21]*Ibid.*, p. 293.

irresistible caricature."[22] The description of the cloth from which his main outfit was made suggests that of Benito Cereno, as do certain other features of his attire and possession, for

> he had on an old-fashioned court suit of General Daendels' of brown velveteen, richly embroidered with silver thistles, with an English epaulette sewn on each shoulder, the coat coming close to round the knees, from which the flaps of the waistcoat were not very distant, a cocked hat bound with gold lace, in shape just like that of a coachman's, white shoes, the long silver headed cane we presented to him, mounted with a crown, as a walking staff, and a small dirk around his waist.[23]

That the dress of the king sparked Melville's imagination, leading him to have Babo dress Don Benito on that fateful day at sea, is the more evident when considering the remarkable shaving scene in the cuddy of the ship. At that time, Delano is so moved observing Babo, "napkin on arm, so debonair about his master, in a business so familiar as that of shaving, too," that "all his old weakness for negroes returned," a weakness retained despite a fleeting sense that Babo, "one hand elevating the razor, the other professionally dabbling among the bubbling suds on the Spaniard's lank neck"—might be a headsman, "the white man at the block."[24]

Shortly before that, Delano was amused by a peculiar instance of African love of fine shows and bright colors—"in the black's informally taking from the flag-locker a great piece of bunting of all hues, and lavishly tucking it under his master's chin for an apron."[25] But when the agitation of the Spaniard so loosened the bunting around him, causing a broad fold to sweep like a curtain over the arm of the chair to the floor, there was revealed, "amid a profusion of armorial bars and ground-colors—black, blue, and yellow—a closed castle in a blood-red field diagonal with a lion rampant in a white." At this point Delano exclaimed: "The castle and the lion, why Don Benito, this is the flag of Spain you use here." True to form, he added: "It's well it's only I, and not the king, that sees this. . . . It's all one, I suppose, so the colors be gay," which playful remark "did not fail somewhat to tickle the negro."[26]

Immediately thereafter, Babo remarked, "Now master . . . now master," as "the steel glanced nigh his throat." When Don Benito shuddered, Babo suggested that Delano resume his discussion "about the gale, and all that; master can hear, and between times, master can answer." But Delano focused on the period of alleged calm that followed the gales,

[22]T. Edward Bowdich, *Mission From Cape Coast Castle to Ashantee* (London, 1966), p. 122. Originally published in 1819.

[23]*Ibid.*, p. 122.

[24]Melville, *Benito Cereno*, pp. 265–66.

[25]*Ibid.*, p. 265.

[26]*Ibid.*, p. 266.

noting that "had almost any other gentleman told me such a story I should have been half disposed to a little incredulity."[27] This remark brought over the Spaniard "an involuntary expression," and either the start Don Benito gave or the sudden and gawky roll of the hull in the calm or any unsteadiness of Babo's hand, "however it was, just then the razor drew blood. . . . No sword drawn before James the First of England, no assassination in that timid King's presence, could have produced a more terrified aspect than was now presented by Don Benito."[28] Within seconds, however, Babo, with napkin in hand, encouraged Don Benito to answer Delano's question about the San Dominick being becalmed for two months, then proceeded to wipe the blood from the razor before stropping it again.

Almost finished, he worked with scissors, comb, and brush. Clipping a wayward whisker, smoothing first one and then another curl, he gave "a graceful sweep to the temple-lock, with other impromptu touches evincing the hand of a master." As Don Benito sat "so pale and rigid . . . the negro seemed a Nubian sculptor finishing off a white statue-head." He then removed the Spanish flag from round the Spaniard and tossed it into the locker from which it was taken. And with his usual attention to detail, surveying Don Benito, he whisked a bit of lint from his velvet lapel. Delano's congratulations deepened Don Benito's distress, and "neither sweet waters, nor shampooing, nor fidelity, nor sociality, delighted the Spaniard," who relapsed into gloom.[29]

Now that the barber-chair scene has been called to mind, we can appreciate a passage from Bowdich's Mission . . . to Ashantee that resonates remarkably with that scene. Bowdich writes of the Ashantee king:

> The King sent a handsome procession of flags, guns, and music to conduct us to the palace on the occasion; and meeting us in the outer square, preceded us to the inmost, where about 300 females were seated, in all the magnificence which a profusion of gold and silk could furnish. The splendor of this coup d'oeil made our surprise almost equal to theirs. We were seated with the King and the deputies, under large umbrellas in the centre, and I was desired to declare the objects of the Embassy and the Treaty, to an old linguist, peculiar to the women. The King displayed the presents to them; the flags were all sewn together, and wrapped around him as a cloth.[30]

Melville was under Ashantee influence in having Babo, in one of the great moments in world literature, use the flag of Spain as an apron, in the process lending a highly charged aura to Babo's interaction with

[27]Ibid., pp. 266–67.
[28]Ibid., p. 267. When this occurred, Delano thought: "Poor fellow . . . so nervous he can't even bear the sight of barber's blood; and this unstrung, sick man, is it credible that I should have imagined he meant to spill all my blood, who can't endure the sight of one little drop of his own? Surely, you have been beside yourself this day. Tell it not when you get home, sappy Amasa."
[29]Ibid., p. 269.
[30]Bowdich, Ashantee, p. 124.

whites around him. Indeed, the transfer of a custom from one culture to another to achieve a different objective is masterfully employed in *Benito Cereno*. With African cultural reality the source of such inspiration, Melville poses real problems for critics because the deeper irony also comes with knowledge of that reality, in the process of its transformation, having been crafted into art that satirizes defenders of slavery.

A variation on that theme occurs when Melville takes a European-made object, the walking staff that was used by the Ashantee king, out of an African setting and places it—more precisely, an object strikingly similar to it—on the *San Dominick*. Such a nuance refines highly ironic play, the means required to place the object on an oceangoing vessel constituting a further refinement. It is one that deflects the reader's thought away from Africa even as the Ashantee king and Benito Cereno are linked once more in the cuddy, a portion of which "had formerly been the quarters of officers; but since their death all the partitionings had been thrown down, and the whole interior converted into one spacious and airy marine hall. . . . " Then Melville's elegant solution to the problem of how to get the object on the ship, a solution that involves the suggestion of its presence without it actually being there, the ship's

> absence of fine furniture and picturesque disarray of odd appurtenances, somewhat answering to the wide, cluttered hall of some eccentric bachelor-squire in the country, who hangs his shooting-jacquet and tobacco-pouch on deer antlers, and keeps his fishing-rod, tongs, and walking-stick in the same corner.[31]

"The similitude," Melville writes, "was heightened; if not originally suggested, by glimpses of the surrounding sea; since in one aspect, the country and the ocean seem cousins-german."[32]

In an extremely subtle stroke, Melville underscores the link between Benito Cereno and the Ashantee king. During the shaving scene in the cuddy, Delano noticed, as Babo brandished the razor, that there was something hollow in Don Benito's manner, that he and Babo, in view of their "whispered conferences," might be acting in collusion, but he abandons the possibility "as a whimsy, insensibly, suggested, perhaps, by the theatrical aspect of Don Benito in his Harlequin ensign. . . . " Harlequin recalls King Herle, the mythical figure; harlequin ensign, *the king's flag*.[33]

But Don Benito was no king, except in the sense that, as Aranda's successor, he was a kind of king of slaveholders. As such, he had no mantle of authority but a cloth of shame—a means by which Babo insulted him and Delano, the former to further terrorize and strengthen control over him, the latter because he knew Delano would not under-

[31]Melville, *Benito Cereno*, p. 262.
[32]*Ibid.*, p. 263.
[33]*Ibid.*, p. 268. See *Webster's Third New International Dictionary* (Springfield, Massachusetts, 1986), pp. 755, 1034.

stand. Babo's final touch seems to have been inspired, at least in part, but only in part, by the attire of the king, who wore a dirk round the waist. Melville writes that Benito Cereno's dress included a "silver-mounted sword, apparent symbol of despotic command," which "was not, indeed, a sword, but the ghost of one. The scabbard, artificially stiffened, was empty."[34]

After the blacks were subdued in a desperate struggle, a number of developments occurred that are related to the barber-chair scene and, like it, to Aranda's skeleton. In fact, part of the reason Melville had Aranda's body shaved down was from consideration of them, especially from one that triggered others as in a chain reaction. In *Voyages*, Delano reports that when he boarded the *Tryal* "the next morning with handcuffs, leg-irons, and shackled bolts, to secure the hands and feet of the negroes," the sight presented to his view "was truly horrid."

> They had got all the men who were living made fast, hands and feet, to the ring bolts in the deck; some of them had part of their bowels hanging out, and some with half their backs and thighs shaved off. This was done with our boarding lances which were always kept exceedingly sharp, and as bright as a gentleman's sword.[35]

A development that contributed to Melville's creation of the shaving scene in the cuddy concerns Benito Cereno's behavior during this bloodletting. Don Benito, according to Delano's account in *Voyages*, "had a dirk, which he had secreted at the time the negroes were massacreing [*sic*] the Spaniards." But Delano did not notice Don Benito's attempt to use it until one of his sailors gave him "a twitch by the elbow," to draw his attention to what was occurring. It was then that he saw Don Benito "in the act of stabbing one of the slaves." Such shavings were occurring elsewhere on the ship, bringing to mind Babo, razor extended while dabbling at the suds on Benito Cereno's neck: A Spanish sailor, according to Delano, opened a razor and made a cut on a Negro's head then "seemed to aim at his throat, and it bled shockingly." After exercising "great authority" over the Spanish crew to prevent them from cutting "these unfortunate beings . . . all to pieces," Delano writes that he put the mangled blacks "in irons."[36]

On discovering what happened following the battle, Melville was reminded of the Battle of Preston Pans:

[34]Melville, *Benito Cereno*, p. 306.

[35]Amasa Delano, *A Narrative of Voyages and Travels in the Northern and Southern Hemispheres* (New York, 1970), p. 328. Originally published in 1817. The leader of the men who suppressed the revolt acted in perfect solidarity with the slaveholder Aranda, in a sense becoming a poor man's successor to him. Melville writes: "'Follow Your Leader!' cried the mate; and, one on each bow, the boats boarded. . . . Huddled upon the long-boat amid ships, the negresses raised a wailing chant, whose chorus was the clash of steel." Melville, *Benito Cereno*, p. 207.

[36]Delano, *Voyages*, p. 328.

Nearly a score of the Negroes were killed. Exclusive of those by the balls, many were mangled; their wounds—mostly inflicted by the long-edged sealing-spears, resembling those shaven ones of the English at Preston Pans, made by the poled scythes of the Highlanders.[37]

It can be argued that the shaving of Aranda's body down to its skeleton was a symbolic reflection of a white historical act, for Melville knew, through *Voyages*, of the shaving of Africans by the Spanish crew, just as he knew, through other sources, of the shaving of the English at Preston Pans by the Highlanders,[38] instances of shaving that he explicitly links. Both dovetailed with his decision to introduce the theme of cannibalism into the tale, and he had good reason to raise it as an issue throughout the story.

Thus far, it has been demonstrated, especially in Don Benito's attire and in the shaving scene in the cuddy, that Ashantee cultural influences figure significantly in *Benito Cereno*, but there is even more striking evidence of that presence in the novella. Just as Melville was able to link Benito Cereno to an Ashantee king, he was able to do the same for Aranda. Bowdich writes, astonishingly enough, that "The Kings, and Kings only, are buried in the cemetery at Batama, and the sacred gold with them. . . . their bones are afterwards deposited in a building there." Moreover, when the Ashantee king dies, others must die: "Here human sacrifices are frequent and ordinary, to water the graves of kings."[39]

Therein lies the key to the solution of the problem of cannibalism in *Benito Cereno*, at least with respect to whether Africans were involved in such an act. The manner in which they prepared the bodies of their kings for burial involved the removal of the flesh from their remains until, in the end, only the skeletons were left. From this knowledge alone, that is, from what is revealed of the burial of kings by Bowdich, Melville had the essential elements of Ashantee burial practices with which to work, enough to fire his imagination.

It should be noted that the sacrifices were for the purpose of providing the king with attendants after death. In a reference to "such Funerals as those," Willem Bosman wrote, in 1704, that "Slaves of the Deceased are killed and sacrificed on [the king's] account in order to serve him in the other world."[40] Melville almost certainly read Bosman, who is referred to by Bowdich.

It is reasonable to conclude, therefore, that Melville, in treating the preparation of Aranda's skeleton, based himself mainly on such sources together with the earlier instances of shaving to which reference was

[37]Melville, *Benito Cereno*, p. 288.

[38]Leslie and Stuckey have written of the relation between Delano's account of such butchery and the battle of Preston Pans. Their conclusion fits perfectly with those found in this essay. See Leslie and Stuckey, "Benito Cereno," p. 297.

[39]Bowdich, *Ashantee*, p. 289.

[40]Willem Bosman, *A New and Accurate Description of the Coast of Guinea* (London, 1967), p. 231. Originally published in 1704.

made. But he may well have, in addition, talked to Ashantees in the
New World and discovered details of the preparation that, like those
found in R. S. Rattray's *Religion and Art in Ashanti*, would seem so
alien to the European mind that Benito Cereno might not want to recall
or to divulge anything at all of the process. We know, for example, from
Rattray, that before the king's body was stripped of its flesh and taken
to the sacred mausoleum at Batama, referred to by Bowdich:

> The royal corpse was carried to "the place of drippings" by the court officer.
> . . . Here for eighty days and nights the body lay in a coffin, which rested
> on supports and was placed above a pit. The bottom of the coffin was
> perforated with holes. As decomposition set in, the liquids "dripped"
> through the holes into the pits. Attendants sat beside it day and night,
> fanning away flies, and sprinkling earth into the pit. On the eightieth day
> the corpse was removed, and the process of disintegration hastened by scrap-
> ing the remaining flesh from the bones.[41]

The evidence argues that Yan greatly telescoped this ancient rite,
over three days shaving and scraping the flesh from Aranda, violating
the usual procedure for preparing the bodies of kings for burial. As quite
a rich slaveholder, a sort of king without honor in Ashantee eyes, it was
only natural that Aranda's body be used in carrying through the terror
thought essential to the success of the revolt. Aranda's skeleton, there-
fore, is at once symbolic of white oppression and the desire of blacks to
be free of it, an object of mockery and an instrument of terror.

Though Bowdich asserted that the grave of the king was watered by
human sacrifices, what that means in Ashantee terms is treated in more
detail by Rattray, who states, echoing Bosman, that "It was incumbent
upon those left on earth to see that the king entered the spirit-world
with a retinue befitting his high station."[42] The retinue included a certain
number of the king's wives and servants, which probably accounts for
the presence of "Follow Your Leader" beneath Aranda's skeleton.

The last chapter of *Voyages* reveals how cannibalism became a diffi-
cult source of inspiration for Melville. The passage in question concerns
the family of Amasa Delano:

> His father, Samuel Delano, was, with his brother Amasa, in the military
> service, under George II. . . . Amasa was an officer in Roger's Rangers, a
> corps well known in those days. Though very young, he was much esteemed
> for his bravery and good conduct; and at the age of twenty was honored
> with a lieutenancy. He was with a party of rangers on an expedition near
> the Canada lines; which being led astray their guide was lost in the wilder-
> ness. They were obliged to separate and to hunt for food; and were com-
> pelled to eat an Indian child which they met in the woods. They soon came
> to an Indian settlement, and they were massacred in a most horrid manner.
> The writer of this journal was named for this unfortunate uncle.[43]

[41]R. S. Rattray, *Religion and Art in Ashanti* (London, 1927), p. 106.
[42]*Ibid.*
[43]Delano, *Voyages*, p. 580.

Delano appears to have had a happy childhood in Duxbury, Massachusetts. At no time were his memories of that period more reassuringly present than when his boat, *Rover*, was sighted shortly after an African elder had gotten him to yield the intricate knot that was thrown to him by a Spaniard. Though the African proceeded to jettison the knot without permission, seconds later, the sight of *Rover* "evoked a thousand trustful associations, which, contrasted with previous suspicions filled him not only with lightsome confidence, but somehow with half humorous self-reproaches at his former lack of it."[44]

Rover brought back memories of his boyhood, including his reputation as an expert swimmer—"Jack of the Beach"—who could "dive into the water like a sea fowl sporting in its natural element," an image that brings to mind an important symbol of the novella, that of the white noddy.[45] As Delano contemplates *Rover*'s return, his thoughts waver between the trustful and the suspicious:

> I, little Jack of the Beach, that used to go berrying with Cousin Nat and the rest; I to be murdered here at the ends of the earth, onboard a haunted pirate ship by a horrible Spaniard? Too nonsensical to think of! Who would murder Amasa Delano? His conscience is clear. There is someone above, Fie, fie, Jack of the Beach! You are a child indeed; a child of the second childhood, old boy; you are beginning to dote and drule, I'm afraid.[46]

Thus, Delano moved, in a matter of minutes, from imagining Benito Cereno, lantern in hand, dodging around a grindstone below deck, sharpening a hatchet to use against him to reproving himself for such a thought: "Well, well, these long calms have a morbid effect on the mind I've often heard, though I never believed it before." And soon thereafter: "Ha! glancing towards the boat; there's *Rover*; a white bone in her mouth. A pretty big bone though, it seems to me.—What? Yes, she has fallen afoul of the tide-rip there."[47]

The only evidence of cannibalism in *Benito Cereno* is in that passage and is drawn from the experience of Delano's uncle, Amasa Delano. His act of cannibalism was recalled in extraordinary form as Delano awaited his return to the *Bachelor's Delight*.

Though no Ashantee, Babo, in his genius, was at ease with Ashantee values and applied them skillfully as Africans on board the *San Dominick*, as they did on the *Tryal*, worked in concert in an attempt to free

[44]Melville, *Benito Cereno*, p. 256.

[45]Delano, *Voyages*, pp. 580–81. It appears that Melville was so struck by Delano's slowness in grasping the obvious that the symbol of that slowness takes the form of a "white noddy, a strange fowl, so called from its lethargic, somnambulistic character, being caught by hand at sea." The reference in *Voyages* to Delano's diving like "a sea fowl" very likely led Melville, bearing in mind the quality of the captain's intellect, to introduce, at the beginning of the novella, the "strange fowl." The white noddy together with the satyr figure and Aranda's skeleton wrapped in canvass are treated in succession and constitute a truly rich concentration of metaphors. See Melville, *Benito Cereno*, p. 220.

[46]Melville, *Benito Cereno*, p. 256.

[47]*Ibid.*, pp. 256–57.

themselves. His ability to draw on the values of non-Senegalese Africans, in reality as in the novella, was not the least remarkable of his achievements. Ironically, Melville has revealed, through the almost tangible presence of Babo in the novella—as distinct from his remote, Olympian stance in reality—the power of African culture and the degree to which it influenced him in shaping the novella. An indication of that power and influence is evident in the last scene:

> Some months after, dragged to the gibbet at the tail of a mule, the black met his voiceless end. The body was burned to ashes; but for many days, the head, that hive of subtlety, fixed on a pole in the Plaza, met, unabashed, the gaze of the whites; and across the Plaza looked towards St. Bartholomew's church, in whose vaults slept then, as now, the recovered bones of Aranda: and across the Rimac bridge looked towards the monastery, on Mount Agonia without; where, three months after being dismissed by the court, Benito Cereno, borne on the bier, did, indeed, follow his leader.[48]

PART IV
THE ARTS, CULTURAL THEORY, AND HISTORY

This section contains two essays on Paul Robeson, both of which devote attention to Robeson's voice and its meaning in the context of his people's art and social transformation. The essay on blacks in North America uses the arts as a major means by which critical aspects of the history of blacks are reconstructed and interpreted. The piece on music and history that closes the section and gives the volume its name concerns the uses of music to make and interpret history in the civil rights movement. This essay, therefore, brings us full circle, back to the uses of art by slaves for that purpose.

"I Want to Be African":
Paul Robeson and
the Ends of Nationalist Theory
and Practice, 1914–1945

[I]n my music, my plays, my films I want to carry always this central idea: to be African. Multitudes of men have died for less worthy ideals; it is even more eminently worth living for.

Paul Robeson, 1934

With displays of scholarly and athletic brilliance, Paul Robeson won attention at Rutgers during World War I. After Columbia Law, he revealed such light as an artist that he was hailed as the finest bass-baritone in the world and as one of the leading actors of his time. All the while, he was fashioning a theory of culture to help liberate his people and, increasingly, to support the cause of the oppressed, irrespective of race. For nearly fifty years his devotion to peoples of African descent, mounting even as his interest in other peoples gained ground, was the motive power behind his political and intellectual endeavors.[1]

While the identity problems of many among his people were magnified in the years of the Great Depression, Robeson remarked that he possessed an "almost fantastic belief and pride in being a Negro" and that he sometimes regarded himself as "the only Negro living who would

[1]Perhaps Robeson's first public statement of nationalism, of affirmation of the need for African Americans to assume responsibility for their own liberation, was his commencement speech at Rutgers. While an undergraduate, he had arrived at an essentially nationalist stance, as Du Bois had done under similar circumstances a generation earlier. His address revealed that Robeson had already developed the essentials of a conception of nationalism which would guide him for the rest of his life:

"We of this less favored race realize that our future lies chiefly in our own hands. On ourselves alone will depend the preservation of our liberties and the transmission of them in their integrity to those who will come after us . . . neither the old-time slavery, nor continued prejudice need extinguish self-respect, crush manly ambition or paralyze effort . . . no power outside himself can prevent man from sustaining an honorable character and a useful relation to his day and generation. We know that neither institutions nor friends can make a race stand unless it has strength in its own foundation; that races like individuals must stand or fall by their own merit;

not prefer to be white." Though on occasion he underestimated the aspirations of large numbers of his people, many of them did indeed suffer from the colonial malaise of wanting to be formed after the image of the overlord.[2] This disturbance, an offspring of oppression, militated against black people framing a more viable culture—that is, a more liberating way of life and a method of transmitting essentials from one generation to another.[3]

Robeson was interested in creating such a culture and in providing such continuity. The thirties was the period of his most creative insights into the nature of black cultures, the time of his most profound reflections on the state of world cultural systems. Despite the cosmopolitanism of his life and learning, he avoided giving primacy to "universal" values in analyzing the ills and in estimating the worth of African Americans. Instead Robeson's scholarship on Africa provided the backdrop for his exploration of the main lines of African American achievement and failure, for his formulation of the terms on which freedom must be won by his people.

I

Paul Robeson's father, like the father of black nationalist Henry Highland Garnet before him, had escaped from American slavery. And like

that to fully succeed they must practice their virtues of self-reliance, self-respect, industry, perseverance and economy" (italics added).
—Paul Leroy Robeson, "The New Idealism," *Targum*,
Vol. 50, No. 30 (June 1919), pp. 570–71.

In this address Robeson also advanced a view that would be central to his thought in the coming half century as he explored the cultural components of various sectors of the world: "It is not a question of who is the strongest but of what form of life is the strongest." Robeson, "The New Idealism," p. 570. In subsequent public pronouncements, whether in the form of essays or interviews (most of his published essays appeared in British publications between 1931 and 1935), Robeson almost invariably directed the bulk of his comments to elaborations on themes set forth in the 1919 speech. One notable variation on the commencement thesis of African American self-reliance was his great concern, in succeeding writings and activities, with peoples of African descent throughout the world— a position integral to Robeson's nationalist predecessors. And like most of the nationalist theoreticians before him—among them David Walker, Henry Highland Garnet, Alexander Crummell, "Sidney," and W. E. B. Du Bois—Robeson, on balance, thought that black liberation was possible in America. His emphasis on Pan-African liberation was such that, in classic nationalist style, liberation in one country was tied to liberation in another. The web of African freedom was for him almost always seamless. A special debt of gratitude is owed Professor Lamont Yeakey, without whose generosity, encouragement, and deep knowledge of Paul Robeson this essay would not have been possible.

[2]*Chicago Defender*, Jan. 26, 1935; *New York Times*, April 19, 1942.

[3]W. E. B. Du Bois's cultural position was very close to Robeson's. Though both men were concerned with problems of cultural transmission, and though both respected each other long before eventually joining forces in the same organization, they appear to have arrived at their cultural positions, as closely related as they are, independently.

Garnet and other nineteenth-century nationalists, Robeson had early contact with people from the Caribbean, having spent hours at the homes of West Indian friends who were close to the Garvey movement, which doubtless accounts in part for his devotion to the cause of West Indian liberation long before he had written on that subject.[4]

Robeson's interest in Africa also began before his writings on the peoples of that continent. Rising into prominence as a leading figure of the Negro movement, he was of course aware of the interest in Africa expressed by African American artists generally. Moreover, his studies, in the early thirties at the London School of Oriental Languages sparked the beginning of a development more momentous than known heretofore: He was destined to be the only artist of the New Negro movement to cultivate scholarship on Africa covering several levels of African reality—linguistic, artistic, historical, and political.[5] Although historians and critics are beginning to concede that Robeson is a towering figure of our era, they remain, almost without exception, oblivious to the fact that he was, for nearly half a century, the only African American to fashion a philosophy grounded almost completely in the heritage of his people in the United States and in Africa.

Despite similarities to a few black thinkers of his time, Robeson moved in his own orbit. Thanks in part to composer and arranger Lawrence Brown, who encouraged his journey back to foundations, to the African American art of folklore, Robeson soon disclosed the possibilities of spiritual and artistic rebirth in black America.[6] More than that, around him revolved for more than three decades the crucial artistic, political, and spiritual questions facing his people in America and throughout the world. Meanwhile, years of study and implementation of his findings were eagerly anticipated by the young artist.

When Robeson went to England on his first visit as a young man of twenty-five, he was mainly in the company of West Indian and African blacks, associations maintained throughout his later more than ten-year stay abroad. Loath to comment on matters whose essentials he had not compassed, his first essay on Africa did not appear until he knew several African languages and many works on African peoples. While studying linguistics and African languages at the School of Oriental Languages,

[4]Interview with Paul Robeson, Jr., July 13, 1971.

[5]For an eminently sensible assault on the thesis that there was a "Harlem Renaissance," see Sterling A. Brown, "The New Negro in Literature, 1925–1955," in Rayford Logan, ed., *The New Negro Thirty Years Afterwards* (Washington, 1955). The renaissance which allegedly took place in Harlem actually was occurring in several centers of black culture—in New Orleans, Kansas City, Chicago, Washington, D.C., Memphis, and elsewhere. Moreover, on its highest level, which was musical, the renaissance of the twenties was but an extension of the ongoing bursts of creativity which began with slave music, sacred and secular. Moreover the creation of slave tales and music helped provide the folkloric base from which subsequent black artists, including the best of the writers, would build. The renaissance began in slavery, not in Harlem.

[6]Interview with Paul Robeson, Jr., July 13, 1971.

he tested his ability as an Africanist, honing his knowledge by "seeking out all kinds of people with whom to argue the [black] colonial question," debating that issue with Rebecca West and with a few liberals in the British Foreign Office, who generally defended the view that Africans should ascend to the level of civilization.[7]

Robeson's wife, Eslanda, herself a student of anthropology under Malinowski, wrote of the Robesons' efforts to know Africans, to discover if white students and professors were correct in asserting that the couple had more about them of Europe than of Africa. Those efforts had begun shortly after the Robesons took up residence in England in 1927.

> Paul and I [would] seek out all the Africans we could find, everywhere we went: In England, Scotland, Ireland, France; in universities, on the docks, in slums. The more we talked with them, the more we came to know them, the more convinced we were that we are the same people: They know us, and we know them; we understand their spoken and unspoken word, we have the same kind of ideas, the same ambitions, the same kind of humor, many of the same values.[8]

Most of what Robeson learned about Africa was learned in London. His wife provided valuable observations on the state of African studies in England during the period they were there.

> In England, on the other hand [in contrast to America], there is news of Africa everywhere: In the press, in the schools, in the films, in conversation. . . . There are courses on Africa in every good university in England; African languages are taught, missionaries are trained, and administrators are prepared for work "in the field." Everywhere there is information about Africa.[9]

The close friendship between Robeson and Jomo Kenyatta provides a clue to one aspect of Robeson's reflections on African societies, for it is likely that the two men discussed Malinowski, under whom Kenyatta studied at London University. The leading anthropologist in England, Bronislaw Malinowski, thought by some to be the anthropologist of imperialism, saw little of intrinsic value in "savage" African societies. If he did not discuss the influential teacher's functionalist theories with Kenyatta, then surely Robeson discussed them with his wife, for Malinowski was sometimes invoked by those who opposed Robeson's defenses of Africans and their cultures.[10]

[7]*Ibid.*

[8]Eslanda Goode Robeson, *African Journey* (New York, 1945), p. 15.

[9]*Ibid.*, p. 13. Mrs. Robeson's assessment of the state of African awareness in the U.S. was accurate enough. Referring to America of the 1920s, her observations were still largely valid, with respect to colleges and high schools, as late as the 1960s: "In America one heard little or nothing about Africa. I had not realized that consciously until we went to live in England. There was rarely even a news item about Africa in American newspapers or magazines. . . . Practically nothing was or is taught in American schools about Africa." *African Journey*, p. 13.

[10]Paul Robeson, *Here I Stand* (Boston, 1971), pp. 33–35. Originally published in 1958.

In an article published in 1931, Robeson identified important elements of character in African Americans—"a people upon whom nature has bestowed, and in whom circumstances have developed, great emotional depth and spiritual intuition."[11] Their value system—especially as reflected in their art and spirituality—has given rise, Robeson contended, to the only significant *American* culture since the inception of the country. However, a deep sense of inferiority, more than any other factor, prevented black people from being aware of the richness, despite oppression, of their heritage. In the tradition of nationalists before him, Robeson focused on that feeling of inadequacy, observing that sufferings undergone had "left an indelible mark" on the soul of the race, had caused the Negro to become the victim of an inferiority complex which led him to imitate white people. "It has been drummed into him that the white man is the Salt of the Earth and the Lord of Creation, and as a perfectly natural result his ambition is to become as nearly like a white man as possible." "I am convinced," the young scholar asserted, "that in this direction there is neither fulfillment nor peace for the Negro."[12]

The centuries-old war against the psyches of blacks had been so destructive that many were not appreciative of great contributions by their people to the world of art. Robeson reported that he had found a particular eagerness among young and "intelligent" Negroes "to dismiss the Spiritual as something beneath their new pride in their race . . . as if they wanted to put it behind them as something to be ashamed of— something that tied them to a past in which their forefathers were slaves."[13] Those blacks who turned their backs on their folk music were, whether they realized it or not, contributing to their own destruction, for the spirituals were, in Robeson's view, "the soul of the race made manifest." This position was linked to his concern about the black artist giving emphasis to the art "of other people in our Negro programs, magnificent and masterly though they may be." He felt that concessions to European music would lead to the "eventual obliteration of our own folk music, the musical idioms of our race . . . the finest expression and the loftiest we have to offer."[14]

Robeson's reflections on African American culture indicated that he was not opposed in the early thirties to the emigration of portions of his people to Africa. Realizing the fatal consequences of the failure of black intellectuals and of many young people to appreciate their folk heritage, he advanced the view that if black musical groups did not "arise all over the land to cherish and develop our old spirituals," some of his people would have to leave the country and "go to Africa, where we can develop

[11]Paul Robeson, "Thoughts on the Colour Bar," *Spectator*, No. 5,380 (August 8, 1931), p. 178.
[12]Paul Robeson, "I Want to Be African," in E. G. Cousins, ed., *What I Want From Life* (London, 1934), p. 72; and Paul Robeson, "The Culture of the Negro," *Spectator*, No. 5,539 (June 15, 1934), p. 916.
[13]*New York Times*, April 5, 1931.
[14]*Ibid.*

independently and bring forth a new music based on our roots."[15] Robeson's interest in cultural independence for blacks grew out of his belief that the black man in America must be in a position to "set his own standards," all the more because American whites, closer to Europeans in life styles, were dangerously, perhaps fatally entrapped by European dependence upon abstractions and hostility toward emotive and intuitive values.[16]

Robeson's description of the causes of the cultural strengths of blacks may well be among the best on record:

> Now, as to the most important part which . . . the Negro is qualified to play in the American scene. I would define it as "cultural" with emphasis upon the spiritual aspect of that culture. With the passing of the Indians, the Negroes are the most truly indigenous stock in North America. They have grown up with that country, becoming part of the soil itself. They have had a better chance than any other of the races which have come to America to identify themselves with the atmosphere of the place, if only because they have been there much longer. They have been unhappy and badly treated, but they have retained (though they have not been allowed fully to express) their best and most characteristic qualities: A deep simplicity, a sense of mystery, a capacity for religious feeling, a spontaneous and entirely individual cheerfulness; and these have found expression in the only culture which Americans can point to as truly belonging to their country.[17]

In fact, the young philosopher observed, the whole of American culture was deriving from black culture "those qualities which appeal most directly to the intelligent European who values a depth of native tradition in art." Despite the long period of repression which the black man's "cultural actualities" have survived, "they can develop only with great difficulty in a hostile environment." The uncongenial American scene was the "new Egypt" out of which Robeson wanted to lead his people.[18]

[15]*Ibid.* The prospect of emigrating from America, even when a young man, did not disturb Robeson, especially since he considered Africa, not America, the true home of his people. Nevertheless, following in the tradition of David Walker, Bishop Turner, Du Bois, and many blacks before him, Robeson thought the Negro far more entitled to remain in America than white people. Robeson considered the suggestion that whites have more right to be in America than blacks an absurd point of view. Paul Robeson, *Here I Stand* (New York, 1958), p. 11.

[16]Robeson, "To Be African," p. 76.

[17]Robeson, "The Colour Bar," p. 178. "Sidney," the brilliant nationalist theoretician of the nineteenth century, as far as we know, never wrote a word on art. Yet he appears to have been, more than any other thinker, Paul Robeson's philosophical and spiritual ancestor, though it is doubtful Robeson knew of his existence. "Sidney's" political and philosophical precepts square perfectly with Robeson's reasons for wanting to rid blacks of a sense of inferiority, for wanting to build unity within their ranks. And the writings of both men—reflective, hermetic in tightness of argumentation—are strikingly similar. In addition, each man, in statement after statement, holds aloft the pure flame of clarity. For "Sidney's" works, see Sterling Stuckey, ed., *The Ideological Origins of Black Nationalism* (Boston, 1972).

[18]Robeson, "The Colour Bar," p. 78.

The new promised land did not have to be Africa if blacks in large numbers decided to build upon the founding stones of their culture, upon the folk amalgam of essentially African elements.

As important as the components of nationalism were, Robeson as early as 1931, aware of the limitations of the nation state, scored nationalism as the ultimate goal of man, pointing out that the "family of nations" ideal must become the reality if mankind is to survive. He wanted finally to see a world striving for deep spiritual and cultural values which transcend "narrow national, racial, or religious boundaries."[19] With the right encouragement, the transforming impulse could come from blacks in America but, as he observed some years later, not unless they were prepared to participate in the new world culture as Africans—a goal to be worked for, not willed. He was convinced, therefore, that if the Negro artist denies his heritage, his potential cannot be realized: "Let us take a concrete example. What would have become of the genius of Marie Lloyd if she had been ashamed of being Cockney? Would Robert Burns have been as great a poet if he had denied his ploughman speech and aped the gentlemen of his day?"[20] Robeson warned of the dangers of the impulse which causes those born to inequality to cloak their true value "under a false foreign culture, applied from outside, when, instead, natural growth [comes] from within."[21]

Robeson remarked that, instead of attempting to create from within, the brains of the best blacks in America were being used to turn "themselves into imperfect imitations of white gentlemen, while it has been left to the astute white man to pick up and profit by what has been cast aside."[22] While Robeson realized that whites were systematically taking advantage of blacks by profiting from and prostituting black art, he also felt that black artists and writers were not displaying enough initiative of their own. He chastised them, arguing that while they were laboring with Brahms and Beethoven, "Stravinsky has been borrowing from Negro melodies." As for popular music, he regretted that Negro music "launched by white men—not Negroes—has swept the world."[23] But Robeson might have made it clear that it was precisely white control of the record industry, radio and newspapers, dance halls, and swank hotels of America which made it virtually impossible for Negro musicians to become as popular and as wealthy as their white counterparts.

[19]*Ibid.*

[20]*Chicago Defender,* January 26, 1935.

[21]*Ibid.*

[22]*Ibid.*

[23]*Ibid.* Robeson's interest in African American music other than the spirituals went beyond abstract involvement. During the decade of the 1930s he sang with Count Basie's Jazz Band and later sang with blues artists Sonny Terry and Brownie McGee. Interview with Paul Robeson, Jr., July 13, 1971. Robeson thought art should enrich the lives of the masses, as opposed to benefiting a narrow self-serving elite. And he was particularly conscious of the extent to which African American art was integral to the lives of very

While abroad, Robeson observed major trends in Western art and met the leading artists of his day—Picasso, Milhaud, Stravinsky, Brancusi, and Epstein, all of whom were interested in African art. Robeson, critical of blacks in the plastic arts, again pointed to the root cause of their failings: "While Negro artists attempt pale copies of Western art, [Jacob] Epstein derives inspiration from ancient Negro sculpture. No Negro will leave a permanent mark on the world till he learns to be true to himself." He reasoned that one could not expect a Negro given to self-hatred to value the positive features of his people until "something has happened to restore his respect for them."[24]

"Why was it," Robeson asked, "a white man who wrote *Green Pastures* and made a fortune from it?" Here again at least a portion of his criticism misfires, since racism prevented black playwrights from having much access to the legitimate theatre.[25] But surely concern over the failure of blacks to write more plays, especially plays attempting to tap the rich veins of their heritage was a legitimate matter for the young artist to air. An actor knowledgeable about the plight of blacks around the world, Robeson was conscious of his people's need for politically sensitive but truly gifted writers, for only then could the Negro writer show his people the profound tragedy of their dependency on white values.[26]

In order to assist people in understanding the psychology of the oppressed, Robeson compared the psychological experiences of the Negro with those of exploited workers, women, and European Jews: "All those people will understand what it is that makes most Negroes desire nothing so much as to prove their equality with the white man—on the white man's own ground." Though such groups might "feel for the Negro,"

large numbers of black people. Still the great majority of American people were not reached by art. Years after returning to the U.S. from England, Robeson spoke at some length on this question:

[L]et us learn how to bring to the great masses of the American people *our* culture and *our* art. For in the end, what are we talking about when we talk about American culture today? We are talking about a culture that is restricted to a very, very few.

Robeson threw down a challenge, defying "any opera singer to take those ball parks like Sister Thorpe or Mahalia Jackson."—Paul Robeson, "The Negro Artist Looks Ahead," *Masses and Mainstream*, Vol. 5 (January 1952), p. 13.

[24]*Chicago Defender*, January 26, 1935.

[25]*Ibid.*

[26]*Ibid.* Robeson expressed an interest in developing a Negro theatre in London with a Pan-African focus, producing plays on Toussaint, Menelik, and other notable blacks. The obvious limitation of such a plan was the small number of black people in London. Still, had he been able to build a Negro theatre there is no reason why his company, if successful, could not have performed in the U.S., the West Indies, and in other areas with concentrations of black people. Robeson eventually realized his dream of doing Toussaint, having acted in a London production of a play by that name written by the West Indian writer C. L. R. James. Interview with C. L. R. James, June 10, 1970.

not many would realize that the same impulse "which drives them to copy those with the desired status is killing what is of most value—the personality which makes them unique."[27]

For Robeson the split of interest among blacks was not only economic but cultural and was manifested in a variety of ways. In his opinion, the privileged among the Negro people, especially those in the North, suffered more than the others from the allure of assimilation.[28] While certain Negro intellectuals tried "to suppress in the Negro papers every element of our own culture in favor of the so-called higher values of white culture," still others among the educated and rich do their utmost to achieve assimilation on numerous levels, and all too badly on most.[29] Robeson drew attention to the seeming paradox of well-to-do Negroes set against themselves, victims of the blandishments and the whiplash of America. The effectiveness of his analysis of the condition of his people would for him rest on his ability to locate the ultimate sources of the vigor and torpor of spirit of African peoples here and abroad.

II

Robeson described the American Negro as that "tragic creature, a man without a nationality." Though he might claim to be American, to be French, to be British, "You cannot assume a nationality as you would a new suit of clothes" (italics mine).[30] With notable courage and insight, he pursued this line of investigation, remarking that the assumption of African nationality is "an extremely complicated matter, fraught with the greatest importance to me and some millions of coloured folk."[31] Thus Robeson introduced a consideration which could not easily be ignored, arguing that a consciousness of the conditions and attributes which made black people a unique people was required before nationality or nationhood could be brought into being. Yet he thought far more than consciousness of kind was necessary for the realization of national-

[27] Chicago Defender, January 26, 1935.

[28] London Daily Herald, January 26, 1935. Perhaps Robeson did not fully realize the extent to which Negro papers in America devoted attention to his views and activities. It is in fact unlikely that the cultural philosophy of any other African American thinker, including Du Bois, received as much attention as that of Robeson throughout the decade of the 1930s. Apparently Negro publishers were not opposed to printing material, especially from Robeson, which broke sharply from mediocre black bourgeois thought and aspirations—which was all the more remarkable considering the fact that there were simply very, very few intellectuals around, black or white, interested in the kinds of cultural issues which preoccupied Robeson.

[29] Jamaican Daily Gleaner, July 17, 1935.

[30] Ibid.

[31] Robeson, "To Be African," p. 71.

ism in a meaningful sense. African Americans would have to know and rely on themselves, to open themselves to African influences and create self-propelled movements rooted in part in their African heritage. Still, he was not altogether consistent on this, for during a later period he referred to African Americans as already representing a "kind of nation."[32]

In the 1930s, however, Robeson found that the inferiority complex of large numbers of black people had helped complicate matters by militating against the development of a sense of nationality. Such self-abnegation was buttressed by the belief that African Americans "had nothing whatever in common with the inhabitants of Africa"—a view which was reinforced by American educators who, with rare exception, carried in their heads grotesque but apparently comforting stereotypes of African peoples and their history.[33] Though blacks in this country were a people in whom self-doubt was certainly present, this condition need not be permanent. But more than viewing Africa from afar would be required if the Negro were to secure some of the benefits of a nation, especially cohesion, in the absence of nationhood in the literal sense.

> In illustration of this take the parallel case of the Jews. They, like a vast proportion of Negroes, are a race without a nation; but, far from Palestine, they are indissolubly bound by their ancient religious practices—*which they recognize as such*. I emphasize this in contradiction to the religious practices of the American Negro, which, from the snake-worship practiced in the deep South to the Christianity of the revival meeting, are patently survivals of the earliest African religions; *and he does not recognize them as such*. Their acknowledgement of their *common origin, species, interest, and attitudes binds Jew to Jew; a similar acknowledgement will bind Negro to Negro* (last italics added).[34]

Life in London provided an excellent vantage point from which Robeson could observe the behavior of his people under the influence of one of the world's foremost representatives of white culture and colonial power. He went before the League of Colored People and conjured his black brothers to avoid becoming "cardboard Europeans,"[35] lamenting the fact that blacks from the West Indies and from various sections of Africa had joined with the American Negro in succumbing to European values. In their respective homes, he told them, this process continued, with the French Negro imitating that culture, the English Negro the English, and the American Negro the American culture. This was not

[32]Robeson, "The Negro Artist," p. 7.
[33]Robeson, "To Be African," p. 72.
[34]*Ibid.*, pp. 76–77.
[35]*Norfolk Journal and Guide*, January 5, 1935. Returning to an abiding theme, Robeson also urged his West Indian brothers to place a higher valuation upon themselves. "We know we are intelligent. We prove it everyday." Furthermore: "The future of the African is tied up with the people of the East, not with those of the West."

only widespread but tragic, since "the Negro is really an Eastern product" and builds something false by imitating occidental culture.[36]

Robeson set himself the task of seeking, through "patient inquiry," to lay the foundations on which a new awareness of black culture and tradition could be based. He determined to investigate a great many questions regarding Africa and America and hoped, before the decade had ended, to have reached the peak of a campaign "to educate the Negro to a consciousness of the greatness of his own heritage." But his "patient inquiry" had begun some years before; for he reported during the same year (1934) that he had already "penetrated to the core of African culture when [he] began to study the legendary traditions, folksongs and folklore of the West African Negro."[37]

Robeson's encounter with West African cultures, from 1927 to 1934, had been no mere academic exercise; he said, writing in the *Spectator*, that it had been "like a homecoming" for him. He wanted to interpret the "unpolluted" African folk song, to do for it what he had done for the spiritual, to make it respected throughout the world; all of which, he hoped, would make it easier for blacks in America not only to appreciate this aspect of their heritage but play a role in exploring the "uncharted musical material in that source." The researches of Robeson into the folklore of West Africa were aided by his proficiency in several languages of the area, languages which he thought had come easily to him in part because he found a kinship of rhythm and intonation with the Negro-English dialect which he had heard spoken around him as a child.[38]

Americans during the 1930s were often as dreadfully uninformed about African languages as they were about other aspects of African culture. Robeson's findings in this regard were for that reason of special

[36]*Louisiana Weekly*, September 9, 1933. Robeson later allowed that there were those who thought a New Western man might emerge to "solve the problem of the further development of the world"; he pointed out that

> We, however, who are not Europeans, may be forgiven for hoping that the new age will be one in which the teeming 'inferiors' of the East will be permitted to share. Naturally one does not claim that the Negro must come to the front more than another. One does, however, realize that in the Negro one has a virile people of many millions, overwhelmingly outnumbering the other inhabitants of a rich and undeveloped continent.
>
> —Paul Robeson, "Primitives," *New Statesman and Nation*,
> Vol. XII, No. 285 (August 8, 1936), p. 191.

Here, in this passage, Robeson must mean by "come to the front" that Negroes should not seek to dominate the new order, for he certainly felt that they could, in some respects, play a messianic role that would help lay the groundwork for new cultural relations among men. More than ten years of living abroad—"Primitives" was published late in 1936—had not diluted his essential nationalism.

[37]Robeson, "The Culture of the Negro," p. 916.

[38]*Ibid.*; Robeson, "To Be African," p. 77.

interest to those who thought Africans communicated their ideas solely through gestures and sign language. "As a first step" in dispelling the "regrettable and abysmal ignorance of the value of its own heritage in the Negro race itself," he decided to launch a comparative study of the main language groups, Indo-European, African, and Asian, "choosing two or three principal languages out of each, and [to] indicate their comparative richness at a comparable stage of development." Robeson estimated that it would take him five years to complete his project, and he hoped that the results would be sufficient to form a solid foundation "for a movement to inspire confidence in the Negro in the value of his own past and future."[39]

Roughly a year later, in the context of a discussion of African and Asian ties, Robeson said that "Negro students who wrestle vainly with Plato would find a spiritual father in Confucius or Lao-tsze. . . ."[40] His meaning became clearer in time as he spelled out the salient cultural components of the East and West. Meanwhile, in addition to studying African languages and drawing conclusions which, though known to the few specialists in the field, were revelations to many, he had long since concluded that blacks in this country were under quite substantial African influences (a position that he retained, like almost all of his cultural views of the thirties, for decades to come). The dances, songs, and religion of the black man in America, Robeson wrote, were the same as those of his "cousins" centuries removed in the depths of Africa, whom he has never seen, of whose very existence "he is only dimly aware." Robeson added that the American Negro's "peculiar sense of rhythm," his "rhythm-consciousness," as it were, "would stamp him indelibly as African."[41]

Thus Robeson joined Du Bois and Carter Woodson before him in affirming African "survivals," but he probed more deeply into the specific, irreducible components of African influence, contending that the American Negro is too radically different in mental and emotional structures from the white man "ever to be more than a spurious and uneasy imitation of him. . . ."[42] Thus emotive, intuitive, and aesthetic qualities of the African American not only linked him to the African homeland but to the West Indian black as well. "The American and West Indian Negro," he argued, "worships the Christian God in his own particular way and makes him the object of his supreme artistic manifestation

[39]Robeson, "The Culture of the Negro," p. 917.
[40]*Chicago Defender*, January 26, 1935.
[41]Robeson, "To Be African," p. 75. Robeson added that a slight variation of the Negro's sense of rhythm "is to be found among the Tartars and Chinese," to whom he is much more nearly akin than he is to the Arab, for example. Robeson, *Ibid*. Alvin Ailey, the gifted black choreographer, supports Robeson's observation on comparative dance styles, contending that African American and black African dance is closer to Chinese dance than to the dances of the Arabs. Interview with Alvin Ailey, winter 1971.
[42]Robeson, "The Culture of the Negro," p. 916.

which is embodied in the Negro spiritual."[43] Robeson realized what few scholars in the United States knew at the time that there was such a thing as black religion in the Caribbean and in the United States, religions with their own distinctive characteristics. As to what gives rise to the ties between people of African ancestry, Robeson ventured that "It would take a psycho-anthropologist to give it a name."[44]

The achievement of Robeson's scholarship on African "survivals" is all the more evident when one takes into account the extreme backwardness of America's colleges and universities vis-à-vis Africa and its descendents in diaspora. When the decade of the thirties opened, even progressive and advanced scholars such as Franz Boas and Ruth Benedict had not realized the role Africa had played in helping to fashion the black ethos in America. Advocates of the "culturally stripped" thesis, Boaz and Benedict were joined by the Chicago School of Sociology, which was an influential promoter of the "tangle of pathology" view of black culture. But unlike Boaz and Benedict, almost all of the remaining white intellectuals were unaware of the role of Africa in world history. Apart from Melville Herskovits later in the decade, few indeed were those who were even close to understanding the continuing positive impact of Africa on blacks in this country, just as there were few who believed Africa had a history worthy of respectful attention.[45]

Since the rehabilitation of Africa was central to Robeson's campaign to heighten the consciousness of American Negroes, he had to confront the fundamental issue of the nature of black African history while continuing his investigation into various aspects of contemporary African cultures. The schools of the West, especially in the United States, stressing African backwardness, made these concerns inescapable for him. He asserted in fact that the younger generation of Negroes looks toward Africa and wants to know what is *there* to interest them; they want to know, he added, what Africa has to offer that the West cannot provide.

> At first glance, the question seems unanswerable. He sees only the savagery, devil-worship, witch doctors, voodoo, ignorance, squalor, and darkness taught in American schools. *Where these exist, he is looking at the broken*

[43]*Ibid.*

[44]Robeson, "To Be African," p. 75.

[45]Herskovits himself was somewhat late in coming to a recognition of African influences on African American life styles. He moved beyond his position, advanced in 1925 in Alain Locke's *The New Negro* (New York, 1925), to advocacy of African survivals in the 1930s. Herskovits, then, came to the African survival position somewhat later than Robeson and decades after Du Bois and Woodson. Nevertheless, Robeson was influenced by Herskovits's later researches into African and African American cultural ties. Paul Robeson, Jr., reports that his father had a number of Herskovits's works in his enormous library — together with the works of Du Bois, Carter Woodson, and scores of other writers on African and other cultures. According to Mrs. Frances Herskovits, Robeson and her husband attended a meeting of anthropologists in London in 1936. Interview with Paul Robeson, Jr., July 13, 1971.

remnants of what was in its day a mighty thing; something which perhaps has not been destroyed but only driven underground, leaving ugly scars upon the earth's surface to mark the place of its ultimate reappearance (italics added).[46]

Still, much that was impressive was not hidden from Robeson. "Africa," he remarked in an interview, "has a culture—a distinctive culture—which is ancient, but not barbarous." He thought it a fabrication to assert that the black man's past in Africa "is a record of mere strife between paltry tyrants."[47] Like Du Bois and Woodson, Robeson was impressed by certain qualities of culture of pre-colonial Africans, especially by their manner of organizing societies in such a way that material as well as spiritual needs were met. Life in Africa has been, he thought, balanced and simplified to a degree scarcely understood in the white world, and the satisfaction of material needs had not called for prolonged or strenuous exertions on the part of the people. He believed African communities, developing in their own way and along their own lines, had reached "a point of order and stability which may well be the envy of the world today."[48]

The insights of Robeson the artist undoubtedly contributed to his penetrating observations on the place of oral tradition in African societies. To be sure, his reflections on this dimension of African life revealed as much about him at the time as they did about Africa—more and more he was regarding himself *as African*. Described by a *New York Times* reporter as "a champion talker," Robeson correctly observed that his ancestors in Africa considered sound of particular importance. Thus, they produced "great talkers, great orators, and, where writing was unknown, folktales and oral tradition kept the ears rather than the eyes sharpened. I am the same. . . . I hear my way through the world."[49]

In addition to securing information about Africa through his linguis-

[46]Robeson, "To Be African," p. 73.

[47]Reverend Father J. C. O'Flaherty, A.M., "An Exclusive Interview with Paul Robeson," *West African Review*, Vol. VII, No. 107 (August 1936), p. 16.

[48]*Ibid.*

[49]*New York Times*, April 19, 1942; *West African Review* (August 1936). Robeson, remarkably, did not hesitate to affirm without a trace of shame, in fact with great pride, some of the very qualities which whites thought stamped blacks as inferior: with pleasure he referred to the African's rich emotional heritage, his genius for music, his religiosity—traits from which many black intellectuals recoiled. So passionate was Robeson's celebration of specifically Negroid or "Eastern" traits that at times he seemed to be forming stereotypes of his own. This conclusion is difficult to avoid when assessing his reflection that "I, as an African, feel things rather than comprehend them. . . ." *West African Review* (August 1936). Yet, as Descartes has demonstrated, there is no necessary contradiction between feeling and reason. Perhaps it is debatable whether Robeson's insistence that Africans possess an "inner logic" that "for want of a better title is often called mysticism" enabled him, in the final analysis, to stop short of stereotyping. Léopold Sedar Senghor, whose approach to African perceptions is almost exactly like Robeson's, discusses this problem of epistemology in "The Problematics of Negritude," *Black World*, Vol. XX, No. 10 (August 1971), pp. 4–24.

tic studies, through contact with great artists such as Jacob Epstein, and through extensive readings on African history and culture, Robeson doubtless learned some of his most valuable lessons on African peoples from firsthand contact with Africans themselves, especially students and workers. In fact, he said that most of his friends were "African chaps."[50] His openness to African culture probably owed a great deal to his early willingness to confront the meaning of the slave experience, which also helps explain the unusual receptivity which he brought to Negro spirituals.

Robeson's belief that his family was of the Ibo people of Nigeria was reinforced one day on a movie set in London at which large numbers of Africans were employed, speaking more than twenty languages. Robeson overheard a group of Africans use words which he instantly understood, though he had not studied their language. He approached those Africans and began conversing with them in Ibo, a language from which members of his family had apparently passed on words and phrases from one generation to another. In this unusual incident, he had indeed experienced "a homecoming."[51]

It should be noted that Robeson, while carefully building knowledge of Africa which he hoped would inspire new pride in millions of Negroes in the United States, was waging a more immediate and directly political-cultural struggle with colonial powers. In England, as his pride in Africa grew, he had also spoken out against those opposing the liberation of the ancestral home. For having posited a respectable level of culture for much of black Africa, he was eventually paid a visit by British intelligence. He has described the circumstances leading up to that encounter.

> As an artist, it was natural that my first interest in Africa was cultural. Culture? The foreign rulers of that continent insisted that there was no culture worthy of the name in Africa. . . . [A]s I plunged with excited interest into my studies of Africa at the London School of Oriental Languages, I came to see most African culture was indeed a treasure-store for the world. . . . Now there was a logic to this culture struggle I was making. . . . The British Intelligence came one day to caution me about the political meaning of my activities. For the question loomed of itself: *If African culture was what I insisted it was, what happens to the claim that it would take 1,000 years for Africans to be capable of self-rule?*[52]

His inquiry had indeed been comprehensive and painstaking, covering major sections of the continent. He had learned Swahili, Zulu, Mende, Ashanti, Ibo, Efik, Edo, Yoruba, and Egyptian. And he had begun to argue that some of these languages were exceedingly flexible

[50]*New York World-Telegram*, January 11, 1936.

[51]*Baltimore Afro-American*, October 10, 1936. Also see Marie Seton, *Paul Robeson* (London, 1958), p. 58.

[52]Robeson, *Here I Stand*, pp. 42–43.

and sophisticated.[53] However, convincing some black Americans that what they had been taught about Africa was false would very likely prove to be difficult indeed. This was, as Robeson had indicated earlier, certainly true of the more privileged, the better "educated," young blacks who were generally not favorably disposed to revising their prejudices regarding their cultural heritage. If large numbers of blacks in America had difficulty grasping the ultimate significance of Robeson's cultural explorations, such was not the case with colonial and racist leaders abroad and, later, in the United States.

III

While pursuing his studies, Robeson had been putting some of his theoretical pronouncements into practice. In both the theatre and on the concert stage, he had since the mid-1920s been involved in an effort to become more and more attuned to his heritage. There is no doubt that, despite a heroic effort in the theatre, his performances on the concert stage represented a far better realization of that objective, for there he had near total control over what and how he would sing, and there he gave unprecedented emphasis to the songs of his people.[54] His belief that blacks must rely on their own musical heritage had been given eloquent expression in 1925 when, with the encouragement of his accompanist and musical advisor Lawrence Brown, he gave a performance consisting

[53]Robeson eventually learned over twenty languages. He did not learn Arabic until he was well into his fifties, at which time he was also studying Hebrew. Interview with Paul Robeson, Jr., 1971. For a list of most of Robeson's languages, see Seton, *Paul Robeson*, p. 77.

[54]Unable to exercise control over the movies in which he acted, Robeson was on balance, despite great effort, unsuccessful in using that medium to raise the consciousness of black people. During the height of his campaign to educate his people to an awareness of the strengths of their heritage, he was frustrated time and again as he attempted to project images worthy of them. The fact that only one of his movies, *Song of Freedom*, achieved a satisfactory level of artistic and political integrity on the African question revealed enough about the nature of racism in the film industry and in the West to indicate that the promise of his grand design had scant chance of being consummated. Indeed, the films with African content, with the exception of *Song of Freedom*, ended up quite badly. *Sanders of the River*, a film in which Robeson played an African, was particularly displeasing to him. Though the filmmakers had added scenes, distinctly imperialist in nature, which he had not seen and over which he had no veto, Robeson later admitted that he had lent himself to "in imperialist point of view" in which he did not believe. He stated that he had been so absorbed with features of the film which focused on African culture that he had failed to take appropriate notice of the entire product. He saw the finished version when it premiered in London and was called to the stage to take a bow. He walked out of the theatre in protest. That film unquestionably compounded the identity problems of some of the people whom Robeson had wanted so badly to liberate. For Robeson and the movies, see the *New York Times*, April 19, 1942; Marie Seton, *Paul Robeson*; and especially, Thomas Cripps, "Paul Robeson and Black Identity in American Movies," *Massachusetts Review* (Summer 1970).

entirely of Negro spirituals—a revolutionary cultural development for that period. The concert won rave reviews from the critics, catapulting Robeson overnight into national recognition as a young artist of great talent. Commenting on his interest in the spirituals (he had by 1925 also won national attention for performances in Eugene O'Neill plays), he remarked that the artist should confine himself to the art for which he is qualified and that one could only be qualified by an understanding that is born in one, not cultivated.[55]

In what can only be described as a nationalist stance, the young artist could not see how a Negro could really feel the sentiments of a German or an Italian or a Frenchman; nor could he see where the achievement lay in singing an opera in the languages of European peoples. Of course, if a black man were to write a great opera on an African theme it would be "just as insignificant for a white opera singer to give a creditable performance of it." Robeson believed that if one did not understand the philosophy or psychology of the Italian, German, or Frenchman, then one could not sing their songs. Since their history had nothing in common with that of his slave ancestors, he decided that he would not sing their music, or the songs of their ancestors, a position which he altered by 1931.[56]

It would be a mistake to interpret Robeson's early attitude toward his repertoire as a product of racial chauvinism. On the contrary, he was careful to point out that only those with an understanding of the culture and history, the language and temperament, of a people should seek to render their music. When he altered his initial attitude and began singing the songs of others, he did not do so before making a serious effort, out

[55]It is noteworthy, in light of recent attacks on Robeson, that Robeson at times seemed to be arguing that one could *only* relate to the music of one's ancestors. Harold Cruse has argued, pathetically, that Paul Robeson could not commune with Negro composers: "Paul Robeson, for example, was an interpreter of Shakespeare, European Opera and the plays of Eugene O'Neill, etc." Harold Cruse, *The Crisis of the Negro Intellectual* (New York, 1967), p. 297. Only Cruse can decode his *et cetera*. Beyond that, there is no small irony here, *for Robeson refused to sing any but the songs of his people for five years* and gave them a place of prominence in his concerts *for more than three decades.* Cruse's reference to Robeson and opera reflects guesswork and deserves attention proportionate to the seriousness of his methodology. Du Bois, with infinitely greater precision, has written that "Robeson . . . more than any living man has spread the pure Negro folk song over the civilized world." W. E. B. Du Bois, *Autobiography* (New York, 1968), p. 397. In addition to that achievement, of course, is one that is not as well known, Robeson's singing of the songs of the African peasantry. For Robeson's relationship to jazz, blues, and gospel composers see footnote 23. With all the illumination of his allusion to Robeson's relationship to Negro composers, Cruse also asserted that Robeson turned "his back on ethnic culture" and lacked "a cultural philosophy." Cruse, *Crisis*, p. 296.

[56]As late as 1934, some four years after Robeson finally began to sing the music of peoples in addition to his own, he still had not altogether reconciled himself to the music of other cultures. He remarked, despite his growing interest in the peoples of the world, that he had "no desire to interpret the vocal genius of half a dozen cultures which are really alien to me. I have a far more important task to perform." Paul Robeson, "Culture of the Negro," p. 916.

of respect for the peoples of the various cultures, to achieve such an understanding. Though he later sang the music of other cultures, Negro music remained the great balance wheel or radiating center of his art.[57]

When Robeson expanded his repertoire to include the music of other people, he displayed a decided preference for the body of world folk music, which was closer to the music of his people than most European "classical music." Though he had warned that it was no "achievement to sing in the white man's Opera House," his exhaustive studies of the languages and music of many lands had led him, for instance, to choose Bach over Schubert because the German romantic spirit was "foreign" to him and Bach's spirituality and religious quality closer to his soul. Further, he found Russian music more satisfying than that produced by Germans because it reflected an experience closer to that projected in Negro music, for the serfs of Russia had lived under an oppression not far removed from that of Negro slaves.[58]

> What was wrong with our despised music if it was akin to the great Russian? Had we a value that had been passed by? Were the outcast Negroes, who were studying to assimilate fragments of the unsympathetic culture of the West, really akin to the great cultures of the East? It was a fascinating thought. I began to make experiments, I found that I—a Negro—could sing Russian songs like a native. I, who had to make the greatest effort to master French and German, spoke Russian in six months with a perfect accent, and am now finding it almost as easy to master Chinese.[59]

The more Robeson learned about music and peoples of other cultures, the more convinced he became that the black man must look to his own heritage to find himself as an artist, the more certain he was that the music of the Negro slave belonged beside the great music of the globe.

> [T]o prove my point that the Negro should hark back to his own tradition, I have only to put on successive phonograph records of a Hebrew melody and a Zulu song. Perhaps I will make it clearer on the stage by singing a Hebrew chant and then the chant of a Negro preacher in the South, a Russian melody and an American Negro folk song. My quarrel is not with the Western culture but with the Negro imitating it. The American Negro

[57]An examination of Robeson concert programs and of Robeson recordings makes this eminently clear. A representative collection of each can be found at the Schomburg Collection of the New York Public Library.

[58]Clearly, Robeson gave great emphasis to using music for purposes of highlighting oppression and bringing the oppressed of the world closer together. While it is true that the desire of his audiences to hear, in addition to Negro spirituals, the music of other peoples led him finally to broaden his repertoire, when he did so he made a conscious effort to make most of that music meaningful within the context of the sufferings of humanity. "The songs of peasants are nearest to my heart, whichever the nation may be. It should be so." *Daily Gleaner*, March 10, 1934.

[59]*Chicago Defender*, January 26, 1935.

[I believe] never thinks that he is an Eastern product: I hope to be able to show him the way.[60]

Robeson had earlier expanded on some of the results of his explorations of other cultures:

> . . . I know the wail of the Hebrew and the plaint of the Russian. I understand both, as I do the philosophy of the Chinese, and I feel that both have much in common with the traditions of my race. *And because I have been frequently asked to present something other than Negro art* I may succeed in finding either a great Russian opera or play, or some great Hebrew or Chinese work, which I feel I shall be able to render [with the] necessary degree of understanding (italics mine).[61]

Even as he broadened his musical interests, Robeson's belief in the intrinsic value of the spirituals was undiminished: He said that he wanted to assimilate and understand, to blend into himself all that the spiritual life of his people may encompass. The oppression of blacks, he felt, linked the descendants of those who created the spirituals not only to Russian serfs but to peasant communities in various parts of the world. The Hungarian or German peasant, he believed, could enjoy the songs of the peasants of Provence and so could the working American Negro. Clearly, he had revised his earlier position on the relationship of his people's music to the music of other cultures.[62]

[60]Fifteen years later in Carnegie Hall, during a period of unprecedented Negro interest in integrationism, Robeson, sixty years of age, illustrated in concert the similarities between a Negro religious chant from America, an African chant, a Czech chant, and a Hassidic chant. He commented, before introducing the African music, that in searching for the source of Negro religious music he had gone back to Africa "and found the same forms that were in the African religious festivals." He found in East African music "melodies and a form which were very close to . . . forms of the early church of the middle ages." He told his audience that such was the case "because the Abyssinian Church and the Church of the Sudan were a part of the eastern churches of Byzantium, and so they too had a music quite comparable to the music of the Near East. . . ." In that same concert, before reciting an excerpt from Shakespeare's *Othello*, Robeson informed his audience that Desdemona had not been killed "from savage passion," that Othello had come from "a culture as great as that of ancient Venice, from an Africa of equal stature." Paul Robeson, *Ballad for Americans*, Carnegie Hall Concerts, May 9th and 23rd, Vol. 2, VSD-79193. Robeson's overall emphasis was on characteristics indigenous to African peoples. Yet as a student of languages and art, he noted important similarities in construction between African languages and "that language which gave us the wonder of Chinese poetry," between "certain works of long-dead West African artists and exquisite examples of Chinese, Mexican and Javanese art." He left no doubt as to his faith in the African heritage, as to his measured regard for Western civilization: "Such [African] achievements can hardly be the work of a fundamentally inferior people. When the African realizes this and builds on his own traditions, borrowing mainly the Westerner's technology (a technology—he should note—that is being shown not to function except in a socialist framework) he may develop into a people regarding whom the adjective 'inferior' would be ludicrous. . . ." Robeson, "Primitives," p. 191.

[61]*New York World-Telegram*, August 30, 1933.

[62]*Daily Gleaner*, March 10, 1934.

IV

Robeson's decision to sing the folk music of cultures in addition to his own—of the Chinese, the Hebrews, Russians, and others—was in phase with his deepening and expanding political involvement, with his ability to identify with oppressed humanity irrespective of color. It was in this context that he described a critical problem of the West, one with dire implications for the whole of mankind—"the cost of developing the kind of mind by which the discoveries of science were made has been one which now threatens the discoverer's very life." In fact, he argued, Western man appears to have gained greater powers of abstraction "at the expense of his creative faculties."[63]

> But because one does not want to follow Western thought into this dilemma, one none the less recognizes the value of its achievements. One would not have the world discount them and retrogress in terror to a primitive state. It is simply that one recoils from the Western intellectual's idea that, having got himself on to this peak overhanging an abyss, he should want to drag all other people—on pain of being dubbed inferior if they refuse—up after him into the same precarious position.

"That, in a sentence," wrote Robeson, "is my case against Western values."[64]

So it was not simply that America was uncongenial to meaningful, creative living; the Western world as a whole seemed, short of very drastic changes, an unlikely place in which new forms of freedom, a new humanity, could develop. The West had gone astray as far back as the time of the Renaissance, probably much earlier:

> A blind groping after Rationality resulted in an incalculable loss in pure Spirituality. Mankind placed a sudden dependence on the part of his mind that was brain, intellect, to the discountenance of that part that was sheer evolved instinct and intuition; we grasped at the shadow and lost the substance . . . and now we are not altogether clear what the substance was.[65]

Robeson believed that before the Renaissance the art, music, and literature of Europe were closer to the cultures of Asia, apparently because European man during the medieval period held spiritual values in greater reverence than in the following epoch. With the advent of the Renaissance, European man had begun to give reason and intellect primacy over intuition and feeling, a process which resulted not only in great strides toward conquering nature but toward utilizing technological advantages to conquer the human world. Robeson held that one who embraced Western values completely would, in time, find his creative faculties stunted and warped, would become almost wholly dependent

[63]Robeson, "Primitives," p. 191.
[64]*Ibid.*
[65]Robeson, "To Be African," p. 74.

on external gratification. Becoming frustrated in this direction, with neu-
rotic symptoms developing, it would be borne in upon the victim that
life is not worth living, and in chronic cases he might seek to take his
life. "This is a severe price to pay even for such achievements as those of
Western science."[66]

As one reads Robeson's brief against Western values, it is evident
that he had little hope that Western man, left to his own devices, will be
able to halt his momentum and pull back from the precipice. He pro-
vided an index into the depth of the European disorder by drawing our
attention to the fact that as abstract intellectualism became enthroned in
Europe the artistic achievements of that section of the world became
less impressive: He found in European art "an output of self-conscious,
uninspired productions" which discriminating people recognize as dead
imitations rather than "the living pulsing thing."[67]

Robeson noted that, with the advance of science, the art of Europe,
in steady decline, had paid dearly. "To what end, does the West rule the
world," he asked, "if all art dies?" He proceeded to pose a question
which, as later developments would demonstrate, was surely the most
important of all questions for him — "What shall it profit a man if he
gain the whole world and lose his own soul?"[68] This he thought the West
had "come very near to doing, and the catastrophe may yet come. The
price of science's conquest of the world has been the loss of that emo-
tional capacity that alone produces great art. Where are the Westerners
now who could paint an Old Master, compose a Gregorian Chant, or
build a Gothic cathedral?"[69]

The absence of such emotional resources was not, as Robeson under-
stood it, confined to the small minority described as artists. A decade
before the atom bomb was dropped on the Japanese, he explained that
what shows among artists "is only a symptom of a sickness that to some
extent is affecting almost every stratum of the Western world." To the
question "is there no one to bring art back to its former level?" he
responded that this is where people of African ancestry and the Eastern
peoples come in. Now that nature has been virtually conquered by the
West, "visionaries dream of a world urn by scientists who would live
like artists." But in Robeson's opinion Westerners no longer know how
to live like artists, having "brought misery with their machines."[70]

[66]Robeson, "Primitives," p. 191.
[67]*Ibid.* Robeson acknowledged that Europe's "entire peasantry, large masses of its
proletariat, and even a certain percentage of its middle class have never been really touched
by attempts of others to reduce life to a mechanical formula," "to kill this creative, emo-
tional side. . . ." "Of such persons one can mention Blake and D. H. Lawrence. In fact
one could say that all the live art which Europe has produced since the Renaissance has
been in spite of, and not because of, the new trends of Western thought." Robeson,
"Primitives," p. 191.
[68]*Chicago Defender*, January 26, 1935.
[69]*Ibid.*
[70]*Ibid.*

This concern—the introduction of a certain malady with the machine—was pivotal to some of the more thoughtful and sophisticated men and women from the Afro-Asian world, and it is possible that Robeson and Jawaharlal Nehru, who met and became close friends during the 1930s, discussed this problem. At that time one of the few Americans to give substantial attention to such a concern, Robeson believed the people who first learn to hold in balance the emotional and the intellectual, to couple the use of the machine with a life of true intuition and feeling, will produce the superman.[71]

Blacks in America would have a better chance of fashioning the new humanity if they cultivated those qualities in their culture which tie them to the East and to Africa. While the Negro "must take his technology from the West," Robeson observed, "instead of coming to the Sorbonne or Oxford, I would like to see Negro students go to Palestine and Peking." He added that he "would like to watch the flowering of their inherent qualities under sympathetic influences there."[72] Nevertheless, he remarked that it has been a boon to the American Negro that he has managed, despite his presence in the white man's uncongenial spiritual world, and despite centuries of oppression, to retain a world view that is still largely non-Western, predicated on sensibilities similar to those of his African ancestors and to those people who live in cultures which place a higher priority on concrete symbols than upon abstractions:

> For it is not only the African Negro, and so-called primitive peoples who think in concrete symbols—all the great civilizations of the East (with possibly the exception of India) have been built up by people with this type of mind. It is a mentality that has given us giants like Confucius, and Mencius, and Lao-Tze. More than likely it was this kind of thinking that gave us the understanding and wisdom of a person like Jesus Christ. It has given us the wonders of Central American architecture and Chinese art. It has, in fact, given us the full flower of all the highest possibilities in man—with the single exception of applied science. That was left to a section of Western man to achieve and on that he bases his assertion of superiority.[73]

[71]No one people were likely, relying solely on their own values, to produce the new man. The ingredients required for such a creation involved "a mingling of new values," some of which resided in Africa, "this new and mystic world. . . . " He noted, in one of his rare references to leadership of African peoples coming from transplanted Africans, that "the lead in culture is with the American Negro, the direct descendant of the African ancestors. . . . Yet the Negroes are the most self-conscious of all. . . . If the real great man of the Negro race will be born, he will spring from North America." In an adjustment of his oft-stated precept that people of African ancestry throughout the world were radically different from whites, he acknowledged that European influences on the North American blacks was so great that the latter differed more "from his South American brother than from a white man." It is likely that Robeson was referring to broader cultural influences, that is, to those that go beyond the arts and religiosity. *Daily Gleaner*, March 10, 1934.

[72]*Chicago Defender*, January 26, 1935.

[73]Robeson, "Primitives," p. 190. There is an epistemological problem here. Scientists are quick to point out that there is not, in their work, so sharp a contrast between reason and intuition. In fact, some of the most distinguished deny a dichotomy altogether, insisting

The American Negro's great asset is his "immense emotional capacity," though, Robeson added, emotive powers are at a discount in the West. The Negro's capacity for feeling, his intuitive and aesthetic gifts, with the proper guidance, might achieve wonders. His attainments in America, as impressive as they were in their own right, were merely sterile compared to what they might be in the future. Robeson thought it essential that American blacks not glory in their gifts and warned them against the perils of isolation, pointing out that it was not only useful but necessary from a social and economic standpoint for the Negro to understand Western culture and ideas, especially science: "Now I am not going to try to belittle the achievements of science. Only a fool would deny that the man who holds the secrets of those holds the key position in the world."[74]

Robeson ultimately rejected the view that cultural traits are inherited in the genes, conceding that many blacks in America had become "pure intellectuals." But he questioned whether they should allow themselves to proceed all the way down "this dangerous by-way when, without

that they rely on intuition as well as reason. Interview with Armand Borel, Mathematics Section of the Institute for Advanced Study, Princeton, New Jersey, Spring 1971. That Robeson makes reference to impressive strides made by the West in *applied* science suggests that he was aware of the role of Egyptian and other ancient civilizations in spawning and developing fundamental principles of science. His one specific reference to Egyptian civilization appears to confirm the suggestion: "We have an amazingly vivid reconstruction of the culture of ancient Egypt, but the roots of almost the whole of the remainder of Africa are buried in antiquity." Robeson, "To Be African," p. 71. It would be especially rewarding to know Robeson's views on science in the ancient Afro-Asian world. Either he never put those views into writing or they are among his private papers. In any event, Alfred Kroeber speaks of "the sciences of Egypt, Mesopotamia, India, China, and Japan, which are less known [than Occidental] science and in part poorly datable." Though Kroeber does not seem to appreciate the fact that Egypt has always been on the continent of Africa, and is therefore African, he does note that "whatever is pre-Greek, whatever the Greeks and their heirs built on, originated there" in Egypt and Mesopotamia, which he refers to as the Near East. Alfred L. Kroeber, *Configurations of Culture Growth* (Berkeley and Los Angeles, 1944), pp. 98, 174. Though there are certainly omissions in his writings on the history of science, Robeson's treatment of the effects of Western science, of the celebration of reason and the essential lack of sufficient regard for emotive, intuitive, and aesthetic values in the lives of the people, is brilliant. He is, moreover, quite correct in arguing that the people of Africa and Asia generally have far greater regard for emotion, intuition, and spirituality than modern man in the West. It should be remarked, however that problems associated with a too heavy dependence on those attributes, while they have not threatened the existence of man, have been substantial in man's history in the Afro-Asian world—which doubtless accounts for Robeson's insistence on the importance of Afro-Asian man's mastering Western technology. See Herbert J. Muller, *The Uses of the Past* (New York, 1952), for a sensitive study of the ironies inherent in the cultures of East and West.

[74]"I am simply going to ask," he continued, "having found the key, has Western man—Western bourgeois man . . . sufficient strength left to turn it in the lock? Or is he going to find that in the search he has so exhausted his vitality that he will have to call in the cooperation of his more virile 'inferiors'—Eastern or Western—before he can open the door and enter into his heritage?" Robeson, "Primitives," pp. 189–90.

sacrificing the sound base in which they have their roots, they can avail themselves of the now-materialized triumphs of science and proceed to use them while retaining the vital creative side."[75] This creative dimension, according to Robeson, had made possible African Americans' artistic and spiritual achievements, the invigorating influence of which was unmistakable in America.

Since the crucial objective of the cultural revolution is man mastering the emotional and intellectual dimensions of his personality, when he learns "to be true to himself the Negro as much as any man" will contribute to the new cultural order. But Robeson cautioned: "Unless the African Negro (including his far-flung collaterals) bestirs himself and comes to a realization of his potentialities and obligations there will be no culture for him to contribute."[76] In Robeson's terms, potentialities had to be developed into actualities that would tighten the bonds between blacks, especially in America. Without moving closer to nationality, to making more effective use of the attributes of a nation, they could scarcely make the leap onto the international plane to help effect the needed cultural transformation. And nations contributing to the new cultural dispensation would be answering the demands of a world-necessity which would lead in time, Robeson hoped, "to the 'family of nations' ideal."[77]

The posture of the artist toward society would be decisive in determining the success or failure of the cultural movement. This relationship was of major concern to Robeson, and the position he took is but one more illustration of his special angle of vision: "The whole problem of living can never be understood until the world recognizes that artists are not a race apart." Artists, Robeson added, do not have potentialities unknown to large numbers of other human beings, for creativity means more than the ability to make music, to paint, or to write. Each man has something of the artist in him; if this is uprooted "he becomes suicidal and dies." Robeson believed that, given the opportunities for creative development, many people could contribute to the sum of the artistic and spiritual achievements of a given society. Positing an organic tie between artist and society—a reciprocity of interests—his aesthetic stance was clearly more African than Western.[78]

When Robeson turned to America he saw the worst qualities of Europe in magnified form. Having applied research and reflection to identifying and interpreting life styles peculiar to people on the major continents of the world, he placed white America in this broad cultural setting and found her wanting. Robeson believed there was very little of value in white America apart from technology; but as a socialist, he thought capitalism militated against scientific innovations being used humanely.

[75]*Ibid.*, p. 190.
[76]Robeson, "To Be African," p. 73.
[77]*Ibid.*
[78]Robeson, "Primitives," p. 191.

The problem of erecting a richer American culture on indigenous foundations, a problem with which a few American intellectuals, among them Constance Rourke, were preoccupied, was being approached from an essentially different point of view by Robeson. While Rourke especially had some appreciation of the importance of African American culture, she did not see the Negro as absolutely pivotal to the development of a distinctively American culture. Nor did Rourke and her associates even begin to approach Robeson's understanding of the relationship between American and world cultural forms. For Robeson as for Du Bois, the Negro, owing to his artistic and spiritual qualities, was America's only cultural hope. In 1933, the great artist had offered a withering criticism of American culture:

> The modern white American is a member of the lowest form of civilization in the world today. My problem is not to counteract his prejudice against the Negro . . . that does not matter. What I have set myself to do is to educate my brother the Negro to believe in himself. . . . We are a great race, greater in tradition and culture than the American race. Why should we copy something that is inferior.[79]

Black liberation in such a country would not be achieved through the NAACP's emphasis on racial cooperation. Many African Americans, Robeson said during a visit to the Soviet Union in 1935, would have to fight and die for their freedom. "Our freedom is going to cost so many lives," he remarked, "that we mustn't talk about the Scottsboro case as one of sacrifice." He continued: "When we talk of freedom we don't discuss lives." Realizing that, given the objective conditions, black people would have to make greater use of violence before achieving their freedom was by no means the only, or even the most significant, example of Robeson's prophetic insight. With awesome precision he predicted that if Negroes persisted in efforts "to be like the white man within the next generation they will destroy themselves."[80]

[79]*Daily Gleaner*, August 21, 1933.

[80]For Robeson's remarks in Russia on the American Negro and the uses of violence, see Paul Robeson, "I Breathe Freely," *New Theatre*, No. 7 (July 1935), p. 5. As for Robeson's warning his people against the consequences of trying to flee their blackness, it was offered in much the same manner as a Garnet caveat a century earlier. See Garnet's Boston speech in Stuckey, *Ideological Origins*. Approximately thirty years following Robeson's warning, Negro Americans were in large numbers engaged in a frenzied effort to escape their blackness. Regarding that period, I have written elsewhere that during the late sixties

> Many must have vaguely sensed in "black power" the suggestion that they would soon, perhaps for the first time, have an opportunity to meet themselves. Without clarity regarding their moorings, for decades led by men with little conception of the forms of freedom proper to their people, a generation of blacks had the painful experience of living, as it were, between time—that is, during a period of profound historical discontinuity. Theirs had been the first generation led by men with no observable interest in Africa.

See Sterling Stuckey, "Blacks in North America" in *World Encyclopedia of Black Peoples* (Michigan, 1975).

While in the Soviet Union, Robeson witnessed the potential of "back-ward races" being realized. Within twenty-five years the peoples east of the Urals, the Yakuts, the Uzbeks, and others, under the influence of socialism, had compressed time: They were running their own factories and directing their own theatres and universities; their ancient cultures were "blooming in new and greater richness." "That showed me," Robe-son remarked, obviously with the Afro-Asian world in mind, "that the problem of 'backward peoples' was only an academic one." He noted that "if provided the opportunity, one segment of humanity would per-form on the same level of culture as any other."[81] Robeson had not come by his socialism through the Soviets. His socialist views actually owed more to the influence of the British Labour Party than to Russia. It was through following developments on the labor front in England that his apprenticeship in socialism began in earnest.

As he took his socialist stance, advanced his obligations as an artist, and acted upon his convictions, Robeson demonstrated, in theory and practice, that there is no necessary tension between being a black nation-alist and a socialist. In addition his conscious selection of songs from the world's store of *folk music*, his uses of and commentaries on the music of his own people, and the essential simplicity of the life he chose to lead—all this and more indicates that socialist and black nationalist aspi-rations were, for Robeson as for Du Bois, easily joined. And like Du Bois, balancing the related and complementary concerns of classical black nationalism and socialism, Robeson resisted, in Alexander Crum-mell's phrase, the intimidations of power and the seductions of ease. C. L. R. James, the brilliant Trinidadian writer and theoretician, has remarked that Robeson had remained, throughout his long stay in England, unmoved by fame and by the blandishments of the rich and powerful.[82]

V

Robeson was criticized by a number of African Americans for spending so much time away from America. Despite the fact that he was making use of his time increasing his knowledge of many cultures, including a number of African cultures; aiding in the struggles of African peoples in the United States, the West Indies, and in the ancestral home; displaying his musical and dramatic talents in England and on the Continent in an atmosphere of freedom unknown in America—Robeson at times also

[81]Paul Robeson, *Here I Stand*, pp. 35–36; *New York Times*, April 19, 1942.

[82]James, author of *The Black Jacobins*, said of Robeson: "That was an unusual man. I've met a lot of people you know, a lot of people in many parts of the world and he remains, in my life, the most distinguished and remarkable of them all. That I will say and that I am going to write." Interview with C. L. R. James, June 10, 1970.

questioned his presence away from the United States.[83] Abroad nearly twelve years, save for brief visits to the States for concerts, on more than one occasion Robeson felt that his work as an artist suffered from his lack of contact with American audiences.

On a return trip to the States shortly after having moved to London, he had said that his roots were in America, that if he stayed in Europe for two years he "would be dead artistically," and that foreign audiences "do not feel as deeply nor respond as do those who attend the American theater."[84] At other times Robeson's disaffection with living abroad—he had sometimes experienced racial discrimination in England—led him to consider moving to Russia or to other parts of the world, including Africa. But his interest in the folk music of other countries, together with widening contacts with ordinary people of many lands, militated against his feelings of rootlessness and helped enable him to live away from the United States. In any event, on the question of a permanent home, he had noted in 1935 that where he lived was not important. "But I am going back to my people in the sense that for the rest of my life I am going to think and feel as an African—not as a white man. Perhaps that does not sound [like] a very important decision. To me, it seems the most momentous thing in my life."[85]

Still, the West, with ills following in the wake of capitalism and industrialization, sometimes caused Robeson to long for environs more congenial to his own personality, which seemed devoid of that concern for superficial "manners" and "culture" which kept people apart rather than together. This attitude led him in a 1935 address before the League of Colored People—an organization made up primarily of West Indian blacks but including some Africans and African Americans—to express his intention of leaving England, or removing himself from living "under the sword of Damocles all my life." Regarding himself as a "Negro wandering through the world," Robeson found opportunities for naturalness and self-expression, which he considered important, limited in England. He therefore wanted to "be where I can be African and not be Mr. Paul Robeson everyday."[86] The search for a greater measure of autonomy as a person of African ancestry was linked to a Robeson first

[83]In 1935 and during an earlier period, Robeson became quite restless in England and considered spending several months in Russia. But he added: "I would also like to live for a time in Africa where I have my roots. I learned in just a few weeks certain tribal dialects, and have retained them. They seemed to come to me effortlessly." At that time he was not satisfied with life in Western Europe. In America on a visit, he told a reporter: "In France, in England and in fact here in America too, I have no difficulty personally." And yet while France and England had drawbacks and "while New York is better than Georgia in this respect, I feel that as long as this burden of race is borne by any of my brothers, I, too, bear it." *New York Herald-Tribune*, October 27, 1935.

[84]*Ibid.*, January 11, 1931.

[85]*Journal and Guide*, January 5, 1935.

[86]*London Daily Herald*, January 26, 1936.

principle — the need for political and cultural autonomy among Africans throughout the world.

Robeson's intense interest in African nationalism was certainly in part a reflection of the growing strength of nationalist currents generally in the thirties. Not a few colonial subjects — including the young Jomo Kenyatta — who moved in European circles at that time were nationalists and, like Robeson, influenced by socialism. Such men and others helped to create an atmosphere congenial to the further development of that nationalism to which Robeson had given precocious public expression in his commencement address in college. Beyond that, nationalism and Marxism were lodestars for the world's leading revolutionaries: Revolutionaries in China were making impressive theoretical assaults on problems inherent in adapting Marxism to the imperatives of that ancient, sprawling land; others sought a communist resolution of the problems of Vietnam, one which would, above all, guarantee the independence of their country. Like Nehru, V. K. Krishna Menon was a friend of Robeson and, more than Nehru, had moved in the direction of Marxism in his quest for a solution to the staggering problems confronting his colonized people. More than most Afro-Asian nationalists then realized, and more than most nationalists in the Americas had perceived, the twentieth century was destined to be the century of nationalist revolutions, under the guidance of socialists, in numerous parts of the world.[87]

[87]Even in those countries where the most sweeping changes have occurred — in China and Russia, for example — the revolutions have been profoundly nationalistic in practice. Perhaps little Cuba, with Fidel Castro supporting the bold movements of Che Guevara, has made the most valiant effort to move beyond nationalism. Still, the Cuban revolution has almost had to be, on balance, essentially nationalistic. The point being stressed, therefore, is that the greatest advocates of anti-imperialism and class war in this century have been nationalists as well. Far more than is commonly held, black nationalism in America has been closely tied to anti-imperialism and has some history of antagonism to private property. In fact, anti-imperialism formed, right from the start, the radiating core of black nationalism in African America. No more persuasive evidence of this can be found than the classical black nationalists' almost total disregard for geographical barriers. The reach of their vision of freedom carried beyond the boundaries of North America, Central America, the West Indies, and South America to the length and breadth of the ancestral home. More than that, thanks to David Walker and Martin Delany, the whole of Asia was brought within the orbit of black nationalist concerns. The cry, primordial in tone, *was for the liberation and vindication of all people of color groaning under European hegemony and abuse.* Beyond that, in Walker, Robert Alexander Young, Alexander Crummell, Henry H. Garnet, Richard H. Cain, W. E. B. Du Bois, and others there was concern for the whole of mankind. It is out of this profoundly humanistic tradition of nineteenth-century classical black nationalism that Robeson emerged. Despite the anti-imperialism and humanism of classical nationalism, perhaps only Garnet among nationalists before Du Bois and Robeson achieved a substantial degree of class consciousness — of explicit skepticism regarding the wisdom of class arrangements and the sanctity of property. With the advent of Du Bois there was outright repudiation of the primacy of private property both within America and around the world, a position upon which, not surprisingly, there was much elaboration in print. It should be noted that Robeson's father opposed individualism in almost all of its forms, stressing the youth's obligation to his people. It was merely a matter

The heavy emphasis which Robeson placed on the international community of Africans and the need for their unity can be, in part at least, taken as a measure of his awareness of the tremendous odds facing his people in America. No doubt this last factor accounts in significant degree for his relative failure to emphasize specific, practical (as opposed to theoretical) means by which liberation might be achieved in America. As he came to know the vast landscape of humanity, he realized that just as oppression of blacks in America was a direct outgrowth of Europe's aggression against the non-white peoples of the world, the liberation of African America was ineluctably tied to the disenthrallment of Afro-Asia. The more he was exposed to people of color from various parts of the world, the more convinced he became of this.

In a real sense, Robeson regarded his relationship to his people in America in almost precisely the same way that he conceived the relationship between African Americans and blacks elsewhere. He asserted that his individual success was as nothing—"did not matter in the least"—compared to the plight of his people. His own father, his own brother, could not go where he went, could not come in behind him, and that displeased him, causing him to believe all the more that the only meaningful freedom is that which a whole people win for themselves. "It is no use telling me that I am going to depend on the English, the French, or the Russians. I must depend on myself." He was speaking generically—all people of African descent must depend on themselves, not on others.[88]

Though Robeson's increasing concern for the oppressed of all lands was causing him to feel his isolation less sharply, the sense of being caught up in a world that could not fully satisfy his spiritual needs continued to plague him during his stay in England. But the high tension of the dialectic posed by the presence of a black nationalist in a white country was eventually, after considerable restlessness of spirit, reduced to manageable proportions. Though Robeson felt compelled to return to the place of his origins, so great was his ability to empathize with others—a fundamental characteristic of classical black nationalists—that for years before returning he had become a champion of all the oppressed. One incident in particular typified his concern for the downtrodden. On one occasion, he heard an English aristocrat talk to his chauffeur as if speaking to a dog. "I said to myself, 'Paul, that is how the Southerner in the United States would speak to you.'"

of time, then, before Robeson, highly susceptible to concern for the whole people, would declare against capitalism. When he did, there was simply little question about the degree of his commitment to socialism. Except for the fact that blacks in America are in the minority rather than the majority, and except for Robeson's reflections on the uses of world cultures, his stance as socialist and nationalist was in numerous ways scarcely distinguishable from the positions of nationalists and Marxists from the Afro-Asian world. For the humanism and anti-imperialism of classical black nationalists, and for their concern for people of color everywhere, see Stuckey, *Ideological Origins*.

[88]*Journal and Guide*, January 5, 1935.

"That incident made me very sad for a year," he later remarked.[89]
The unhappy occurrence was fateful for Robeson, reinforcing in his
mind the unity of the struggle of the oppressed throughout the world—
in fact, contributing to his belief "that the fight of the oppressed workers
everywhere was the same struggle."[90] Thus, his appearance in Spain
to sing songs of freedom during the Spanish Civil War was a natural
development, a logical extension of his broadening interest in the politi-
cal and cultural conditions of oppressed peoples of other lands.[91] Just as
moving from the art of another people to concern for them as people
had the appearance of virtual inevitability for Robeson, interest in the
political and social conditions of a people usually led him to the music
of that people. Because theory and practice for him so often seemed to
merge toward oneness, when he caught the vision of the unity of man-
kind he committed himself to the alleviation of oppression irrespective
of the color of the aggrieved. His sympathy for those suffering from
fascism was an aspect, as natural as any other, of his campaign, often by
example, to call forth the best in his people as an aspect of their recogni-
tion of their greatness. To have turned his back on a struggle profoundly
affecting the course of freedom in the world would not only have been
unwise abstractly but would have reinforced a leadership in African
America already striking for cultural insularity, already noted for reluc-
tance to become involved in American foreign policy.

VI

Since blacks lived in the heart of the seriously afflicted Western world,
and since the West was responsible for the colonized status of his people
in Africa, Robeson thought unity among Negroes the world over no less
desirable on the cultural than on the political level and strongly urged
them to work for cultural unity. On the basis of an assessment of present
and future cultural needs, his prescription for the direction which black
cultures should take was tied to his desire to see his people storm still
higher heights of greatness. *His theory of black culture was analogous
to but more far-reaching than the politics of Pan-Africanism: Robeson*

[89]A year before leaving England, Robeson commented on the feeling of isolation which
he had so often experienced away from his people. He told an interviewer that he had
once thought of going to Russia, "but that was like running away. . . . I must here pay
tribute to the [English] workers. . . . They helped me get over my isolation." K. A. Harvey,
"Paul Robeson—The Man and His Art," an exclusive interview, *Millgate*, Vol. XXXIII,
Part II, No. 396 (September 1938), p. 711.

[90]Quoted in Seton, *Paul Robeson*, p. 59.

[91]"Giant Negro singer Paul Robeson drove from France to Barcelona, Spain. Purpose
of his visit: to go to the front lines, where a huge loudspeaker will throw his voice, during
a lull in fighting to Leftist and Rightist alike." *Time* (January 31, 1938).

visioned a unified, systematically developed black culture extending across geographical barriers, one directed toward a global, messianic objective — "The world today is full of barbarism, and I feel that the united Negro culture could bring into the world a fresh spiritual, humanitarian principle, a principle of human friendship and service to the community."[92]

For all of their handicaps born of oppression, Robeson considered Africans "the healthiest race of the world." His claim that they "will sooner influence others than be influenced by them" is not readily understood, considering the substantial emphasis he placed on the inferiority complex of so many of his people. Yet his position on the Negro as protagonist is altogether consistent with his view that black people constituted, as a group, a significant cultural force in the Americas, on the continent of Africa, and in much of Europe.[93] It is likely that his remarks on Negroes from various European possessions imitating the "mother country" were not meant to include the masses of African peoples but primarily those who had considerable contact with white people.

Rarely did Robeson single out American Negro culture for exclusive attention — rather, he wanted to see the unified development of black cultural communities throughout the world. That desire, revolutionary in conception, flowed logically from his belief that black cultures generally were impelled by roughly similar sensibilities. While he thought Negroes in America would play a special role in helping to effect the liberation of their people elsewhere, Robeson emphasized the vital roles to be played by blacks in the Caribbean, South America, and Africa in forwarding the liberation of African peoples. In short, there could be no substitute for united political and cultural action across geographical boundaries.

The struggle of African peoples the world over would be a difficult one, Robeson thought, and he was not optimistic about them being liberated in the immediate future. Taking the long view of developments, he foresaw, with notable clarity, no alternative to determined, protracted struggle before genuine freedom would be realized. Meanwhile, considering black people everywhere to be of the African family, he contended that wherever found they must "stand in one camp, fighting for freedom and social justice." In addition to North America, they were found in a number of "centers of Negro population" — the Caribbean, Brazil, the

[92]*Daily Gleaner*, July 17, 1935.

[93]Robeson found it unfortunate that fusion between American and Negro culture has been so substantial. He was more sensitive than most of his fellows to the hybrid nature of the American Negro, a view which in fact was more sound than his sometimes stated contention that African American religion and art were wholly African. Robeson considered it "deplorable" that the fusion between black and white had been biological as well as cultural, rendering "the number of racially pure Negroes in America . . . very small." *Ibid.*, March 10, 1934.

whole of South America, and Africa. "In these various regions Negroes speak different languages, but in spite of that, even the American Negroes feel instinctively in sympathy with their own blood, the black men of the whole world."[94]

But Robeson did not stop at the boundaries of Pan-Africanism; he later went beyond them to establish an Afro-Asian political perspective which complemented his cultural views on the relationship between those two areas of the world and how that relationship bore on the liberation of Africans in the New World. Noting that it was understandable that he should be interested in 13,000,000 Negroes in America, 150,000,000 in Africa, and 40,000,000 in the Caribbean, he said that he had also come to feel that India constituted one of the most decisive cases for racial freedom. If colored people there and elsewhere gained their freedom, he promised, "it will surely have a strong bearing of the case of the American Negro."[95]

While he was not optimistic with respect to the coming of genuine freedom in Africa, Robeson did believe that Africans would in time win liberation: "I have great faith in Africa. I believe that the people of the African continent will seek out their own destiny. . . . Differences between sections of the continent would indicate the eventual formation of a federation of independent black states rather than a single great Negro republic or empire."[96]

Robeson, who abhorred "rabid nationalism," rejected the suggestion that the emergence of black nationalism would constitute a menace to white people as a whole; he thought African nationalism would threaten only those who wanted to see the continuation of white overlordship. Nevertheless, at times Robeson underplayed the role of racism in imperialist policy in Asia and Africa, remarking in an interview in 1936 that it was "not a race problem at all," that race did not enter. But later, in the same discussion, he disclosed that it was not a matter of race not entering—rather, it was a question of emphasis, of the relative importance of race and economics. Economic considerations were, he believed, more important in understanding imperialism than race.[97]

Distressed by the Italian invasion of Ethiopia, Robeson opposed what he called the "civilizing influence of European nations that go out to do their civilizing with bombs and machine guns."[98] There was, in his opinion, no reason to believe that Italy could work out Ethiopia's problems. Nevertheless, he urged that close attention be given to the roles being played by the victims of colonial oppression. "Look at the war in Africa now. What is this Italian army fighting Ethiopia? Three fourths of them are black fellows. And what goes on in Manchuria—yellow

[94]*Ibid.*, July 17, 1935.
[95]*New York Post*, December 10, 1943.
[96]*Ibid.*, June 11, 1936.
[97]*Ibid.*, January 11, 1936.
[98]*New York World-Telegram*, January 11, 1936.

Japanese making war on yellow Chinese. The race question isn't of primary importance."[99] Robeson was correct in giving primacy to economic considerations in accounting for imperialism, yet his own reflections on Western culture lead one to conclude that racism has been a most vital factor in European aggression against the peoples of Asia and Africa.

VII

Robeson had said earlier in the decade that he would eventually go to Africa and return with music as revolutionary as African art.[100] In 1936 his wife and son applied for visas to visit South Africa. Robeson was unable to accompany them at the time, though there is reason to believe that he might have encountered some difficulties in securing a visa: His wife and little son discovered that he was very well known to South African blacks.[101] Robeson himself had wanted to visit South Africa, whose people and culture were of particular interest to him, before moving on to Uganda. His desire to visit Uganda grew out of friendships with Ugandans and a special interest in the music of that land.

It was not until 1938, however, that Robeson finally went to Africa. In Egypt to make a film, he took the occasion to test his views on the dances and songs of the continent. For most of what he knew about Africa and the various cultures of the continent had been learned from his many contacts with Africans in Europe and from his elaborate book, music, and language libraries.[102] Though he did not visit sub-Saharan Africa, he was familiar with the music of East, South, and West Africa. Moreover, he had learned enough African languages to enable him to communicate with large numbers of Africans from the major areas of the continent. That expertise was put to good use artistically, for he became the first major artist outside Africa to sing in various African languages, presenting African songs in concerts in America, Europe, and in the West Indies.

Meanwhile, as his popularity and income increased, as the most dazzling praise was lavished upon him as artist and man, Robeson seemed to become increasingly radical, proclaiming solidarity with the peasants and workers and ethnic minorities of the world. In fact, from

[99]*New York Herald-Tribune*, January 12, 1936.

[100]T. Thompson, "A Great Personality: Paul Robeson Speaks About Art and the Negro," *Millgate*, Vol. XXVI, Part 1, No. 303 (December 1930), p. 157.

[101]Eslanda Robeson, *African Journey*, p. 58.

[102]Robeson was reported to have owned one of the finest libraries on Africa of anyone in England. His son noted that when the Robeson family returned to America in 1939, Robeson, owing to the size of the library, had to leave most of his books behind. Interview with Paul Robeson, Jr., July 13, 1971. Some of the books from the Robeson collection are now located in the rare books collection at Northwestern University. Northwestern purchased seven books on African languages which bear Robeson's signature. Included are Robeson texts in Egyptian and Arabic.

1937 to the outbreak of World War II, he practically gave up his professional career, at least in conventional terms. He came to resent performing before audiences in which the well-to-do occupied the better seats and instructed his agent to see to it that tickets for his engagements were scaled down so that working-class people could have access to good seats. Further, he announced that he would never again act in a Hollywood movie, so often had that industry presented blacks in a negative light. But it was his decision to carry his art to the people that was perhaps unique in the modern history of the performing arts in the West. This revolutionary position presaged the free concerts he later gave in the United States and in the West Indies. If he had not seen an earlier dream of a Negro theatre come to fruition, he had managed to bring his roles of performing artist and philosopher of culture to an unusual level of consistency.[103]

The growing strength of reaction in Europe doubtless caused Robeson to devote less time to academic studies. As Hitler and Mussolini made their malevolence increasingly vivid, the singer-actor-scholar came more and more to identify with the movement against Nazism and fascism. As he did, he said he found new faith in life, a faith which generated new enthusiasm and energy, causing him virtually to "live around the piano." At the time his commitment to the well-being of oppressed non-African peoples the world over was greatest, he revealed that his dedication to the liberation of people of African ancestry had, if anything, deepened. For him, there was no contradiction in such a development; it was the most logical of processes. He explained: "Everything I have done is an extension of my feelings about my own people. I feel some way I've become tied up with this whole problem of human freedom. I have no end to my artistic horizon."[104]

A year before leaving England, in 1938, an interviewer asked him why he was so interested in his people. Robeson rejoined, "My father was a slave. Can I forget that? Hell, I can't forget that! My own father a slave!" Penetrating to foundations, the highly successful artist added: "There can be no greater tragedy than to forget one's origin and finish despised and hated by the people among whom one grew up. To have that happen would be the sort of thing to make me rise from my grave." Commenting further, he noted: "Sure, I got a better deal, but not the people I came from. For them things got worse, in fact. They are prevented from joining trade unions, and are shot down, as in Jamaica and Trinidad. There is no extension of democracy for them; things, on the contrary, are being tightened up. My personal success as an artist has not helped them."[105]

[103]Robeson's belief in the value of Negro theatre helps explain his support of the Harlem Suitcase theatre, enabling that group to hire a full-time artistic director, the accomplished Thomas Richardson. See Lofton Mitchell, "Time to Break the Silence Surrounding Paul Robeson?" *New York Times*, August 6, 1972.

[104]*New York Times*, April 19, 1942.

[105]Harvey, "Paul Robeson," p. 710.

As his more than ten years' stay abroad approached an end, Robeson said that contact with the cultures of the world—with oppressed peasants and workers—had made his loneliness vanish, had helped prepare him to "come home and sing my songs so that we will see that our democracy does not vanish." Having observed a Europe increasingly under the menace of Hitler's Germany, he remarked that he felt closer to America than ever, that he felt peace rather than, as before, lonesome isolation. "I return," he said, "without fearing prejudice that once bothered me," for "people practice cruel bigotry in their ignorance, not maliciously."[106]

By 1939 the goal that Robeson had earlier set for himself, that of making black people aware of their greatness, had not been attained. But no one man, however gifted, dedicated, and charismatic could possibly have accomplished such a difficult objective, for only a mass movement, one based in significant measure on the kinds of revolutionary values set forth by Robeson could have had a chance of bringing a sense of greatness to people subjected to brutal oppression for nearly four centuries. It should be noted, however, that African American newspapers gave extraordinary coverage to Robeson's activities abroad, usually in the form of reprints from foreign newspapers. And when interviewed, Robeson had seldom missed an opportunity to communicate with his people, almost invariably addressing himself to African concerns, speaking through European media to African people around the world. Considering the volume of news stories on Robeson, and given his example of striking advances in numerous areas of human endeavor, it seems reasonable to conclude that not a few people of African ancestry began as a result to rethink negative attitudes toward themselves and their people everywhere. While it is unlikely that Robeson succeeded in giving great numbers of his people a new perception of themselves and their potential, one must nevertheless conclude that for a man working largely on his own accomplishments toward that end must have been impressive. Perhaps only Garvey affected the sense of African consciousness of more black people in Africa, the West Indies, and the United States over the first forty years of the century than Robeson. Such was the regard in which the great singer and actor was held by Africans in England that the West African Student Union inducted him into their organization—a special honor for a New World black. In sum, his influence on African peoples on the continent and in diaspora was unusual both materially and spiritually.[107]

[106]Julian Dorn, "Paul Robeson Told Me," *Tac*, Vol. 1, No. 12 (July–August 1939), p. 23.

[107]Robeson gave a number of benefit performances for African liberation movements during the 1930s and 1940s. In addition, he provided financial aid for West Indian causes: one of his first concerts on returning to London after his passport was returned in the late fifties was for the benefit of West Indian students. The extent to which he was esteemed by significant numbers of Africans can be determined in part from an incident attending the filming of a movie in which he was cast. As he prepared to make *Song of Freedom*, a film unit connected with the project went to Africa to shoot background material. "According

Robeson's most lasting contribution, however, may turn out to be the one we have, ironically, known so little about: After years of study and reflection, he succeeded in bringing together most of the salient strands of black nationalism while extending meanings in a variety of ways. It is likely that, of those responsible for the architecture of that ideology, remarkably few, perhaps only Dr. Du Bois, had much impact on the shaping of Robeson's thought. But what is decisive here is not the extent to which he was influenced by other black nationalists but the way in which the great artist carried to new heights of clarity and power a number of important points of ideology shared by nineteenth-century nationalists. Beyond that, Robeson had added original nationalist formulations in the arts, politics, and in that elusive region where one finds the springs of the African American ethos. And he had, through his scholarship, art and uses of experience, attempted with some success to become less Western, to move closer to being African — all the while developing a new, more spacious conception of what being African could mean.[108]

With the lineaments and substance of Robeson's thought now accessible to us, it is evident that he made possible such intense reciprocity between cultural and political nationalisms that the two were rendered virtually indistinguishable. In fact, he perceived art as such a direct in-

to a reporter in the *Sunday Graphic*, September 20, 1936, 'the entire population [of Sierra Leone] crowded to the landing stage, hoping to see Robeson.' His picture, framed or unframed, according to the financial standing of its possessor, was in every shack." Of all the films that Robeson made, before vowing never again to act in Hollywood movies, *Song of Freedom* pleased him most — and pleased African leaders most. Seton, *Paul Robeson*, pp. 106–7. It is likely that the Robeson papers, now being used exclusively by his official biographer, will throw more light on Robeson's considerable financial contributions, through benefit concerts, to black liberation causes.

[108]Robeson's affirmation of self-reliance and pan-African solidarity, of the shaping force of oppression and the necessity to maintain the group — these and more characteristics of his thought linked him to Walker, Delany, Garnet, Crummell, Bishop Henry McNeil Turner, and other 19th-century African American nationalists. And like those men, Robeson did not eschew support from white allies. Original with Robeson, however, were his views on the uses to which his people should put African languages — he held that languages were "unnecessary barriers" to unity — in attempting to realize their potential for cultural and political growth. And there is his striking formulation that African peoples should, wherever found, not only stand in one camp, fighting for freedom but should seek out and build upon, as he was doing, their common denominators with an eye to developing a more expansive and unified black culture. In addition to his interest in the sensibilities which inform African American and African cultural forms, there is the sophistication with which he related African to world cultural patterns, seeking the grand synthesis that would, ultimately, preclude conflict among people without vitiating that which is creative and positive in various cultures. Robeson's realization that no such new order could be achieved within a capitalist industrial system was fundamental to his cultural philosophy. *With its deep roots in the African heritage and its receptivity to the cultures of the East, Robeson's philosophy was on balance, for all his admiration for European socialism, vastly more non-Western than the theoretical formulations of any black thinker of note to emerge in the New World in this and in the previous centuries.*

strument of revolutionary change that any dichotomy between the cultural and political would be meaningless and false before his system of thought. Not dissimilarly, Robeson's vaulting conception of Negritude, his suffusing of the cultural with the political and the political with the cultural eliminated any future need to label his form of Negritude merely, or even primarily, cultural. Thus, the whole of his ideology was political and cultural: Black nationalism had reached its highest stage of ideological development.

While a long line of West Indians and African Americans had stressed the imperative need for "more advanced" New World blacks to play the vanguard role in the liberation of African peoples, Robeson considered sensitive and intelligent Africans best suited to determine the imperatives of their freedom, the terms of their new lives.[109] The least culture-bound of New World blacks, Robeson, as few men, knew much about many levels of the African experience: He had called attention to the supreme artistry of West African sculpture, which inspired leading European artists; recognized the intricacies of African musical rhythms, which were more complex than anything attained by Western composers; stressed the flexibility and sophistication of a number of African languages, which could convey subtleties of thought beyond what was suspected by those unacquainted with African linguistics; and emphasized the rich cultural heritage of Africa, which was related to the great civilizations of the East.[110]

Robeson's commitment to the oppressed of the world, especially to those of African ancestry; and his growing radicalism in the face of new and fiercer barbarisms from Europe—these very traits, backed by the singular compass of his gifts, were destined to make him a marked man in America. The acute provincialism of most Negro intellectuals and civil rights leaders in the United States made them, when Robeson later incurred the hatred of American rulers, ill-suited to appreciate the values he was defending. Nevertheless, there is little doubt that Robeson meant it when he said he was returning to America without bitterness. The very qualities which led him to take that position, however, would soon cause him to lash out against continued American oppression of people of African ancestry. In time, forces of repression would plunge him into an isolation in the land of his birth far more painful and protracted

[109]Only Robeson, of that long line, appears to have avoided the pitfall that New World blacks should take the lead in "uplifting," in "redeeming" Africa. Though he thought transplanted Africans in the Americas should be prepared, if necessary, to die for Africa, he generally held that men born on the continent were themselves best suited to decide what was good for Africa: "A continent of almost 200,000,000 people [a substantially higher figure than this previously quoted 150,000,000], with virility and intelligence, will eventually work out its own destiny." *New York Post*, January 11, 1936. Robeson's intimate knowledge of various aspects of African cultures, in combination with his belief that Western civilization was dying, no doubt contributed to his position that Africans must do their own leading.

[110]Robeson, "Culture of the Negro," p. 916; Robeson, "Primitives," pp. 191–92.

than anything he had encountered abroad. Still, he experienced, on his return in 1939, years of continued acclaim before various ruling elites attempted to silence him completely.

VIII

Following his return to the United States, Robeson promptly began to devote a great deal of time to directing the Council on African Affairs, which W. E. B. Du Bois, on an invitation from him, joined some years later. Their presence on the council brought together men who not only had done impressive scholarly work on Africa but men whose activities on behalf of Africa on the political plane had for some time been unrivaled by others in the United States. Two of the century's greatest champions of African humanity and liberation were finally working under the same organizational umbrella.[111]

During the early stages of the war, Robeson was concerned, not surprisingly, about the disposition of colonies following the war and preoccupied with the overall reorganization of the war-ravaged world. In a speech at Hamilton College in 1940, on the occasion of receiving an honorary doctorate, he expressed his continuing interest in the major cultures of the world, stating that when the war was over and realignments of power had been effected, "not only Western culture, but also that of Hindus, Africans and Chinese would each contribute to the realization of a true and lasting human culture."[112] His approach was cultural in the broadest sense, rooted in an old concern, the need for an international culture based on sets of perceptions and sensibilities which

[111]Throughout the decade of the 1930s, Du Bois had asked Robeson to contribute articles to *The Crisis* but Robeson had not done so. Actually, Robeson had been instrumental in founding the council in 1937. The council, which existed for nearly two decades, was the most important organization in America working for African liberation during the 1940s and 1950s. W. Alpheus Hunton, who for years served as secretary to the council, did not exaggerate in contending that "The Council on African Affairs for many years stood alone as the one organization in the United States devoting full-time attention to the problems of the peoples of Africa." In addition to being a clearing house for information on Africa, the council, under Robeson's direction, rendered a multiplicity of services to Africa. Dr. Z. K. Mathews, a leader of the African National Congress in South Africa, has written that when a severe drought struck the Eastern Cape Province of the Union of South Africa, "hundreds of Africans . . . had cause to be thankful that such a body as the Council on African Affairs was in existence. . . . The Council made available financial aid and food supplies of various kinds. . . . Many African children, women and older people in the area concerned owed their lives to the assistance given by the Council." The council, through its African Aid Committee, which Dr. Du Bois headed, also aided "the families of 26 miners shot down during a strike in the coal pits of Enugu, Nigeria." Alpheus Hunton, "A Note on the Council on African Affairs," Appendix E in the original, Robeson, *Here I Stand*, pp. 126–28.

[112]Quoted in Seton, *Paul Robeson*, p. 131.

would increase the chances of man affirming life and enlarging his capacities for utilizing the most vital and creative elements of human character.

The president of Hamilton College, in presenting the doctorate to Robeson, remarked:

In honoring you today, we do not, however, press our enthusiasm of your histrionic and musical achievements alone, we honor you chiefly as a man— a man of tremendous stature, energy, and physical dexterity; a man of brilliant mind, a man whose sensitive spirit makes possible your penetrating interpretations; a man who, above all else, travels across the world as an example of the humanity and the greatness of our democratic heritage.[113]

Americans by the thousands, black and white alike, were responding to Robeson with great enthusiasm in the years immediately following his return. His performances brought forth such throngs that room had to be made on concert stages for some of the people in his audiences. In June 1941, he sang before 23,000 people in Newark, providing encore after encore. Three weeks later 14,000 people, on a chilly evening, turned out to hear him sing in New York, and two weeks later, singing with the Philadelphia Orchestra, Robeson broke the season's attendance record.[114]

In July of 1943, Robeson, backed by the New York Philharmonic, sang before 20,000 people. Howard Taubman said

. . . but by the end of the evening it was unmistakable that Mr. Robeson was the principal attraction. He was not, however, the whole show. The 20,000 in the field and concrete seats shared that distinction with the baritone. For when Mr. Robeson completed the listed group of songs at the end of the concert, the audience virtually took over. Roars arose from every section of the amphitheatre. Men and women shouted their favorite encores. Mr. Robeson smiled and said, 'I'll get to 'em I hope.' He got to a good many. When the reviewer left, Mr. Robeson had been singing encores for half an hour. . . . Some in the far reaches of the stadium took to chanting their requests in unison. Mr. Robeson kept assuring the crowd, 'O.K., I heard it.' The encores were virtually a concert in themselves.[115]

But acclaim was not new to him, and success had not caused him in the past to forget his convictions. New American successes did not alter that pattern. Near the close of the war, he returned to the theme of the necessity of the great white powers being prepared to accept fully the humanity of Africans and other colonial peoples. Remarking that Americans in the past had not known much about Africa "beyond the caricatures occasionally represented in American movies," he added that large

[113]New York Times, January 22, 1940.
[114]Ibid., April 30, 1941; June 24, 1941; July 10, 1941.
[115]Ibid., July 2, 1943.

numbers of Americans had begun to realize that the welfare of Africans and other dependent people was linked to their own, a truth brought home to them by the significant role played by colonies and colonial peoples in the prosecution of the war.[116]

World War II had indeed marked a great watershed in American attitudes toward Africa. Already certain Americans looked to Africa, Robeson warned, as "the last great continental frontier of the world for the white man to cross . . . the jackpot of World War II."[117] Other Americans were contending that while there had been "some mistakes and shortcomings in colonial rule," Africans were too backward to be granted immediate freedom—an argument Robeson had heard in England from more sophisticated, if limited, British intellectuals.

Robeson believed that those Americans who opposed Afro-Asian liberation did not understand the nature of the times, did not realize that revolutionary changes were occurring in the history of mankind. This sentiment was brilliantly advanced in an article in the *American Scholar*. He wrote that "we stand at the end of one period in human history and before the entrance of a new." It was his opinion that "all our tenets and tried beliefs were [being] challenged. . . ."[118] The liberal intellectual members of the professions, scientists, artists, and scholars had a special responsibility, considering the nature of the challenge.

> They had an unparalleled opportunity to lead and to serve. But to fulfill our deep obligations to society we must have faith in the whole people, the emergence into full bloom of the last estate, the vision of no high and no low, no superior and no inferior—but equals, assigned to different tasks in the building of a new and richer human society.[119]

Not one to respect the chasm between the ideal and the reality of freedom, Robeson's commitment to bridge, to unify, to meld those realms toward oneness was made long before his return to the United States. His efforts on behalf of the oppressed, especially Africans, within five years of World War II, would cost him dearly.[120] To be sure, Robe-

[116]Paul Robeson, "Opening Statement," *For a New Africa: Proceedings of the Conference on Africa, New York, April 14, 1944* (New York, 1944), p. 10.

[117]*Ibid.*

[118]Paul Robeson, "Some Reflections on Othello and the Nature of Our Times," *American Scholar*, Vol. 14, No. 4 (Autumn 1945), p. 391.

[119]*Ibid.*, p. 392.

[120]Whatever other Americans came to believe, the government never made a secret of the sources of its fear and hatred of Robeson. In a brief intended to support the denial of his right to travel abroad, the government disclosed that Robeson's fight for the freedom of black people was a fundamental reason for its attempt to silence him:

> . . . Furthermore, even if the complaint had alleged, which it does not, that the passport was cancelled solely because of the applicant's recognized status as spokesman for large sections of Negro Americans, we submit that this would not amount to an abuse of discretion in view of appellant's frank admission that *he has been for*

son's expansive perspective on the world and his willingness to support his views with everything that he possessed meant that conflict between him and white America had been utterly predictable: more especially because the rulers of America realized, probably before 1945 and certainly thereafter, that if ever there was a New World black prepared to risk all in defense of Africa it was Robeson.

As cold-war fever and hysteria enveloped America, Robeson's philosophy and activities inspired unusual fear and hatred in government circles. The multi-faceted genius had compared the postwar era with that breakdown of medievalism which presaged the Renaissance. He foresaw a similar "shattering of a universe" because entrapped, pent-up forces of color, for centuries subjected to European suzerainty, were beginning to break loose, threatening to make the European vision of itself sadly unrealizable, the Eurocenter focus of world power soon irretrievable. The day was not too distant when the most incandescent dreams of nationalists from the early nineteenth-century to Robeson himself would achieve, however uncertain the workings of the human will, the tangibility of freedom. It was, after all, that goal to which Robeson had devoted his life.

years extremely active politically in behalf of independence of the colonial people of Africa (emphasis mine).

Robeson, *Here I Stand*, p. 71.

As the government broadened its attack to include Du Bois as well as Robeson, many black people, lacking leadership from the NAACP, were willing to answer a thrusting question from Du Bois — applicable to himself and to Robeson — in the affirmative.

It was a dilemma for the mass of Negroes; either they joined the current beliefs and actions of most whites or they could not make a living or hope for preferment. Preferment was possible. The color line was beginning to break. Negroes were getting recognition as never before. Was not the sacrifice of one man, small payment for this?

For accounts of the extraordinary lengths to which American society went to isolate, to render non-persons, Du Bois and Robeson, see Du Bois, *Autobiography*, Chapters XXI–XXIII; and Robeson, *Here I Stand*, Chapter III.

Paul Robeson's
Here I Stand

The complex mix of forces that produced Paul Robeson's character and outlook will become apparent long before the reader has completed *Here I Stand*. Indeed, the title of the book's Prologue—"A Home in That Rock"—is from one of the great Negro spirituals and contains a world of meaning in itself:

> I got a home in that rock, don't you see (2)
> Between the earth an' sky
> Thought I heard my Savior cry
> You got a home in that rock, don't you see
>
> Poor man Lazarus, poor as I, don't you see (2)
> Poor man Lazarus, poor as I
> When he died he found a home on high
> He had a home in that rock, don't you see
>
> Rich man Dives, lived so well, don't you see (2)
> Rich man Dives, lived so well
> When he died he found a home in Hell
> He had no home in that rock, don't you see
>
> God gave Noah the rainbow sign, don't you see (2)
> God gave Noah the rainbow sign
> No more water but fire next time
> Better get a home in that rock

A discussion of Robeson's early life, "A Home in That Rock" goes far toward explaining why Robeson was later able to affirm, in remarkable measure, the revolutionary ethic at the heart of the song.

Robeson's roots were established in a religion that reveals African influences through musical creativity that allows virtually no break between the sacred and the secular; indeed, the sacred music could be said to contain seeds of the blues and jazz that bloomed in the first decade of Robeson's life. The role of the Negro home in that process deserves attention, especially when that home was, as was Paul Robeson's, headed by a minister: "Here in this little hemmed-in world where home must be theatre and concert hall and social center, there was a warmth of song. Songs of love and longing, songs of trials and triumphs, deep-flowing rivers and rollicking brooks, hymnsong and ragtime ballad,

gospels and blues, and the healing comfort to be found in the illimitable sorrow of the spirituals."[1] The poor people who sang those songs and entered the makeshift theater were mainly the children of southern migrants, some of whom, like Robeson's father, were former slaves. Among Robeson's friends and playmates at such gatherings was Emma Epps, who lived across from him on Green Street in Princeton. At ninety, she recalled: "Though we had trouble convincing him of it, Paul always had a voice. He could always sing."

Though he spent eight years in segregated elementary schools, in high school Robeson had positive experiences with whites, except for clashes with a racist principal who hated him for his qualities as an outstanding scholar and athlete. As a result, he regarded whites, on balance, as individuals, but he realized that most whites did not welcome competition from blacks: "From an early age I had come to accept and follow a certain protective tactic of Negro life in America, and did not fully break with the pattern until many years later. . . . Always show that you are *grateful*. (Even if what you have gained has been wrested from unwilling powers, be sure to be grateful lest 'they' take it all away.) Above all, *do nothing to give them cause to fear you.* . . ."[2]

Throughout his youth, Robeson's father insisted on "personal integrity," which included the idea of "maximum human fulfillment." These values were related to an ethical system that favored what Robeson would come to see as socialist rather than capitalist values. Success "was not to be measured in terms of money and personal advancement, but rather the goal must be the richest and highest development of one's own potential."[3]

The selflessness inherent in Pastor Robeson's outlook—and the lack of greed that it promoted—was apparent in the generosity of one black to another that so impressed Robeson in his youth. Indeed, a form of socialism was acted out in that Princeton black community, and Robeson's identification with the working class was no mere abstraction. His family—Robeson himself—was an extension of that class. "I had the closest of ties with these workers," he later wrote, "since many of my father's relatives—Uncle Ben and Uncle John and Cousin Carraway and Cousin Chance and others—had come to this town and found employment at such jobs . . . domestics in the homes of the wealthy, serving as cooks, waiters and caretakers at the university, coachmen for the town and laborers at the nearby farms and brickyards."[4] Not only were many of his relatives ex-slaves, but by the time Robeson was born ex-slaves and their children constituted almost the entire black population of America, a population not yet differentiated along class lines.

[1]*Here I Stand*, p. 15.
[2]*Ibid.*, p. 20.
[3]*Ibid.*, p. 18.
[4]*Ibid.*, p. 20.

Not surprisingly, Robeson's commencement address at Rutgers, which is not treated in *Here I Stand*, gave serious consideration to the liberation of the masses of blacks and argued that his loyalty to them was sacred. At a family reunion in Philadelphia in 1918, he spoke on "Loyalty to Convictions": "That I chose this topic was not accidental, for that was the text of my father's life—loyalty to one's convictions. Unbending. Despite anything. From my youngest days I was imbued with that concept. This bedrock idea of integrity was taught by Reverend Robeson to his children not so much by preachment . . . but, rather, by the daily example of his life and work."[5]

The brutal experiences he underwent at Rutgers put his spiritual and physical resources to an extreme test. As a freshman at the age of seventeen, he went out for the football team and his teammates tried to kill him. Providing the symbolism for his ultimate relationship to America, they ganged up on him. They broke his nose, dislocated his shoulder, and cleated his hand, tearing away all the fingernails. He considered putting football behind him but remembered that his father had impressed upon him "that when out on the football field or in a classroom or anywhere else . . . I had to show that I could take whatever they handed out. . . . This was part of our struggle."

Robeson continued to develop many of the talents that later brought him such acclaim years before he completed his undergraduate work at Rutgers, even though at no point in this process were things made easy for him. His successes in the classroom at Rutgers, and later at Columbia Law School, resulted from rigorous application of his intellect to the subjects at hand despite extraordinary demands on him from extracurricular activities ranging from athletics to acting and singing, at which he performed brilliantly. One of only two black students on the Rutgers campus during his entire four years, he was valedictorian of his class, a debating champion, and a tremendous football player, twice selected for the All-American team. Undoubtedly, his father's insistence on maximum human fulfillment was a crucial factor in the flowering of Robeson's genius. Yet the chemistry of mind and body that enabled him to achieve so much in so many fields remains one of nature's mysteries.

"A Home in That Rock" is followed by developments that occurred mainly in the post–World War II period. But flashbacks in several of the chapters that follow, especially to Robeson's London years (1927–39), provide the long view essential for understanding how his thought evolved and matured over time. It is the Prologue, however, that remains the bridge across the decades separating Robeson's formative years in New Jersey and his return to America after years abroad during a period of momentous change in the world. Robeson's narrative strategy of explaining his actions in the fifties by relying on the events of his formative years is strikingly effective.

In discussing his London years and the broadening of his intellectual

[5]*Ibid.*, pp. 8–9.

and cultural horizons, Robeson frankly addresses the question of social-ism and its advances in the Soviet Union. He found the Soviet Union attractive largely because he thought Africans could learn much from an experiment that, in less than twenty years, had brought many formerly "backward" people of color into the scientific/industrial world of the twentieth century. His deep interest in Africa, together with his belief in scientific socialism, was, to be sure, a source of later concern to the U.S. government, and his argument that "the power of the Soviet Union . . . would become an important factor in aiding the colonial liberation movement" seems to us now to have been prophetic.

Robeson's emphasis was on the need for people of African ancestry to take the lead in their own liberation. His essays and interviews in the thirties indicate that he no longer expected more privileged blacks to play the role he once envisioned for them. Appalled by the extent to which most were dependent on their European masters for cues on how to think and behave, he located this problem in an inferiority complex born of oppression and urged that black students, including those from the United States, be trained in less hostile environments, such as Peking or Palestine; otherwise, too few would rise above being "cardboard Europeans." His one great hope, well before his London years, was that the black masses would move forward to determine their own destiny, as Asian people were clearly already doing by the thirties.

But Robeson's concerns for people of color did not prevent him from seeing that the destinies of the oppressed are interlocked, which he dis-covered on the cultural plane in his years abroad. Among working peo-ple, he thought cultural connections were evident, particularly through folk music, and these connections had political consequences of which he became increasingly conscious. Just as he saw the need for blacks to have allies in America, he saw possibilities for alliances of the oppressed across geographical and racial boundaries.

Robeson, of course enjoyed remarkable successes on the concert stages of the British Isles and Europe and won new acclaim as an actor in the theater and in films, especially in *Showboat* and in *Othello*. It was in these years that his voice took on all the power of its earlier promise. And it was then that it became, above all others, associated with the trials and triumphs of the human spirit, and therefore with the great social issues of the day: the Spanish Civil War, anti-Nazism, and the liberation of Afro-Asia.

While Robeson tells us less about his personal life in the forties than he does of other periods, his discussion of the changing context of world affairs as a consequence of World War II is superb and would have many implications for race relations in the United States then and later. Robeson felt that African American resistance to oppression would be more effective in the new global context, and he became the supreme emblem of that resistance as he organized not only for civil rights in the United States but also for the liberation of Africans everywhere. But opposition was powerful, and the government, with the cooperation of

various power elites, began to mount a campaign to silence and destroy him.

Shortly after his return to the United States from a concert tour in the West Indies in 1948, Robeson remarked that if he never heard another kind word, the reception he had received from his people in Jamaica and Trinidad would be sufficient to last him for the rest of his life. This sentiment, and his feeling that he had drawn his first breath of fresh air in years, was indicative of the climate for race relations and politics in the United States. Perhaps he also sensed the end of an era in his own life with the intensification of developments that were becoming increasingly ominous for the nation and the world.

In the years between his return from England in 1939 and his visit to the islands, the acclaim that he received went beyond anything he had previously known in the United States. Theodore Dreiser called him an "artistic and social genius," Walter Damrosch said that Robeson was "gifted by the gods as musician and actor," and Mark van Doren, the Shakespeare pundit at Columbia University, said, "I honor him without limit." Rockwell Kent, the artist, wrote in 1944 that he was among "countless thousands who honor [Robeson] in their hearts as few men who have ever lived have been honored."[6] By 1944, Robeson had reached the heights of his acting career with the new and lasting resonance he had given the role of Othello. In some ways, his characterization of the Moor was drawn as much from his own commanding authority in a white world as from the play itself. Informed by his consummate acting skills, Robeson's Othello was more authentic than that of any other actor of his time.

But a few years later, he set aside his career to march "up and down the nation" to protest the oppression of blacks. His fame and wealth had not softened his defense of the oppressed. Indeed, he found his people had come through their trials "unbroken . . . a race of such magnificence of spirit that there exists no power on earth that could crush them."[7] No one of the forties was more closely identified with uncompromising struggle and none had as much to lose as he. His example was unique among artists of his stature and was cause for growing concern among leaders of the white establishment at least as early as 1947.

After more than ten years abroad, he had returned with an uncanny ability to enter into and possess the songs of many peoples, his lyricism seeming to flow from some inner realm common to humanity. When his soul was at rest and set to music, his voice had about it a quiet radiance—like gold in sunlight. Such was its peculiar magic that, like daybreak, it could reach across vast distances well before revealing its full power. One doubts that power has ever been expressed more convincingly in song.

⁶From signed documents in the Paul Robeson Archives that are quoted by Lloyd Brown in "Paul Robeson Rediscovered," *AIMS*, Occasional Paper No. 19 (1976), pp. 6–7.
⁷Paul Robeson, *Selected Writings* (Paul Robeson Archives, 1976), p. 65.

As artist and man his reputation preceded him. On the day of his arrival in Jamaica in 1948, the poet Louise Bennett wrote:

> Him come at las, him deh yah chile!
> Him eena newspapa!
> "Paul Robeson arrives today!"
> Come look pon him picksha!
>
> Lawd wat a sight fe cure sore y'eye!
> Lawd wat a tale fe tell!
> Me slap eena Trelawny bush,
> But me dah-feel de spell!
>
> Him gwine ta pon Ward Theatre stage
> Real-real live, wat a ting!
> Him gwine fe bow, him gwine fe smile,
> And den him gwine fe sing!
>
> Him gwine fe sing! Miss Matty,
> Me won' deh-deh, but me know;
> Is like a garden full o' song
> Eena him heart a-grow!
>
> An doah de voice look like it dah-
> Come out o' him mout part,
> It soun to we like him dah-coax
> De song out o' him heart.
>
> An wen him done, de clappin an
> De cheerin' from de crowd!
> An every nayga head swell, every
> Nayga heart feel proud!
>
> Proud o' de man, de singer, an
> Lawd, a tenkful to yuh,
> Dat wen we feel proud o' him race
> Dat race is fe we to![8]

But in the United States, Robeson's continued friendship with the Soviet Union and his unyielding defense of the rights of his people were

[8]Louise Bennett, "Him Deh Yah," in *Jamaica Labrish* (Jamaica, 1966), p. 38. Dawn Lindo has translated the poem as follows:

> He has come at last, he is here, child!
> He is in the newspaper!
> "Paul Robeson arrives today!"
> Come and look at his picture!
>
> Lord, what a sight to cure sore eyes!
> Lord, what a tale to tell!
> I am all the way in the heart of Trelawny,
> But still I feel the spell!
>
> He is going to stand on Ward Theatre stage.
> In living flesh, what a thing!
> He will bow, he will smile,
> And then he is going to sing!

increasingly seized upon and used in an effort to curb his influence. In 1949, hatred of him exploded in one of the ugliest riots of the century in Peekskill, New York, not long after he had declared, on behalf of the youth of Afro-Asia, that colored people did not want war with the Soviet Union. "It is unthinkable," he said, "that American Negroes could go to war on behalf of those who have oppressed them for generations against the Soviet Union which in one generation has raised our people to full human dignity" (*New York Times*, 21 April 1949). His speech, made at the Paris Peace Conference, was a turning point in Robeson's life; its reception in the United States constituted a watershed in the history of the practice of liberty and free speech in this country.

The Establishment reaction to Robeson was largely nonracial in one important respect: His admiration for the Soviet Union made him, almost by reflex action, an object of hatred. But his fame, along with his African ancestry, gave a particularly ugly edge to that hatred. His continuing commitment to the independence movements of colonial Africa and the uses to which scientific socialism might be put in that process, against the backdrop of the Paris speech, caused increasing concern in high places. The attack on Robeson became brutal in 1949 and remained so for nearly ten years. As Lloyd Brown, Robeson's close friend and a collaborator in the writing of *Here I Stand*, states in his preface: "And then suddenly, the spotlight was switched off. . . . The blackout was the result of a boycott of Robeson by the Establishment that was meant both to silence him and to deny him any opportunity of making a living. All doors to stage, screen, concert hall, radio, TV, and recording studio were locked against him."[9]

Robeson's salary plummeted from over $100,000 a year to less than $6,000 a year and remained there for nearly a decade. His passport was

He is going to sing! Miss Matty,
I alone was there, but I know,
His voice is like a garden full of song
Growing in his heart!

And even though the voice
Seems to come out of his mouth,
It sounds to us as though he is coaxing
The song out of his heart.

And when he had finished, the clapping and
The cheering from the crowd!
And every black man's head swelled, every
Black man's heart felt proud!

Proud of the man, the singer, and
Lord, I am thankful to you,
That when we feel proud of his race,
That race is our own too!

[9]*Here I Stand*, p. ix.

revoked, and his access to his international audience was cut off. As efforts to oppose him intensified, he fearlessly met the challenge and, under increasingly difficult conditions, worked with renewed zeal for the liberation of his people. More frequently than ever, he moved through the black communities in this country and, characteristically, took up the cause of oppressed blacks in the South (especially in Mississippi) and in Africa (especially in South Africa). He carried his message into the homes of blacks in the ghetto, discussing the issues of the day and eating at their tables. It was the kind of communion he had known from the start.

His essential orientation, brilliantly elaborated in his written work of the fifties and earlier, set him at variance with leaders of the NAACP and the Urban League. Apart from W. E. B. Du Bois, whose interests were close to his, he had little in common with national black leaders other than the desire that color prejudice be ended. It is difficult, in fact, to imagine more fundamental differences between Du Bois and Robeson and more conservative black leaders. In time, as the pressures on Robeson mounted, the failure of the black bourgeoisie to support him fueled the campaign against him. That support would have guaranteed him at least a measure of neutrality from organizations representing black people. But the forces opposing Robeson struck fear into the hearts of most black intellectuals and professionals, many of whom whispered his name for years.

Much earlier in the century, Robeson had shared with Du Bois the assumption that educated blacks, as a natural obligation, would attempt to help their people. And like Du Bois, he had not foreseen the emergence of a black middle class that would at times place its interests above the interests of black people as a whole. These miscalculations, fateful for both men, were related to Du Bois's being forced out of the NAACP in 1948 and Robeson's having to struggle to be heard by the national black community.

For the first time in history, leaders of the major rights organizations felt safe in expressing no ostensible interest in Africa. The relationship of the flowering of freedom in the United States to the rights of black people everywhere was not a concern of theirs. For them, freedom meant equal rights for blacks in the United States, nothing more. Not surprisingly, consciousness of Africa, and its influence in determining values proper to people of African ancestry in America, was threatened as never before. A new ideological and spiritual low was reached.

It was in such an atmosphere that Robeson sought to communicate his message. As he moved from one community to another, his audiences tended to be made up mainly of trade-union and other working-class blacks. Many who stood before him were the spiritual descendants of the blacks of his childhood in Princeton. Before such audiences he repeatedly took up the question of African liberation, as he did in "How I Discovered Africa," in which he wrote:

A thousand years? No, Africa's time is now! We must see that and realize what it means to us, we American brothers and sisters of the Africans. We must see that we have a part to play in helping to pry loose the robber's hold on Africa. For if we take a close look at the hands that are at Africa's throat, we will understand it all: *we know those hands*.[10]

The destiny of the colonial people of Kenya captured the interest of some members of the black rank and file and some black high school and college students. No one raised the issue with greater authority than Robeson, who had known Jomo Kenyatta personally and had a special interest in East African cultures and languages. There was no more important subject for him than African liberation, and no more important audience to which to address it. Indeed, during his London years of studying African cultures and associating with Africans, Robeson came to consider himself African. When he spoke to such audiences, few present could have known the full range of his education,[11] how deeply he had probed his spiritual heritage, and to what extent, despite his father's background of slavery, his own family was working-class. When he stood before them, it was a rare moment, a genuine hero of the working class addressing that class.

Robeson's expressions of happiness on greeting his people were at times expressions of love in a voice too gorgeous in color for the subject at hand, and the spoken word as tone poem would soon end as he began a fighting speech. On such occasions—and they were many in the fifties—the strain on his voice weighed on the minds of some who heard him, as it must have weighed on his own as the years went by, as his speeches remained lengthy and passionate. By the mid-fifties, when he was a few years away from the age of sixty, there was little indication that the repression was coming to an end, and no assurance that when it did he would still have one of the great voices of our epoch.

Even as he addressed crowds obviously devoted to him, there was a definite sense, considering the forces arrayed against him, that Robeson was isolated. As the fifties unfolded and those forces were unrelenting, his audiences were at times quite sparse. At such times he must have wondered, as he does in *Here I Stand* when discussing a black family that is threatened by a mob, "Where are the other Negroes?" Where were the Negroes when Robeson was under siege? It is a central question in the history of the African American in the last half of the century.

In 1952, Robeson and Lloyd Brown began planning the work that eventually became *Here I Stand*, in which Robeson was to respond to questions about why his views were causing such concern in America. By the

[10]*Selected Writings*, p. 68.

[11]In the fifties, Robeson took up two new and difficult languages, Arabic and Hebrew, and continued to work on others he began studying in the 1930s at the London School of Oriental Languages, where he had earned a reputation among his teachers for having a "special facility" for learning languages.

summer of 1957 the book had been written, and it was published the following year. Before beginning the actual writing, Brown had spent a great deal of time observing Robeson at meetings and listening to him talk "about all the things that were of interest to him" so that his thought and language might be faithfully represented on paper.[12] After the project was finished, Robeson was satisfied that Brown had succeeded in putting him into words, as was Eslanda, Robeson's wife.

Directed primarily to ordinary blacks, the prose of *Here I Stand* is clear and at times eloquent. It is not the language of Robeson's earlier essays, which make use of a marvelous economy of expression in the service of his erudition. In fact, in essays such as "Primitives," "I Want to Be African," and "Reflections on Othello and the Nature of Our Times," the pure flame of learning lights up the page. *Here I Stand* is ideal for the audience to which it is primarily addressed, an audience that includes the black religious community, which even then was reasserting its authority in American life. And it is indispensable reading for anyone who would understand Robeson.

In establishing the context for a discussion of his politics, Robeson makes a telling remark: "At the outset, let me point out that the controversy concerning my views and actions had its origin not among the Negro people but among the white folks on top who have directed at me the thunderbolts of their displeasure and rage."[13] In a fascinating discussion of his views, he writes that through several decades—before and during the cold war—his basic perspective on world affairs had remained the same:

> More than twenty years have passed since I first visited the Soviet Union and voiced my friendly sentiments about the peoples of that land, and before that I had expressed a keen interest in the life and culture of the African peoples and a deep concern for their liberation. Indeed, before the "cold war" brought about a different atmosphere, those broader interests of mine were considered by many Negroes to be quite admirable.[14]

Even the NAACP thought his interests admirable as late as 1944 when he received its Spingarn Medal for his work on behalf of "freedom for all men." But when the larger society, following the war, changed its attitude, the NAACP changed its attitude as well. But Robeson "saw no reason" why he "should change with the weather." He tells us that he "was not raised that way."

It has now been thirty years since the publication of *Here I Stand*. The appearance of the 1988 edition comes in the year of what would have been Robeson's ninetieth birthday, twelve years after his death in 1976. The militant surge of the sixties has contributed to the creation of a very different audience for *Here I Stand* from that of the time of its

[12]Interview with Lloyd L. Brown, fall 1987.
[13]*Here I Stand*, p. 68.
[14]*Ibid.*, p. 29.

first appearance. Robeson had predicted in the book that blacks, by relying mainly on their own resources, could challenge the foundations of racism in America (a theme that courses through his writings for well over two decades prior to the sixties). Another factor in the changing audience is the less hostile atmosphere in which Soviet–American relations are now being conducted.

As one looks back on the cold-war period, it is evident that America's greatest loss was the denial of freedom to very large numbers of its citizens as fear became the prevailing state of consciousness. There is no way to calculate the losses to art resulting from Robeson's virtual confinement in America. What is certain is that, in modern history, no one of comparable artistic ability has been denied freedom for so long. That denial is today a major form of persecution to be considered in discussing violations of human rights in the United States. In the final analysis, one must consider Robeson's genius as an actor as well as a singer in determining the scope of the crime that was committed against humanity, against world art.

Robeson's conception of the guiding values of a new day is resonant with meaning and demonstrates, almost painfully, the extent to which he was in advance of his times. In "Reflections on Othello and the Nature of Our Times," he states that scientists, artists, members of the professions, and liberal intellectuals "must have faith in the whole people, the emergence into full bloom of the last estate, the vision of no high and no low, no superior and no inferior—but equals, assigned to different tasks in the building of a new and richer human society."[15]

On his seventy-fifth birthday, he sent warmest thanks to friends in the United States and throughout the world and added:

> I want you to know that I am the same Paul, dedicated as ever to the worldwide cause of humanity for freedom, peace and brotherhood. . . . Though ill health has compelled my retirement, you can be sure that in my heart I go on singing:

> > "But I keeps laughing
> > Instead of crying,
> > I must keep fighting
> > Until I'm dying,
> > And Ol' Man River,
> > He just keeps rolling along!"[16]

[15]Paul Robeson, "Reflections on Othello and the Nature of Our Times," *The American Scholar*, 14 (Autumn 1945), p. 391.

[16]*Selected Writings*, pp. 96–97.

Toward A History of
Blacks in North America

As a result of forces unleashed by the Renaissance and the Commercial Revolution—the sharp increase in trade that resulted from the imperial expansion of Spain and Portugal in the fifteenth and sixteenth centuries—millions of Africans were forcibly brought to the Americas to work as slaves. The desire of Spain and other European nations to exploit rapidly the New World's considerable resources was the governing factor in a process of slave trading which, having begun officially in 1517, lasted more than three centuries. Finding the American Indian generally unwilling or unable to provide the severe labor required, Europe turned to the more populous African continent, and to a people whose agricultural way of life was more consistent with the economic arrangements envisioned for the New World. Moreover, the slave societies of West Africa, together with internecine strife among the peoples of that region, contributed to the vulnerability of Africans before the rapacious designs of slave traders. Africans generally were not averse to selling prisoners of war into slavery—an attribute which in turn contributed much to the essential respectability of selling them to European slave traders. West African slavery was of the domestic or household variety, which permitted some slaves to rise to positions of real influence within the society of their captors. While West Africans were not opposed to turning over large numbers of Africans to slave traders, it is altogether unlikely that they had any way of conceiving the draconic nature of New World slavery.

In any event, the European thrust into Africa was part of an expansionism which resulted in the eventual domination of most of the world's peoples of color in Africa, Asia, and the Americas. Africans arriving in North America from the seventeenth to the nineteenth century were victims of this process and would be among the last to begin to emerge from the striking conditions of powerlessness that attended European overlordship.

Slavery, however, was not the immediate lot of the earliest African arrivals in the hemisphere or, for that matter, in North America. As for the Western Hemisphere generally, Africans arrived centuries before the Pilgrim Fathers landed in New England in 1620. They came with the Spanish explorers Vasco Núñez de Balboa, Hernán Cortés, Francisco

Pizarro, and Lucas Vazquez de Ayllón and played some part in their explorations. Moreover, the first Africans to arrive in colonial North America came as indentured servants in 1619, a year before the Pilgrim ship *Mayflower*. By the 1670s, however, indentured servitude had given way, with political and religious approval, to human bondage.

The Period of Slavery

While the early distinctions between black and white indentured servants were not greatly pronounced, it soon became evident that North American slavery would assault the African's sense of humanity and attempt to reduce him, in theory and practice, to a subhuman beast. Indeed, an effort was made to destroy the African psychologically, the better to control him physically, and it was thought advisable to teach him to understand that his color stamped him for perpetual inferiority. Even as the African was being enslaved, the American Indian was considered an encumbrance in the landscape. In the face of African enslavement and early designs to appropriate the Indian's land, the Americans— more loudly than slaveholders elsewhere in the hemisphere, and with greater intensity than settlers at any time before—proclaimed interest in the rights of man. Theirs was a singular expression of moral schizophrenia.

Still, the founders of the Republic doubtless thought that slavery would eventually become extinct and that blacks would either remain in America or emigrate to Africa. Because the number of slaves had swelled from 50,000 in 1710 to 462,000 in 1780, emigration, from the founders' point of view, was clearly the more congenial possibility.

The missed opportunity to bring slavery to an end following the War of Independence (1775–83) against England meant that the nation was misshapen at birth, its freedoms deformed. No one saw this more clearly than the slave except, possibly, the original inhabitants of the land, the American Indians. The compromises at the Philadelphia Constitutional Convention of 1787—maintaining the slave trade until 1808, declaring slaves to be fractions of people in order to increase southern congressional representation, agreeing on a fugitive slave provision—became the classic model for the betrayal of the Negro in American life.

Africans resisted slavery with the means at their disposal. There were instances throughout the colonial period and later of slaves running away, feigning illness, sabotaging farm equipment, killing individual whites, joining "enemy" armies (as in, for example, the Revolutionary War), conspiring to overthrow slavery, and revolting openly. Owing to a virtual absence of mountain ranges that could supply refuge and to white numerical superiority, there were far fewer revolts and conspiracies in America than elsewhere in the hemisphere. Slave resistance in this region necessarily took on more subtle forms, so much so that, in some

instances, certain kinds of disaffection went completely unnoticed by whites.

Pan-Africanization

In the seventeenth, eighteenth, and nineteenth centuries many slaves, both North and South, were more African than American in their religion, art, and sometimes, language — that is, in the essentials of culture — because it was common practice for those born in Africa to be shipped into the colonies. Africans from a multiplicity of tribes were flung together, with men of religion at the center of the new life, as they had been on the continent. One of the African religious leader's main tasks was to mediate between the members of various tribes, to build upon common denominators so that a community of perceptions and passions might be framed. The vision of most West Africans of the inextricability of art and religion and life was a crucial factor in the equation of Pan-Africanization, the process of converting multi-tribal groupings into a single people. One price paid for Pan-Africanization, especially deep into the nineteenth century, was growing Americanization, an inevitable by-product in this country of the clash of cultures of master and slave. No less ironic was the considerable extent to which the larger society took on features of the culture of the oppressed.

Pan-Africanization yielded a rich harvest, a renaissance of African genius on American soil: A new and surpassing folklore provided a base upon which later sparks of black genius could settle and accumulate. Africans also fashioned the basic dance styles within which their descendants moved to create still newer forms. Slaves did not create solely out of their African heritage. From the crucible of bondage, they observed the world around them, taking in what they liked, rejecting the rest, and, with brilliant imagination, so melded the new with the old and deeply felt that original artistic forms were brought into being. This essentially artistic response was profoundly political, for it helped Africans preserve their humanity under terrible circumstances in both slavery and "freedom."

Despite yeoman work by numerous anti-slavery societies in the North, by the end of the first decade of the nineteenth century, "free" blacks had little about which to be optimistic. The manner in which the Northwest Territory was developed reflected the moral contradictions locked in the heart of the new American nation. Though slavery and involuntary servitude were, according to provisions of the Northwest Ordinances of 1785 and 1787, not permitted in the new states of that region, racism became rampant in those areas. Nevertheless, slavery in the North was in fact all but dead in the first decade of the nineteenth century — affected by a residuum of revolutionary idealism, to be sure, but, perhaps as important, the victim of changing economic needs. In

any case, judicial rulings, constitutional interpretation, and gradual abolition acts, from a formal point a view, had effected slavery's demise.

Early Black Organizations

As increasing numbers of northern blacks secured their freedom in the late eighteenth and early nineteenth centuries, a number of black organizations, both religious and secular, came into being to help them make the adjustment to their new life. Most prominent of the groups was the Free African Society, a mutual aid organization founded in Philadelphia in 1787 and headed by Richard Allen (1760–1831), the preeminent black divine prior to the 1830s. After encountering much racism in the white churches, Allen later became the head of the African Methodist Episcopal (AME) Church, which became an independent organization of national scope in 1816 and later established itself as the most important single institution in black America.

Ties to Africa

Until the American Colonization Society was founded in 1816, free Negroes in the North were called "African" and apparently regarded themselves as African. Though by then educated blacks were substantially different culturally from their brothers and sisters in the motherland, their writings reflected a profound concern for people of African ancestry everywhere. There are, however, reasons for believing that numbers of unassimilated, uneducated blacks in the North, and certainly in the South, were substantially African. The essential isolation of the latter group from white people—and their contact with blacks from the West Indies and with others born in Africa—helped them, well into the nineteenth century, preserve African traits in religion, in the arts, and in numerous indefinable ways.

After the formation of the American Colonization Society—which most "free" blacks thought came into being to strengthen slavery by sending them to Africa—blacks became increasingly reluctant to be called African. Thus, they began to jettison this appellation, preferring instead the world "colored," and much later the designation "Negro." They were quick to point out that, as a result of centuries of suffering and unrequited toil, they were at least as entitled to remain in America as the white usurpers of the continent. Even so, by the 1820s an emigration movement to Haiti had been mounted, which was followed decades later by calls for substantial emigration from physician and journalist Martin Delany (1812–1885) and appeals for selective emigration from clergymen Henry Highland Garnet (1815–1882) and Alexander Crummel (1818–1898).

Northern Racism

It is small wonder that not a few "free" blacks, but by no means the majority, were interested in taking up life on foreign shores, for life was anything but pleasant for African peoples in the North. It was, to be sure, the North which took the lead in promulgating laws of segregation. African Americans were proscribed, either by custom or by statute, in almost every walk of life—in schoolrooms, churches, public conveyances, hospitals, jails, hotels—even in death. Moreover, their most ardent defenders, white abolitionists, generally were averse to social equality and to hiring blacks in their places of employment. With rare exceptions, the incubus of racism had tainted even the best of whites, who almost invariably felt that they knew what was best for black people.

Racism in the North, and the violence which often attended it, led thousands of former slaves to take up residence in Canada, where they felt they could lead less harried lives—lives also removed from the reach of the fugitive slave law. Sometimes, as in Cincinnati, Ohio, in 1829, attacks were carried out against entire black communities. In that city, between 1,000 and 2,000 blacks, pressured by a murderous white mob, left for Canada following the pogrom of 1829. Some states, among them Oregon, Ohio, Illinois, and Indiana, passed black codes that barred blacks from entering their territory unless they put up varying sums of money guaranteeing "good behavior" and produced certificates as evidence of their "free" status.

The Negro Convention Movement

The most effective forum for African American protest in the antebellum period was the Negro Convention Movement, which began in 1830 and lasted for years following the outbreak of the Civil War (1861–65). The Convention Movement was dominated until the 1850s by advocates of moral suasion as a means of social advancement and liberation. Foremost among the delegates were Frederick Douglass (1817–1895), an ex-slave who commanded respect from white as well as black abolitionists, and Henry Highland Garnet, an ex-slave and Presbyterian minister of celebrity among his own people. Though such matters as emigration, particularly to Canada, came before the convention, the main issues debated were concerned with strategies for ameliorating the plight of free blacks and with designs for the liberation of the slaves of the South, whose numbers had increased sharply after the close of the eighteenth century. In fact, according to U.S. census figures, the black population had grown from 757,000 in 1790 to 4,442,000 in 1860.

It should be noted that a number of proposals brought before black conventions and associations—especially those calling for emigration,

for the mastering of trades, and for violent social upheaval—were predicated on the recognized necessity for blacks to assume responsibility for their destinies. The awareness of the need for certain forms of independent development, especially the importance of blacks leading themselves, was strong among men of the stature of Garnet, Douglass, Delany, Crummel, and "Sidney," while the "cosmopoliting" sentiment was prevalent among less distinguished leaders such as William Whipper (1805–1885), the premier theoretician of African absorption into white America. The 1830s appeared to be the period in which advocates of the absorption of blacks into the larger society were in the ascendancy. Even more decisively, however, the 1850s seemed to belong to the proponents of autonomous development, as was the case in the period immediately following the Revolutionary War until the 1820s. While at no time did one current of thought sweep the other from view, the nationalist *ideology* was dominant among black leaders of antebellum America. The cosmopolites, apart from Whipper, seemed never to come even close to developing their thought to the dimensions of ideology.

Still, the degree to which even the most disaffected blacks embraced certain values of the larger society is worth noting and is reflected particularly in the meetings of conventions and associations of various kinds. Extant literature from the last quarter of the eighteenth century to the advent of the Civil War reveals that, for all of African American interest in Africa, most of the cultural values of articulate blacks were not easily distinguishable from those of educated whites. For example, with an exception here and there—Frederick Douglass being one—most black leaders appeared to be oblivious to the genius of slave folklore.

The 1850s

Since white people in the North were not prepared to accept even the most gifted black as an equal, many such blacks, to say nothing of ordinary ones, began to despair of liberation in America. That this was especially the case was revealed during the 1850s. The fugitive slave law of 1850, which greatly encouraged whites to return runaway slaves to their slave masters; the Kansas–Nebraska bill of 1854, which left it to the residents of those territories to determine if they would enter the Union as slave or free states; the *Dred Scott* decision of 1857, in which the Supreme Court ruled that a black man had no rights which a white man was bound to respect—these events together with mounting "scientific" racist dogma created an atmosphere which made all the more plausible Garnet's preachments of violence. In 1843 Garnet had failed, largely owing to Douglass's opposition, to win majority support for a proposal of slave insurrection at a convention in Buffalo, New York. Those two, Douglass and Garnet, laid down the principal strategies of moral suasion and armed struggle for black abolitionists regarding approaches to ending slavery. By the 1850s, Douglass had joined Garnet

in his belief that emancipation was not at all likely without a resort to violence on the part of the enemies of slavery.

Garnet and Douglass knew well that the profitability of slavery, together with the psychosexual benefits of holding blacks in bondage, militated against the death of the master–slave relationship. And so did many white abolitionists, who became directly embroiled in a verbal war which intensified, as slavery burgeoned as never before, between 1830 and 1860. But no one contributed more to exacerbating sectional differences than did slaves themselves. Resistance ranging from the Denmark Vesey conspiracy of 1822 to Nat Turner's bloody uprising of 1831 and the scores of thousands of runaways helped trigger the war of nerves that preceded John Brown's bold assault at Harpers Ferry in 1859 and the clash of armies that led to the shattering of the slavocracy.

Social Impact of Slavery

As slavery neared its end, it is clear that it had taken its toll of Africans, having destroyed forever that clarity which had guided them in times past. Millions of slaves lived and died without ever knowing freedom. Most saw or heard so often of bondsmen being auctioned that the possibility of separation from "family" hung like a curse over their heads.

While slavery dealt grave wounds to millions of Negroes, that institution was profoundly harmful to whites. No major structure escaped the blight of racism, and not many white people were able to avoid a sense of self-esteem dangerous to the very existence of people of color. With white supremacy lodged in the American psyche, with racist distinctions woven into the fabric of American law and politics, to oppose such a mentality and such a system could result in placing a person's life in jeopardy. Slavery's impact was such that whites, North and South, eventually walked away from that institution with many of the psychic traits of the overlord.

Poor whites in the South, however, were especially damaged by slavery. Generation after generation, they had been cynically and cruelly guided toward hatred of black people to ease their minds over the mean lives guaranteed by slave labor in their midst. Themselves victimized by slaveholders, many became so married to racism that it must have seemed that hatred of blacks was altogether natural. As oppressed as poor whites were, as sadly deficient the lives of white workers elsewhere, the slave had felt a sorrow, an anguish, a pain at the center of being that only those who have been made to bow down, as a people, have come to know.

W. E. B. Du Bois has observed in *Black Reconstruction* (1935) that:

> . . . slavery represented in a very real sense the ultimate degradation of man. Indeed, the system was so reactionary, so utterly inconsistent with modern progress, that we simply cannot grasp it today. No matter how

degraded the factory hand, he is not real estate. The tragedy of the black slave's position was precisely this; his absolute subjection to the individual will of the owner.

The Civil War

Though slavery was the root cause of the Civil War, blacks were first prevented from fighting for the Union. As northern forces encountered growing difficulties, African American enlistments were permitted, with more than 200,000 black soldiers fighting to save the Union and to secure their own freedom. By the thousands, slaves rushed to the armies of the North as they penetrated the South. The war measure that allowed the enlistment of black troops emancipated the great mass of slaves. The Emancipation Proclamation was later ratified by the Thirteenth Amendment to the Constitution which abolished slavery.

Reconstruction

The special agony of blacks in America is that they became as colonial a people as the modern era has seen. They had no realistic prospect of gathering together, after emancipation, into a sovereign nation with land on which to erect structures of their own. So effective white domination during slavery, so powerless the newly freed, so distant Africa from the shores of memory of educated blacks, it is doubtful that the nationalist ideal, except in cultural terms, was a practical reality.

More than anything else, the freedmen wanted land and education. During Radical Reconstruction (1867–1877), when the attempt was made to rebuild the war-ravaged South along democratic lines, only black education was realized in any meaningful degree. Though blacks by the millions had provided whites with two centuries of unrequited toil, helping to lay the foundations for American industry, their requests for land received short shrift indeed. The nation was morally unprepared to make reparations for the stupendous crimes committed against Africa and her peoples. Though surviving generations of African Americans, numbering more than 4,000,000 in 1860, were in a horribly weakened state, emancipation had rescued them, in theory at least, from the more brutal features of slavery. They could legally wed, own property, travel, make contracts, learn to read and write, and more.

Three options had been available to the North—to permit southern whites, once they had accepted the amendment abolishing slavery, to determine the destinies of freedmen; to extend full manhood suffrage to blacks as a measure for self-protection; or to place the freedmen under guardianship for the purpose of helping them in employment, education, and matters relating to the courts. The nation, under President Andrew

Johnson, began by entrusting the fate of blacks to southern whites, who promptly attempted to reenslave the freedmen.

The journalist and reformer Carl Schurz reported to Congress on the reign of terror which began in the South immediately following the war:

> Some planters held back their former slaves on their plantations by brute force. Armed bands of white men patrolled the county roads to drive back the Negroes wandering about. Dead bodies of murdered Negroes were found on or near the highways and by-paths. Gruesome reports came from the hospitals—reports of colored men and women whose ears had been cut off, whose skulls had been broken by blows, whose bodies had been slashed by knives or lacerated with scourges. A number of such cases I had occasion to examine myself. A veritable reign of terror prevailed in many parts of the South. The Negro found scant justice in the local courts against the white man. He could look for protection only to the military forces of the United States still garrisoning the "States lately in rebellion, and to the Freedmen's Bureau."

The Right to Vote

The Freedmen's Bureau, established by Congress in 1865, attempted to meet some of the needs of blacks in employment, education, and the courts. But, racism in its ranks, opposition from the white South, a northern reluctance to spend the required sums of money, and poor management militated against its success.

Frederick Douglass in 1866, as recorded in *The Life and Times of Frederick Douglass*, appealed to Andrew Johnson for the enfranchisement of his people:

> Your noble and humane predecessor [Abraham Lincoln] placed in our hands the sword to assist in saving the nation, and we do hope that you, his able successor, will favorably regard the placing in our hands the ballot with which to save ourselves.

Finally, permitted to vote under Radical Reconstruction, blacks on balance gave a good accounting of themselves, helping to establish democratic government, free public education, and progressive social legislation. Seven black men were elected to the House of Representatives in the 43rd and 44th Congresses. Southern whites, however, were determined to put an end to black participation in government. To effect that goal, they chose familiar paths of violence and fraud and brought Reconstruction to a close in state after state. The North, having grown tired of racial problems, and far more interested in profits for industry, abandoned the Negro, as it had under Johnson's Presidential Reconstruction (1865–66), to the tender mercies of the South. Thus, the nation missed a second great opportunity to realize genuine democracy between blacks and whites.

Erosion of Political Gains

Though Reconstruction had actually been crushed by 1877, blacks continued, on a smaller scale, to hold public offices and to vote. Moreover, their special contributions in the areas of free public education and progressive social legislation remained fixtures in southern states. Systematically, however, the South moved to lock the Negro out of American life—to reduce him to a state of slavery simply different in guise. By century's close, there were signs that blacks had been beaten into nearly complete submission. Lynched by the thousands, placed on chain gains, segregated in almost every conceivable way, massively disfranchised, virtually excluded from public office, reduced to the new tyranny of sharecropping, and subjected to sustained questioning of their humanity by white scholars, blacks by 1900 had reached their lowest point since emancipation.

Separate But Equal

Four years earlier, in 1896, the Supreme Court, in *Plessy v. Ferguson*, held that segregation of the races in interstate travel was constitutional, as long as the facilities were equal. This court, since the days of slavery, had been a model for the vulgarities of white supremacy in America. The executive branch of the federal government in its turn, and on its highest level, had for roughly two decades prior to *Plessy v. Ferguson* offered little more elevated thought on race than the debased thinking of the Supreme Court justices. Thus, blacks could not look to that quarter for relief in the midst of violent abuse with any rational hope of humane response. An indication of the nature of the humanity of the white nation could be determined by the high walls of segregation that were erected at precisely the same time that the final removal of the American Indian was taking place.

Meanwhile, the growth of capitalism in the North—greatly accelerated by the Civil War—was such that, before the close of the century, the United States was becoming a nation to be reckoned with. Powerful forces of change were propelling America toward irreversible urbanization. With immigrants shortly before World War I still pouring into the country, with the tiny flow of blacks northward at the turn of the century increasing by the war years to tidal proportions, and with labor, especially the American Federation of Labor, hostile to black workers, there was for blacks both promise and a snare locked into the emerging industrial order. Moreover, the ethic of greed was not only decisive in the industrial system but was the controlling American ideal.

As the century opened, the inability of the teeming millions of Africa and Asia to parry the blows of European imperialists was a measure of the problems which confronted the African American minority.

Booker T. Washington

Few men were more aware of the meaning of those power relationships than Booker T. Washington (1856–1915), ex-slave, educator, and the most distinguished southern leader to emerge after the Civil War. Washington's program of conciliating, when not actually humoring, white America certainly took into account both the sincerity of racists and the instruments of violence at their disposal. The leader of a nearly beaten people, he did not challenge in a frontal manner the dogma of white supremacy in the social, economic, or political spheres. Rather, he taught his people the value of manual labor, of hard work and thrift, of the Christian virtues, of being clean and quiet—suggesting such practices would eventually soften prejudice against them and clear the path toward final freedom. A believer in self-reliance, Washington was the central figure in generating interest in the importance of black people owning their own businesses. An able, even brilliant politician, a master of the psychologies of blacks and whites alike, at home on platforms before almost any audience, Washington commanded a wide following among his people and was considered to be *the* Negro leader by white men of power and influence.

Washington's emphasis was on industrial education at a time when the advances of industry were rendering obsolete most of the jobs for which he would have his people trained. He also emphasized racial separation, even subordination, when social policy was being shaped on the grounds of alleged Negro inferiority. It was he, a year before *Plessy v. Ferguson*, who rose overnight to national acclaim for having declared, in a speech before the Atlanta Exposition, "in all things social we [the races] can be as separate as the fingers on the hand. . . ."

Nonetheless, Washington worked vigorously behind the scenes to mitigate problems of his people, especially through financing legal battles to remove disabilities in voting rights. Unfortunately, his public pronouncements were far better received and acted on than his private efforts. Whatever Washington's contributions, they did not strengthen the spiritual life of either the Negro or the nation. Through Washington, in his capacity as foremost black leader and educator in America, Negro education, politics, employment, and social life were often manipulated to meet the imperatives of capitalism and racism.

W. E. B. Du Bois

Though initially sympathetic to certain features of Washington's program, W. E. B. Du Bois (1868–1963), a Harvard-educated black of New England birth, openly broke with him as it became clear that Washington's policies had not begun to reverse the tides of violence and deprivation that were engulfing black America. Du Bois, recalling Frederick

Douglass and Henry Highland Garnet, restated first principles: Blacks must not be satisfied with anything less than full manhood rights, the right to equality before the law, and social freedom.

As Washington's authority waned—a reversal that was in part due to the disaffection of black intellectuals with his program—the influence of his opponents grew stronger. The formation in 1905 of the Niagara Movement—headed by Du Bois and supported by important figures such as William Monroe Trotter (1872–1934), AME Zion Bishop Alexander Walters, and educator John Hope (1868–1936)—was an important step in the eventual diminution of Washington's power in influential black circles. The Niagara Movement failed organizationally, its membership being drawn almost exclusively from a handful of black intellectuals. Ideologically, in its reassertion of fundamentals, the movement not only signaled rising opposition to Washington but, in its emphasis on legal redress of grievances, prefigured the National Association for the Advancement of Colored People (NAACP). In fact, the Niagara Movement projected the essentials of human rights upon which civil rights campaigns would be mounted for half a century.

The NAACP, which came into being in 1909, succeeded the Niagara Movement as the principal threat to Washington's leadership. In contrast to the Niagara Movement, which was all black, the NAACP was interracial in composition. Of national Negro leaders, however, only Du Bois joined the new organization. Ida B. Wells (1869–1931), the chief crusader of the period against lynchings, rejected an invitation to join, as did William Monroe Trotter; both distrusted the motives of the white sponsors. The organization set itself the task of overturning every law that blocked the Negro from enjoying all the rights being exercised by other Americans. In 1910, shortly after the founding of the NAACP, the National Urban League was formed to address in particular the problems faced by black people in American cities. It was, however, the NAACP that took the lead in opposing racism in American life.

Racism before World War I

Racism was everywhere, and among those responsible for its continuance and expansion were Presidents Theodore Roosevelt and Woodrow Wilson. The former was not above questioning the bravery even of those black soldiers who were in part responsible for his reputation as a military hero in Cuba. Roosevelt further disgraced his office following the Brownsville, Texas, riot of 1906 in which Negro soldiers were accused of having "shot up the town." Without allowing them a fair hearing (one citizen of the town was killed), the white president cruelly issued dishonorable discharges to the entire battalion, thereby disqualifying its members from employment in either the civil service or the military of the United States. (It was not until 1972 that the U.S. Army cleared the

soldiers and changed their discharges to honorable. Only one had survived to witness the vindication of the battalion.)

Given to preachments about freedom, Woodrow Wilson possessed a mentality on questions of race that was representative of the region from which he came, the American South. He was sufficiently imaginative to pioneer in racist practices in the nation's capital, introducing and supporting, by executive order, segregation of most Negro federal employees in eating and restroom facilities.

Meanwhile, economic crises in the South, continuing flagrant abuse of Negro rights in that region, and a sharp decline in European immigration contributed to a great migration of Negroes to the North which peaked during the years of World War I. The Bureau of the Census statistics show that the northern and western states received 330,000 black newcomers in the period from 1910 to 1920—a trend which would continue for decades until the number of blacks in the North was greatly increased. By 1910, in any case, there were about 10,000,000 blacks in the United States, with the great majority still residing in the South. Many of those who came north took jobs in northern industry.

The Inter-War Years

Thousands of blacks returned from World War I to an America not at all safe for their people. In the year following the war, seventy Negroes were lynched. Some were burned alive, others hanged, and still more castrated—the dismembered portions of their bodies viewed as coveted souvenirs. Ten Negro soldiers, some still in uniform, were among the lynched. Other Negroes were flogged, branded, tarred, and feathered.

The summer of 1919 witnessed such clashes between the races that it was later called "Red Summer," red with the blood of black and white people as, between June and the end of the year, twenty-five race riots occurred. Sometimes sparked by economic insecurity born of a growing shortage of jobs, riots were also encouraged by tensions growing out of housing and recreational problems between blacks and whites. Usually, a rumor that a white woman had been assaulted by a black man was sufficient to whip white crowds into frenzied indignation. All in all, violence against Negroes following the war amounted to a veritable pogrom.

Marcus Garvey

The virulent nature of the violence had been obvious to Marcus Garvey (1887–1940), a Jamaican black who headed the New York–based Universal Negro Improvement Association (UNIA). The premier black nationalist organization in U.S. history, the UNIA attracted and held large

numbers of West Indian and African American blacks, particularly recent arrivals in the North. Garvey, who possessed brilliance of imagination, was one of the few black leaders prepared to exploit the disaffection of the great mass of blacks not reached by other leaders.

Though Garvey's rallying cry to blacks was the necessity of a return to Africa, perhaps his lasting achievement was his ability to direct the attention of the masses toward the sources of their sorrow and rage. He had them know that their unhappiness stemmed from not having a place in the sun, and it was precisely that place to which he would lead them and millions more. His assurances of the greatness of the black race somehow enabled thousands, perhaps millions, of his people to have respect for themselves at a time when Negroes were the victims of wholesale violence and mounting despair. After a brief period of quite remarkable institution-building, Garvey, owing to legal problems with an unadmiring federal government and problems with black leaders such as Du Bois and A. Phillip Randolph (1889–1979), experienced a considerable decline. Garvey was jailed for allegedly using the mails to defraud and was eventually deported.

Du Bois and Garvey, ideologically, were closer together than either man was to Booker T. Washington. Garvey, a master at touching the lower depths, had been able to popularize the Pan-African ideas that Du Bois had held since young manhood. Though Du Bois, with notable dedication, mounted a campaign of Pan-Africanism designed to meet the needs of blacks everywhere, his immediate impact was felt by literate segments of African peoples. Du Bois's brilliant and daring conception, gradually arrived at, to place the weight of black people of the world behind the African American movement, fell on deaf ears within the councils of the NAACP, which favored a more narrowly focused attack. Garvey, by contrast, had little trouble mobilizing scores of thousands to support his Pan-African programs.

The NAACP

The NAACP relied mainly on the courts as a means of securing freedom for black people. But that organization also, in years of terrible violence, carried out a tireless, highly publicized, and relatively successful campaign against lynching. The NAACP's most clear-cut victories, however, occurred before the Supreme Court. The organization's lawyers, in 1915, demonstrated the unconstitutionality of the South's "grandfather clause," which stated that only those whose fathers or grandfathers had voted before emancipation—that is, only whites—were eligible to vote. Two years later, the Supreme Court declared unconstitutional a Louisville, Kentucky, ordinance, challenged by the NAACP, which required Negroes to live in certain parts of that city. Some years later, before the

Supreme Court, NAACP lawyers won a ruling declaring unconstitutional the South's white Democratic primary, from which blacks were excluded.

The New Negro Movement

Apart from the work of Du Bois, who was director of research and publications for the organization, the NAACP had no cultural program for black Americans. This was so despite the fact that, among blacks, one of the most significant expressions of creativity in modern history had been gathering strength since the first decade of the century. The musical dimension of the New Negro movement was part of a larger, on-going renaissance which began with the striking artistic advances of slaves. Such developments were profoundly related to the conception of freedom black leaders might have laid before their people and the nation. Of civil rights leaders, however, only Du Bois and James Weldon Johnson (1871–1938) seemed deeply concerned about the relationship between art and freedom.

Developments in Music Though a phase of the New Negro movement, mistakenly called the "Harlem Renaissance," occurred in the 1920s, that movement itself began near the close of the previous century with the advent of new musical developments. The New Negro movement's most important overall disclosure was that the creativity of blacks, so rich during slavery, was still being tapped. As with the art of the slave, the finest creation of the period from 1890 to 1930 was black music, especially jazz and the blues. During that time, a host of talented composers and instrumentalists appeared on the scene. Foremost among the composers was Edward Kennedy "Duke" Ellington (1899–1974) who, by the time of his death, was widely acclaimed as America's greatest composer. Jelly Roll Morton (real name, Ferdinand Joseph La Menthe; 1885–1945), the jazz and blues composer, and W. C. Handy (1873–1958), the "father" of the blues, completed an important triumvirate of African American composers. It is likely that all three built on the contributions of Scott Joplin (1868–1917), the creator of ragtime music near the close of the nineteenth century.

One of the greatest musical innovators to appear in the 1920s was Louis Armstrong (1900–1971), who grew up in New Orleans, Louisiana, a principal incubator for musical geniuses of the period. Indeed, Armstrong's over-all impact on the history of jazz was perhaps second to none. His style of trumpet-playing and singing influenced instrumentalists and vocalists as well. In fact, his singing, developed in the 1920s, influenced vocalists over the next half a century. In a real sense, the literal and spirited attempts of artists to capture with the voice the pecu-

liarly inventive sounds of instrumental bebop (bop), developed in the 1940s, owe much to certain features of Armstrong's rhythmically ingenious recitation of nonsense syllables, known as scat singing.

The Negro spiritual was sung by gifted black concert singers of the 1920s. While Roland Hayes (1887–1977) and Marian Anderson (1902–1993) made notable contributions toward revealing the beauty of this art form, it was Paul Robeson (1898–1976), more than any other artist, who made the spiritual a respected form of music throughout the world. Moreover, he urged his people to draw upon the creative springs of their heritage and proceeded to engage in brilliant investigations of African folklore and languages in order to reveal new possibilities for cultural growth. His portrayal of the title role in *Othello* in 1930 and later owed much to his admitted efforts to present the Moor as essentially African. A virtuoso athlete who won All-American football honors, a lawyer, linguist, and student of world cultures, Robeson was for three decades acclaimed as one of the world's greatest actors and singers. In him, the New Negro movement found universal genius and its ideal projection.

While New York City was the principal showcase for the black artist of the New Negro movement, the city was less important than Washington, D.C., for producing brilliant literary talent, less remarkable than New Orleans or Kansas City for producing gifted musicians, and less significant than Chicago as a center for the blues. Jazz artists approaching maturity in the South or elsewhere eventually were attracted to New York City because of financial opportunities. There was no "Harlem Renaissance."

Literature Only Sterling A. Brown (1901–1989) in literature rivaled the achievements of the musical greats. In *Southern Road*, a volume of poems which appeared in 1932, Brown presented, through remarkable uses of Negro speech, mythology, and musical forms, almost a new form of poetry. *Southern Road* remains the most important single statement of an aesthetic and philosophical position in Negro creative literature of that time. Jean Toomer (1894–1967), whose *Cane* had appeared in 1923, possessed all the technical equipment of a great poet but lacked Brown's patience and thoughtfulness. For all its brilliance of language, *Cane* seldom yields depth and the full view. Langston Hughes (1902–1967), the most popular poet of the New Negro movement, focused on the values and experiences of ordinary northern Negroes wherever he found them. In their best work, these poets wrote of their people with such sensitivity and skill that subjects chosen and values affirmed achieve fullest resonance in the consciousness of those who have studied Negro life with the greatest care.

Continuing Development The New Negro movement did not end at the close of the 1920s. Rather, the artistic gains leading up to and including that decade were later consolidated and extended with the appearance of a seemingly unending stream of musical greats—Earl "Fatha"

Hines (1905–1983), Jimmie Lunceford (1902–1947), William "Count" Basie (1904–1984), William "Chick" Webb (1909?–1939), Lester Young (1909–1959), Eleanora "Billie" Holiday (1915–1959), Coleman Hawkins (1904–1969), Roy Eldridge (1911–1989), Ella Fitzgerald (b. 1918), Sarah Vaughan (1924–1991), Charlie "Bird" or "Yardbird" Parker (1920–1955), John "Dizzy" Gillespie (1917–1993), Aretha Franklin (b. 1942), John Coltrane (1926–1967)—too many to list. In short, blacks have produced the only American music of universal appeal, but white artists and entrepreneurs have made more money from that music.

While black musical achievements have attracted global attention, Negro creative writing, while clearly not yet comparable, generally improved in the decades following the 1920s. In addition to Sterling A. Brown, Jean Toomer, and Langston Hughes, there have been many gifted writers. They include Arna Bontemps (1902–1973), Richard Wright (1908–1960), Margaret Walker (b. 1915), Ralph Ellison (b. 1914), James Baldwin (1924–1987), John O. Killens (1916–1987), Gwendolyn Brooks (b. 1917), Toni Morrison (b. 1931), Imamu Baraka (Le Roi Jones; b. 1934), John A. Williams (b. 1925), Paule Marshall (b. 1929), and a dozen more. The New Negro movement in its finest expression is a continuation of the unifying creative process that began in slavery. The springs of creative energy on which slaves drew have shown little inclination of running dry—persuasive proof that a renaissance of serious dimensions continues to unfold.

The Great Depression

Unfortunately, the art of black performers, composers, and writers was not directly harnessed, except in the case of Robeson, to the struggle to end oppression based on race and class. Du Bois, however, was deeply concerned about such matters. As the Great Depression brought new misery to his people, he fought within the NAACP for programs both cultural and otherwise that would extend power to the mass of black people, even if the exploitation of certain forms of segregation, particularly in the economic and educational spheres, proved necessary. The values expressed by Du Bois at the time, largely in the pages of the NAACP magazine, the *Crisis*, which he edited, recalled those of antebellum nationalists. He anticipated the essentials of the black power movement which, some three decades later, sounded the death knell for nonviolence in the civil rights movement. Du Bois's support of certain forms of self-segregation led to conflict with NAACP officialdom and precipitated his resignation from that organization in 1934.

While Americans generally suffered grievously during the Great Depression, African Americans suffered even more. Yet programs designed to benefit the general populace in the end brought a measure of relief to blacks as well; such programs as those of the Works Progress Adminis-

tration, the Civilian Conservation Corps, and the National Youth Administration helped large numbers of blacks weather the economic storm. A decisive advance came as a result of a threatened march on Washington in a campaign led by black unionist and radical A. Phillip Randolph. He warned the president, Franklin D. Roosevelt, that unless blacks were admitted to jobs in the war industry and government, they would march on Washington to lay their grievances before him. Roosevelt acquiesced and issued Executive Order 8802 that established the Fair Employment Practices Committee and barred discrimination in defense industries and federal bureaus.

World War II

Despite the real gain of securing jobs in industry during the war years, the majority of black people, who still lived in the South, were relegated to the most menial jobs. Southern blacks in very large numbers were denied access to the voting booths and were segregated in all manner of ways. And blacks as a whole were insulted by whites ranging from Ku Klux Klansmen to members of the national Congress. Roosevelt, however, avoided the racial crudities of his predecessors, and his ascendancy marked an advance, but by no means a permanent one, in the way the nation's highest officer related to one of the nation's oldest groups of "citizens." There is little doubt that there was a man in the White House, for the first time in the twentieth century, to whom Negroes could appeal with at least a reasonable expectation of receiving a sympathetic hearing—either from him or from his charismatic and humane wife, Eleanor.

Problem of African Origins Though African Americans returned from World War II less inclined than ever to abide racism in American life— their numerous clashes with white soldiers on Army bases abroad and in the United States indicated that, as far as they were concerned, the times were changing—it is doubtful if more than a few of them had knowledge of the historic relationship between Africans and their people in the New World. The prospect of African Americans in the 1940s being exposed to such information was not very good: The only organization in the country actively opposing colonialism and imperialism in Africa was the Council on African Affairs, formed in London in 1937 by Paul Robeson and Dr. Max Yergan. Devoted to offering financial and material aid to Africans, particularly to blacks in South Africa, the council for more than a decade provided reports on European oppression of Africans and linked such injustices to the plight of blacks everywhere, especially in the United States.

After Du Bois's departure from the NAACP in 1934, not one civil rights organization of major import—including the NAACP, the Urban League, and the Congress of Racial Equality (CORE)—had a serious

position on the African question. Throughout the 1940s, then, Du Bois and Robeson were the only people of wide reputation in the country who consistently championed the cause of complete and final African liberation. After a return to the NAACP in 1944, Du Bois was forced out of that organization in 1948, and soon thereafter he accepted an invitation from Robeson to join the council. The U.S. Government listed the organization as "subversive" and, during a period of intense anti-Communist hysteria following the war, attempted to silence, if not destroy, Robeson and Du Bois. Though both men were dedicated socialists with sympathies for Russia and the new China, it should be noted that their intensive activities on behalf of African liberation and their unyielding stance against the oppression of blacks in the New World figured prominently in the ruling class's feverish, perhaps pathological hatred of them. Never before in the nation's history had men of the stature of Robeson and Du Bois been so persecuted by the governing elite.

Both names ceased to be heard. And in that silence, consciousness of Africa was lost. Interest in the history and culture of black people seemed altogether foreign to civil rights leaders, who did not appear to understand that freedom means internal moorings—not a mere absence of racism. Massive confusion eventually grew out of this abandonment of historical and cultural reference points.

Developments Since World War II

After 1945, many doors began to open. In 1950 Negroes numbered more than 15,000,000 in a total population of almost 151,000,000, and their dazzling individual successes and even "first" accomplishments were hailed as progress for the race and "an answer to Paul Robeson." By the early 1950s, with Robeson barred from the concert stage and from public platforms, such answers were no longer felt required. But the irony was that no Negro could rise high enough not to be subjected to insult or even death on racial grounds. Even so, during and between the world wars, the growing numbers of blacks in the labor movement (especially in the Congress of Industrial Organizations) and the increasing numbers of Negro college graduates and professionals had helped establish a rather sizeable black middle class in America.

Yet millions of African Americans, particularly those in the South, remained among the most oppressed people in the world. Lynchings were still, despite some considerable tapering off, all too evident, as was police violence against blacks. Besides, acute racism in the North could be found in housing, employment (especially in the lucrative construction industry), and education. There was every evidence that the nation, despite undeniable advances, faced grave difficulties on the racial front unless such problems were seriously addressed.

Though America emerged from World War II as the most powerful

industrial nation in the world, the damage done to world colonialism and imperialism as a result of war strain, independence movements, and the presence of a powerful antagonist quick to point out abuses of blacks in America had made it impossible for the United States to oppress black people at pleasure. In a word, power relationships created objective conditions which, more than ever before, favored rebellion in America.

The Move Toward Nonviolence

The post–World War II period marked the beginning of a massive application of tactics seldom employed by blacks in previous times—the use of nonviolent direct action in the fight against racism. A number of developments occurred, however, which helped prepare the ground for the nonviolence movement. One of these was the brilliant victory scored by the legal staff of the NAACP in *Brown v. the Board of Education of Topeka* in 1954. This case, which challenged the "separate but equal" provision in *Plessy v. Ferguson*, was masterminded by an extremely able group of black lawyers headed by the future Supreme Court justice Thurgood Marshall (1908–1993). The *Brown* decision had ramifications far beyond the boundaries of public school education; the ruling struck down, or at least prepared the way for the demise of, laws of segregation generally.

Carrying out the Supreme Court's decree against segregated schools was not easy, as shown by the attempts to desegregate Central High School in Little Rock, Arkansas, in 1957. Such was the bitterness over black youths entering the school that President Dwight D. Eisenhower ordered military forces to Little Rock to maintain order. The nine black students—Minnie Jean Brown, Carlotta Walls, Elizabeth Eckford, Gloria Ray, Thelma Mothershed, Melba Patillo, Jefferson Thomas, Terrence Roberts, and Ernest Green—provided surpassing examples of courage as they walked to school through angry, cursing, and sometimes violent mobs of whites.

An ugly mood exploding into violence took the lives of two people as James Meredith (b. 1933) became the first black student to enter the University of Mississippi in 1962. Deputy marshalls and federalized National Guardsmen were required to guard Meredith's admission— even though Negroes, since Autherine Lucy's expulsion from the University of Alabama in the face of violence in 1956, had been admitted to a number of other white colleges and universities in the South.

The Montgomery, Alabama, bus boycott, which began in 1955, was a precursor of the shift in tactics toward nonviolence that was to become important in the next decade. Moreover, the success of the boycott in strategy, discipline, and unity indicated that a remarkable leader had appeared in the Reverend Dr. Martin Luther King, Jr. Though some held that northern Negroes, following World War II, would take the

lead in opposing racism, King's efforts in Montgomery signaled the beginning of great bursts of protest energy from southern Negroes.

The 1960s

In fact, the 1960s witnessed the greatest agitation for the rights of blacks since the antebellum years. Among the new civil rights groups to achieve attention was CORE, founded in 1942 in Chicago but not generally known for the two decades. Imaginative and aggressive, in the early 1960s CORE was led by a group of young white officials including Jim Robinson, Gordon Carey, and Marvin Rich. Later, James Farmer became the director of CORE. That organization played an important role in the initial phases of both the student sit-in movement, organized to end segregation in eating facilities in the South, and the "freedom rides," mounted to end segregation in interstate transportation. In the employment of nonviolence, CORE was perhaps second only to the Student Non-Violent Coordinating Committee (SNCC), which was founded in 1960 and very early received financial support from King's Southern Christian Leadership Conference (SCLC). CORE, SCLC, and especially SNCC spearheaded the civil rights drives of the 1960s.

While no individual or collection of individuals rivaled King's hold on the imagination of his people, or King's ability to dramatize a project, SNCC was the most effective civil rights group of the decade. In the deepest, most hostile regions of the South, SNCC possessed the most brilliant organizer—Robert Moses, who enjoyed a reputation among some civil rights workers even superior to that of King. But Moses, unlike most leaders, did not seem to enjoy fame, preferring to operate along the margins of anonymity. Other SNCC leaders were Dianne Nash and John Lewis (b. 1940), who helped found the organization; Stokely Carmichael (b. 1942), a West Indian who journeyed south as a freedom rider and later emerged to head SNCC; H. "Rap" Brown (b. 1943), who urged his people to rely on the gun; and James Forman (b. 1929), who, after being expelled from Chicago's Emergency Relief Committee, rose suddenly and meteorically to a position of high leadership among the students.

Mainly through the sustained organizational activity of SNCC, and through King's ability to rally masses and to evoke feelings of guilt in large numbers of whites, sufficient pressure was placed on the national government to force through important civil rights legislation by the Congress. One of the largest demonstrations in American history—the March on Washington of 1963, mounted largely under the guidance of Bayard Rustin (1910–1987)—preceded the passage of the Civil Rights Bill of 1964. More than a quarter of a million people participated in the march, demanding sweeping civil rights legislation. They later received it at the urging of President Lyndon B. Johnson, successor to the slain

John F. Kennedy. The congressional civil rights bill, among other things, forbade discrimination in most places of public accommodation, including restaurants and hotels; granted the U.S. Attorney General greater powers to fight discrimination and segregation in education, in voting, and in the use of public facilities; and sanctioned an attack on discrimination in federally assisted programs, either by withdrawing funds upon failure of a program to comply or by terminating such programs.

Voting Rights

Between the March on Washington and the passage of the civil rights bill, a black church in Birmingham, Alabama, was bombed, and four children lost their lives. This crime was one of scores of racial bombings in Birmingham carried out after World War II which the Federal Bureau of Investigation failed to solve. Violence also attended the 1965 voter registration drive in Selma, Alabama. Largely mounted by SNCC, the Selma project was a vital step toward securing the Voting Rights Act of 1965. In protest over the murder of a black worker and a white Boston clergyman, the civil rights workers led a march from Selma to Montgomery, in which marchers were protected by Alabama National Guardsmen called into federal service by President Johnson. After the march, a white woman was assassinated while transporting marchers back to Selma. The presence of close to 50,000 blacks and whites in Montgomery, the state capital, to rally at the close of the march, however, served notice on the nation that blacks were determined to win full voting rights in the South.

President Johnson, only days following the march, sent his right-to-vote proposal to Congress. The proposal outlawed literacy tests in counties and states in which less than 50 percent of the adults voted in 1964 and the U.S. Attorney General received authorization to send federal examiners to register Negroes in areas where local registrars were discriminating against them. Before the year ended, more than 250,000 Negroes in the South had registered for the first time, and Negroes had won seats in the city councils of several southern states, in addition to a seat in the Georgia legislature.

Meanwhile the southern movement of blacks had for some time been triggering reactions in the North which initially took the form of support projects for southern efforts. White liberals aided in the support projects, especially through financial contributions. Indeed, they had been mainstays of northern support for the earlier Montgomery bus boycott. But in Chicago, a mainly black group, the Emergency Relief Committee (ERC) for Fayette and Haywood counties, Tennessee, founded by sisters Yvonne Stevens and Wilhelmina Evans, courageous and principled black women, brought together a large number of black churches and individu-

als to support voter registration in the Tennessee counties, helping to create an appropriate climate for greater attacks on Chicago's racial problems. Some northern blacks active in the freedom rides participated in massive boycotts of northern public schools in protest against the poor quality of education being received by black children. Still other blacks in the North, who had been active on behalf of civil rights in the South, helped form the vanguard of a movement that later culminated in the demand for the teaching of black history and black studies in the schools. Chicago's Amistad Society assisted in both campaigns.

Malcolm X

In the early 1960s, Malcolm X (1925–1965), then a minister in Elijah Muhammad's important Nation of Islam (Black Muslims), had prophetically warned blacks that integration could never solve their problems. The black man's problems could only be solved, he noted, with the assumption of power to determine one's own destiny. Moreover, Malcolm X had, with the eloquence and passion which distinguished his style, pointed up the indivisibility of the human rights movement, asserting that all blacks, no matter how high or low their station, in Africa and in the New World, were in the struggle together. His acceptance of an invitation to address black students at Tuskegee Institute in 1964 was a major development in the civil rights movement. It meant that black students were moving closer to him and he closer to those whom he had ridiculed for their advocacy of nonviolence and integrationism.

Following the Tuskegee engagement, Malcolm X was invited to visit Selma to address a civil rights gathering in a church. His influence thereafter mounted in civil rights circles, even as it declined (following differences with Elijah Muhammad) within the Nation of Islam. Malcolm was assassinated in 1965 as he addressed a gathering of his newly established Organization of Afro-American Unity. As happens sometimes in history, he became larger in death than he had been in life.

Urban Uprisings

Still, with the passage of important civil rights legislation, it appeared to many that blacks had reached freedom's threshold. That illusion was shattered by urban uprisings, the first in Watts, a Negro section of Los Angeles, in August 1965. Other explosions of varying degrees occurred in dozens of northern cities between 1965 and 1968, highlighting serious problems facing oppressed blacks in housing, in unemployment, and in the area of police brutality.

The Black Panthers

The Black Panther party, which had sprung to life in the 1960s, addressed in particular the problem of police brutality. Headed by Huey P. Newton and Bobby Seale, and later supported by brilliant writers such as Eldridge Cleaver (b. 1935), George Jackson (1941–1971), and Angela Davis (b. 1944), the party encouraged self-defense on the part of Negroes being abused by police. The gun became the party's chief symbol and service to those on the lower depths its watchword. The Black Panther party was quite successful in recruiting prisoners and black youths, male and female, to its ranks. The Panthers focused so much attention on police violence in black communities that the party became the object of efforts to suppress it across the country—efforts which involved the murders of Panther officials Fred Hampton and Mark Clark in Chicago in 1969. The disturbing deaths of Clark and Hampton were followed by the murder of George Jackson under suspicious circumstances in San Quentin prison in 1971.

Northern Racism

As the Panthers demonstrated, northern whites possessed impressive racism of their own. Nothing illustrated the depth of that racism quite so clearly as the reaction to attempts by Martin Luther King, Jr., to utilize tactics of nonviolence to effect social change in the North. A King project to eradicate segregation in housing met with vicious opposition in Chicago and Cicero, Illinois, in 1966.

Despite failures in the North, King's increasing opposition to American involvement in the Vietnam war drew criticism from some black leaders who felt civil rights workers should not comment on U.S. foreign policy. Besides formulating a Vietnam position critical of America's role in that country, King gave increasing attention to devising ways of attacking poverty, and of bringing blacks, poor whites, Chicanos, American Indians, and other oppressed peoples together. While attempting to aid a group of striking garbage collectors in Memphis, Tennessee, on April 4, 1968, King was assassinated as he stood on the balcony of his motel.

Black Nationalism

Approximately one year after the Watts rebellion, in August 1966, SNCC leader Stokely Carmichael (under the quite substantial influence of the late Malcolm X) startled the country by calling, in the midst of unprecedented interest in integration, for "black power" and a recoil from inte-

grationist goals. Just as Carmichael's call stunned SCLC and NAACP leaders, the phrase struck responsive chords, apparently deep, in the hearts of large numbers of black people, most of whom were hearing the word "black" used in a wholly different way—without derogation. Many must have vaguely sensed in "black power" the suggestion that they would soon, perhaps for the first time, have an opportunity to meet themselves. Without clarity regarding their moorings, for decades led by men with little conception of the forms of freedom proper to their people, a generation of blacks had the painful experience of living between time—that is, during a period of profound historical discontinuity. Theirs had been the first generation led by men with no observable interest in Africa.

The effect of Carmichael's call was to begin the bridging of time, the forging of a consciousness that had been lost with the domestic exiling of Robeson and Du Bois. To champion Africa, to press for the non-negotiability of certain values, to gather power to shape the destinies of a people was black nationalism as framed by Robeson and Du Bois. In a deep sense, Malcolm X had been an important link back to Robeson and Du Bois, though he had never met them.

Problems of the New Nationalism

Clearly, after integration so frenzied that not a few Negroes tried to flee their blackness, the handling of so new a thing would not be easy. Almost immediately spiritual and psychological rending occurred, causing some advocates of "blackness" to embarrass others by identifying all manner of obscenities with being black. Advocacy of black power brought to the surface serious clashes of values and a split of interest along class lines in black America. Some proponents of black power argued that black power meant black capitalism, a view promptly challenged by others.

Nonetheless, black power sentiment forced long repressed blackness toward the center of consciousness, and that meant many blacks with almost no conception of their past would be a little less inclined, whatever the cost in pain and confusion, to seek absorption into American life. There was groping, almost alone, back toward a self which some, perhaps most, had never known. Unfortunately, by the early 1970s, some leading advocates of black power abandoned the concept in favor of some form of Marxism, before exploring its meaning over time—in antebellum and in later years. For them, black power never moved beyond the status of a slogan. Sadly confused, they had confronted and abandoned black power, unaware that there is no necessary conflict between a class analysis and black nationalism, as Robeson and Du Bois had shown as early as the 1930s.

Whatever their shortcomings, the new advocates of black power had pointed out a bedeviling problem facing their people, that is, their pow-

erlessness over the centuries. Emphasis on power was timely, for huge segments of the black populace had remained in a state of virtual depression since World War II. Even the considerable advances of the civil rights movement—which among other things helped to enable seventeen blacks to be elected to Congress by 1974—had little impact on ghetto dwellers in the urban centers of the North.

In the South, a great many blacks remain too poor to enter hotels and restaurants to benefit from the public-accommodations rulings of the new civil rights legislation. Such is small wonder, for most Deep South states remain among the bottom ten in the nation in per capita income. But, greatly increased Negro voting has been a powerful factor discouraging the level of violence once exercised against southern blacks with impunity.

The 1970s

The very successes of the groups most responsible for the civil rights gains of the 1960s—SNCC, SCLC, and CORE— contributed to their decline. They had carried the fight to the most flagrant centers of repression, scoring victories almost inconceivable in prevous decades. For their efforts, thousands were jailed and beaten, still others murdered. Yet for the first time in the century, the civil rights movement had engaged the imaginations and energies of significant sectors of the mass of black people—and served as a source of inspiration for groups ranging from American Indians to many of the younger generation of whites, including women. The Berkeley "Free Speech" and the "New Left" movements contained leaders who had been active in and inspired by the civil rights movement. Before the close of the 1960s, however, SNCC and SCLC, operating on relatively unfamiliar terrain, had floundered badly in attempting to meet the needs of northern blacks. And CORE, as the decade closed, was but a shadow of its former self.

As late as 1970, when the black population had risen to nearly 23,000,000—with slightly more than half in the South—unemployment among blacks was twice that of whites. In 1972 the rate of black joblessness rose to a staggering 10.2 percent. While the black middle class was doing better than ever before—thanks largely to the civil rights movement—so much remained to be accomplished in improving the quality of life of blacks as a whole that it appeared nothing short of structural changes in the society would be proportionate to the problem. Such changes might be accomplished peacefully or violently or not at all, the latter meaning prolonged oppression for a long-suffering segment of humanity. But whatever the solution, it must be linked to forces within the larger society and, ultimately, to developments within the Third World as it continues to struggle against the imperialism and colonialism which originally placed the African in North America.

Going Through the Storm:
The Great Singing Movements
of the Sixties

There was no movement in the South that was not a great singing movement.

Wyatt Tee Walker

Everytime a new person comes forth I re-draw my parameters and borders. The whole story has yet to be told.

Bernice Johnson Reagon
Conference convener and planner

For decades experts have held that integration was the goal of the civil rights movement of the 1950s and 1960s. If that were so, then it seems such was the case in previous generations despite the efforts of W. E. B. Du Bois and a few others to go beyond the absence of racism in defining freedom for their people. However, if the meaning of music in the fight for freedom is not a factor in the analysis, evidence of an alternative view would be much more difficult to come by, at least for the period up to the mid-sixties and the rhetoric of black power.

Thanks to singer and music scholar Bernice Johnson Reagon, such evidence was dramatically presented at a Smithsonian conference, "Voices of the Civil Rights Movement," January 30 to February 3, 1980, which was co-sponsored by Howard University. Unimpressed by commentary on the movement, which almost totally ignored the role and meaning of music, Reagon invited principal singer/activists of the civil rights movement to the conference, which meant that the cream of the leadership was there, for it was something of a rarity for movement people not to sing, and many sang well. Hundreds of other activists together with scholars of African American history were present.

Because spiritual preferences in handling adversity can tell us much about the values an oppressed people might bring to freedom, the Smithsonian conference offered a rare opportunity for students of liberty to consider its potential riches when those whose culture is deeply musical are the subjects. And since so much of black music is inspired by religion, finding first expression there while conveying the worldliness of the "secular," the conference offered the opportunity for reconsideration of the

"sacred/secular" dimension of black culture. But this was implicit, one suspects, and might have led to heated debate had it been under review. Still, what occurred enables us to reflect on that dimension in new and vital ways.

Until the most recent phase of the movement, culture was not a real force in opposing racism, largely because the legal approach did not depend on the spiritual energy of the oppressed to drive it. Hence, there was no practical way, considering that approach, by which black people in significant numbers could enter the arena of struggle and become directly involved. Nonviolent direct action, by contrast, enabled tens of thousands to struggle for their rights. The leadership and large numbers of black people were at last on the same cultural frequencies, and that had not happened before.

In the fifties and sixties, "integrationist" leaders urged what no others had before, that the sacred music of their people, in the heat of battle, be relied on as a source of renewal and resolve. In fact, there was no need to call forth what was a force in its own right. A genuine cultural revolution, an upsurge of spiritual and artistic energy from below, seems now to have occurred largely on its own. Indeed, music backing nonviolent resistance was perhaps as powerful a means of fashioning a new day as guns have been in other places in our time. Yet a quarter of a century has elapsed without scholars noting the cultural tide that largely carried forward the movement. Much of this was strongly suspected by the conference organizer, but there was need to hear the voices of others on such questions.

The song leaders, most of whom had not seen each other since 1965, were to play key roles in helping former activists reconstruct, review, and analyze the movement — an act of self-reliance with all sorts of implications in its own right. In other words, those who made the history were going to interpret it, which they considered an essential step in the coming of freedom for their people. Out of it all, a primary document of unique merit would be left for others to ponder. The method used to provide the data, and much of the interpretation itself, was proper to the black community, for oral history was that method. Music was to be used to recount and largely to interpret the past.

That black culture was so powerful at a time when integrationist sentiment among southern blacks seemed so high is ironic and helps account for the failure of scholars to understand the movement.* Such

*With prophetic genius, W. E. B. Du Bois broke from the prevailing view in foreseeing a great struggle for genuine freedom being launched by southern Negroes. In October of 1946, at the Southern Negro Youth Congress, in Columbia, South Carolina, he asserted of the South: "This is the firing line not simply for the emancipation of the American Negro but for the emancipation of the African Negro and the Negroes of the West Indies; for the emancipation of the colored races; and for the emancipation of the white slaves of modern capitalistic monopoly." See W. E. B. Du Bois, "Behold the Land" in *Freedomways* Vol. 4, No. 1 (First Quarter 1964), pp. 8–9. Paul Robeson, who did more than any other

sad irony was surely uppermost in the minds of those who were about to reexamine their past.

It would not be enough, therefore, for those at the Smithsonian simply to sing the old songs, for it was common knowledge that there was singing in the movement; nor was it enough for outsiders to know that the music could somehow strengthen one's resolve, for that, too, was not unknown. The challenge before those gathered was more daunting: All were to listen to the voices around them, to add theirs and be guided by sound. If the voices were right in tone and timbre, the feeling might well be right in an ongoing process, the one reinforcing the other. In that atmosphere, personal testimony regarding the movement, it was hoped, might lead not only to revelations about sources of personal inspiration but about the significance of culture as a force for liberation. Indeed, the collective memory of movement people regarding song was the primary mode of analysis to be tested, the principal source of resonance on the occasion.

The obligation fell to Betty Mae Fikes, of the Selma Freedom Chorus, to tell her story in ways that would make it easier for those following her, to begin the process that would bind all together spiritually. And she did so eloquently, stating the challenge before them and indicating at the start that the movement that burst upon the consciousness of the nation owed a great deal to a cultural heritage that must be understood if black people and their history are to be understood.

Betty Mae Fikes recalled that the influence of her courageous grandmother was so profound that she felt she was "born into the movement." With that special relationship to its past and present, she was keen that the movement not be misrepresented: "We are taking the place prepared for us by King; so we must get our history right. We must lay the foundation for others." The importance of the movement in her life was unmistakable, and it brought back a rush of memories: "I see around me now all the beautiful people who made me what I am today. I could be calling names from now until midnight and still be calling them. The movement must be experienced before you can understand it." As "Nobody Knows the Trouble I See" was being sung in the background, she confessed: "When I'm down and out, I hum it out, sing my Gospel, hug myself real tight, and look up. Someone greater than us understands. Gospel is our heritage."

She was present in Selma one night when Fred Shuttlesworth, James

figure of the century to preserve slave songs, also noted the potential for creative social protest in the South. At a meeting in New Orleans in 1942, he observed that southern blacks "were courageous and possessors of a profound and instinctive dignity, a race that has come through its trials unbroken, a race of such magnificence of spirit that there exists no power on earth that could crush them. They will bend, but they will never break." See, Paul Robeson, *Selected Writings* (New York, 1976), p. 64.

Bevel, and John Lewis were in a mass meeting, and "This Little Light of Mine" was sung "five different ways with the same meaning." In that time of agitation for racial justice, she wanted to know what she could do to help. She said she wanted to know what she could do if not go to jail, and she sang a song she sang then, juxtaposing sadness and joy in ironic oneness:

> Nobody knows the trouble I see
> Nobody knows but Jesus
> Nobody knows the trouble I see
> Glory hallelujah

explaining, "That's my way of communicating."

Assumptions of the organizers that the story has not been told, that "if we could hear perhaps we could dissect the movement," proved sound. Emphasis on culture was ingenious, for song made it easier for speaker after speaker (and singer after singer) to recall the reason he or she had entered the movement and thereby to reconstruct an aspect of history of unique significance. Though some who participated in the conference did not say why they had joined the movement, on the testimony of those who did we must alter previously held views that the protests of the fifties and sixties resulted essentially from a sudden awakening of consciousness among southern blacks.

Prominent figures from the major civil rights organizations were present—among them Ella Baker and E. D. Nixon of the NAACP, James Farmer of CORE, John Lewis and Bob Moses of SNCC, Wyatt Tee Walker and James Bevel of SCLC, and Fred Shuttlesworth of the Alabama Christian Movement. Though numerous leaders of the movement were in attendance—indeed, most of the principals—more remarkable were the grass-roots activists who formed the great majority of the singers at the Smithsonian. The conference was the largest ongoing gathering of prominent civil rights leaders ever assembled and the first for the purpose of reflecting on past action while creating the spiritual context of the past. Since none of the participants in the five days of deliberations appeared unfamiliar with the music and its uses, their presence at the Smithsonian was an indication of the importance of culture—of spiritual and artistic values—on the civil rights movement.

NAACP representation did not rival that of SNCC, SCLC, and CORE because those organizations formed the cutting edge of black protest; so no violence was done to the spirit of the movement by the manner in which invitations to the conference were extended. Still, Ella Baker, E. D. Nixon, and Amzie Moore of the NAACP were invited, and no one can accuse those three of not supporting their people as a whole, no more than one can deny their influence on SNCC, CORE, and SCLC. Some—Fannie Lou Hamer, Amzie Moore, Rosa Parks, and Martin Luther King, Jr.—were invoked and influential in their absence. But

it was not simply the presence of people from main theaters of activity that was impressive: There was the astonishing degree to which they gave expression to old feelings in explaining why they had joined in the struggle. To do so on assignment and with conviction was an unusual expression of self-confidence and of respect for the organizer and convener, Bernice Johnson Reagon.

Proceedings were on a deeply felt level until the transition to a more subdued one the day before the conference adjourned. Bernice Reagon's planning it that way was an example of her skill in determining the emotional pace of the conference. The photographic exhibit, "We'll Never Turn Back," a project on which Ms Reagon's associate Worth Long worked, complemented the voices of the movement, and Worth, in his easygoing, appealing way, was the perfect guide through a retrospective that would have been stronger still had some movement photographers who promised photos delivered, and had it been possible to contact others who seemed to have dropped from sight.

The organizers hoped to record the movement from the perspective of those who made it, an objective determined in part by dissatisfaction—building over the years among movement people—with the manner in which scholars, journalists, and free-lance writers have attempted to tell the story. Each of the sessions was taped and filmed, which means that the most complete record to date of what constituted the culture of the movement—indeed, the movement itself—was put together over the five days of the conference. For approximately thirteen and a half hours a day—the sessions were to begin at 9:00 A.M. and last until 11:00 P.M.—many of the participants addressed the challenge to recall the impulse that had led them into the movement and to recount the essentials of their experience through song and personal testimony.

Though those in attendance were not asked to focus on strategies for attacking injustice in America, the fires of commitment flared, lighting up the house with something more than the glow of nostalgia. But the peculiar interplay of time, event, and personality—the negative thrust of the past against humanity organizing itself for social change—will determine if the activists of the sixties have played out their historical role. What is certain is that the deeper meaning of the movement is just beginning to be revealed, as is clear from a consideration of the record of the conference.

I

Songs were sung to Jamila (Montgomery Trio) by "a man who looked like he just came off the boat from Africa." The songs about the beauty of the little girl's color probably influenced her decision, hardly consciously made, to become a singer: She loved to sing "all the time, at-

tended Mount Zion A.M.E. Church of Montgomery and was called to sing with other young people at meetings." She joined the Taborians singing group of the Knights and Daughters of Tabor, an organization which "grew out of the needs of blacks to get things done that needed to be done—helping with burials, helping people get out of town." She remembers the "powerful walk" of E. D. Nixon and recalls attending the Highlander Folk School where she was accompanied in song by Guy Carawan who, together with his wife, helped create new freedom songs. They sang "Meeting Tonight" and "I'm So Glad I'm Fighting for My Rights."

Jamila smiled when she said, "About ninety percent of the songs sung by the Taborians were spirituals and gospels." It was in later years, as a member of the Montgomery Trio, that she began singing songs by Bevel and Jimmy Collier, "who used popular tunes." But numbering from fifteen teenagers to as few as five at times, the Taborians had mostly sung and heard spirituals, such as those elderly Georgia Black of Holt Street Baptist Church would sing. According to Jamila, she would "raise songs whenever she felt like it," songs like "We Are Soldiers," songs of courage:

> We got to hold up the
> Bloodstained banner
> One Day I'm gonna get old
> And Can't fight anymore
> But I'm gonna
> Fight anyhow
> We got to hold it up
> Until we die.

"Things about your culture can make you withstand the billy clubs and the dogs," Jamila believes. "You could feel how powerful it was at the time." Fred Shuttlesworth would later echo this sentiment, one that has hardly found a place in the scholarly literature of the movement.

John Lewis, whose concern for others led him to become a preacher and in time Chairman of SNCC, recalled that "though poor, we had voices. . . . We sang 'Nobody Knows the Trouble I See,' 'Steal Away,' 'Amazing Grace,' and 'Down By the Riverside.'" Told "not to get in trouble with the high sheriff," he preached his first sermon at fifteen, attended NAACP youth meetings, and met James Bevel at a Baptist seminary in Nashville. Later he and Miles Horton were introduced at Highlander where he learned songs from Guy Carawan, feeling more than anything the power of the music. The songs irked unsympathetic whites at the Trailways Bus Station in Nashville. A waitress warned: "No singing; no music!" Bevel recalled the voice of Mahalia Jackson "galvanizing the crowd" at the March on Washington and James Weldon Johnson's "Lift Every Voice and Sing," which was sung at the Smithsonian:

> Lift every voice and sing Till earth and Heaven ring
> Ring with the harmony of liberty
> Sing a song full of the faith that the dark past as brought us,
> Sing a song full of the hope that the present has taught us
>
> Facing the rising sun of our new day begun
> Let us march on till victory is won
> God of our weary years
> God of our silent tears. . . .

In Americus, Georgia, one night when the stars were out, some of Lewis's SNCC associates were told, "This will be our last night." Amanda Perdue reported that she and others started singing, "a storm came up from nowhere, water seeped under the doors, the police were frightened and let us out." And fear was relieved by song "when armed white men drove up to a SNCC retreat in Mississippi." There was need for old music and new words:

> This may be the last time,
> This may be the last time, children
> This may be the last time, I don't know
>
> It may be the last time we can sing together
> May be the last time, I don't know
> It may be the last time we pray together
> May be the last time, I don't know
>
> It may be the last time that we walk together. . . .
> It may be the last time that we dance together . . .

Putting pain to music to overcome fear and capture the experience for others occurred again and again in the movement as during slavery. The conference called for exploring memory to confront anew the sorrow and joy of that process. As this was done, one difference among the participants reflected longstanding conflict. Matt Jones of the Danville Freedom Singers, recalling North/South conflict in SNCC, complained that John Lewis had lost the chairmanship of the organization to Stokely Carmichael. Not only that, but SNCC had opened a New York office. Though SNCC had long since faded from the scene, Matt declared: "John Lewis is still Chairman of SNCC."

Music brought young and old together in Nashville when Bevel was there: "Guy got them to sing that song after a bomb threat had emptied an auditorium . . . brought them together with the song." A major influence in the singing movement, Bevel alternated between staccato-like explications of his position from a floor mike to singing on stage with others. From an aisle one morning, he began a singing tribute to Dr. King with: "Tell Coretta to call six men to bury Martin." After hearing him speak for the first time in years, Bob Moses remarked to his wife, Janet, "I see Bevel is a sharp as ever." Later he did not hear Bevel attack a remark of his about Mrs. Hamer's indebtedness to Amzie Moore. But

during the Saturday afternoon session, Bevel approached him and quietly asked if they might talk. They did when the session ended.

Hollis Watkins recalled the Mississippi Summer Project with regret and bitterness. His feelings were shared by others near the front of the audience who joined in contending that the invitation to whites to enter Mississippi in the summer of 1964 to aid in registering blacks for the ballot, in citizenship training, and in other vital areas was a mistake so serious that blacks were generally traumatized—an argument later responded to from the stage. A co-worker of Bob Moses and Curtis Hayes in McComb, Hollis credited his becoming an activist to his parents. The more he thought of it, the more he realized they were responsible for that decision. He wished he could be half the man his father was, then left the stage when his voice, in the middle of a song, could no longer contain the feeling. His regard for his parents recalled Cordell Reagon's return to his father's house and the song Len Chandler composed on that occasion, "Father's Grave," which Cordell sang:

> With my swing blade in my hand,
> As I looked across the land
> And thought of all the places I'd been,
> Of that old house that I called home,
> Where I'd always been alone,
> And of that weedy grave that held my dearest kin.
>
> Chorus (after each verse):
> And as I cut the weeds from o'er my
> Father's grave, father's grave,
> I swore no child I bore would be a slave.

II

For decades black people could not enter libraries in the South. In that way, James Forman explained, a large number were unaware of the history of struggle of their people. Encouraged to join the movement by a member of Chicago's Emergency Relief Committee for Fayette and Haywood counties, Tennessee (a subcommittee of CORE), and to join SNCC by Diane Nash, Forman argued that the history of blacks during Reconstruction and following is vital to understanding the basis of post-slavery oppression of black people. He suggested that the critical period from Reconstruction to its overthrow and the methods of disfranchisement were not well known, that the events of the fifties and sixties must not be similarly distorted or hidden from view. Speaking on a panel chaired by Stephen Henderson, he noted that, in SNCC's view, the civil rights struggle was "connected with every struggle in the world," and consequently the impact of the black struggle on different parts of the world must be determined.

The importance of news releases, correspondence, and other SNCC

documents to the reconstruction of the sixties was mentioned. Forman indicated that SNCC does not have control of many of its own documents, which are held by the Martin Luther King Center for Non-Violent Change in Atlanta, and he warned that "we should never put our records in one place." Those in the movement "must fight for written and oral history." It is "our right . . . to trace our lineage. Other people know their place of origin. We must know ours."

While Forman thinks the civil rights movement made "structural inroads into the fabric" of American life, Wyatt Tee Walker believes "nothing has changed and everything has changed." The greatest change is that it "freed our minds. Black people began to see themselves differently; that was the most significant occurrence. We freed ourselves from the slave mentality." That freedom has made a difference in how white people see us: "They no longer call us niggers." But analysis of the period "was left to people on the outside whose assessments of the movement have been at odds with the internal testimony of how we perceived ourselves."

Speaking on "Activist Communities," chaired by Howard Zinn and joined by Diane Nash-Bevel, Walker said the reason the Nation of Islam did not make more converts was that the Nation offered no music: "There was no movement in the South that was not a great singing movement." When Lawrence Guyott sharply challenged him for not mentioning the Mississippi Summer Project in citing milestones of the movement, with good humor Walker said he was "absolutely convinced" that the Mississippi Summer Project should have been mentioned.

Before singing it, Guy Carawan informed the audience that it was Miles Horton who put "The truth will make us free" in "We Shall Overcome." Carawan led everyone in singing the old spiritual—the theme song of the sit-in movement.

> We shall overcome
> We shall overcome
> We shall overcome, someday
> Oh, deep in my heart, I do believe
> We shall overcome someday.
>
> We are not afraid
> We are not afraid
> Oh, deep in my heart, I do believe
> We shall overcome someday
>
> The truth will make us free
> The truth will make us free
> The truth will make us free someday.

As young men, Pete Seeger and Woody Guthrie visited Horton's Highlander Folk School and spread Highlander songs "all over the North." At the conference, Seeger noted the genius involved in creating

new music in a foreign tongue: "People created the most astonishing new things with European language . . . some of the most important art in the world . . . out of the pain of their lives; out of hopes for their children." Describing himself as "Just a lucky person to be a link in a chain," he sang in unions in the thirties where communists were urging that blacks be brought in, and he thinks the music of the sixties another chapter in the "long, glorious struggle of music being used to protest."

The most certain evidence of the influence of culture at the conference was that speakers joined in song after song, at times to the accompaniment of a singing audience. One occurrence of this was when Shuttlesworth and Charles Sherrod were being led onto the stage, one behind the other, by facilitator Vincent Harding. Each of the three picked up the chorus while crossing the stage, then faced the audience, singing with everyone:

> Never turn back, while I run this race
> Never turn back, while I run this race
> Never turn back, while I run this race
> 'Cause I don't want to run this race in vain

Harding was well-placed as facilitator, for he not only knew the song but set the tone for the remarkable statements which followed. Beyond that, as one reflects on the scene, the conclusion is inescapable that the song selection and the impeccable timing of its introduction resulted from careful planning. But given the authenticity of the moment, there was little opportunity to reflect on the strategy behind any of the sessions. An essential aspect of that strategy was that individual singers and groups of singers came to Washington to re-create experiences rather than stand before the audience as emblems of the past.

Though song leaders were listed on the program, their orchestration of musical developments was carried out with such skill as to go unnoticed. They determined, from the audience, much of the music that came back to them from the stage (and around them) as panelists and facilitators left their seats to go there. At other times, facilitator/song leaders had the task of preparing everyone for the speech, panel, or song to come, as did Cordell Reagon one morning with:

> Woke us this morning with my mind on Freedom
> Woke us this morning with my mind on Freedom
> Woke us this morning with my mind on Freedom
>
> Hallelu, hallelu, hallelujah
>
> Walkin' and talkin' with my mind on Freedom
> Walkin' and talkin' with my mind on Freedom
> Walkin' and talkin' with my mind on Freedom
>
> Hallelu, hallelu, hallelujah. . . .

James Farmer then wove story around music, provided commentary on the uses of song during the Freedom Rides, and sang some songs.

During the attempt of the Freedom Riders to eliminate discrimination on buses and at depots in interstate travel, sixty-seven stitches were taken in Jim Peck's head, Dr. Walter Bergman was paralyzed, and there was strangling smoke from a burning bus. With death so near, even CORE decided to hold back. But Diane Nash called from Nashville to say she would be leading a group of Freedom Riders. Farmer promised to join her following his father's funeral, and he did.

A song used to help steel activists for the continuing trial—

> Ain't gonna let nobody turn me 'round
> turn me 'round, turn me 'round
> Ain't gonna let nobody turn me 'round
> I'm gonna keep on a-walking, keep on a-talkin'
> Marching up to freedom land

was disturbing to keepers of the Mississippi prison who took away remnants of comfort from nearly bare cells to punish the singers, who then sang, after initial hesitation:

> Paul and Silas bound in Jail
> Had no money for to go their bail
> Keep your eyes on the prize, hold on
> Hold on, Hold on
> Keep your eyes on the prize, hold on

Farmer remembered Parchman prison from Leadbelly and said "everyone became a song writer: we would have been scared if we hadn't sung. . . . We wrote new words to old songs." Prisoners at Parchman sang gospels and spirituals but "not freedom songs," a distinction that will be challenged by some. Wearing a patch over one eye following recent surgery and looking out over the audience of blacks and whites, Farmer welcomed whites "back into the marriage" from the "temporary separation."

III

Despite the cool formality of technology on display and brick and mortar of spacious construction, the singers sang with the spirit and passion of movement days, inspiring one leader to remark:

> Man, after hearing singing like that, I could [pointing through the lobby to Constitution Ave. outside the Smithsonian] walk right through a mob out there and never know it was there.

Nor was the inspiration of Fred Shuttlesworth dampened when he spoke of the meaning of faith in Birmingham. Referring to an attempt on his life and conscious he might push emotion to overflowing, he stopped a sermon that had built to intensity in a flash. One of nine

children and helped raised by a stepfather, his mother saw to it that he "came to know Christ: Had I not gone to Birmingham and known Bull Connor, I wouldn't know as much about Jesus Christ." He spoke of the "only man to challenge Bull Connor and live" being castrated and dashed with turpentine, "which cauterized the wound: he lives today." Thus, Shuttlesworth is "in the struggle for life. If you can't take it you can't make it and we had to go on through the storm." Introduced as a "legend" by Vincent Harding, Shuttlesworth was as impressive a man as any at a gathering where a lot gathered, with impressive women.

Cleo Kennedy, while looking at him, had announced his presence, an upper register the flow of silver on night air as she sang: "God sent Shuttlesworth to Birmingham." Her singing and that of Carleton Reese (both of the Alabama Christian Movement Choir) caused Shuttlesworth to "feel like being in the movement for the first time in a long time. I made those young people." For him

> It's been a great honor and a blessing to have lived in the generation of Martin Luther King. . . . Everybody talkin' about Heaven ain't going there. I choose brotherhood.

Charles Sherrod had never talked this way before. He said that the belief in Jesus kept him strong and recalled having "pulled . . . from deep down inside: 'Come on death. Where is thy sting; grave where is thy victory?'" He conveyed the sense of the church as movement, arguing that "There was rebellion against the church but those who rebelled were the children of the church." He added that "All black people had was the church and white folks tried to take that." He feels a need to abandon forever symbols of religion in favor of living it and wants to see the church encompass "all our needs." When Harding, who introduced him as a legend as well, turned to Sherrod and asked, "What about the song?" he sang, to hand-clapping rhythms of the audience, his own "Nothing But a Soldier":

> Daddy never knew me, never wiped my tears,
> Never saw me crying, never knew my fears
> Working for the white man, sun-up 'til sun-down,
> Came home wet and tired, he would always wear a frown;
>
> I became a young man, proud as I could be
> Used to hear them saying, "Hang him on a tree,"
> Tree limb couldn't hold me, segregation tried
> Jumped the gun for freedom, getting closer every stride.

The importance of the past to the life of the movement was illustrated by the presence at the Smithsonian of Ella Baker, whose life spans the period from the founding of the Niagara Movement by Du Bois in 1905 to the present. A living link with the past, she can identify with the changing face of the movement because she has knowledge of human nature available to one who has lived long and is heir to the best experiences of her people. With concern for others so early shaping her charac-

ter—since the age of six—it must at times seem to Ella Baker that she has always been in the struggle. For her, it was the example of her mother. For others, especially those in SNCC, which she helped bring into existence, it was her example. A participant on the "Ethics and Morality" panel with E. D. Nixon and Bob Moses, she believes "he who struggles for those who have less enriches himself. If people can't trust you; if there isn't something you stand for, life is meaningless." The conference could help participants "renew their strength. . . . The struggle is eternal until the battle is won."

E. D. Nixon's life also symbolizes the continuity of the struggle for black liberation in this century. When considered "just furniture," he learned lessons as an organizer for A. Phillip Randolph's Brotherhood of Sleeping Car Porters. Decades later, he telephoned eighteen ministers before one, Martin Luther King, Jr., agreed to hold a meeting at his church following the arrest of Rosa Parks for sitting in the "white section" of a bus in Montgomery. Mr. Nixon believes with "hard work, faith in God, a good family life, and economic sense to back up 'We Shall Overcome,' we shall be free. . . . We have come a long way just to make a few steps." Even so, the "black man was reborn" with the Montgomery bus boycott. For him, participation in the movement has been "the greatest honor in my life."

There was conscious shaping of old song:

> Wade in the water, wade in the water children
> Wade in the water, God's gonna trouble the water.
>
> Jordon River is chilly and cold
> God's gonna trouble the water
> It chills the body but not the soul
> God's gonna trouble the water.
>
> Tell me who's that comin' all dressed in white . . .
> Well it looks like children fighting for their rights . . .
>
> Tell me who's that comin' all dressed in red
> Well it looks like children Martin Luther King led . . .
> Wade in the water . . .

as well as the abstract symbolism of:

> Joshua fit de battle of Jericho, Jericho, Jericho
> Joshua fit de battle of Jericho
> and de walls came tumblin' down
>
> You may talk about yo' king of Gideon
> You may talk about yo' power of Saul
> Dare's none like good ole Joshua
> at de battle of Jericho.
>
> Up to de walls of Jericho
> He marched with spear in hand.
> Go blow them ram's horns
> Joshua cried, 'Cause de battle am in my han'.

After Dorothy Cotton (SCLC) led the audience in singing, she then re-marked:

> We began tonight singing the songs of our fathers and mothers, of our
> ancestors. Citizenship classes began with the songs of our ancestors. . . .
> Fannie Lou would stand up and tell tales of intimidation of people on
> plantations and sing her songs. . . . She went back and changed the face of
> those towns. . . . Topsie Eubanks of Macon, Georgia, went back to teach
> others to vote. She was a poll watcher at home sixty to sixty-five years of
> age. . . . We sang a lot of songs.

The presence of so many movement figures acted as a check on the
degree to which the past might be distorted and enabled personal testi-
mony to be related in a new and richer light. The spiritual resonance
achieved suggests distortion was at a minimum. "They just took the
Smithsonian," Jamila remarked, "and put it down in Mississippi."

> They turned the whole thing into a church. You knew when you saw people
> walking up there that that's what they were doing. I do believe I was among
> them in doing that.

In that atmosphere, Sam Block helped re-create the mass rally effect of
Mississippi in the sixties, speaking of developments as in a movement
scene, those in the audience swaying left, and then right, as one.

The movement laid the basis for a new awareness of black culture,
infusing it with fresh symbols of struggle even as the shaping influence
of the past was felt. This reciprocity between past and present, a process
perhaps too immediate to have been fully grasped at the time, was car-
ried out at the Smithsonian and an effort made to determine how devel-
opments before the recent rights struggle determined aspects of its char-
acter and influenced those who waged the struggle. Thus, understanding
the values of their ancestors, from whom scholarship has attempted to
separate them, is indispensable to understanding the struggle for black
rights addressed by those at the conference.

Skepticism about scholarship on the movement is justified because
the cultural dimension, for all its power, and the ancestral past, for all
its presence, have not been appreciated by scholars. The "integration"
objective that scholars propound is far too superficial an explanation of
the values contended for by the great majority of activists in the post–
World War II era, which helps explain why SNCC recoiled almost in
horror before the prospect of "integration" in conventional terms.

IV

A sign of change came and swiftly went but left its imprint on those at
the conference. A few male singers were rebuked for warmly gentle
remarks that are accounted sexist today. Black women in numbers larger

than some realize or are comfortable with regard themselves as feminists today, and some were present at the conference. If there is an interesting approach to feminism among blacks, it is likely to be found among former activist women. Still, the issue was not on the agenda, and to have placed it there would have accorded sexism the attention it receives today among blacks rather than during the sixties.

Use of the term "black" was widespread at the conference—a marked change from the sixties when "Negro" was practically unquestioned before Stokely's call for black power. But one should not assume the use of black music at the conference reflects a conscious development since the sixties, for such consciousness could not produce appropriate preferences in song or convincing performance style. Only what Harding calls "living tradition" makes communion with the past, and the application of its values to the present, the richly rewarding experience it was in the struggle and at the Smithsonian.

That the flow of time is uninterrupted was indicated by the anniversary of the sit-ins on Friday, February 1, the third day of the conference, 1980. Yet the deepest kind of resistance to social justice exists in the South, as made clear recently when four white men and a black woman were assassinated following the retreat of the police from a Greensboro, North Carolina, neighborhood. Within minutes of their departure, Klansmen and Nazis entered the neighborhood where an anti-Klan demonstration was being mounted and committed the most cold-blooded political murders since Chicago police, under the direction of States Attorney Edward Hanrahan, carried out a plan to murder Fred Hampton and Mark Clark in their sleep.

An aspect of the sixties that may be irretrievable is the faith some activists had in law enforcement at the federal level. Even when stretched to the point of breaking, there was the belief that there might be some redeeming worth to the Federal Bureau of Investigation. James Forman, once heard to shout, "The F.B.I. is going to hear about this!" at the Smithsonian called for the dissolution of that organization and the CIA. And Fred Shuttlesworth, who once had some faith in the FBI, confessed at the conference that he did not then realize "crooks" comprised the agency.

Answers to the question, Is the spirit of the movement still alive?— not an agenda item—were provided in the aisles, in the back of the auditorium, and in the lobby leading there. Mike Thelwell came up an aisle, clasped the hand of Forman, pumped it, smiled at length, then pumped it again and again while Forman remained seated, smiling in turn. Stokely entered before proceedings ended and stood in the rear where he and Thelwell embraced, drew back and looked at each other, and embraced again.

One remembers, finally, Bob Moses requesting that Bernice have the audience sing "Mrs. Hamer's favorite song." As Bernice led, the audience joined in with

This little light of mine, I'm gonna let it shine (3)
Let it shine
Let it shine
Let it shine

The light that shines is the light of Love
Lights the darkness from above
It shines on me, and shines on you
And shows what the power of love can do

I'm gonna shine my light both far and near
I'm gonna shine my light both bright and clear
Where there's a dark corner in this land
I'm gonna let my little light shine

Then Moses, in a ceremony of recall and renewal, guided each partici-
pant inward to his or her "little light." Those moments were the only
moments of silence, even though he talked, over the five days of the
conference.

A ride to Indianola and "old church songs being sung all the way"
was recalled. Moses believes Amzie Moore, who welcomed him to Cleve-
land, Mississippi, to organize for SNCC, prepared the way for Fannie
Lou Hamer as E. D. Nixon had for Rosa Parks. While reflecting on his
years in Mississippi, Moses took the occasion to address Hollis Watkins,
Willie Peacock, and Curtis Hayes on white participation in the Missis-
sippi Summer Project, pointing out that white liberals must also be con-
fronted, that one must not give up because of difficulties resulting from
white participation in the movement.

Amzie's role and his own were explained "in light of Paul Robeson's
position." A section of an essay written by Robeson in 1955 was read:

> But the common people, even in the most difficult hours, never gave up.
> The Negro people built their schools, churches and small business, their
> fraternal orders and civic organizations. They took pride in the struggling
> all-Negro town of Mound Bayou. They fought oppression with whatever
> weapons they had. That's what the valiant Negroes of Mississippi have
> done. They have, as it were, for the past 80 years been preparing for major
> battles—husbanding their strength, preparing their leaders, mastering the
> tactics of popular democratic struggle. The liberation currents abroad in
> the world have stimulated the freedom-yearnings of Negroes and many
> veterans of World War II are impatient for the realization of the "promissory
> note" of equality in the name of which that great anti-Hitler conflict was
> waged.

Travel abroad during World War II helped strengthen Amzie's desire
to lead a movement of his people. Referring to Robeson's thesis that the
way was prepared for protests of Mississippi blacks long before the
fifties, Moses said Amzie was planning change before SNCC entered the
county. In fact, he set SNCC principles in Mississippi according to a

prescription for change from Amzie and again quoted Robeson in explaining his own relationship to the movement:

> My ancestors in Africa reckoned sound of major importance; they were all great talkers, great orators, and where writing was unknown, folktales and oral tradition kept the ears rather than the eyes sharpened. I am the same. I always hear, I seldom see. I hear my way through the world. I always judge by sound.

Ella Baker and Amzie were responsible for Bob's involvement in the movement. He remarked that "Amzie was one of the people who returned from World War II that Robeson was talking about."

> Amzie heard Japanese propaganda about blacks and returning wanted to do something. It was Amzie who opened the door to us. He had faith in young people. Amzie was supported in part by the Southern Conference Educational Fund. The Post Office [in Cleveland, Mississippi] cut him down to two hours a week for years. Amzie was my father in the movement. He taught me how to organize. He was there as a spark for his people. Amzie had the vision of the voter registration project. I listened to Amzie. I was like Paul Robeson. I heard my way through the world. Amzie has always been there. He was there before we came, while we were there, and after we left.

Index